PISANELLO

Giovanni Paccagnini
PISANELLO

Phaidon Press

Translated by Jane Carroll

Phaidon Press Limited, 5 Cromwell Place, London sw7 2sL

Published in the United States of America by Phaidon Publishers, Inc.
and distributed by Praeger Publishers, Inc.
111 Fourth Avenue, New York, n.y. 10003

First published 1973
Originally published as *Pisanello e il ciclo cavalleresco di Mantova*
© 1972 by Electa Editrice® - Industrie Grafiche Editoriali S.p.a., Venice
Translation © 1973 by Phaidon Press Limited

isbn 0 7148 1556 x
Library of Congress Catalog Card Number 72-86573

Printed in Italy

CONTENTS

THE SALA DEL PISANELLO IN THE GONZAGA COURT: SUCCESSIVE
ALTERATIONS AND REDISCOVERY

An isolated reference to Pisanello's most important mural painting executed for the
Gonzagas at Mantua occurs in some documents dating from the late fifteenth century,
about thirty years after the artist's death. Mysteriously, there is no other reference to
the Sala del Pisanello before or after this. Three short letters, written on 15 December
1480, all give the news of the collapse which had taken place the previous night in a
room in the Gonzaga palace known as the Sala del Pisanello, when part of the timber
roof structure of the room had given way.[1] The news is reported with no more than a
bare outline of the facts, which gives a sense of drama when related to the importance
of the discovery.

'Yesterday evening', wrote Filippo Andreasi from Mantua to Marchese Federico
Gonzaga, who was at Goito at the time, 'at about the first hour of the night, a beam and
part of the ceiling in the Sala del Pisanello came down. According to Job, the remain-
ing beams are rotten in the walls and are unsafe. Early this morning I went with Mae-
stro Luca to arrange for something to be done so that the rest of the roof does not give
way: this and other steps will be taken.' The court architect Luca Fancelli also informed
the Marchese of the collapse: '...as I understand you have been informed, a main beam
in the Sala del Pisanello has fallen in, with part of the ceiling, since all the beams were
fastened together in the past because they were rotting in the walls, and they now have
no support. I am having them propped up and the rest of the ceiling pulled down, so
that it cannot fall on anyone, and then your Excellency will decide what is to be done...'
Marchese Federico replied immediately to Andreasi: 'We have read what you have writ-
ten to us regarding the partial collapse of the Sala del Pisanello and the steps you have
taken to prop up what remains, so that no further collapse of the kind can occur: we
are pleased with the measures you have taken in this respect and must commend you
for it; on our return we shall give what we consider to be the necessary orders: every-
thing possible should be done to preserve it.'[2] After this correspondence there is no other
mention of the Sala del Pisanello and no further news of that disastrous night of 14 De-
cember 1480. Not even an incidental reference to the room is to be found in the docu-
ments relating to the Gonzagas which have come down to us, while the wall painting
and the actual structure of the room itself were to disappear without trace during the
innumerable alterations carried out on the court buildings from the second half of the
fifteenth century onwards.

The three letters of 15 December 1480 form a strangely ephemeral correspondence, but they are a clear indication that the Sala del Pisanello was still at that time held in high regard, even though for some time Mantegna's classicism had reigned supreme at Mantua. Nevertheless they have tended to be regarded as no more than interesting documentary evidence of just one of the many works of art at the court of Mantua which time or man have destroyed.

A few Pisanello scholars were prompted to search among Pisanello's rich graphic repertoire for drawings which showed iconographical and stylistic characteristics similar to those of the well-known Gonzaga medals, some of which appeared to have been prepared as studies for a mural painting which was probably the one in the lost room in Mantua. However, the documents were never used in connection with the main object of the research, the Sala del Pisanello itself, or any traces of it which might have still existed in the confusion of interlocking and superimposed structures of the Ducal Palace at Mantua. The fact that the room had disappeared seemed to be taken implicitly to mean that it had been destroyed. When Rossi published in the last century the three letters which proved the existence in 1480 of the Sala del Pisanello in the Gonzaga court buildings, he tried to explain its subsequent disappearance by suggesting that the room had been 'involved in the destruction of the Ducal Palace at Mantua, when Giulio Romano was given the task of modernizing it according to current taste.'[3] It is surprising, however, that what was no more than a conjecture could have been accepted without any objections or even reservations for almost a hundred years, to such an extent that the original hypothetical nature of Rossi's supposition has been imperceptibly altered to that of incontrovertible fact. Thus all further enquiry was precluded by a statement which had carelessly given the idea that the question was by this time settled once and for all and the documents of 1480, far from encouraging further research into this important matter, more or less became its tombstone.

A number of factors which might have been useful pointers in locating the Sala del Pisanello passed unnoticed. The connection established between the disappearance of that room and the works carried out by Giulio Romano in the first half of the sixteenth century perhaps diverted attention to the new buildings which were constructed in that period on the banks of the Mincio, around the magnificent medieval architecture of the Castello di S. Giorgio. This new Gonzaga palace was called the Corte Nuova, to distinguish it from the older Bonacolsi and Gonzaga palaces built in the thirteenth and fourteenth centuries around the Piazza di S. Pietro, which were collectively known as the Corte Vecchia.[4] Since certain buildings had been demolished or altered to make way for the new ones designed by Giulio Romano, it could be assumed that the Sala del Pisanello had been lost in the demolition of these old buildings, or during the radical transformation of the Castello di S. Giorgio. This Castle was the hub of the Corte Nuova and its rooms had been largely redesigned by Giulio Romano in 1531, on the occasion of the marriage of Duke Federico Gonzaga to Margherita Paleologo del Monferrato.

Every attempt at identifying the site of the vanished room has in fact always referred to the Castello di S. Giorgio.[5] Yet one had only to examine the building work done at the Gonzaga Palace prior to Giulio Romano's alterations, and to consider in an historical perspective their development during the fifteenth century, to realize that the

Sala del Pisanello was unlikely to have been located in the Castle. The Castello di S. Giorgio, constructed by order of Francesco Gonzaga by Bartolino da Novara between the last years of the fourteenth century and the beginning of the fifteenth, had originally been intended for military purposes, to form a strong defence for the approach road linking the old town with the village of San Giorgio on the opposite bank of the Mincio.[6] This imposing example of late Gothic military architecture was a massive fortress with dimly lit rooms, altogether unsuitable for the residence of a prince; and thus it had remained for about fifty years. Towards the middle of the fifteenth century Marchese Ludovico had the interior of the castle completely renovated by Luca Fancelli, so that he could transfer his residence there from the fourteenth-century buildings standing round the old Piazza di S. Pietro, where the Gonzagas had lived until then. The work of radically transforming the castle interior continued up to the 1480s and as well as Fancelli and other artists, it is known that Mantegna took part with some important mural paintings, such as the cycles in the chapel and in the Camera Picta.[7]

After modernization the magnificent Castle apartments became the object of universal admiration. They had moreover been made perfectly sound, since the rooms were now roofed with strong masonry vaults. It is therefore impossible to believe that in 1480 the Castle could have still contained a room—the Sala del Pisanello—in such a precarious condition that it even endangered the life of the princes who had been living there for over twenty years. On the contrary, the serious condition of the roof timber of the Sala del Pisanello which caused the collapse of the ceiling (the beams were 'rotten in the walls' and therefore had been unsafe for some time), should have pointed to the fact that the room could not have been in a building which had been recently modernized, but rather in some part of the court which had been left for a long time without maintenance and exposed to progressive deterioration. This area must have been somewhere within the Corte Vecchia comprising the imposing Gothic buildings constructed by the Bonacolsi during the last years of the thirteenth century, such as the Palazzo del Capitano and the Domus Magna, around which other buildings were erected by the Gonzagas during the fourteenth century. The Gonzaga family had lived continuously in these palaces, which were altered and enlarged during the fourteenth century and the first half of the fifteenth, from the year 1328 when they had driven the Bonacolsi from Mantua until 1459 when Marchese Ludovico transferred his residence to the new apartments in the Castle, on the occasion of the Council which Pius II held in in Mantua. It was therefore logical to suppose that the room decorated by Pisanello was in that older part of the palace, where fragments of mural painting done in the second half of the fourteenth century and the early fifteenth century showed through in many places on the various layers of masonry of the old buildings. These fragments, together with certain documentary evidence, proved that late Gothic painters had been intensely and continuously active at the court of Mantua during that period.[8]

These, briefly, were the factors which a few years ago led me to believe that a systematic search for the lost Sala del Pisanello should be carried out among the buildings of the Corte Vecchia. After some exploratory investigations in various parts of these buildings, it became clear that the most promising structure was that of a minor late Gothic building which stood beside the Palazzo del Capitano. Its ground floor rooms

had been altered by Isabella d'Este when she had established her new apartments there on the death of her husband in 1519,[9] and here graceful pictorial motives had already been discovered which reflected that taste for heraldic and emblematic decoration which was part of the culture of early Quattrocento court life.[10] The façade of this edifice, built by the Gonzagas in the second half of the fourteenth century and overlooking the garden beside the Palazzo del Capitano, had been altered over and over again until it had become a plain wall punctuated by rectangular windows. However, attention was drawn to it by traces of the original late Gothic construction which had been revealed at the end of the last century when the plaster was removed from the oldest façades of the Corte Vecchia buildings. At ground floor level one could detect the arches of a portico of the same date as the first Trecento building. This had been filled in, as could be seen from the nature of the masonry, in the fifteenth century, when the wall of the upper storey had been heightened. It was possible to trace on the wall the outlines of three large ogival windows similar to those which the Gonzagas had made in the walls of the Palazzo del Capitano, in place of the round-headed windows which had originally been used in the Bonacolsi building. The pointed arches of the large windows, which were later walled-in and replaced with the present rectangular openings, stood out in particular because of their exceptionally large size in relation to the quite low height of the façade. Perhaps partly because of the prevalence in this façade of open over solid areas, the pointed windows were mistakenly believed to be the remains of a loggia, whose interior it was thought was transformed during the last century into the Neoclassical room known as the Sala dei Duchi, or the Sala dei Principi.[11]

However, the only princely thing about this room (Fig. 235) was its name (Room of the Princes). This had been given to it because of the eighteenth-century frescoes of the large wall frieze enclosing, within Baroque frames and garlands, portraits of the Gonzagas from the first Captain Luigi who took power in 1328, to the last Duke Ferdinando Carlo who lost it ingloriously in 1708. A guide-book of the early nineteenth century relates that the portraits were 'covered with whitewash in the year 1796 and suffered considerable damage, but in 1808 they were diligently cleaned and then restored'.[12] However, what really happened was a complete *rifacimento* of the portraits and the damaged decoration during which a commonplace composition in tempera was superimposed over the fresco of the frieze, its academic Neoclassical style giving the Sala dei Principi a mediocre appearance which it retained up to our times. At the same time the height of the room was reduced by the placing of a reed ceiling about one and a half metres below the level of the earlier wooden ceiling.

Interest in this room was centred on the valuable evidence of its earliest history provided by the traces of large late Gothic openings visible in the façade and by their relationship with the solid surfaces of the other walls. From these and certain other signs, it was possible to guess what the function and the architectural form of the room must have been in the first half of the fifteenth century: a spacious room, in which the three contiguous interior walls formed a vast, integral surface area strongly illuminated by the light coming through the large central windows of the exterior wall. Since nothing was ever done without a purpose, this construction seemed to have been planned as an area for a large and important mural painting. The best possible conditions had been

created in order for it to be seen, the light having been adroitly distributed over the wide areas of the walls by means of windows which were quite out of proportion in comparison with the rather small dimensions of the façade. However, investigations carried out in the early part of this century all seemed to point to the fact that nothing was left of the old mural painting apart from 'the trace of a Gothic motive of geometric patterns' surviving under the roof above the present reed ceiling.'³ This decoration turned out to be a mixtilinear Gothic motive from the end of the Trecento, but it related however to the older structure of the room, which had originally been a loggia opening on to the garden and covered by a saddle roof, as could be inferred from the course of the residual geometric decorations. When in the fifteenth century the loggia was transformed into a room by raising the front wall containing the large windows, it was given a horizontal wooden ceiling. The holes made for the supporting beams could be clearly seen above the nineteenth-century reed ceiling.

Might not this be the late Gothic room whose wooden ceiling had collapsed in 1480? Curiosity was further roused by the clue provided by a half-length drawing of a woman which was found traced in charcoal on the fragment of an ogival arch which was probably that of the door which led into the adjacent Palazzo del Capitano. The drawing (Fig. 238) was almost totally scraped away and was partially covered with a red colour so its quality could not be assessed, but it did present certain features belonging to a form of expression born in that climate of courtly culture of the end of the Trecento, in which Pisanello had been trained as an artist. The wall where this drawing was discovered was therefore immediately explored but with results which were totally disappointing. The old masonry, laid bare by the removal of the modern coat of plaster, had nothing to show but a layer of dark *arriccio*, devoid of decoration. The investigation was then extended to the other walls, the plaster being removed from the surfaces included between the bottom edge of the eighteenth-century frieze and the floor, but with equally negative results. The plaster on these areas turned out to be of the same kind as that on the nineteenth-century reed ceiling, and could therefore be assigned to the last, Neoclassical, *rifacimento* of the Sala dei Principi. This fact later made it easier to understand the reasons for the disappointing lack of any trace of decoration on the lower parts of the walls, where the older layers of plaster, apart from some parts of undecorated *arriccio* which had remained firmly stuck to the masonry, had been demolished and replaced during the last century.

In the meantime, however, some other very interesting clues had emerged which gave a new impetus to the search: in the areas of *arriccio* existing on the long inside wall it was noticed that here and there were traces of lines disappearing under the layer of eighteenth-century *intonaco* which had not yet been removed; it was not possible to distinguish any meaningful figures, but it was felt that they must be the remains of *sinopie* made for a fresco. Part of this *intonaco* was then removed from the bottom border of the frieze, and at last a first concrete result was attained in this long search: the discovery of a *sinopia* showing a group of trees (Fig. 236) whose foliage was still largely covered by the eighteenth-century frieze and which from its size seemed to be part of a large-scale composition. The Pisanellian *ductus* of the *sinopia* could well be taken as confirmation of the hypothesis which had prompted this search; but it also became clear at this

point that if any parts of the decoration corresponding to the *sinopia* were still in existence, they must lie hidden under the *intonaco* of the eighteenth-century frieze which now covered the upper part of the walls and the area under the roof where the top of this frieze had been relegated when the reed ceiling was installed. It was therefore essential that no part of the room should be left unexplored, and since there had to be a brief interruption in the work in the Sala dei Principi—for first of all there was the problem of how to salvage the frieze with the Gonzaga portraits which had been superimposed on the older surfaces and which, because of its historical interest, could not be destroyed—the search was continued meanwhile in the attic. In the dark, damp space between the nineteenth-century reed ceiling and the modern roof, the wall surfaces, which were in an advanced state of decay, still retained the remains of plasters of various eras, all covered with a mixture of dirt streaked by rain water which dripped through the roof (Fig. 239). After the attic had been cleaned, the same frescoed geometric motives originally believed to be the only remains of the decoration of the old room came into view again on the two short walls. The late Trecento decoration reached as far as the two slopes of the old saddle roof, whose rafters would formerly have been visible, until the time when this entrance loggia to the palazzo's *piano nobile* was transformed into a room and covered with a horizontal wooden ceiling. The *intonaco* of the eighteenth-century frieze in the Sala dei Principi reached as far as the holes made for the beams which had once supported the now lost timber ceiling, and a band of about a metre in depth remained on the three interior walls, above the reed ceiling. In some places where the eighteenth-century *intonaco* had fallen off it was possible to discern fragments of another frescoed frieze depicting a fictive polychrome marble hanging which, because of its resemblance to other decorations carried out in the Gonzaga Palace in the late Renaissance, could be dated around the last decades of the sixteenth century.

But it was some traces which emerged on the wall common to the attic of the adjacent Sala dei Papi which provided the first proof of the existence, in the areas covered by the frieze of Gonzaga portraits, of vast decorated surfaces executed by Pisanello. On this side of the room, after part of the superimposed layers of eighteenth- and sixteenth-century *intonaco* had been removed, an older, very dirty, decorated surface was discovered, which could be construed as part of a fifteenth-century frieze painted on the wall up to the level of the lost wooden ceiling. It was seen that this frieze continued along the wall when the superimposed *intonaco* was removed, bringing to light a dusty surface which, after cleaning, revealed the outline of a frescoed frieze of incomparable elegance. Ribbons, flowers and leaves fluttering in serpentine rhythm stood out against the dark background, winding round faintly-outlined figures of animals: a dog, a fawn and an eagle, all known to be heraldic devices of the Gonzaga family (Fig. 240). The stylistic affinity of this motive with that of certain decorative designs in the Vallardi Codex in the Louvre was obvious and it was quite surprising to note that the frieze appeared to be unfinished and that the *spolvero* technique had been used (Fig. 244). Another cause for surprise was the discovery of an obviously intentional rectangular gap, half-hidden under a coat of limewash, near part of the frieze which had been destroyed by the insertion of a beam into the wall when the roofs of the Sala dei Principi and the Sala dei Papi had been renewed. When the surface was cleaned it could be clearly seen that the edges of

this gap had been chiselled; at the bottom of the gap were several drips of glue demonstrating that it had been produced by a crude attempt at detachment (Figs. 243, 244). It is difficult to understand why this was attempted, especially in view of the apparently illogical and quite casual choice of fragment for removal.[14]

After this important find the search assumed a feverish rhythm and discoveries followed one another in quick succession, as though a barrier which for centuries had guarded the secret of this room had suddenly fallen. The excitement was great when the eighteenth-century *intonaco* was completely removed on this side of the attic and it was realized that the beautiful Pisanellian frieze survived on almost the whole wall, and that it comprised the end of a fresco depicting a Battle, whose pictorial quality, notwithstanding the many gaps and the poor condition of the surface, left not the slightest doubt as to the identity of the artist who had produced it.

What follows in this chapter is a brief account of the long research and restoration operations carried out in order to uncover and retrieve what remained of the decoration of the Sala del Pisanello and of every other piece of evidence documenting the vicissitudes the room had undergone over a period of more than five centuries. In order to explain more clearly the various stratifications which had formed over the years on the walls of the room and the position of the various finds in relation to the nineteenth-century redesigning of the room's interior—which was the last and most unfortunate of a series of radical transformations carried out from the fifteenth century onwards—a list is given in the notes[15] of the main alterations and of the location of the fragments recovered in the Sala dei Principi and in the attic above. The first painted surface to be found was, as we have seen, the end part of the great Battle, painted on the wall adjacent to the Sala dei Papi, and whose upper part, measuring over half a metre in depth, had been confined to the attic area by the erection of the reed ceiling in the last century. But even over this limited surface area, situated on the highest point of the wall, Pisanello's micrographic vision had concentrated a great quantity of details some of which, after cleaning, were found to be miraculously well preserved. This stage of the work, when the Quattrocento surfaces which had survived in the attic were being uncovered, brought to light the undulating spirals of the heraldic frieze, the geometric armour of warriors incised on the background, black as night, lance-shafts crossing and breaking at the impact of opposing formations, figures of trumpeters and standard-bearers, and the emblematic portraits of two bare-headed *condottieri* (Fig. 57). The initial scepticism which had arisen from the first, unsuccessful investigations carried out in the room, now turned into almost exaggerated optimism regarding the possibility of bringing back to light vast surfaces of the vanished decoration lying under the eighteenth-century frieze which spread over the four walls of the Sala dei Principi and also partly covered the attic area. When all research operations were concluded and a set of new mural works by Pisanello, outstanding in quantity as well as in quality was uncovered, it had to be admitted that the surviving frescoes were only a part, albeit an important part, of those for which the *sinopie* had been carried out: of the painted surface only about two-thirds of the great Battle had survived, together with two smaller fragments which continued over the two contiguous walls. But the condition in which the decoration was found had not come about just by chance, as we shall see when examining the technique used for

these mural paintings and what happened to them during the successive stages of their execution.

After the top part of the Battle scene had been found, it was noticed, as the salvaging operations in the attic proceeded, that the fresco continued round on to the adjacent left hand inside wall with a fragment, full of gaps, on which the heraldic frieze spread for almost another two metres, its motive terminating above the heads of some warriors and a fluttering standard (Fig. 246). Further to the left the iconography of the fresco took on a worldly tone with the representation against a dark background of a canopy under which two women's heads were outlined (Fig. 247), very beautiful but somehow pathetic because of the sorry condition they were in. One was partly disfigured by holes and lopped off by the reed ceiling, the other had its upper half missing where the painted surface had been destroyed during the erection of the nineteenth-century ceiling. To the side of these two figures, on the rest of the long interior wall, the *intonaco* of the fresco was totally missing and only the *arriccio* remained, covered with the same dust as that found on the frescoes, though this did not obscure the *sinopie* where Pisanello had outlined a vast landscape background with elegant late Gothic architecture (Fig. 248). The *sinopie* were however badly damaged by falls of plaster and above all by the holes made in the wall for the insertion of the new ceiling. Also on the shorter wall on the Palazzo del Capitano side, the *arriccio* was found to bear *sinopie* depicting some trees and the towers of a castle (Fig. 249) which stood out beyond the ridge of a mountain landscape. Nothing remained however, apart from a small fragment of dark *intonaco*, on the external wall where the masonry had been completely renewed.

While these salvaging operations were going ahead in the attic, work was begun on the restoration and removal from the Sala dei Principi of the huge eighteenth-century frieze with the portraits of the Gonzagas. By probing the *intonaco* at various points, it had been possible to verify the existence of decorations by Pisanello corresponding with those found in the attic.[16] Finally it was also possible to take away the residual layer of plaster superimposed on the Quattrocento surfaces, beginning with the wall on which the end part of the Battle had already been discovered in the attic area. It was then realized, with astonishment and almost incredulity, that Pisanello's fresco had survived under the eighteenth-century frieze on the whole surface of the wall (Fig. 250); a large gap interrupted it to the right of the central door, but on the *arriccio* the *sinopia* relating to the missing painted part was preserved, a beautiful drawing of a knight in a large fur hat. Through the dense layer of dust which covered the surface, interlocking figures of fighting warriors could be glimpsed. After careful removal from the Quattrocento *intonaco* of the very top layer of this accumulation of dirt and whitish efflorescence, it was understood what a providential part it had played in preserving the decorations—and only then did the shape of certain details become more clearly discernible: a dead warrior lying on his back on the ground and another bending over at his feet (Fig. 251); a knight clad in armour and vizored helmet—outlined against the black background but still partly covered in the middle by a fragment of sixteenth-century plaster (Fig. 253); a superb lioness (Fig. 252) with her cubs (the lion, which appeared after cleaning, was at this stage still immersed in dust and invisible). It was saddening to see a pictorial cycle of such great importance reduced to so wretched a state: it seemed that what was

left was nothing but a worn shadow of its former beauty showing through the faded impressions of figures remaining on the walls. But after the surfaces had been reinforced and cleaned, it transpired that this initial pessimism was only partially justified.

The large fresco, painted on the wall which was common to the Sala dei Principi and the Sala dei Papi, extended without a break on both sides of the Battle in two other fragments, the one to the right depicting a rugged mountain landscape, the one to the left a group of warriors in cataphract gathered round an elegant knight whose face was disfigured in the middle by a deep hole (Fig. 254). Fortunately the lower part survived of the faces of the two female figures which had been found in the attic, barbarously cut in half by the reed ceiling. These were the last painted surfaces to be uncovered in the Sala del Pisanello; on the other surfaces beautiful *sinopie* came to light, but nowhere was there any trace of the corresponding frescoes. On the dusty surface of the long internal wall, and the adjacent short internal wall, the outlined buildings were spread out in an incredible series of late Gothic edifices—houses, towers, churches, castles—which extended over a vast hilly landscape, crossed by solitary figures of warriors on the left, and on the right animated by a row of gentlewomen looking out from a large balcony hung with richly-decorated fabrics; and among the woods and rocks were some of the typical animals of Pisanello's graphic repertoire (Figs. 255-7).

This was what remained of a mural painting which, even in the sorry condition in which it was uncovered, could immediately be seen to be a work of outstanding importance. Certainly the gaps left by the missing parts of the painted surface were serious ones, and there were many of them; it could be calculated that not more than about a fifth of the paintings planned by Pisanello for the decoration of the four walls had survived; and what had survived were in the poor state already described. Nevertheless, the quantity of frescoes discovered was in itself quite extraordinary; and one also had to take into account the vast series of *sinopie* which had come to light or which existed under the frescoes, for they partially made up for the loss of so many painted decorations, and comprised a new, rich collection of large drawings of fundamental importance to the study of Pisanello's graphic art.

Moreover, considering the vicissitudes undergone by the Sala del Pisanello during the course of five centuries, it seemed almost incredible that such a sizeable part of its decorations had been able to survive so much abuse. Neglected for a long period after the collapse of 1480, the room, as we have seen, underwent at least three radical transformations between the sixteenth and nineteenth centuries; and each time new plaster had been applied and the decorations renovated according to current tastes. But the most serious damage to the remaining works of Pisanello was inflicted during the last and totally mediocre Neoclassical alteration to the room, carried out at the beginning of the last century. It was then that the upper part of Pisanello's mural cycle was sliced through by the new reed ceiling placed below the earlier wooden ceiling which had been destroyed. Great gaps were caused by the numerous large holes made in the walls along the line where the close-set series of ceiling supports was inserted, and by other, even larger openings, lower down on the two long walls, probably made for the scaffolding needed for putting up the new ceiling. The fifteenth-century frescoes which still existed beneath the frieze with the

Gonzaga portraits, had however managed to survive since, because of the iconographical interest attached to the portraits, the eighteenth-century plaster had been preserved and merely repainted in tempera. Those parts which did not escape destruction were the decorations with large figures which Pisanello had planned for the lower part of the walls. Probably the eighteenth-century plaster in these areas was damaged during the last century by the damp which had also caused some disintegration of the frieze, and for this reason it is likely that the *intonaco* here was completely renewed—after the earlier layer of plaster had been demolished right down to the wall itself—together with the intermediate Quattrocento decoration, of which at any rate some of the *sinopie* had survived until then on the *arriccio*. Some fragments of *sinopie* belonging to figures in the foreground were in fact discovered when the modern plaster was removed from the lower surfaces of the walls.[17] It is however clear that the destruction of so great an area of Pisanello's decoration was no less unwitting than the preservation of what has been saved under the eighteenth-century frieze. In fact their preservation was due to the methods used for renovating the wall surfaces in the two preceding alterations to the room carried out in the late sixteenth and the early eighteenth centuries. These methods consisted in re-covering with new mortar the damaged and unsound remains of the fifteenth-century *intonaco*, which was covered with a thick layer of dust, instead of applying the radical and technically better process of completely demolishing the old disintegrated plasters, as was unfortunately done at the beginning of the last century to the bottom part of the walls.

The text of the three letters of 1480 on the subject of the collapsed wooden ceiling in this important room in the Corte Vecchia, contains no reference to the cycle painted by Pisanello on the walls; therefore we do not know the condition of the decorations before and after the disaster which brought about their ruin. It is strange that these letters, which are so specific in their reference to the damage to the ceiling, contain not the slightest mention of the much more serious damage which must have been caused to the wall paintings by the collapse, and by the demolition of the rest of the ceiling which was carried out by Fancelli 'so that it cannot fall on anyone'. It may be that this omission is an implicit indication of the unfinished state of the decorations, which I shall refer to later when discussing the question of their execution; but the fact that the news of the collapse was sent immediately by both Andreasi and Fancelli to Marchese Federico, and the desire which the latter expressed that 'everything possible should be done to preserve it' undoubtedly signified that great importance was still attached to the decoration of the room, even though at least twenty-five years had passed since the death of Pisanello and even though the taste was now for the Classical style which Mantegna had brought to Mantua.

An examination of the fifteenth-century surfaces, carried out while they were still in the state in which they were rediscovered, showed that the problem of preserving this pictorial cycle had never been dealt with, and that not long after 1480, any plans to restore the room and its decorations must have been abandoned once and for all. As already stated, during the surveys carried out in the attic, it was found that a first coat of frescoed *intonaco* painted with decorative motives simulating a fictive marble hanging had been superimposed on the old surfaces, probably towards the end of the sixteenth

century. Only a few fragments remained of this *intonaco*, which consisted of a coating no more than a few millimetres thick on which had been spread a thin layer of slaked lime in preparation for the new fresco. All the rest had flaked off before the walls were once again re-covered with coarse-grain *intonaco*, which in the eighteenth century was decorated with the portraits of the Gonzagas. This layer of *intonaco* was in fact found to be directly superimposed on the Quattrocento surfaces, except in the places where the fragments of the intermediate decoration had remained to form a diaphragm.

Even more interesting was another observation made after the removal of the late Cinquecento fragments: Pisanello's *sinopie* which then emerged were almost obscured by a dense deposit of dirt—old dark dust and mildew—of the same kind as that which also lay on the painted surface of the Battle and of the other fragments recovered on either side of it. This proved that these *sinopie* were not covered by their corresponding frescoes and that the walls of the room had remained for a long period uncovered and exposed to the disintegrating action of dampness and dust. The mixture of dirt which had formed on the walls over that long period, together with the pictorial material which had broken up as a result of damp in those areas painted in tempera—very extensive areas, as will be seen when we examine the technique used by Pisanello—made it even more difficult for the mortar to adhere well when it was placed over the Quattrocento *intonaco* which was as smooth as stucco. Thus the new plaster did not bind with that underneath, and in time it became detached to the point of falling off almost completely, thereby causing further damage to the older surfaces. In 1701, when the walls were renovated once again, an attempt was made to obviate the difficulty by beating the surface with a hammer until it became rough so that the eighteenth-century layer would adhere to it better. However, because of the factors already mentioned—the smoothness and poor permeability of the fifteenth-century *intonaco*, and the insulating layer of extraneous matter—this procedure did not achieve the desired stability and served only to cause further damage to Pisanello's decorations which had already suffered so much ill-treatment. The eighteenth-century plaster itself did not adhere well to the walls and almost everywhere it was found to have come away, which made it easier to remove.

The decayed condition of the salvaged works provided clear evidence of the severe trials they had undergone, and one's immediate impression was that the original pictorial and graphic qualities of the decorated surfaces had been almost totally lost. The frescoes and large drawings in *sinopia* were almost unintelligible because of the layers of dirt and everywhere they were disfigured and fragmented by the hammering the walls had been subjected to several times, while over vast areas the pigments barely adhered to the disintegrating *intonaco* which had been attacked by mildew and salts, and were therefore unstable and without cohesion (Fig. 250). The uncovering of the Quattrocento surfaces had moreover created an extremely precarious situation, particularly with regard to the frescoes, since it transpired that the thin layer of *intonaco* on which they had been executed was to a great extent detached from the *arriccio*, and therefore in very grave danger of being lost once the lining formed by the superimposed layer of eighteenth-century plaster, which up to then had more or less protected it, was removed. The material in fact began to move on coming into direct contact again with atmospheric agents,

and it became a matter of extreme urgency to save the decorated surfaces before any irreparable falls could take place. The frescoes were therefore immediately taken off the walls, and in order to avoid dividing up the vast decorated surfaces which, by reducing to manageable proportions the size of the parts to be removed, would have made the operation much easier but would have spoiled the wholeness and unity of the decoration, some new and complex technical problems had to be overcome. Only the small areas of *sinopie* up in the attic were removed separately, the existence of the reed ceiling making this unavoidable. But the frescoes, which were all on the short side of the room where the ceiling supports were not load-bearing, were removed in one piece, after the supports had been pulled out of the wall and that part of the ceiling propped up. In the same manner, all the *sinopie* already mentioned were detached in one piece, and so were those which came to light after the removal of the frescoes. The decorations thus recovered were then reassembled on special rigid supports so that they could be placed in the exhibition rooms which had been prepared for them.[18] The astonishing results attained from this long operation modified earlier impressions. Here was an outstandingly important series of new masterpieces by Pisanello (Figs. 15, 19, 26, 48), not, it is true, with the final appearance which the completed pictorial surface must have been intended to have, but at least in a condition which allowed a clear understanding of their poetic message, a message known to few of the artist's contemporaries and which had lain hidden for five centuries.

NOTES

1. ROSSI, U., 'Il Pisanello e i Gonzaga', in *Archivio Storico dell'Arte*, 1888, pp. 453–6.

2. ROSSI, U., op. cit., pp. 455–6. The text of the three letters, published with some slight variations by Rossi, has been checked against the original manuscripts preserved in the State Archives of Mantua (Fondo Gonzaga, busta 2424 and Copialettere Gonzaga, lib. 101, p. 35, busta 2897). The letters were also published in their entirety in the article by AMADEI, G., 'Il Pisanello a Mantova', in *Civiltà mantovana*, III, 1968, p. 308. The text of the first two letters is also reproduced by Sindona (SINDONA, E., *Pisanello*, Milan, 1961, p. 112, n. 41).

3. ROSSI, U., op. cit., p. 456.

4. The Gonzagas, after they had driven the Bonacolsi from control of the city in 1328, installed themselves in the palaces which the Bonacolsi had occupied until then, situated around the old Piazza di S. Pietro (today Piazza Sordello).

5. CARPI, P., *Giulio Romano ai servigi di Federico II Gonzaga*, Mantua, 1921, p. 32; BRENZONI, R., *Pisanello*, Florence, 1952, p. 130; MARANI, E. and PERINA, C., *Mantova. Le Arti, II*, Mantua, 1961, p. 248.

6. LUZIO, A., *I Corradi di Gonzaga Signori di Mantova*, Milan, 1913, pp. 87–91; PACCAGNINI, G., *Mantova. Le Arti, I, Il Medioevo*, Mantua, 1960, pp. 158–61; id., *Il Palazzo Ducale di Mantova*, Turin-Rome, 1969, pp. 10–14.

7. MARANI and PERINA, *Mantova, Le Arti, II*, cit., pp. 263–7, 272–6; PACCAGNINI, *Il Palazzo Ducale*, cit., pp. 50–80.

8. GEROLA, G., 'Vecchie insegne di Casa Gonzaga', in *Archivio Storico Lombardo*, 1918, pp. 97–110; GIROLLA, P., *Pittori e miniatori a Mantova sulla fine del '300 e sul principio del '400*, Mantua, 1921, pp. 4–5; COTTAFAVI, C., 'Mantova: Palazzo Ducale, Palazzo del Capitano', in *Bollettino d'Arte*, 1932, pp. 378–9.

9. The first apartment inhabited by Isabella d'Este after her marriage in 1490 to Francesco II Gonzaga, was situated in the Castello di S. Giorgio and comprised a few rooms and two small chambers. After the death of her husband and the quarrel with her son Federico she moved into some of the rooms on the ground floor of the Corte Vecchia, which had been suitably adapted for her. Cf. GEROLA, G., 'Trasmigrazioni e vicende dei camerini di Isabella d'Este', in *Atti e Memorie dell'Accademia Virgiliana di Mantova*, pp. 253–90; COTTAFAVI, C., 'I Gabinetti d'Isabella d'Este: vicende, discussioni, restauri', in *Bollettino d'Arte*, 1934, pp. 228–40; MARANI and PERINA, *Mantova. Le Arti, II*, cit., pp. 178–9; PACCAGNINI, *Il Palazzo Ducale*, cit., p. 98.

10. GEROLA, 'Vecchie insegne', cit., pp. 101–6; MARANI and PERINA, *Mantova. Le Arti, II*, cit., p. 255; PACCAGNINI, *Il Palazzo Ducale*, cit., p. 18.

11. MORETTI, G., *Relazione ufficiale regionale per la conservazione dei monumenti in Lombardia*, Milan, 1899, p. 89; PATRI-

COLO, A., *Guida del Palazzo Ducale di Mantova*, Mantua, 1908, p. 7; PACCAGNINI, *Il Palazzo Ducale*, cit., pp. 30–1. In fact on the upper storey there are two rooms behind this façade, the Sala dei Principi with two large central windows and the adjacent Sala dei Papi with one window at the side.

12. ANTOLDI, F., *Descrizione del Regio Cesareo Palazzo di Mantova*, Mantua, 1815, p. 5.

13. PACCHIONI, G., *Il Palazzo Ducale di Mantova*, Florence, 1921, p. 17.

14. It is possible that when the re-roofing was carried out in the early years of this century (in 1910 the roof of the Sala dei Principi, in 1912 that of the Sala dei Papi), an attempt was made to salvage the decorated surface on that part of the wall where the end of one of the beams supporting the roof of the adjacent Sala dei Papi was then inserted. Perhaps because the salvaging attempt did not succeed, the damaged surface was then covered again, but traces of the procedure had not disappeared, for with the passing of time the glue had become wrinkled, making the superimposed coat of whitewash come away from the wall.

15. The room, as far as one can discover from an examination of its surfaces and its masonry, must have been left without any maintenance up to the late Cinquecento, probably until the time when Duke Guglielmo Gonzaga began further alteration works to the Corte Vecchia so that he could transfer his apartments there. The floor was then lowered by about one metre (on the bottom part of the walls a fragment of the Trecento frieze from the room underneath is visible), the large Gothic windows were filled in and replaced with the present rectangular openings, the small entrance doors were walled up and two other large ones were opened in the centre of the short walls, leading to the adjacent Sala dei Papi on one side and to the Palazzo del Capitano on the other. The surfaces were then covered with new frescoed *intonaco*—as proved by the fragments discovered—decorated with fictive polychrome marble, and the fireplace in red Verona marble was installed, identical to the one which was put into the Sala dei Papi in the same period with the inscription 'GUL. D. G. MAN. ET. MONT. FER. DUX.'. At the beginning of the eighteenth century the room underwent another change: the *intonaco* was renewed and on the upper part of the walls a frescoed frieze was made, which showed nineteen medallions enclosing portraits of the Gonzagas, from the first Captain Luigi to the last Duke Ferdinando Carlo. Because of the damage the room suffered at the time of the French occupation, during the first decade of the last century a complete reorganization of the whole room was begun; the wooden ceiling was replaced with the present reed ceiling, set about one and a half metres lower than the previous one, the *intonaco* on the lower part of the walls was completely renewed while only that at the top bearing the Gonzaga portraits was retained, for their iconographical interest. After the recent removal of the frescoes and *sinopie*, traces of other windows and doors of the original fourteenth-century room have also come to light (PACCAGNINI, *Il Palazzo Ducale*, cit., pp. 30–5).

16. Before removing from the four walls of the room the large seventeenth-century decorative frieze, the nineteenth-century repainting in tempera which had completely altered the original composition had to be taken off. Thus the Baroque volutes framing the half-length portraits of the Gonzagas reappeared, as did the relative inscriptions which also indicated the date in which this decoration had been carried out. Under the portrait of the last Duke Ferdinando Carlo (Fig. 237) the date 1701 came to light during the cleaning. Subsequently the frieze was removed; the nineteen portraits of the Gonzagas were laid on canvas and then moved to special supports. At present they are displayed along the upper part of the long Passerino corridor.

17. The only fragments of *sinopia* discovered on the lower part of the walls are: on the long interior wall the upper part of a horse's head (Fig. 258); on the Battle wall fragmentary lines of a horse lying on the ground (Fig. 259); on the opposite wall a bush; on the outside wall the almost vanished trace of a knight.

18. The exhibition rooms containing the recovered frescoes and *sinopie* by Pisanello are: the former Sala dei Principi, where the fresco of the Battle with the two fragments from both sides of it have been set up, the adjacent Sala dei Papi on whose long internal wall is displayed the *sinopia* of the Battle, and the first room of the Appartamento Guastalla where the huge *sinopia* once on the long internal wall and the one discovered on the contiguous short wall have been arranged. The work of recovery and restoration, documented in detail elsewhere, was carried out with the greatest care by the Mantuan restorers Assirto Coffani and Ottorino Nonfarmale and their excellent team of technicians.

PISANELLO'S TECHNIQUE

It was pointless to regret what had been lost of this great undertaking which, according to Pisanello's plan, was to have comprised a continuous painted surface over all four walls of the room. In any case, all regrets were immediately dispelled by the vividness and beauty, by the unending quantity of images which sprang from those surfaces, as though from the pages of a palimpsest which had suddenly revealed an important part of the text of a great poem long hidden from view. These images, throbbing with life, gave a feeling of direct contact with the work in the various stages of its creation, for their incomplete and fragmentary nature was due not only to damage caused to the room by the various alterations but above all perhaps to technical and historical factors which we shall take a look at as we proceed. Moreover, the lacerations which over the years had been inflicted on the various layers of plaster, and which are normally buried beneath the last coat to be applied, were now laid bare and so disclosed the procedure followed by the artist and his assistants. The opportunity offered by what remained of the decoration to increase our knowledge of the technique of mural paintings—commonly called frescoes even when, as in this case, they differ to a great extent or even totally from the *buon fresco* or true fresco—was in itself very welcome. In particular, the chance to examine at first-hand the procedures used by Pisanello in one of his most important mural paintings made it easier to understand the artist's work and his poetic and cultural world.

The methods employed by Pisanello in this room in Mantua appeared to be very complex and were the result, not only of his extraordinary skill in graphic representation, but also of his lengthy study of the new painting techniques which were being tried out during that century in an attempt to find a new kind of artistic expression and to relate it ever more closely to the world of nature. Perhaps no other painter of the first half of the Quattrocento made such a systematic application of these methods of mural painting which were a mixture of *fresco* and *secco*. These techniques, although there was nothing new about them—they had already been used, but for other purposes, even in the most important mural paintings of the Trecento[1]—were not easy to master; frequently they resulted in conspicuous failures, even at a later date when mural painting *a secco* was no longer a secret known to few artists. These methods were pursued with great enthusiasm in order to intensify and widen the chromatic range used for mural decorations, of which the fresco method still remained the essential basis and the ultimate objective even when

many details or colours were applied or finished off in *secco*. The extent to which these mixed methods were widespread in late Gothic painting is apparent from those chapters in Cennino Cennini's *Libro dell' Arte*, written at the end of the fourteenth century, which were dedicated to the methods of wall painting—in *fresco*, in *secco* and in oil.[2] This book, whose importance is increasingly acknowledged by modern criticism,[3] is more than an account of the procedures adopted by the Florentine workshop of Agnolo Gaddi, where Cennini worked in his youth for twelve years, for with that affectionate manner which makes his writing so warm and alive, Cennini draws on all his experiences as an artist. Although his talent was modest, he was keenly aware of what was going on, especially in the Tuscan workshops, during that period astride two centuries which was in such a state of ferment and which saw the apprenticeship of many great artists of the early Quattrocento. Pisanello even in his later works retained the outlook and method of working which he had learned in those late Gothic workshops. This does not mean that he was behind the times: on the contrary, he was a modern and up-to-date artist in those years dominated by the International Gothic style. Although the tradition of the great Trecento cycles of central and northern Italy always remained deeply rooted in his art, as we shall notice in the Mantua decoration, Pisanello's mural technique gradually evolved to the point of actually inverting the relationship between painting *a fresco* and painting *a secco*. In the Mantua decoration the fresco technique in fact becomes only an intermediate phase in the whole process: for aesthetic and stylistic reasons it was followed by a complete new layer of colour *a secco*, which was to give the work its final appearance.

Cennini's notes on the art of 'colouring' were hardly a starting-point for Pisanello who had already made great progress in this field thanks to the example and the teaching of Gentile da Fabriano and the contact which both painters had with the main trends in painting in central and northern Italy, as well as with those from abroad. Continual refinement of his pictorial matter allowed Pisanello to express the boundless wealth of perceptions which his restless sensibility and his subtle powers of observation extracted from his visual experiences. But within that very fine-woven fabric of colour there is the complementary and indeed absolutely fundamental element which is the drawing itself, which constitutes the very structure of the image, and without which the colour would be nothing but inert matter. This aspect of Pisanello's pictorial work must have been the result of constant practice which in his youth had become an unalterable visual and mental habit, acquired during his early, intensive graphic training along the lines recommended by Cennini for anyone who wished to dedicate himself to the art of painting. 'The basis of the profession, the very beginning of all these manual operations, is drawing and painting'; but the real beginning is drawing, because only after the hand is fully trained by long years of graphic practice does Cennini advise the artist to begin painting.[4] The path which Cennini tells young apprentices to follow is a long one, from patient drawing with a stylus on a panel prepared with bone dust, to constant copying of the best works done by great masters or, better still, by one master in particular, 'the best one every time, and the one who has the greatest reputation', until at last they can enter 'the triumphal gateway of copying from nature' as they begin to 'gain some judgement in draughtsmanship'. In order to reach this last stage of drawing from life,

there must be absolute mastery of the graphic tool, and the young artist must know how to obtain every possible inflexion with silver or lead point, with pen or pencil, drawing the images on sheep parchment or paper, either natural or tinted in various colours: and the drawing must not be understood as an outline around figures or areas of colour, but as the very structure of the colour, as a way of setting down in 'relief' images in space, connected by light and shade values, according to the way in which the light falls on the figures. Pisanello's exceptional graphic ability can be explained only by assuming that in his youth he received a training of this kind, following the working methods of the late Gothic workshops of Tuscany in which drawing was considered to be of paramount importance in the process of creating a work of art. This concept and practice are reflected in Cennini's book but they are also supported with greater theoretical knowledge, with regard to painting and sculpture, by a late Gothic Florentine artist of quite another stature—Ghiberti, for whom 'drawing is the basis and theory of these two arts'.[5] Moreover, it was not just by chance—and I shall return to this point later—that Ghibertian sculptors like Nanni di Bartolo or Michele da Firenze were working at Verona on the Brenzoni monument in the church of S. Fermo and in the Pellegrini chapel in the church of S. Anastasia, in other words in the very churches where Pisanello carried out his two well-known wall paintings in that city.

In discussing Pisanello and in examining the extraordinary series of *sinopie* in the room in Mantua which, though they may not be drawings in the ordinary sense of the word, are nevertheless very great works of graphic art, one becomes aware of the exceptional importance and the peculiar significance which drawing had for this great artist right from the beginning of his activity. For Pisanello, drawing was in fact much closer to Leonardo's '*discorso mentale*' than to that ability to conceive 'much drawing out of your own head' which, according to Cennini, derives from long practice at drawing with a pen. Indeed, between Pisanello and Leonardo, artists so different both in cultural background and historical context, there were certain similarities of temperament which led them both to consider drawing as the most direct expression of their thoughts and experiences. From the '*discorso mentale*' origin of the science of painting, which for Leonardo was the highest form of knowledge, the next step was to realize the visual image in a much more direct manner than that of translating a thought into the Italian language, in which, though he declared himself to be '*homo sanza lettere*', Leonardo was able to express himself admirably. But it was precisely because of this function of expressing everything in the mind that his drawing assumed so many various aspects, according to the ultimate purpose and meaning of the images traced by the hand, and bore the imprint of the poetic or prosaic tone of the '*discorso mentale*', which sparked the artist's imagination or guided the investigations of the scientist.

For Pisanello too, drawing had its autonomous importance as a direct means of expressing his thoughts and it was 'an instrument of sharp awareness',[6] an extremely rich and variable idiom which the artist made use of in grasping and investigating every aspect of his visual experience. An examination of his drawings must take into account the variability and discontinuity of the techniques he used in translating those experiences, according to the nature of the '*discorso mentale*'. These continual variations, as Dell'Acqua has pointed out, are 'impossible to set out in a rigid and consistent formalistic

scheme'[7] and they partly reflect, or so I believe, the working methods employed in the artist's workshop. The advanced stage reached by research in the field of Pisanello's graphic work can be judged by comparing the early, hastily made attributions to Pisanello of a large quantity of heterogeneous drawings, with the subtle distinctions made by present-day criticism.

Firstly, from the profuse collection of works which are presumed to have come from Pisanello's workshop, those works have been weeded out which were obviously by hands completely extraneous to his ambiance. Furthermore, efforts have been made to identify accurately the characteristics which differentiate the master's own drawings from those done by pupils and collaborators (or those gone over again in pen whose authorship remains in doubt when traces of the original lines in silver point, pencil or other technique have disappeared). However, opinions still differ widely and they oscillate between two basically opposite points of view: one pays particular attention to the formal aspect of Pisanello's drawings, and has been systematically put forward by Miss Fossi Todorow in her recent monograph on the subject;[8] the other concentrates mainly on the significance of the drawings in relation to the artist's world and his cultural sources, and is firmly supported by Degenhart.[9] Personally I lean towards the latter view since I do not believe that the best way of understanding an artist who expresses himself in a very rich range of variations, is to choose only the cream of his graphic works. Nor do I believe one should suspend judgement on the numer of very good drawings about which there can be no doubts, and attribute to the school of Pisanello many others which are also in fact by Pisanello himself, even though they are not of the same fine quality and do not possess that lyrical tone which is found in his very best works.

It could perhaps be said that the style of some of the drawings is often prosaic; but without a certain amount of prose—if this term can be used to describe the everyday sketches which the artist jotted down for one reason or another—even his poetry loses meaning, uprooted from the historical terrain in which it germinated. Pisanello eludes all attempts at studying the characteristics of his graphic art on the basis of selected examples from the various periods of his activity, since the *ductus* of his drawings, as variable as his own restless sensibility, reflects the most diverse situations even at the highest level of expression. The wealth of sensations and observations which his searching eye obtained from his experience of reality or which flashed suddenly into his 'mental discourse', was matched by a variety of formulations composed with the use of different graphic and pictorial techniques of which he was an incomparable master, and from which he managed to draw endless variants and modulations with lead point, silver point, quill pen, pencil, brush, inks of different colours, bistre and watercolour; applied on parchment, or on white, grey, pink, red, green paper. One is reminded, when surveying the variety of expression in his graphic repertoire, of the lovingly and minutely detailed instructions given by Cennini when pointing out how vast and varied was the field of application for drawing, and how this was the real training ground for the artist. However, even if the drawing itself reached the height of artistic expression, it always remained subordinate to the ultimate purpose for which it was executed and of which it was just one stage in the whole creative process. (Had there been full artistic appreciation of the autonomous and absolute value of graphic works, so many drawings would not then

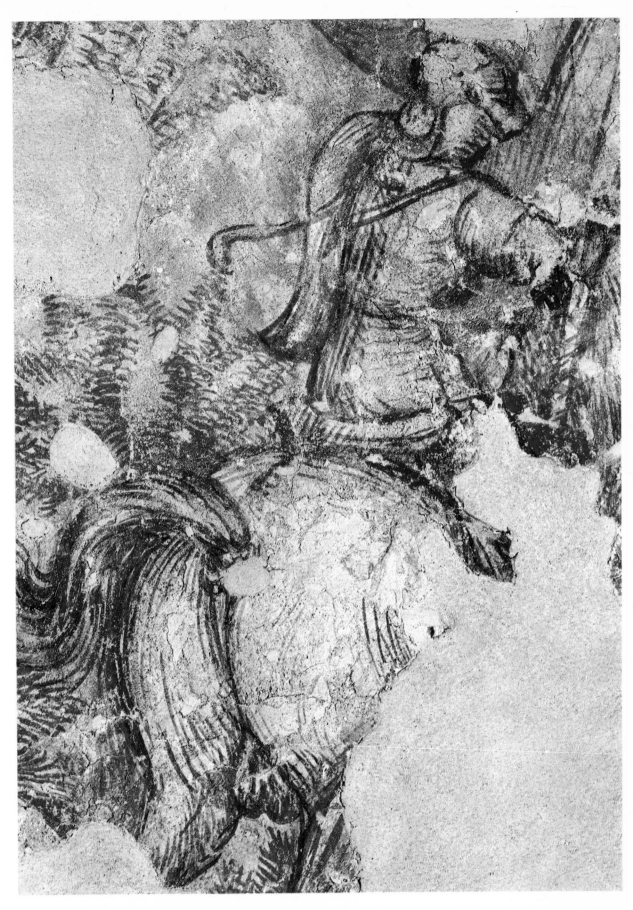

I. Arthurian chivalric cycle: knight (Meldons li envoissiez), detail of sinopia. *Mantua, Ducal Palace.*

have been lost after they had served their purpose.) Pisanello's repertoire was no exception; and this explains why it contains not only drawings by himself and other excellent artists, but also such a large number of apparently unimportant sketches of iconographic and decorative motives, all used in connection with his workshop's activities with the idea of keeping up to date with contemporary artistic developments. It is therefore essential to take into consideration all the drawings—even though certain qualitative distinctions must be made between them—without ever losing sight of their historical significance. It would be much more difficult to understand Pisanello's development as an artist if one excluded from his repertoire, or isolated as unrelated phenomena, the numerous copies which he or his assistants made from works of other contemporary painters and sculptors, Tuscan, Lombard, Venetian, French, Flemish, etc., or from late Roman sarcophagi, copies which have been discussed in studies by Degenhart and Schmitt.[10] The fact that these copies are often drawn with a steady and prosaic line is an indication of their function; it is also possible to show that some of them were produced in the workshop. But what really matters is that these sketches are a record of Pisanello's cultural background and taste; and they are therefore invaluable and indeed indispensable to any attempt to reconstruct the course of his artistic training and development.

It must be remembered that in order to carry out such large-scale and ambitious mural cycles as the one in Mantua, preparatory drawings of great complexity were necessary. These would occupy the artist and his workshop throughout the long process of producing the cycle: from the very first ideas which were captured in small, rapid sketches, to the more elaborate drawings which would be constantly referred to as the composition was gradually traced in the form of large *sinopie* on to the *arriccio* on the walls, to the drawings made for the *spolveri* and the cartoons, to the innumerable full-size models which were made of all the figurative and decorative details. With the aid of these drawings, the graphic and pictorial structure of the decoration was worked out. Pisanello himself directed and developed these huge operations from the initial ideas to the last phase of painting, but he could not alone have coped with the enormous amount of work required in carrying out such a huge quantity and variety of figures and ornamental motives. The process of covering extensive wall areas with a pictorial fabric richly woven with an infinite number of details painted with the tip of a brush in minute, dense strokes, almost like a small panel painting, was highly complicated. One need only look at the room in Mantua to understand the size of the problem; and Pisanello did several wall decorations on that scale. The assistance of a team well trained in the master's graphic and pictorial techniques was therefore indispensable for the execution of such complex works,[11] and Pisanello was an exacting artist continually changing the details he had done, even when they were very beautiful, as we shall see when we examine the technique followed in the Mantua decoration. Therefore it is not only possible, but I would say inevitable, that Pisanello's assistants participated in the preparatory drawings for a large number of details, although it was Pisanello himself who directed the collaboration along the lines he desired. It was not a case of participation by outsiders, but of participation by assistants using the technical procedures applied and taught by the master which were part of the method adopted by his workshop, and which were therefore allied to his own poetic inspiration.

In order to demonstrate the integral nature of this complex process, reference will be made to many drawings by Pisanello and his school which relate to the Mantua room, regardless of whether or not they were done by Pisanello himself; the question of their authorship has in any case been dealt with by the scholars already mentioned. These drawings will in fact be examined later in their function of iconographical motives. Some of them were already part of the workshop's repertoire, while others were created during the long process of producing the painted cycle in Mantua—a process unfortunately never completed—as we shall see when we follow its development from the moment when the drawing of the *sinopie* was begun.

In the Mantua room the *sinopie* for the Battle scene were mainly carried out in black with a thick brush (Fig. 66), while those on the other walls were sketched with a fine brush dipped in red *sinopia* (Plates IV, XII), following the Trecento method of 'working on walls', as indicated by Cennini.[12] These large drawings on the wall, even though different in technique and purpose from normal drawings on paper or parchment, add a new and important chapter to the graphic repertoire of Pisanello. They make up a series of works which, although they were only provisional sketches destined to be covered over by the subsequent pictorial decorations, or perhaps indeed because of this, represent with intense vitality and freedom the images which were going to be translated into the terms of a fresco painting. They are drawings of extraordinary power and freedom of expression and yet they were not the result of a spontaneous imaginative outburst; on the contrary, they were preceded by a long mental and technical preparation, involving far more than the artist's early ideas for the composition which had been captured in rapid sketches on paper, or stored in his memory. It included the laborious work of making studied calculations for dividing up the surface areas, siting the composition plans on the actual surface of the walls, outlining the figures in charcoal—which was a suitable medium in view of the many alterations which were bound to be necessary during this phase—and experimenting with the dimensions and the relationships between the figures so as to establish them harmoniously in the framework of the whole story to be represented. Only after the entire surface of the *arriccio* had been divided up in this way and the composition briefly sketched in charcoal,[13] did the images begin to take shape, being traced first with brush and ochre, then with red *sinopia* or in black.

The procedure followed by Pisanello was substantially the same as that described by Cennini, which continued to be used during the fifteenth century in Florentine workshops, including those of the most important modern Florentine artists who, like Pisanello, used *sinopie* together with the new techniques of cartoons and *spolveri*. However, although the composition for the Battle was outlined in black, some of the images were traced in red, while on the other walls, where red *sinopia* predominates, a number of details were gone over in black in order to obtain a more accentuated pictorial effect in the shaded and chiaroscuro passages, which were also given films of colour—ochre, grey and red. There is a distinction to be drawn, not so much between the colours which are used for the *sinopie* with the same intensity of expression, but if anything, in the strength of the thick, rough line made in black with a heavy brush, almost like an engraving, to denote the contours of the figures in the first *sinopia* of the Battle: this line can be differentiated from the quick, nervous line done with the point of a fine brush dipped in

red and which traces, with a few accents in black and ochre, the essential shapes of the images in the other *sinopie*. The dense and concise lines used by Pisanello to define his initial idea for the Battle had the function of establishing the essential structural relationships between the images, and the main lines of development of the close-woven plastic composition formed by the interlacing figures of warriors and horses, which were made to stand out against the background by that vigorous style of drawing. But the composition of the Battle was to undergo several major modifications during the various stages of its execution; and the *sinopia* itself was altered a number of times in many areas, where new *intonaco* was applied and the images replaced with others differing not only in their iconography, but in their light, flowing lines, incredibly modern in feeling (Figs. 1, 2). Once the composition of the Battle had been defined on the *arriccio* with the *sinopia*, Pisanello began to analyse its formal structure and its iconographical content. He virtually produced a second draft since so many changes were made to the first, making comprehensive drawings and tracings, from which finally he prepared cartoons and *spolveri* for the fresco. This kind of technique—clear traces of which remain on the frescoed surface (Fig. 244)—is of special interest since it shows that Pisanello was fully acquainted with the procedures which were beginning to be used systematically in mural paintings in Tuscany by a number of great artists—including Paolo Uccello, Andrea del Castagno, Domenico Veneziano and Piero della Francesca—around the middle of the century. This method of working, developed in a climate of intensive research, gave the works of that period a striking individuality and uniqueness of form. It enabled the painter to prepare on paper in his studio, instead of directly on to the wall with *sinopie*, all the graphic details, in full size, of the images which were to be transferred on to the *intonaco* to be painted. Thus the actual process of executing the fresco, which necessitated very complex operations and involved works which were generally on a large scale, was simplified.[14]

Pisanello, in his graphic art above all, sought individuality and naturalness for the images which crowded his imagination and constituted the live material of his mural cycles and which required interminable finishing touches painted *a secco*; it is therefore understandable why this technical method was particularly suited to him. However impossible it may be to reduce to a scheme the mural technique of an artist as skilful and variable as Pisanello, a close examination of the Battle allows one to follow the general outline of the working method he adopted when executing the painted surface. After completion of the long process of graphic preparation, which determined the arrangement of the composition on the *arriccio*, the *sinopie* for the Battle were covered with a layer of very smooth *intonaco* which was to constitute the support for the mural painting. The *intonaco* however was not applied in stages over relatively small areas which could be finished in one day, as in the normal '*buon fresco*' method, clearly specified in Cennini's advice to anyone starting to work in fresco: 'Then consider in your own mind how much work you can do in a day; for whatever you plaster you ought to finish up.'[15] Pisanello applied the *intonaco* gradually, beginning at the top, over surfaces which varied in size, but were generally very extensive, and would require not just one day to finish them but a vast amount of work and the use of different painting techniques mostly applied *a secco*. While the plastered surfaces were still wet he began drawing the various parts of the Battle again, making radical changes to the content and the composition of the *si-*

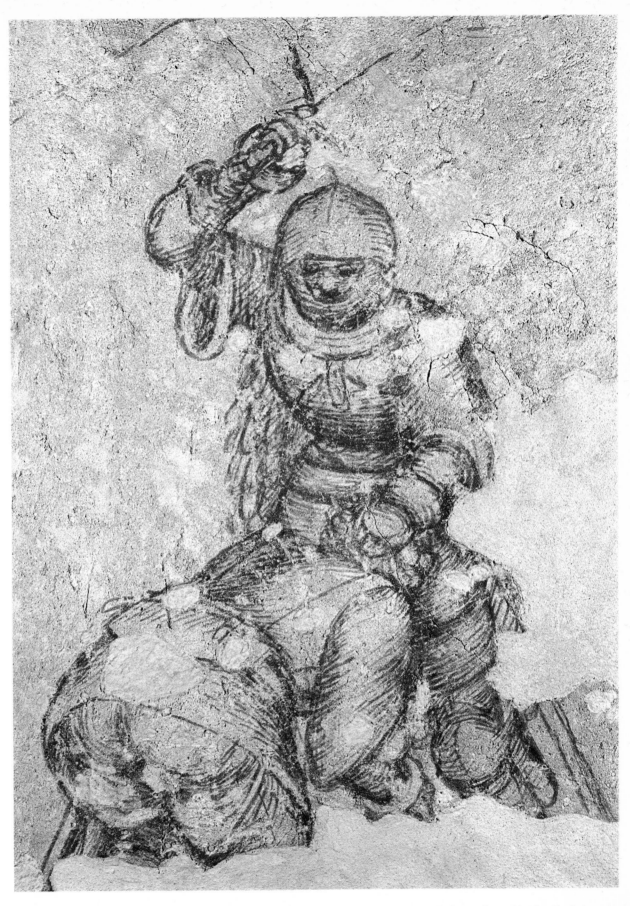

II. *Arthurian chivalric cycle: knight in the act of killing a kneeling warrior (Bors and Priadamus?), detail of* sinopia. *Mantua, Ducal Palace.*

nopia. During this further draft, for some of the decorative motives and figures,[16] he made use of cartoons and *spolveri* which had been prepared in advance; but apart from these exceptions he drew freehand with a fine brush dipped in *verdaccio*[17] the various episodes of this great battle, sketching the images with incomparable boldness and the inspiration of one possessed (Figs. 58-61). It is quite clear however that this freedom and speed of execution was not due to improvisation, but was made possible by a series of studies on paper, to which the artist kept referring during this first draft in *verdaccio*, which was to form the graphic structure of the pictorial surface. On the upper end part of the wall, which was the first to be plastered, the very elegant frieze showing the emblems and fluttering leaves was marked out on the fresh plaster by means of the *spolvero* technique using perforated paper. The charcoal dots are very apparent both within and on the edges of this motive. Here the light-coloured *intonaco*, standing out against the dark background which was drawn in after the *spolvero* technique had been applied to the frieze, was to have been covered, as a number of decorative motives were, by gilded *pastiglie*. This appears never to have been done, however. It may be that the iconography of the frieze, in which the devices of the Gonzaga family—an eagle, a fawn and a dog—alternate in medallions, was connected with heraldic questions which had still not been fully settled, so their execution was left until last, while work continued on the figures of the warriors below, whose lances, some of which crossed the frieze where it was left blank, were decorated with gilded or silvered *pastiglie* engraved with patterns of leaves and flowers (Fig. 3). When all the figures of the Battle had been traced in *verdaccio* Pisanello painted the background in black (perhaps with some substance thinned with oil,[18] as this is a shiny surface different from the reddish black background of the frieze, which seems to have been painted on the *intonaco* while it was still wet), thus making the figures stand out. On that dark surface, at the top right hand side, were engraved the black coats of armour of a group of warriors (Fig. 4), outlined with geometric sharpness. It is likely that the colour of those suits of armour had a particular significance, and I shall refer to this when putting forward some theories about a possible interpretation of the iconography of the decoration in the Sala del Pisanello.

This phase of the work was concluded when the composition of the Battle was all well set out with its graphic and chiaroscuro values defined. It now looked like a large monochrome fresco. The figures were sketched in free-flowing lines which moved rapidly, now close together, now thinning out, describing the volumes and the essential relationships of light and shade. They showed up against the dark background in luminous relief with a descriptive power certainly not inferior to, though very different from, the pictorial delicacy which the finished surface was to have assumed, and which it did partially assume, when it had its final layers of colour added. But Pisanello's restless spirit led him to change his ideas from one day to the next, and this can be seen even in the last stages of the process, which in his own mind was never-ending. Thus the frescoed monochrome composition carried out on the *intonaco* ready for the next stage of highly refined pictorial techniques, was modified once again, as some parts of the plaster were removed and replaced with a new layer, on which other figures were first traced in charcoal, then finished with brush and *verdaccio*.[19]

It was at this point—and one can imagine how long and laborious were the operations

leading up to it—that the real pictorial decoration of the wall surface was begun, painted *a mezzo fresco* and *a secco*,[20] but not before graphic and pictorial models of the details had been prepared, especially of the heads and faces of the human figures and also of the horses which Pisanello loved so much. These details were analysed with the help of drawings in which minute, sensitive lines indicated every slightest modulation in the structure which was to be given in fine, vibrant brush strokes to the definitive pictorial decoration.[21] On the surface which had been prepared in monochrome fresco Pisanello first of all painted, beginning at the top, all the parts to be done in *mezzo fresco*: some land-scape backgrounds and the animals featured in them, the heads of the most important male figures or that part of the warriors' faces which could be glimpsed under their raised vizors (Fig. 7), the two beautiful young women (Fig. 5), part of the figures of the war-ring soldiers and their horses, some crests and other details which I shall not list, as their interest here is only relative. In this phase too there were many alterations and *pentimenti*, sometimes showing new figures painted on directly over the previous ones (Figs. 10,18); at other times areas of *intonaco* have been scraped away and replaced with a very thin white layer of gesso, similar to the imprimitura on a panel, and on this the artist painted, *a secco*, faces of warriors, or sometimes whole figures, such as that of the solitary warrior riding in the wooded landscape, on the far right hand side of the wall. These alterations were introduced during the last stage, when Pisanello applied on the extensive surfaces which still remained to be coloured, the painting techniques *a secco* which were to have concluded the chromatic orchestration of the decoration. He created rich and sensuous relationships with the silvering and gilding of armour, swords, lances and trappings, with the large studs on the horses' harness and the soldiers' tunics which were added in decorated stucco, with the brilliant colouring of the brocades and silks of the garments, caparisons and standards, the soft, delicate furs, the hazy shimmer of plumed helmets. The complex manner in which the materials were arranged must have endowed the Battle scene with exceptional luminosity and chromatic subtlety, as can be noticed in those areas where the pictorial values have remained unaltered. Not much has been pre-served of the decoration with its final layer of colour, but a number of details which have not undergone any chemical change, thanks to the protection afforded by the isolating materials placed on top of them, have the freshness of almost unblemished paintings.

It should be noted at this point that the condition of the materials used on the paint-ed surface of the Battle varies according to the techniques employed in the *mezzo fresco* and *secco* painting over the various parts of the basic composition, which was done in monochrome fresco. Incredibly strong, looking like a work just finished and still fresh, are the lines done in *verdaccio* which set out the Battle episodes on the dark background. Even though the Battle scene matured over a long formative process it gives the impres-sion of spontaneity and effortlessness. Those areas painted in *mezzo fresco* are well pre-served on the whole (although the repeated alterations to the room have caused a num-ber of gaps and scars) and in some places the structure and feel of the brush strokes have remained almost unaltered, which rarely happens with mixed-method wall painting of that period. The layers of colour applied in *secco*, however, have suffered serious losses because with the disintegration of the binding substances over the years the pigments had flaked and were often detached from the *intonaco*. In some areas where suits of armour

had been covered with silver-leaf almost everything was missing from the surfaces, and the surviving fragments no longer have the white shining metallic effect which Pisanello intended, but have become opaque and black through oxidization.[22] But a careful examination of the surface gives rise to a question of particular importance regarding the chronology and development of the decoration of the room, since between the upper and lower parts of the Battle scene there are some remarkable differences in appearance, and seemingly in condition, which cannot be blamed on the various alterations made to the room. If we examine, in the upper part of the Battle, those parts which were finished in *secco*, which are prevalent in the whole scene, we can see that even where they are almost completely destroyed, the corresponding surfaces everywhere retain traces of pigments applied in tempera, or of gold and silver on the coats of armour (Figs. 7, 11, 12) and of variously decorated *pastiglie*, which covered the monochrome fresco underneath, and which represented the rich materials of the garments, hats, caparisons, gilded leathers and other objects. None of this survives in the figures sketched in fresco in the lower part of the Battle (Fig. 56), which were to have been finished in *mezzo fresco* and in *secco* like those above, but which do not retain on their surfaces the slightest trace of these procedures.[23] The only possible explanation for this is that the work was broken off, leaving in the initial state of monochrome fresco the figures of warriors and some horses in the bottom part of the composition. Confirmation of this supposition can be found in the fact that for technical reasons Pisanello, before finishing in tempera the garments and the ornaments adorning his knights, or before putting the gold and silver on the warriors' armour, lances and swords, on the harness, caparisons and standards, incised the outlines of the parts to be coloured (Figs. 7, 11) with lines indicating the exact shape of the objects.[24] This created on the surface clear-cut volumes similar to those which Paolo Uccello formed with the armour of his warriors in the *Battle of San Romano*. However, those precisely-drawn lines which place in perspective the armour-clad men (although the perspective is limited to individual figures or groups) were all part of the procedure of painting in *secco*, referred to above, which Pisanello carried out gradually over small areas, incising their edges in the plaster. The areas filled in with tempera or gold and silver leaf were then given incised outlines which were gone over with a stylus: the images of the warriors and their armour thereby assumed the precision of geometric volumes, spread over the background plane (Plate X). In the bottom area of the Battle, and also in parts of the middle area, the monochrome figures of knights bear no trace at all of these engraved lines, although they were a necessary part of the technique with which the artist delineated one at a time the areas to be covered with *pastiglia* and painted in *secco*: it is therefore evident that the last coat of colour was not even begun on those surfaces. If we then turn to the long inside wall, adjacent to that of the Battle, this sudden interruption of the work appears even more clearly. In the painted fragment recovered at the end of this wall Pisanello, having here too radically altered the motive of the *sinopia*, completed the group of knights which is linked with the adjoining battle scene (Figs. 7, 13). But, when he arrived at the motive which in the *sinopia* represents a splendid group of women arranged in two rows within a decorated balcony, he plastered over the upper part so that he could outline in *verdaccio* the canopy and the two young ladies on the right, whose beautiful faces he also painted; at the same time he

sketched, further to the left on *intonaco* which had not yet been smoothed off, the half-length figures of two other women (Figs. 5, 17); then he stopped. The manner in which the *intonaco* ends with its edge pared off suggests that this edge was to have formed the join with a further coat of *intonaco*,[25] which however was never applied; and everything points to the fact that the *sinopie* found on the long wall and on the other short wall were left at that point, that is without their planned pictorial surface, and even without the layer of *intonaco* with its subsequent monochrome sketch as was done in the Battle, of which there is no hint at all on these walls. It seems then that the realization of the grandiose decoration, whose overall plan had been defined by Pisanello with the beautiful *sinopie*, was mysteriously interrupted after the execution—itself incomplete—of the pictorial surface of the Battle and of the fragments recovered on either side.

NOTES

1. PROCACCI, U., *Sinopie e affreschi*, Florence, 1960, pp. 33–4; BORSOOK, E., *The Mural Painters of Tuscany, from Cimabue to Andrea del Sarto*, London, 1960, p. 14; MEISS, M., and TINTORI, L., *The Painting of the Life of S. Francis in Assisi*, New York, 1963, pp. 13–20; id., 'Additional Observations on Italian Mural Technique', in *The Art Bulletin*, September 1964, pp. 377–9.

2. CENNINI, CENNINO, *Il Libro dell'Arte*, translated by THOMPSON, D.V., as *The Craftsman's Handbook*, New Haven, 1933, New York, 1954, Chapters LXVII-XCIV.

3. SCHLOSSER, J., *La letteratura artistica*, Florence, 1956, pp. 93–4; VENTURI, L., *Storia della Critica d'Arte*, Turin, 1964, pp. 90–3; MELLINI, L., 'Studi su Cennino Cennini', in *Critica d'Arte*, 1965, No. 75, pp. 48–64; MAGAGNATO, L., Introduction to *Il Libro dell'Arte*, ed. by BRUNELLO, F., Venice, 1971, pp. v–xxvii.

4. CENNINI, op. cit., Chapter IV et seqq.

5. GHIBERTI, L., *I Commentari*, critical ed. by SCHLOSSER, J., Berlin, 1912; ed. by MORISANI, O., Naples, 1927, p. 23.

6. GRASSI, L., *Il disegno italiano dal Trecento al Seicento*, Rome, 1956, p. 89.

7. DELL'ACQUA, G.A., *I grandi maestri del disegno: Pisanello*, Milan, 1952, p. 11.

8. FOSSI TODOROW, M., *I disegni del Pisanello e della sua cerchia*, Florence, 1966.

9. DEGENHART, B., *Pisanello*, Vienna, 1941; id., *Pisanello*, Turin, 1945; DEGENHART, B., and SCHMITT, A., 'Gentile da Fabriano in Rom und die Anfänge des Antikenstudiums', in *Münchner Jahrbuch der Bildenden Kunst*, III, XI, 1960; id., *Italienische Zeichnungen der Frührenaissance*, Munich, 1966; id., *Disegni del Pisanello e di maestri del suo tempo*, Venice, 1966.

10. DEGENHART and SCHMITT, *Münchner Jahrbuch*, 1960, cit.

11. For the decoration of the Pandolfo Malatesta chapel begun in 1414, Gentile da Fabriano had a team of at least eight people, as can be seen from the safeconduct which the painter requested when he left Brescia in 1419 (MARIOTTI, R., 'Nuovi documenti di Gentile da Fabriano sui freschi della Cappella Malatestiana a Brescia', in *Nuova Rivista Misena*, 1892, p. 3 et seqq.).

12. Since it is of particular interest for the working method followed by Pisanello in the Mantuan mural decoration, the first and most significant part is reproduced here of Chapter LXVII of the *Libro dell'Arte* in which Cennini describes 'El modo e ordine a lavorare in muro, cioè in fresco, e di colorire o incarnare viso giovanile' (The method and system for working on a wall, that is, in fresco; and on painting and doing flesh for a youthful face):
'In the name of the Most Holy Trinity I wish to start you on painting. Begin, in the first place, with working on a wall; and for that I will teach you, step by step, the method which you should follow.
'When you want to work on a wall, which is the most agreeable and impressive kind of work, first of all get some lime and some sand, each of them well sifted. And if the lime is very fat and fresh it calls for two parts sand, the third part lime. And wet them up well with water; and wet up enough to last you for two or three weeks. And let it stand for a day or so, until the heat goes out of it: for when it is so hot, the plaster which you put on cracks afterward. When you are ready to plaster, first sweep the wall well, and wet it down thoroughly, for you cannot get it too wet. And take your lime mortar, well worked over, a trowelful at a time; and plaster once or twice, to begin with, to get the plaster flat on the wall. Then, when you want to work, remember first to make this plaster quite uneven and fairly rough. Then when the plaster is dry, take the charcoal, and draw and compose according to the scene or figure which you have to do; and take all your measurements carefully, snapping lines first, getting the centers of the spaces. Then snap some, and take the levels from them. And this line which you snap through the center to get the level must have a plumb bob at the foot. And then put one point of the big compasses on this line, and give the compasses half a turn on the other side. Then put the point of the compasses on the middle intersection of one line with the other, and swing the other semicircle on the upper side. And you will find that you make a little slanted cross on the right side, formed by the intersection of the lines. From the left side apply the line to be snapped, in such a way that it lies right over both the little crosses; and you will find that your line is horizontal by a level. Then compose the scenes or figures with charcoal, as I have described. And

always keep your areas in scale, and regular. Then take a small, pointed bristle brush, and a little ocher without tempera, as thin as water; and proceed to copy and draw in your figures, shading as you did with washes when you were learning to draw. Then take a bunch of feathers, and sweep the drawing free of the charcoal.

'Then take a little sinoper without tempera, and with a fine pointed brush proceed to mark out noses, eyes, the hair, and all the accents and outlines of the figures; and see to it that these figures are properly adjusted in all their dimensions, for these give you a chance to know and allow for the figures which you have to paint. Then start making your ornaments, or whatever you want to do, around the outside; and when you are ready, take some of the aforesaid lime mortar, well worked over with spade and trowel, successively, so that it seems like an ointment. Then consider in your own mind how much work you can do in a day; for whatever you plaster you ought to finish up. It is true that sometimes in winter, in damp weather, working on a stone wall, the plaster will occasionally keep fresh until the next day; but do not delay if you can help it, because working on the fresh plaster, that is, that day's, is the strongest tempera and the best and most delightful kind of work. So then, plaster a section with plaster, fairly thin, but not excessively, and quite even; first wetting down the old plaster. Then take your large bristle brush in your hand dip it in clear water; beat it, and sprinkle over your plaster. And with a little block the size of the palm of your hand, proceed to rub with a circular motion over the surface of the well-moistened plaster, so that the little block may succeed in removing mortar wherever there is too much, and supplying it wherever there is not enough, and in evening up your plaster nicely. Then wet the plaster with that brush, if you need to; and rub over the plaster with the point of your trowel, very straight and clean. Then snap your lines in the same system and dimensions which you adopted previously on the plaster underneath.

'And let us suppose that in a day you have just one head to do, a youthful saint's, like Our Most Holy Lady's. When you have got the mortar of your plaster all smoothed down, take a little dish, a glazed one, for all your dishes should be glazed and tapered like a goblet or drinking glass, and they should have a good heavy base at the foot, to keep them steady so as not so spill the colors; take as much as a bean of well-ground ocher, the dark kind, for there are two kinds of ocher, light and dark: and if you have none of the dark, take some of the light. Put it into your little dish; take a little black, the size of a lentil; mix it with this ocher; take a little lime white, as much as a third of a bean; take as much light cinabrese as the tip of a penknife will hold; mix it up with the aforesaid colors all together in order, and get this color dripping wet with clear water, without any tempera. Make a fine pointed brush out of flexible, thin bristles, to fit into the quill of a goose feather; and with this brush indicate the face which you wish to do, remembering to divide the face into three parts, that is, the forehead, the nose, and the chin counting the mouth. And with your brush almost dry, gradually apply this color, known in Florence as verdaccio, and in Siena, as bazzèo. When you have got the shape of the face drawn in, and if it seems not to have come out the way you want it, in its proportions or in any other respect, you can undo it and repair it by rubbing over the plaster with the big bristle brush dipped in water.

'Then take a little terre-verte in another dish, well thinned out; and with a bristle brush, half squeezed out between the thumb and forefinger of your left hand, start shading under the chin, and mostly on the side where the face is to be darkest; and go on by shaping up the under side of the mouth; and the sides of the mouth; under the nose, and on the side under the eyebrows, especially in toward the nose; a little in the end of the eye toward the ear; and in this way you pick out the whole of the face and the hands, wherever flesh color is to come.

'Then take a pointed minever brush, and crisp up neatly all the outlines, nose, eyes, lips, and ears, with this verdaccio.

'There are some masters who, at this point, when the face is in this stage, take a little lime white, thinned with water; and very systematically pick out the prominences and reliefs of the countenance; then they put a little pink on the lips, and some "little apples" on the cheeks. Next they go over it with a little wash of thin flesh color; and it is all painted, except for touching in the reliefs afterward with a little white. It is a good system.

'Some begin by laying in the face with flesh color; then they shape it up with a little verdaccio and flesh color; touching it in with some high lights: and it is finished. This is a method of those who know little about the profession.

'But you follow this method in everything which I shall teach you about painting: for Giotto, the great master, followed it. He had Taddeo Gaddi of Florence as his pupil for twenty-four years; and he was his godson. Taddeo had Agnolo, his son. Agnolo had me for twelve years: and so he started me on this method, by means of which Agnolo painted much more handsomely and freshly than Taddeo, his father, did.' (From the translation by THOMPSON, D.V., pubished as *The Craftsmn's Handbook*, op. cit.).

13. Many traces of the first charcoal drawing, which enable us to follow the graphic development of the original idea, have been preserved in this *sinopia*, especially in the central group of the Battle (Fig. 58).

14. Examples of the *spolvero* technique being used in the fourteenth century can be found, but generally in these cases it was for ornamental motives (BORSOOK, cit., p. 21). Cennini too mentions the use of *spolvero* in panel paintings for the representation of drapery (CENNINI, cit., Chapter CXLI). But it was only towards the middle of the Quattrocento that the use of *spolvero* was extended to the whole composition, or to the main figures to be painted on the prepared *intonaco*, and painters continued to draw *sinopie* on the *arriccio*, as can be seen for example in Florence in Paolo Uccello's frescoes in the Chiostro Verde, or in those of Andrea del Castagno in S. Apollonia (PROCACCI, op. cit., pp. 64, 65, 67; BORSOOK, op. cit., p. 26; MEISS, *The Painting of the Life*, etc., cit., pp. 17–19). In this connection Meiss remarks that 'Nothing is a more accurate barometer of the increasing individuality, lifelikeness, and therefore uniqueness of forms than the introduction of the *spolvero* in the fifteenth century' (op. cit., p. 18).

15. CENNINI, op. cit., Chapter LVXII.

16. For example the very beautiful pictorial group, quite different from the *sinopia*, which was discovered on the end part of the long inside wall, seems to bear traces of the use of a cartoon, while in the frieze only those of the *spolvero* technique are discernible (Fig. 244).

17. The colour 'known in Florence as verdaccio, and in Siena as bazzèo' was made up of 'one part of black, the two parts of ocher' (CENNINI, op. cit., Chapters LXVII and LXXXV).

18. The black colour which was applied to the dry background after the figures of the warriors had been completed, ran in some places, dripping on to the figures themselves; but this was not important since these surfaces had to be completely covered with a new coat in *secco*, applied in tempera or oil. Oil painting was also known to Cennini who speaks of it as though it were a method often used in Italy by artists from northern Europe: 'Before I go on any farther, I want to teach you to work with oil on wall or panel, as the Germans are much given to do' (CENNINI, op. cit., Chapter LXXXIX). Vasari's assertion that the invention of the technique of painting in oils is ascribable to Jan van Eyck was long ago disproved: it is known that Theophilus had already referred to the technique in his *Diversarum artium schedula*, and probably it was in use even before this treatise was written.

19. Some traces of the alterations made in charcoal on the new *intonaco* are still visible.

20. 'Mezzo fresco', 'fresco su secco' or 'fresco-secco' are terms describing techniques which were not always identical, but which were very similar to the true fresco technique,

34

and which were used for many parts of mural paintings. They were generally added to fresco decorations and their main characteristic was that they could be painted on *intonaco* which was almost dry, or which had already dried but had been wetted again before work was restarted. They were made with pigments dissolved in lime-water or in other media, and sometimes with special treatments which are not fully understood today but which have been discussed at length, with varying conclusions, by a number of scholars. Mural paintings done in this manner had considerable resistance, though less than the true fresco had, against the disintegrating action of time, and they could be elaborated without the need to observe the strict limits of the *giornate* which were necessary for the *buon fresco*. These techniques were often used in conjunction with the true fresco, for the purpose of reinforcing certain colour effects. The pictorial techniques carried out 'in secco', which necessitated the use of a binding medium such as egg yolk, fig latex, resins, oils, glue, etc., for holding together the pigments and making them adhere to the *intonaco*, lasted far less well, and not infrequently during the course of work the surfaces on which they had been applied already began to flake off. However, these 'secco' procedures enabled the artist to give his mural decorations a richness and abundance of pictorial inflexions similar to those of works painted on panels or on other materials in the painter's studio.

21. Probably the so-called variability of the graphic and pictorial characteristics of many of Pisanello's drawings is partly an indication of the different function of each one of them, or each group of them, in relation to the process of executing his mural paintings.

22. Cennini in this connection advised the use in mural decorations of fine gold and 'as little silver as you can, because it does not last; and it turns black, both on wall and on wood, but it fails sooner on a wall' (Chapter XCV). However, the gold and silver of the jewelled lance-shafts are in many places well preserved.

23. A few of them were partly coloured; in addition to the knight already mentioned, painted in *secco* at the far right end of the Battle on a new plaster surface applied to the dark background, some of the horses were painted in *mezzo fresco*, but their harness was not executed in *secco*.

24. Cennini mentions engraving the outlines in the surfaces which are to be coloured over in *secco*, with pigments or with gold or silver, in Chapter LXXXIII ('If you wish to make a mantle for Our Lady in azurite, or any other drapery which you want to make solid blue, begin by laying in the mantle or drapery in fresco with sinoper and black, the two parts sinoper, and the third black. But first scratch in the plan of the folds with some little pointed iron, or with a needle'); and in Chapter XCXIII ('When you have got your whole ancona drawn in, take a needle mounted in a little stick; and scratch over the outlines of the figure against the grounds which you have to gild, and the ornaments which are to be made for the figures, and any special draperies which are to be made of cloth of gold.'). This technique was already in use in Siena in the fourteenth century, as can be clearly seen in the mural decorations of Simone Martini and of Ambrogio Lorenzetti. In the Veneto, Altichiero made frequent use of it.

25. That is, the coat of *intonaco* for the subsequent *giornata*, in accordance with the usual fresco procedure. I do not use this term, however, since it is not strictly correct for the complex and long procedure with which Pisanello carried out even small parts of his painted surface.

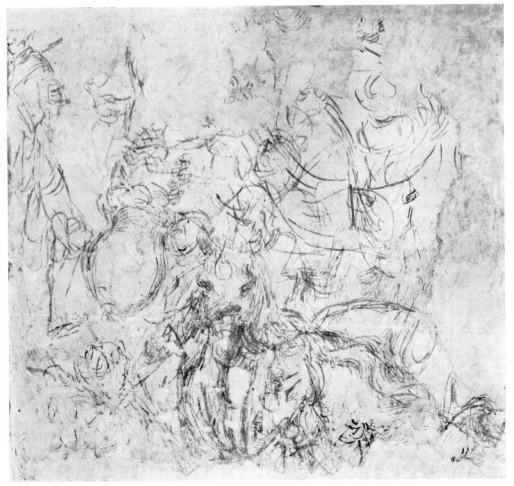

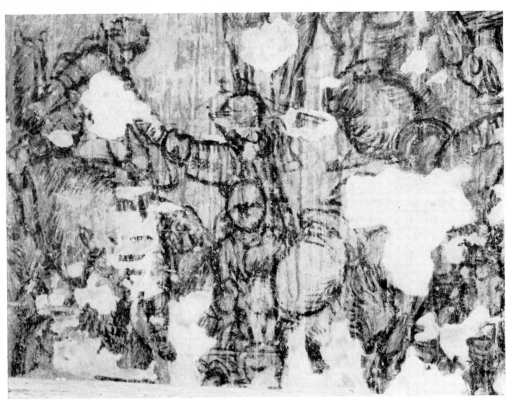

1. *The Battle; detail of the* sinopia *on the left, which was later altered.*

2. *The Battle; alteration to detail in Fig. 1 carried out on a layer of light-coloured* intonaco *superimposed on the first* sinopia.

3. *The Battle; decorative details of lances, fresco.*
4. *The Battle; detail of warriors in black armour, fresco.*

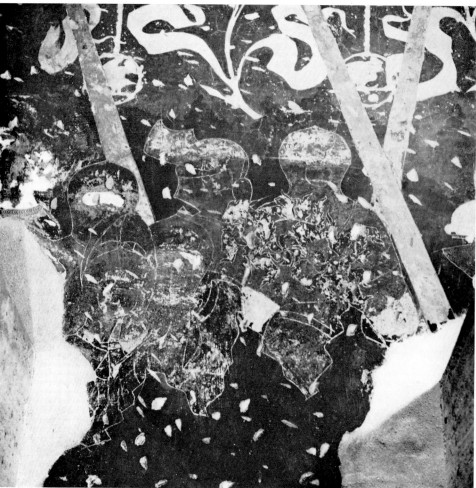

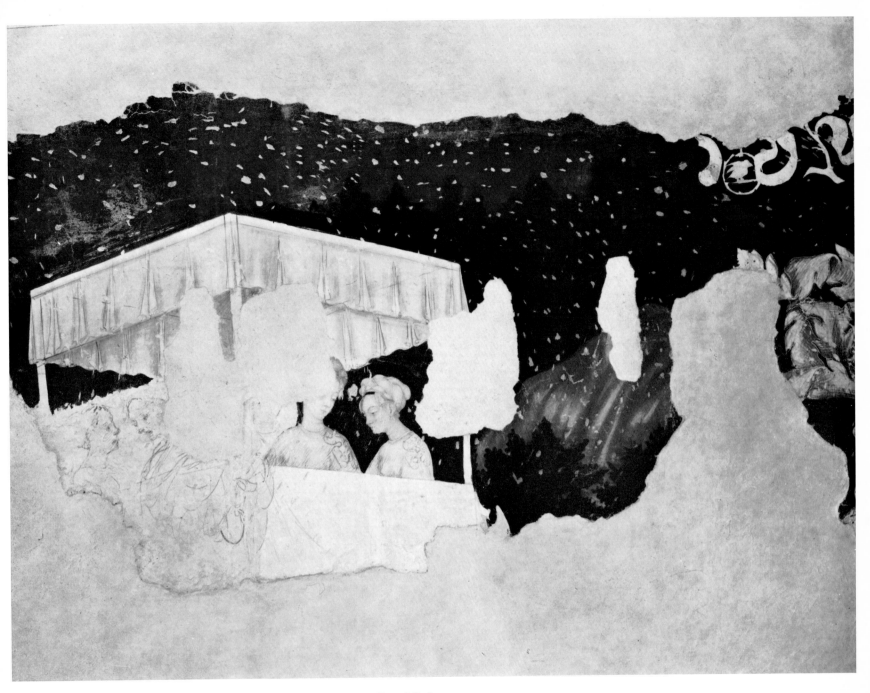

5. Detail of fragment showing ladies under a canopy, fresco. Mantua, Ducal Palace.

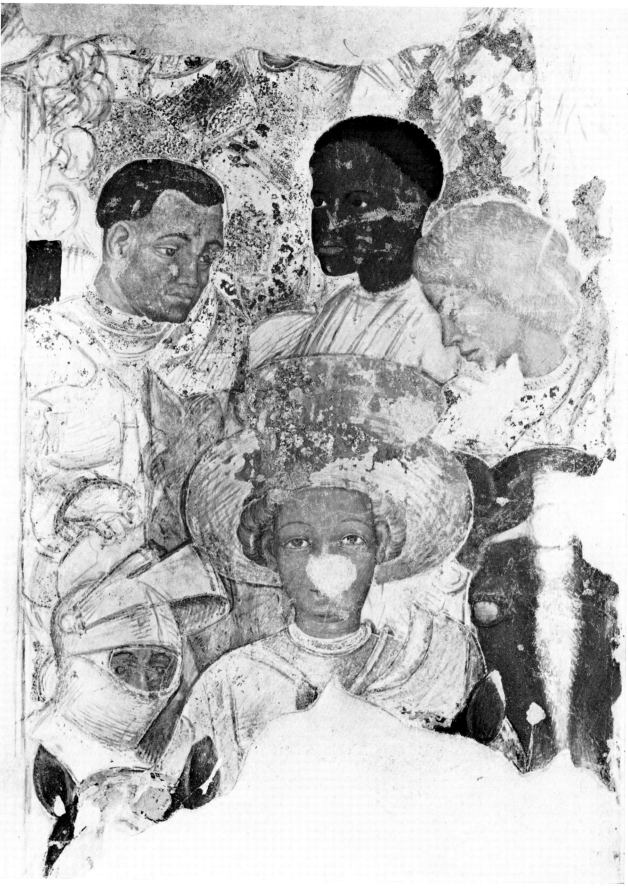

6. *Head of a Negro. Paris, Louvre (Drawing No. 2324).*

7. *Group of knights; detail of the fresco at right end of long inside wall.*

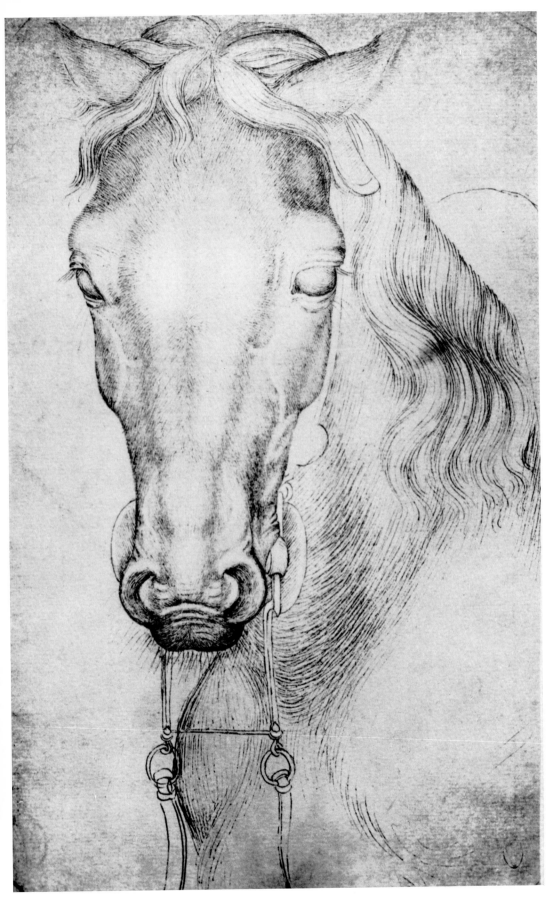

8. Head of a horse. Paris, Louvre (Drawing No. 2360).

9. *Warrior, detail of fresco. Mantua, Ducal Palace.*

10. *Warriors, detail of fresco (a* pentimento *can be detected in a head seen in profile which was subsequently replaced with a warrior seen from the front).*

11. *Warrior, detail of fresco (showing the outlines engraved for the execution of the* secco *pictorial surface).*

12. *Detail of the decoration in engraved gold-leaf, of a horse's caparison.*

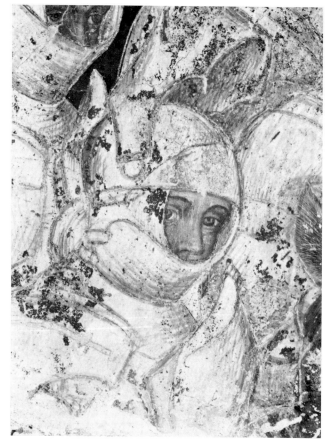

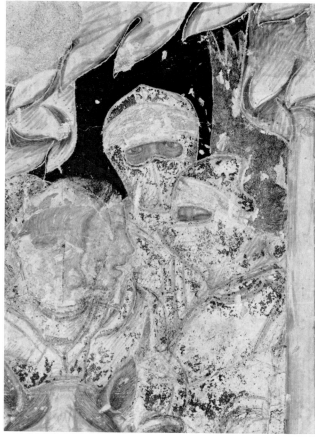

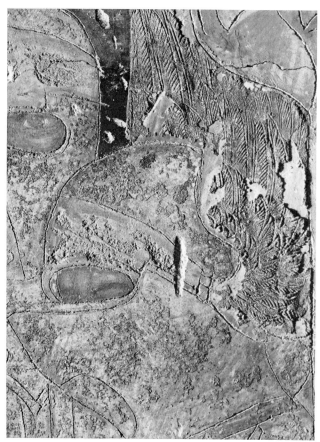

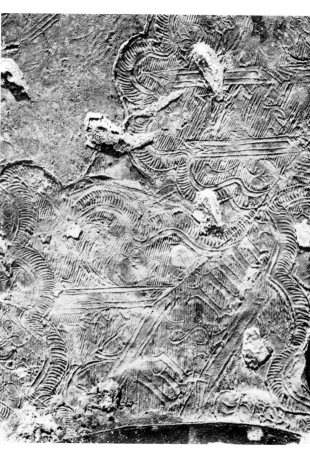

On the opposite page:

13. *Group of warriors, detail of the* first *sinopia,* completely altered in the fresco.

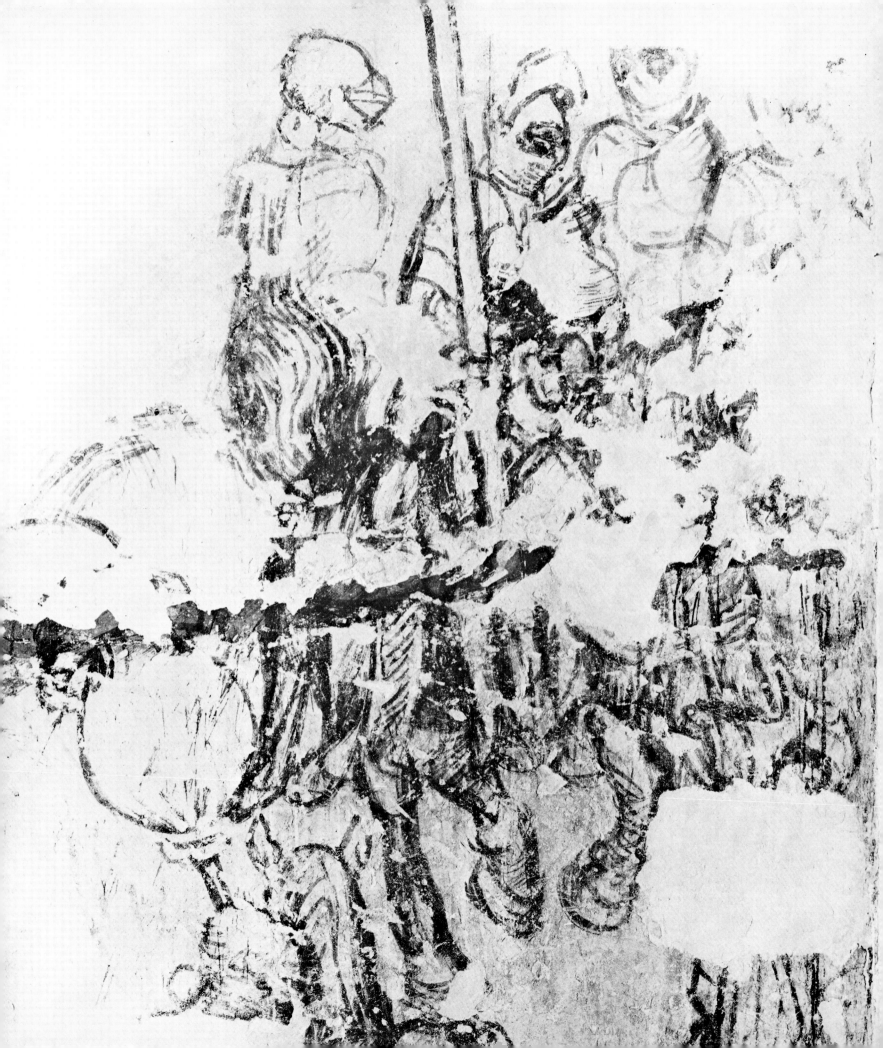

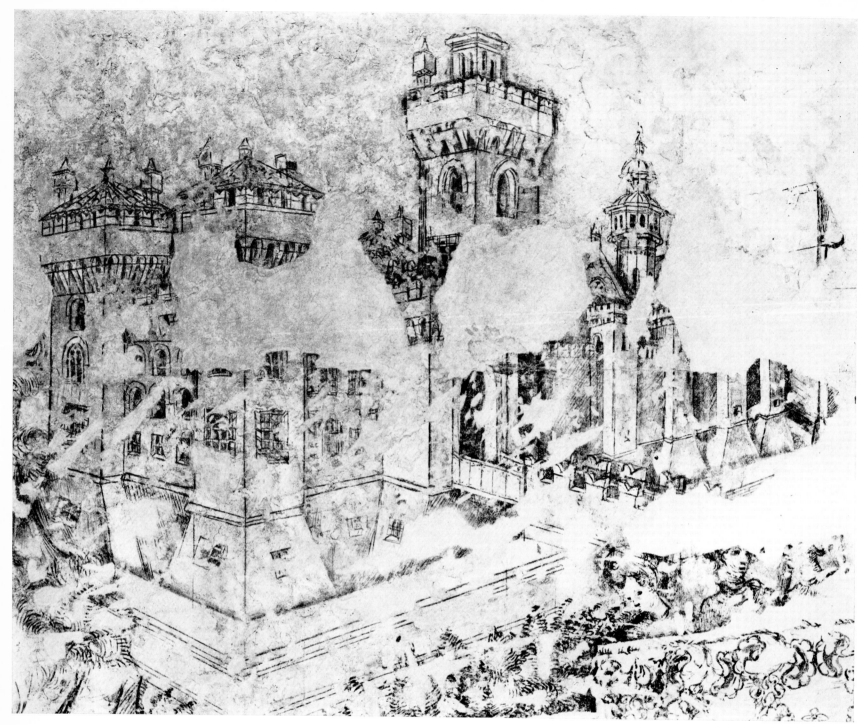

14. The great castle, detail of sinopia.

Chapter Three

THE CHIVALROUS ICONOGRAPHY OF THE MANTUAN CYCLE AND ITS LINKS WITH THE ARTHURIAN LITERARY TRADITION

Whatever the reason for the interruption of this exceptional artistic undertaking, it certainly could not have been unimportant. It must lie in the events of the last years of the painter's life or else in events relating to the Gonzaga family, whose history as captains and *condottieri* followed the chivalresque pattern of the time and gave rise to the project for decorating the 'Sala del Pisanello'.[1] The iconographical content and the symbolic significance of the decoration must have had a function connected with that of the numerous other heraldic motives dating from the previous century which already enriched the walls of the Gonzaga court apartments, evoking the spirit and ideals of chivalrous culture.[2] For the present there seems to be no possibility of rediscovering the exact meaning of this pictorial cycle. Nevertheless, it is worth discussing the questions it poses and presenting the partial answers which research has so far been able to give.

The condition in which the remains of this decoration have come down to us, and especially the almost total loss of the most meaningful figures, which must have been mainly on the bottom part of the walls, makes it extremely difficult to interpret the parts found above, representing intermediate episodes between those in the foreground and the landscape in the background. But both the details and the general tone of the scenes portrayed lead us straight into the atmosphere of a great poem of chivalry. Pisanello gives new meaning—as we shall see when we examine the work at close quarters—to themes drawn from the chivalrous literary tradition and in particular from the French Arthurian romances, which were so popular in the world of courtly civilization. This leads one to reflect upon the historical reasons for the kind of subject matter which imbued Pisanello's pictorial expression, giving it that particular accent and meaning, so that all his art could be called chivalrous.

It is well known that Breton and Carolingian legends were very widespread in Italy and were read both in the older French versions and in the rewritten and hybrid versions of the later French and Italian prose romances. The libraries of the most important Italian courts, of the Visconti, the Este, the Gonzagas, the Carraresi and of Alfonso of Aragon, were well stocked with them; and furthermore, the inventories show that the Gonzaga library had one of the richest collections of these much prized French texts. Among the hundreds of manuscripts in the library when an inventory was drawn up in 1407, on the death of Francesco Gonzaga, there were at least sixty-seven volumes listed under the heading of books in *lingua francigena*: chivalrous themes prevailed with twenty-

two *chansons de geste* and twenty-three prose romances.[3] Although the epic adventures of the Carolingian period were well represented in this large collection of French books, the Arthurian cycle, inspired by the ideal of courtly love, was the most admired of the prose romances. Illustrated texts were eagerly read by the noblemen and the ladies and knights of the court, who liked to see reflected in the literary and visual fantasies of those unreal adventures of chivalry a comforting ideal image of their world in crisis. The richness and variety of the chivalric poems and romances possessed by the Gonzaga family had long been famous even outside Mantuan circles, for in the fourteenth century many noblemen from the Po Valley used to ask the Gonzagas to lend them some of their books, such as *Meliadus*, *Guilelmus de Orenga*, *Phebus li fort*, *Aspremont* and others.[4] It is interesting to read the letter which Luchino Visconti wrote in 1378 to Ludovico I Gonzaga to ask if he would lend him 'unum romanzum loquentem de Tristano vel Lanzaloto', in other words a book about the deeds of the two most famous heroes of the Arthurian cycle, who occupied an important place in the Gonzaga collection of French romances.[5] In fact, several codices in the library contained accounts of the famous exploits of Lancelot.[6] His deeds were also the subject of a vanished mural painting of the Trecento from which the Saleta Lanzaloti took its name. This room, which existed in the second half of the fourteenth century, was located in the oldest of the court buildings.[7]

The story of Tristram, known all over the western world through the poems by Thomas and by Béroul and the later versions in prose, enjoyed extraordinary success in Italy, to an even greater extent than that of the deeds of Lancelot.[8] Proof of the popularity at the court of Mantua of this fascinating legend is provided by the nine French codices containing parts of the interminable compilation in prose of the *Roman de Tristan*, a confused accumulation of all kinds of themes from Breton material.[9] However, this keen interest in the story of Tristram does not necessarily mean that the mural cycle in the Sala del Pisanello was intended to represent the chivalrous deeds of that hero in the same way that those of Lancelot had been represented in the previous century in another room in the Mantuan court. While some of the episodes can be interpreted as deriving from a romance of Tristram, others seem to relate to characters and fantasies from various romances of chivalry. What in fact emerges from those parts of the decoration which have been rediscovered is that the content of the illustrations must have derived from a number of different sources, all drawn from the copious narrative material of the Arthurian cycle, which was so widely represented in the Gonzaga library.

The same conclusion can be drawn from an examination of the historical situation of the Mantuan marquisate around the middle of the fifteenth century, for this would naturally be reflected in a mural cycle carried out in that period. Such an important project as the decoration of a large room in the Gonzaga court was bound to have been planned and carried out strictly according to the wishes of the patrons, who would have decided on the content and on the manner in which it was to be symbolically linked with current events.[10] The approximate date of 1447, which I suggested at the time of the discovery,[11] not only underlined the fact that the decoration belonged to Pisanello's last years of activity, but also refuted the view hitherto held, that the work had been painted during the last years of the rule of Marchese Gianfrancesco, who died in 1444. This view was based on evidence provided by some documents relating to Pisanello's long

46

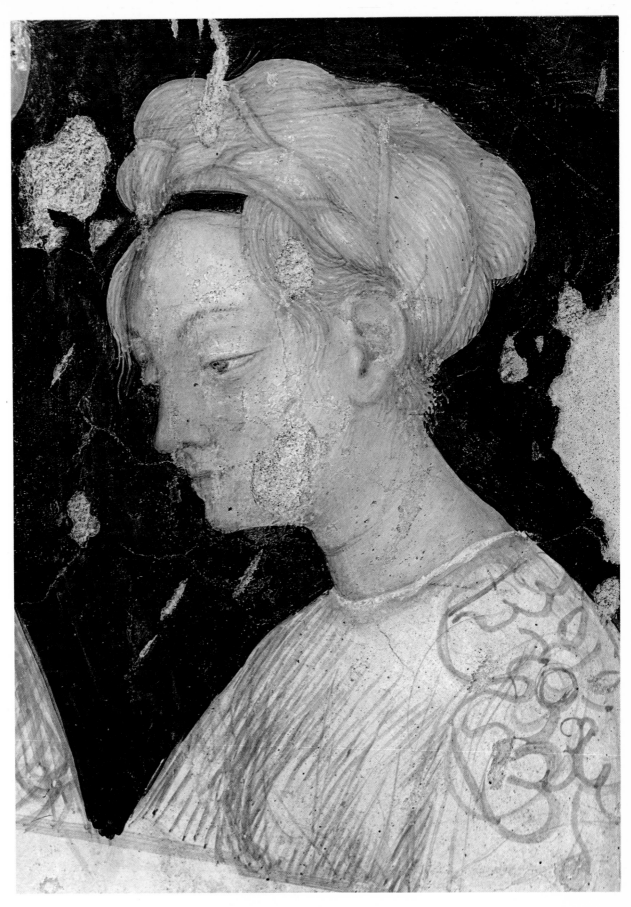

III. Arthurian chivalric cycle: portrait of a lady, detail of fresco. Mantua, Ducal Palace.

stay in Mantua in 1439 and his intermittent presence there during the years 1440–41.[12] However, it was proved to be an incorrect dating because the frescoes and the *sinopie* showed a strong affinity with the most advanced stylistic aspect of Pisanello's last works, noticeable above all in the drawings and medals of the Neapolitan period (*c.* 1448–9). It must also be remembered, with regard to the historical origin of the Mantuan pictorial cycle, that the consequences of the unsuccessful war conducted in 1439 by the Gonzagas against the Republic of Venice made it highly unlikely that the Sala del Pisanello was carried out in 1439 or in the years immediately following. In that stormy period, Marchese Gianfrancesco had other things on his mind and it is most unlikely that he would have planned such a complex and costly artistic project, especially since the content of the decoration was in sharp contrast with the bitter reality of the very difficult military, political and economic situation which he had to deal with in the last five years of his life. While he had remained a loyal ally of the Republic of Venice, Gianfrancesco had been able to obtain great advantages from that alliance, with his shrewd military and political leadership. Some of his greatest ambitions were realized when he was elected general commander of the Venetian army in 1432 and the following year the coveted title of marchese was conferred on him by Emperor Sigismund, with whom he also established a family connection through the marriage of his eldest son Ludovico with the Emperor's granddaughter, Barbara von Brandenburg. In the last years of his long reign, however, Gianfrancesco devised an injudicious political plan, aligning himself with Filippo Maria Visconti against Venice in the mistaken belief that he would thereby manage to seize the cities of Verona and Vicenza. This brought his successes to an end and led the Gonzaga state to the brink of ruin. The war against Venice, after some initial success in 1439, was disastrous for the Gonzagas and the peace terms imposed in 1441 were very severe. Marchese Gianfrancesco was not even able to shake off the charge of traitor which Venetian public opinion had levelled at him.[13] Embittered by the misfortunes which afflicted his state during those troubled years, and harassed by the consequent financial difficulties, he was unable even to meet the modest requests for money which were sent to him from Ferrara by Pisanello. The artist had taken refuge with the Este after the Republic of Venice had banished him from Venetian territory, and denied him access to Mantuan territory because he had been part of Gianfrancesco's retinue during the brief occupation of Verona in 1439.[14] In vain Pisanello, who had planned to move to the Neapolitan court of Alfonso of Aragon in order to extricate himself from his awkward situation with the Venetian Republic, wrote to Marchese Gianfrancesco in 1443 begging him for financial assistance to cover the cost of the long journey; he repeated his request the following year, with the same negative result.[15]

A few months later Marchese Gianfrancesco died, leaving the territory of the Gonzaga state divided between his four sons Ludovico, Carlo, Alessandro and Gianlucido. The eldest son Ludovico, who succeeded to the title of Marchese of Mantua, managed to overcome the difficulties of the first years of governorship; his skill as a *condottiere* and cultured politician soon brought him more power and prestige than the Gonzagas had ever enjoyed before. This ambitious and intelligent prince, educated in the famous humanist school established at the court of the Gonzagas by Vittorino da Feltre, managed to transform his court into an important centre of art and culture, bringing to Mantua

some of the greatest artists of the day to carry out important projects which in a few decades altered the whole aspect of the city. He realized that a shrewd policy regarding the arts could further the attainment of his aims, and with carefully planned patronage he raised the prestige of the Gonzagas among the courtly society of the first half of the fifteenth century. The Sala del Pisanello is one of the most important early manifestations of that patronage, inspired—before Alberti and Mantegna had introduced to Mantua the spirit of their classicism—by that 'chivalrous humanism' which around the middle of the Quattrocento still pervaded the taste and customs of the courts of northern Italy,[16] and in particular those of the Gonzagas and the Este where French culture had been well established for a long time.

The spread of French culture in Mantuan court circles was certainly not due just to the fascination exercised by French chivalric poems and romances. The International style, which flourished at Mantua in the period straddling the fourteenth and fifteenth centuries, was sustained by links and contacts with foreign culture, and especially with the French and Flemish artistic environment. This is demonstrated, not only by the objects and furnishings recorded in contemporary inventories, but also by the direct participation of artists from Germany and Bohemia, from France and Flanders and from other regions of Europe. French and Flemish painters and tapestry-makers were particularly prized: Zanino di Francia, Stefano di Francia, Nicola di Francia, Guidone and Adamante di Francia, and the Flemish artist Rinaldo di Bruxelles, are all recorded as having painted frescoes, made stained-glass windows, decorated cupboards, chests, caskets, and woven fine tapestries decorated with figures and foliage.[17] This International style with its strong vein of French culture, introduced with so much enthusiasm by the Gonzagas into the decorations and furnishings of their apartments, created in the Gonzaga palace an atmosphere of heraldic symbolism, and conferred an aristocratic air of chivalry on the humanism which had been fostered at the Mantuan court by Vittorino da Feltre, and which was not unlike the 'courtly humanism' which had developed at Ferrara through the influence of Guarino. Guarino himself, in his short poem in honour of Pisanello,[18] pointed to the similarity of taste and culture which existed at that time between the two neighbouring and closely related courts at which the artist worked. This parallelism was confirmed by the humanist from Parma, Basinio, a pupil of Vittorino, when around the middle of the fifteenth century he composed at Ferrara his elegy 'ad Pisanum pictorem ingeniosum et optimum'.[19] Furthermore, it is significant that it was precisely artists like Pisanello and Belbello da Pavia who worked at Mantua and Ferrara during the most intensive period of the International Gothic, in the fourth and fifth decades of the century.

In these two centres the new interest in the classical world awakened by Guarino and by Vittorino da Feltre had not diminished the fascination of the chivalresque tradition. The vitality of this tradition in northern Italy was represented not only by the popularity at the courts of the Gonzagas, Este and Visconti, of romances in *langue d'oïl*, but to an even greater degree by the uninterrupted flow of vernacular versions of those courtly fantasies, rewritten in Franco-Italian, Italian and dialect, which continued to be written up to the time of Boiardo. It was, then, a tradition very much alive in the whole of northern Italy, but at Mantua and Ferrara more than anywhere else it was reflected in the life and customs of the court. At Ferrara—as De Robertis observed when examining

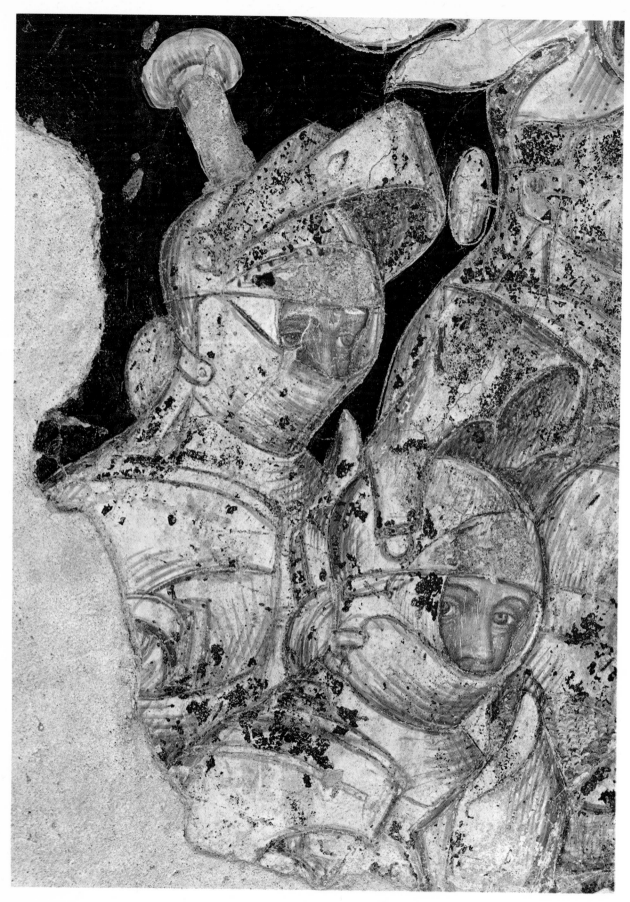

IV. Arthurian chivalric cycle: warriors, detail of fresco. Mantua, Ducal Palace.

the cultural position of that centre at the time of Guarino—the court considered itself to be custodian and preserver of that tradition, 'determining a distinctive climate, in which a cultural tradition became the very life and colour of an era and a factor of coherence and continuity'.[20] This was the time when Pisanello was at work painting and casting medals for Lionello, pupil of Guarino, and it was the period of Boiardo's chivalric poetry, when Ferrara as a cultural centre was at its peak.

Of equal importance, however, was the fact that in Mantua the tradition of chivalry was preserved and transmitted by the French poems and romances in the Gonzaga library, and reflected in the vanished mural cycle dedicated to Lancelot, and in the heraldic decorations which since the late Trecento had adorned the court apartments. In this atmosphere of courtly civilization a plan began to take shape in Ludovico's mind to entrust to Pisanello the task of celebrating the military and chivalrous virtues of the Gonzaga family through an ideal representation related to the virtues of the knights of old and to the legendary Arthurian world, which was to be painted on the walls of a room in the palace at Mantua. 'Tu facis heroas divinae munera famae / Tu facis aeternum nomen habere duces / Mantua dum maneat, dum sit Gonzagia proles', wrote Basinio in his elegy, and it is very likely that he was referring to this last undertaking of Pisanello's at the court of the Gonzaga family.[21]

Another indication that the French romances of the Gonzaga library still fed chivalric fantasies into Marchese Ludovico's imagination is found in a rather strange letter which he wrote from Goito in 1453 to his wife Barbara. In it he informed her that the long and bitter struggle against his brother Carlo, who for some time had been his fierce rival and adversary, had ended with the latter's final defeat. The Marchese, in describing the armed battle which had taken place in the hilly country to the north of Mantua between Goito and Valeggio, and during which he had 'broken, destroyed and smashed' his enemies, uses expressions which echo those of chivalrous narrative: '...yesterday morning the enemy came, in fine battle array, to the country between Valeggio and here; having received word that they had come to do battle, we resolved together with Messer Tiberto that it was time to act, so we mounted our horses and set off towards them. When we reached them, although they had the great advantage over us of being on top of a hill, we fought with them with the grace of God, of Our Lady and St. George. The battle was fought closely and bitterly for about two hours, and many men and horses were slain on both sides. It was one of the most beautiful battles we have ever seen, and we watched it from a fine vantage point, for there were neither trees nor rocks in the way...'[22] It hardly seems as though he were taking part in a fratricidal struggle, in which many were slain 'on both sides' (the defeated Carlo only just managed to escape death, and was unable to return to his domain, which Ludovico confiscated and annexed to the marquisate of Mantua, and he died in exile a few years later, at Ferrara). It was more like a chivalric contest watched as a spectacle from a 'fine vantage point'. In his mind he saw this episode as following the pattern of the descriptions he had read in the romances of chivalry, where the heroes try their prowess, challenging and vanquishing each other in one new adventure after another. The attitude displayed by Ludovico in this important episode of his life indicates that the rivalry with his brother Carlo, even though each adversary aimed at eliminating the other from the military and political scene, re-

flected and conformed with those conventions which the tradition of chivalry had introduced into their way of life.

Thus the new fresco which Marchese Ludovico devised was to be a vast portrayal of that world of chivalry, with a series of selected episodes which were to make up an overall heraldic and symbolic picture. The iconographical ingredients were to be those which had already become common for this type of material; they are to be found, for instance, in a fourteenth-century poem attributed to Dino Compagni:

> Dall'altra parte del ricco palazzo
> intagliat'è la Tavola Ritonda,
> le giostre e 'l torneare e 'l gran sollazzo;
> ed èv' Artù e Ginevra gioconda,
> per cui 'l pro' Lancialotto venne pazzo,
> March'e Tristano ed Isolta la blonda;
> e sonvi i pini e sonvi le fontane,
> le giostre, le schermaglie e le fiumane,
> foreste e lande e 'l re di Trebisonda.

> E sonvi tutti i begli accontamenti,
> che facevan le donne e' cavalieri;
> battaglie e giostre e be' torneamenti,
> foreste e rocce, boscaggi e sentieri;
> quivi sono li bei combattimenti,
> aste troncando e squartando destrieri;
> quivi sono le nobili avventure,
> e son tutt'a fin oro le figure,
> le cacce e' corni, vallett' e scudieri.[23]

('On the other side of the sumptuous palace, / the Round Table is portrayed, / jousting and tournaments and great diversions; / and there are Arthur and gay Guinevere, / with whom brave Lancelot was madly in love, / Mark and Tristram and the blonde Iseult; / and there are pine trees and fountains, / jousting, skirmishes and streams, / forests and moors and the king of Trebizond. / And there are many pleasant encounters, / between ladies and knights; / battles, jousting and fine tournaments, / forests and rocks, woods and paths; / there are fine contests, / lances broken, steeds slaughtered; / there are noble adventures, / and all the figures are in fine gold, / the hunters and trumpeters, the pages and equerries.')

But though the scenic background of the Arthurian representation painted by Pisanello was made up of iconographical elements similar to those described by the poet, the material drawn from chivalric tradition assumed a character and a tone which, while reflecting the full and natural development of the artist's poetic world, scarcely confor-

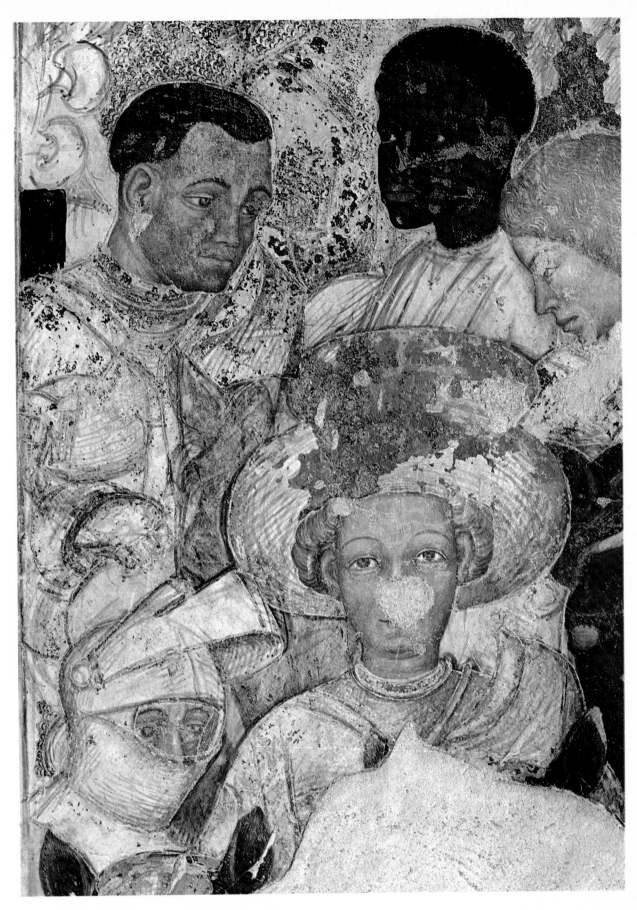

V. *Arthurian chivalric cycle: warriors, detail of fresco. Mantua, Ducal Palace.*

med with the lofty-sounding and commemorative nature of the theme as proposed by the patron or his learned advisers. There is no doubt that Marchese Ludovico intended that this great mural dedicated, as far as can be deduced from the remaining figures, to the Round Table should increase the splendour and prestige of his court with a representation of the Arthurian world inspired by concepts of nobility, and military and chivalrous virtues. It was to be clearly understood as a symbolic reference to the Gonzagas and their prestige as *condottieri*, to which they attached supreme importance. Was the fact that Pisanello's vision did not match those commemorative concepts, one of the reasons why the decoration of the room was interrupted? There are one or two possible theories, which I shall refer to later, concerning the unfinished state of the pictorial cycle—an enigma made even more mysterious by the lack of any record of Pisanello's activity after 1449—but there will probably never be any sure answer.

In the meantime an attempt must be made to interpret the iconographical significance of the figures, and also to deduce from the various scenes and fragments still visible what the planned narrative structure could have been, and how the theme must have been developed on the walls of the room. It must be remembered that the *sinopie* and the frescoes which have been rediscovered are the remains of the decoration on the higher wall surfaces only, and that they largely comprised the landscape backcloth for an Arthurian representation, the main significance of which would have been found chiefly in the more important episodes in the foreground, which have now disappeared or were never executed, on the lower areas of the walls. Even the great Battle (Fig. 15), though it is so complex and rich in detail that it seems to be almost a complete realization of Pisanello's artistic ideas, is without the lifesize figures which were envisaged for the lower part of the composition. A comparison with the corresponding *sinopia* shows in the lower area traces of the foreground figures which have been lost in the fresco (Figs. 66, 259). Nevertheless, from the structure of those parts which remain, it seems clear that the composition was not divided into episodes, and nor did it have any real narrative development which would enable the cycle to be considered, even in the broadest sense, a pictorial version of the romances of chivalry which inspired it. The Arthurian deeds are represented as real incidents, taking place in a single landscape with one episode leading into the next and all portrayed on one huge pictorial surface covering the four walls of the room (Figs. 19, 26, 48, 55). The apparently archaic structure of the composition in which all the images, even those at the top which represented the most distant planes, seemed to have been brought to the surface, had neither a beginning nor an end, and it circled round on itself. However, the central area must have been the large *sinopia* on the long inside wall (Figs. 19, 26), which had as its background a winding landscape of hills, woods, towns and castles, and which flowed on in episodes which continued with the same rhythm and the same iconography over the left and right hand walls.

If we think of Pisanello's fresco of *St. George and the Princess* in the Verona church of S. Anastasia where the images are studied in every detail, yet placed so high up and out of sight that they seem painted only for the artist's own satisfaction, it is not so surprising that Pisanello, in the room at Mantua, should have placed at the highest point, to the right of that superb landscape background, the most densely-peopled group he ever portrayed. The remains of this extraordinary representation formed part of a wider

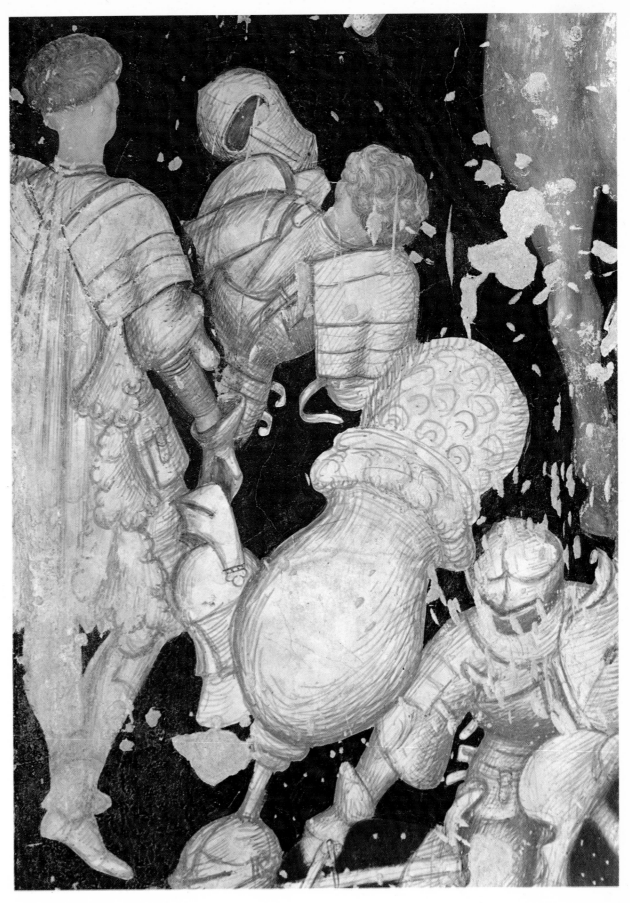

VI. Arthurian chivalric cycle: The Battle; knight standing, looking at a fallen warrior, detail of fresco. Mantua, Ducal Palace.

context including the large castle resembling the Castello di S. Giorgio (Fig. 14), the group of ladies arranged in a large decorated balcony (Figs. 19-24) containing two fragmentary but enchanting portraits which are two of Pisanello's most vivid female figures, and the solid band of armed knights, also including many beautiful portraits (Fig. 18), which echoed the Battle scene painted on the adjacent wall. Other episodes, at the opposite end of this very long *sinopia*, are linked with those of the contiguous left hand wall, in which we can see a number of solitary warriors crossing narrow wooded valleys in the mountain landscape, which spreads continuously over the two walls in a rhythmic pattern of diminishing hills seen from above (Figs. 27, 48).

Obviously these warriors represent the knights errant of the romances of courtly literature, setting out among the tortuous valleys and mysterious ravines of that landscape in search of fabulous adventures in which to try their prowess. But without the help of some remaining fragmentary inscriptions in French on this part of the *sinopia*, it would be impossible to distinguish the characters and pick out which episodes these images refer to among the innumerable adventures which turn up again and again in Arthurian legends with the same characters or with slight variations. Research on the interpretation of these mutilated inscriptions has made it possible to recognize the names of some of the knights represented, from the elegant Gothic lettering written beside them. The images also bear serial numbers, corresponding to the order of the knights as they appear in the landscape, from right to left. The relative inscriptions are as follows: II - ... *lor . as . dures . mains* . (Fig. 39); III - *arfassart . li . gros* . (Fig. 40); IIII - ...*rot* . (?) (Fig. 41); V - *Malies . de . lespine* . (Fig. 42); VIII - ... *ons . li . envoissiez* . (Fig. 43).

Although the inscription marked 'IIII' is still difficult to interpret, since all that is left is the ending ... *rot* or ... *roc*, there are no problems about reading in the other inscriptions the names of the knights of the Round Table, *Cabilor as (aux) dures mains*, *Arfassart li gros (cuer)*, *Malies de l'Espine*, *Meldons l'envoissiez (l'enjoué)*.[24] These personages are found in *Lancelot*, where together with other knights they are engaged in displaying their prowess during a feast at the court of King Brangoire,[25] and in *Tristan* at the end of the long line of knights leaving the court of King Arthur to set out in search of the Holy Grail.[26] Arfassart and Malies de l'Espine are also included in the long list of the knights of the Round Table which is given at the beginning of the sixteenth-century edition of *Gyron le courtois*.[27] These are little-known knights, far removed from the valour and fame not only of the famous Lancelot and Tristram, but even of many other heroes of Arthurian romances. Why did Pisanello choose to represent these particular knights, who play secondary roles in the romances, making them the protagonists of a beautiful, evocative scene which seems to express the very spirit of chivalry, with figures of solitary warriors riding through a deserted and mysterious landscape? A comparison with the episode from *Lancelot*, where these knights appear, points to the relationship which exists between the figures in the *sinopia* and those of the literary text. In fact there is a significant concordance between the serial numbers shown beside the knights in the *sinopia* and those given to the same knights in *Lancelot*: this concordance is of particular help in establishing the iconographical meaning of the images shown in the *sinopia*. The episode in *Lancelot* refers indirectly to Bors, the valiant knight of the Round Table, cousin of Lancelot, who in another romance, *La Queste del Saint Graal*, was to be one of the

56

main protagonists in that most important adventure of the Arthurian world. In this episode Bors wins a tournament at the court of King Brangoire and a feast is given in his honour, during which the king's daughter asks for a gift from each of the twelve knights who are present together with Bors. Each of them then declares that he will carry out memorable deeds for her; the names of the knights and their declarations are specifically indicated with a serial number. Here in the original text is the description of the promises made by the twelve knights, and of the declaration of loyalty which Bors makes to the king's daughter, with whom he is in love:

'Lorse sen ua la damoisele a la table as . xij . pers. Et dist au premier cheualier. Sire iou vous ai serui si voldra sauoir sil vous plaist quel guerredon vous men rendrois. Et cils qui tous fu esbahis de la grant biaute de li. dist oiant tous. Damoisele pour vous ferai iou tant que deuant . j. an ne iousterai a cheualier. que iou naie ma destre gambe sour le col de mon cheual & de tous chiaus que iou porrai conquerre vous envoierai les armeures. Et chou vous creant iou loiaument. Et cils cheualiers auoit non kallas li petis Et vous vait elle a lautre qui deles lui sees . quel guerredon a(u)rai iou de mon seruice. Damoisele fait le tel. que a lentree de la premiere forest que iou trouuerai ferai tendre mon pauellon et serai illueques tant que iou a(u)rai conquis . x . cheualiers ou iou serai ochis. Et se iou lez conquier vous en a(u)rois tous lez cheuaus. Et cils cheualiers auoit non talibors as dures mains. Et li tiers si dist quil nenterroit jamais en chastel deuant a ce quil a(u)roit . x . cheualiers outres. Et se iou lez conquier damoisele vous en aurois lez heaumes. Et cil cheualiers auoit non alpharsar. Et li quars dist quil ne coucheroit iamais o damoisele nu a nu deuant quil ait conquis. iiij . cheualiers. ou il sera oultres. Et se iou les conquier damoisele vous en a(u)res les espees. Et cils cheualiers auoit non sarduc li blans.

'Lors dist li quins que deuant . j . an nencontreroit il damoisele par coi elle mainst cheualier aueques li . quil ne se combache tant au cheualier quil laura conquis ou li cheualiers lui. Et toutes lez damoiseles que iou conquerrai . iou les vous envoierai por seruice. Et cils cheualiers auoit non melior de lespine. Et li sisimes dist quil ne conquerra en cel an cheualier a qui il ne cope la teste ou il sera pris ou ochis. Et de tous ceuls que iou conquerrai damoisele vous envoierai iou lez testes. Et cils cheualiers auoit non angoires li fel. Apres celui dist li septismes quil nencontreroit en cel an damoisele qui en conduit de cheualier soit que il ne baiseche a force la damoisele ou il sera vaincus. Et cil auoit non patrides au cercle dor. Apres dist li witismes quil cheuauchera . j . mois en sa chemise le heaume en la teste et lescu au col et le lance el poing et lespee en la main ou au coste. Ne ia nencontrera cheualier a qui il ne iouste. Et de tous chiaus que iou conquerrai vous envoierai lez cheualx Et cils cheualiers auoit a non meldons li enuoisies.

'Apres dist li noeuismes damoisele pour vous ferai iou tant. que iou yrai au guez del bois. et le garderai si que nus cheualiers ni abeurra son cheual a qui iou ne men combate et de tous chiaus que iou conquerrai vous envoierai iou lez escus. Et cils auoit non Garingans li fors. Apres dist li disimes quil ne finera iamais desrer deuant quil auera trouue la plus bele damoisele de toutes Et sachies fait il que iou le prendrai en quel lieu que elle soit. Et se on le me contredist iou me combaterai tant que iou le conquerrai ou iou serai outres. Et se iou le conquier iou le vous amenrai pour vous serurir. Et cils auoit non malquins li galois. Apres dist li onzimes Damoisele pour vous ferai iou tant que de toutes

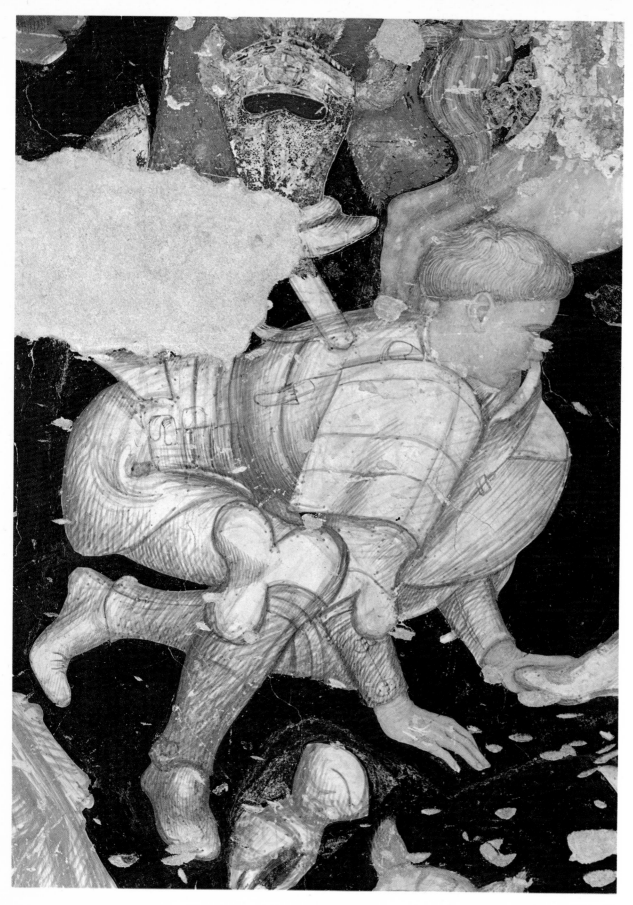

VII. *Arthurian chivalric cycle: The Battle; kneeling warrior pierced by a lance, detail of fresco. Mantua, Ducal Palace.*

reubes ne vesterai fors la chemise mamie et sa guimple a(u)rai tornee entour mon chief Et auec chou ne porterai fors mon escu et ma lance. Si cheualcherai en tel maniere tant que iou aurai abatu . x . cheualiers ou iou serai vaincus. Et tous ceus que ie conquerrai vous envoierai iou. Et cil auoit non agrocol li biaux parliers. Lors dist li douzimes. Damoisele. pour vous ferai iou tant que deuant. j . an ne monterai iou sour cheual qui ait frain ne cauestre ains le lairai aler tout a sa volente. si que iou ne li taurrai ne voie ne sentier. Et a tous lez cheualiers que iou enconterrai me combaterai iusques a outrance. Et de chias que iou conquerrai vous enuoierai les chaintures & lez aumosnieres Et cils cheualiers auoit non li lais hardis.

'Quant tout li . xij . cheualier orent parle. lors vint la damoisele a bohort. Si li dist sire quel guerredon puis iou atendre de vous Damoisele fait il en quel lieu que iou soie deliures et en ma poeste me poes prendre pour vostre cheualier. et metre moi por vostre droit desrainier. Et encore plus. Sachies que quant iou aurai akieuee ma queste iames ne finerai desrer deuant que iou aurai veu la royne Genieure Et pour lamour de vous le prendrai en conduit de . iiij . cheualiers quel que il soient. fors seulement que mesires lancelot del lac ni soit. Car se il y estoit iou ne men aatis mie. quar iou feroie que folx. Sire fait elle moult grans mercis . si sen uait atant Et lors commence la ioie & la feste. Et karolent jusques a la nuit.'

(Then the damsel went to the table of the twelve peers, and said to the first knight, 'Sire, I have served you and should like to know what reward you will give me'. And he, who was greatly struck with her extreme beauty, said for all to hear: 'Lady, I shall do as much for you as before. For one year I shall not joust with any knight but when I have my right leg on my horse's neck and I shall send you the arms of all I can defeat. And I promise you this faithfully'. And that knight was called Kallas le Petit. Then she turned to another, who was sitting beside him: 'What recompense shall I have for my services from you?' 'Lady', said he, 'at the entry to the first forest I shall come to I shall set up my tent and shall stay there until I have defeated ten knights, or been killed. And if I conquer them, you shall have all their horses.' This knight was called Talibors aux Dures Mains. And the third said he would not enter a castle until he had vanquished ten knights. 'And if I defeat them, lady, you shall have their helmets.' This knight was called Alpharsar. And the fourth said he would never lie with a lady until he had conquered four knights, or been defeated. 'And if I conquer them, lady, you shall have their swords.' This knight was called Sarduc Le Blanc. Then the fifth said that for a year, each time he met with a knight escorting a lady, he would joust with him until one of them should have mastery. 'And all the ladies I capture, I shall send to you to serve you.' This knight was called Melior de l'Epine. The sixth said that within the year he would conquer no knight without cutting off his head, if he himself was not captured or slain. 'I shall send you the heads of all I slay, lady'. The name of this knight was Angoires le Fel. After him, the seventh said that within the year he would forcibly kiss any damsel he encountered being conducted by a knight, or be defeated. His name was Patrides au Cercle d'Or. Then the eighth said he would ride for one month in his shirt, his helmet on his head, his shield hanging from his neck, his lance in his grip and his sword in his hand or at his side, and he would refuse battle to no knight he encountered. 'I shall send you the horses of all those I conquer.' This

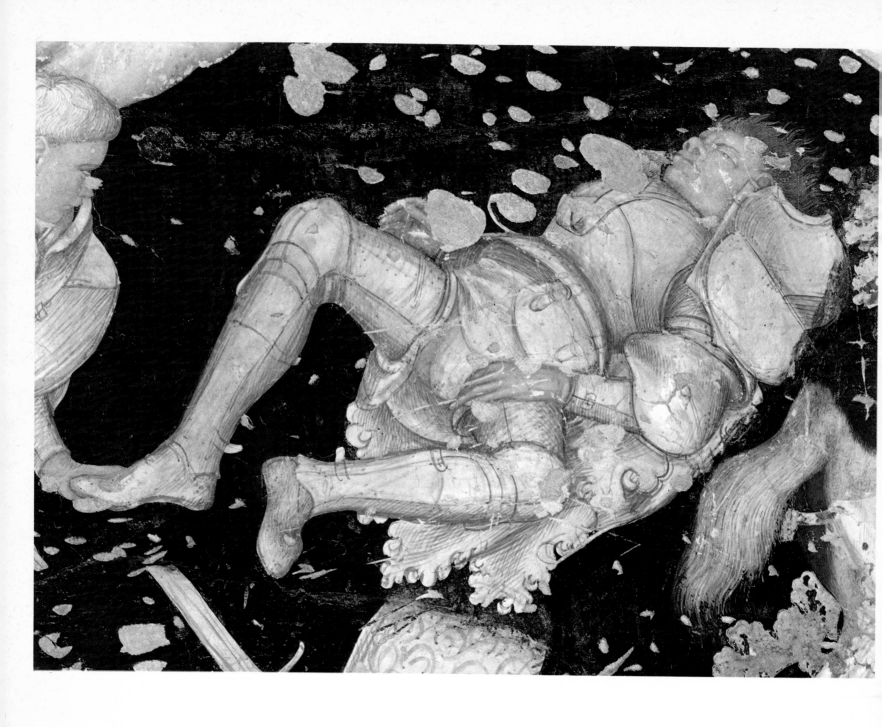

VIII. *Arthurian chivalric cycle: The Battle; dead warrior lying on his back on the ground, detail of fresco. Mantua, Ducal Palace.*

knight's name was Meldon le Ennuyeux. Then the ninth said, 'Lady, I shall do this for you; I shall go to the edge of the wood and shall guard it so that no knight will water his horse there without my fighting him and I shall send you the shields of all those I conquer.' That knight's name was Garingan le Fort. The tenth then said he would never cease to travel until he had found the most beautiful lady of all. 'And I shall take her prisoner whoever she may be. And if any attempt to deny me, I shall fight him until I defeat him or am myself overcome. If I capture her, I shall bring her to serve you.' His name was Malquin le Galois. Then the eleventh said, 'Lady, I shall do this for you; I shall wear no garment but the shift of my true love and I shall wind her wimple around my head and with this I shall bear only my shield and lance. I shall ride thus until I have defeated ten knights or been defeated. And all those I conquer I shall send to you.' This knight was called Agrocol le Beau Parleur. The twelfth said, 'Lady, I shall do this: for a year I shall mount on no horse which has halter or bit and I shall leave it free to wander, down any path or way. I shall engage in combat with all the knights I meet and I shall send you the belts and purses of all those I defeat.' That knight was called Le Lais Hardi.

When all the twelve knights had spoken, the lady came to Bors, and said 'Sir, what recompense shall I have from you?' 'Lady', he said, 'as long as I am free and strong, you can count on me as your knight, and use me to defend your cause. And what is more, you should know that when I have accomplished my quest, I shall never cease to ride until I come before Queen Guinevere, and for love of you I shall take her from the four knights who have charge of her, unless Sir Lancelot du Lac be there; for if he should be there, truly what I suggest would be madness.'

'Sir', she said 'I thank you.' Then she left and the feasting began; they danced until evening.)[28]

As can be seen, the following knights: II Calibor as dures mains, III Arfassart li gros, V Malies de l'Espine and VIII Meldons li envoissiez, have the same numbers in *Lancelot*, which would seem to suggest that the figures in the *sinopia* derive from that romance. And indeed, however different in spirit they may be, there are many links between the figures of knights in the Sala del Pisanello and the twelve knights and their exploits described above.

Let us begin with Cabilor:[29] although this area is badly damaged and difficult to distinguish, the *sinopia* shows an open pavilion, set up on the wooded landscape, in front of which a knight with another person by his side appears to be busy putting on his armour, helped by a kneeling equerry who is fastening his jambes. It seems likely that the knight shown preparing himself to fight with the armed knight approaching the pavilion, corresponds to Talibor in *Lancelot*. To the left of Cabilor is the armed figure of Arfassart who is riding up a steep path, followed by a page (Fig. 46). There are no indications however to show more clearly the link with the episode in *Lancelot*. The next knight marked with number IIII in Pisanello's *sinopia* ought to be, according to the literary text, Sarduc li Blans. But there is no connection between the claim of Sarduc li Blans and the illustration in the *sinopia* which shows, beside two horses, a small knight on foot, of whom only the helmet with raised vizor, part of the surcoat, and the feet remain (Fig. 47). Perhaps this figure and the fragmented name ending in ' ... *rot*' (Fig. 41) relate to Calaarot le Petit, a personage in *Tristan* included in the list of knights of King Arthur

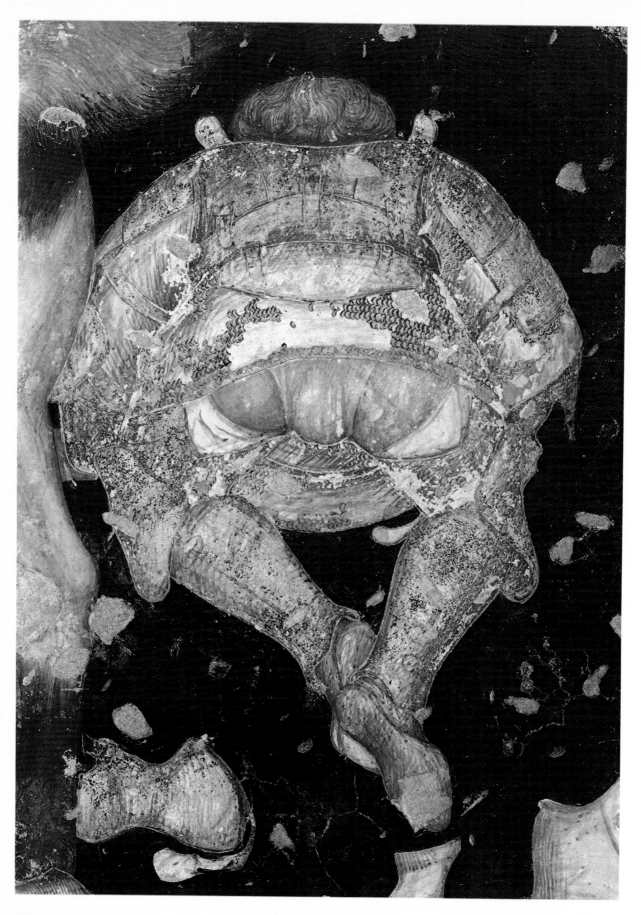

IX. Arthurian chivalric cycle: The Battle; warrior fallen face downwards, detail of fresco. Mantua, Ducal Palace.

who set out in search of the Grail, and who might therefore correspond to Kallas le Petit, the first knight in the episode in *Lancelot*, even though the serial number in the *sinopia* is different from that in the literary text.

On the adjacent wall the series of knights continues with Malies de l'Espine who has pulled his horse up sharply in front of some figures, unfortunately lost, at whom he is staring fixedly (Figs. 48, 50, 51). Although the beautiful figure of Malies[30] is partly damaged, it is nevertheless clearly discernible, while almost nothing remains of the scene which was shown in front of the knight. On the few parts of plaster which escaped the blows of the hammer it is possible however to discern a woman seated on the ground, a young man standing in front of her and, higher up, their mounts. It may be, then, that the iconography of this scene in the *sinopia* reflects the story of Melior in *Lancelot*.

There is certainly a connection between the graphic image and the literary image in Meldons li Envoissiez,[31] whom Pisanello has represented (Plate IV; Fig. 52) with all the attributes which are given to this knight in the text of the romance.

There are no other inscriptions or numbers in this *sinopia*, but Pisanello probably portrayed all twelve knights whose promises are listed in the single episode of *Lancelot*. The missing ones may have been, like the others we have examined, in the middle area of the *sinopia*, where the series of twelve knights perhaps continued to the left over the vast surface, now lost, of the shorter wall. It is possible that fragments of a female figure, portrayed in the landscape below the castle whose towers stand out behind the hills, belonged to the scene which represented the exploits of the seventh knight, Patrides au Cercle d'Or (Fig. 49).

At first it seems difficult to identify the two largest and most beautiful figures of knights, drawn on the bottom part of the walls, with the exploits which Angoire li Fel and Garigan li Fors promise to carry out in the *Lancelot* episode. One portrays the decapitation of a warrior, the other an armed knight (Plate XII; Figs. 53, 54) who, riding alongside a stream, is turning his horse towards his adversary on the opposite side. (Of the latter, shown on rough ground, lower down the wall, only his poised lance remains, and a few traces of the front part of his horse.) If, moreover, we take an overall look at the composition, it seems unlikely that Pisanello would have wanted to give these two particular knights such a prominent position which makes them stand out so clearly from the others, while in *Lancelot* all twelve knights followed one another without distinction of status, like heraldic emblems differing from each other but all of equal value. The iconographical correspondence between the mural cycle and the episode in *Lancelot* which I have pointed out here, is not sufficient to convince us that Pisanello really intended to represent the exploits promised in *Lancelot* by the twelve knights taking part in the feast given by King Brangoire. Indeed there is no hint in Pisanello's decoration of a feast taking place at court, an essential part of the scene described in *Lancelot*; and it cannot be assumed that the event was represented on the foreground surfaces as these were intended for the illustration of the more important deeds of the main protagonists. Moreover, the bold and self-confident picture which the twelve knights give of their vaunted deeds in *Lancelot* has nothing in common with the representation in the *sinopia* of solitary knights wandering over a landscape where behind every hill seems to lurk an ambush or else the possibility of some miraculous event. On the other hand, no

images could better conjure up the atmosphere of fabulous mystery which pervades the legend of the Grail. And if this is the poetic tone which Pisanello gives to his characters, he certainly could not have drawn his inspiration from the worldly story of *Lancelot*, but rather from the mystical symbolism of the romance dedicated to the search for the Grail.

The legend of the Grail must have had a special interest for the Gonzagas since, as well as the romance in verse *Perceval ou Conte del Graal* by Chrétien de Troyes,[32] they also possessed the romance in prose *La Queste del Saint Graal*.[33] Their library contained both an incomplete copy of this romance in prose[34] and the later version incorporated in *Tristan*,[35] a text which as we have seen was very well known at Mantua. It is therefore interesting to note that in the version of the Quest which is incorporated in *Tristan* we meet the twelve knights again, among the names of the *preux* who swear on the day of Pentecost at Camelot—capital of the territory of Logres ruled by King Arthur—to dedicate themselves for a year and a day to the most risky and mysterious undertaking that a knight ever faced, the search for the Grail. Almost at the end of the long list of those brave knights—headed by the three main heroes of the Quest, Galahad, Perceval and Bors, followed by other protagonists of the most important deeds to be narrated in the Arthurian cycle[36]—the names of the twelve knights reappear, in the same order as in the *Lancelot* episode and in Pisanello's *sinopia*.[37] The picture given of the twelve knights in the romance of *Lancelot* had evidently been used as a model for the compiler of this version in *Tristan*, who gives their names, though with some variations, in the same order as in *Lancelot;* consequently it is easy to understand why, even though they exchanged their worldly attire of *Lancelot* for the austere dress of the *Queste*, they still preserve the general appearance and the arrangement which they had in the original story, and Pisanello follows the same model when he depicts them in his *sinopia*.

The large illustrations in the bottom part of the *sinopia* showing the decapitation of a warrior and a chivalric duel—discussed above—probably represented important deeds by the protagonists of this pictorial cycle, which were to have been portrayed mainly in the large foreground scenes. It is possible however that the significance of these images is connected with that of the knights in search of the Grail drawn in the middle ground, and therefore all the episodes in this area of the *sinopia* may have been dedicated to the Quest. It would in fact have been strange and incongruous if the representation of the Quest had been restricted entirely to the figures of knights in the middle ground, while the great heroes of the search were not in evidence, not even Bors who, as we have seen, was present at the feast given in his honour by King Brangoire in the *Lancelot* episode, though as the main protagonist he was quite distinct from the series of twelve knights. It is therefore probable that the decapitation scene—despite the fact that similar incidents abound in romances of chivalry—relates to that episode in the *Queste* in which Bors, after having fought at length against Priadam, at last brings him to the ground, weak and wounded, takes off his helmet and raises his sword threatening to cut off his head unless he declares himself defeated. Priadam commits himself to Bors' mercy, begging him not to kill him, and Bors lets him go free. The passage which seems to be the literary source of the scene portrayed in the *sinopia* is as follows: 'Et quant Boorz le voit einsi lassé, si li cort sus plus et plus, et cil vet tant guenchissant çà et la qu'il chiet a terre tot envers. Et Boorz l'aert au hiaume et le tire si fort qu'il li errache de la teste et le giete en

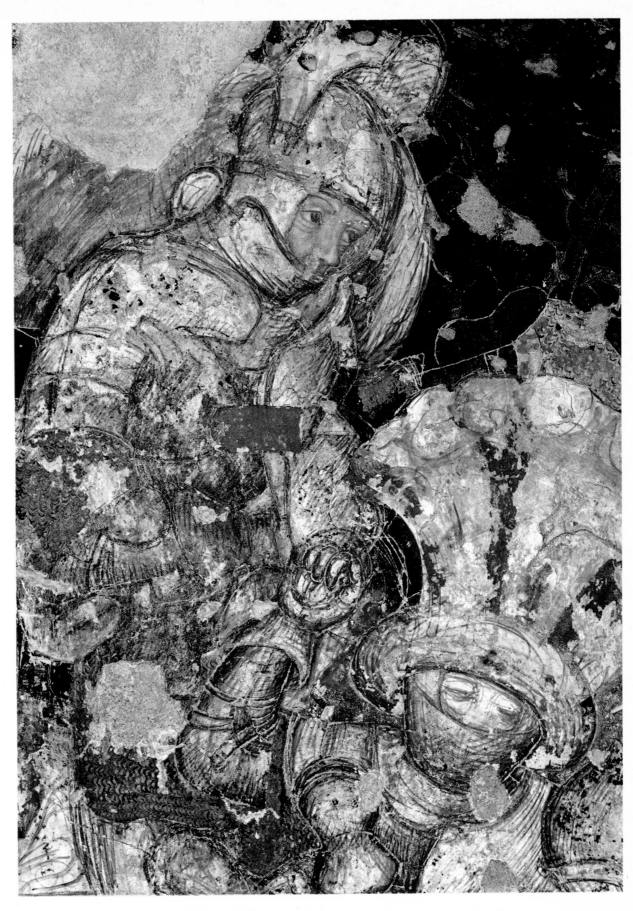

X. *Arthurian chivalric cycle: group of fighting warriors, detail of fresco. Mantua, Ducal Palace.*

voie, et le fiert dou pont de l'espee sus le chief, si qu'il en fet le sanc saillir et les mailles dou hauberc entrer dedenz; et dist qu'il l'ocierra s'il ne se tient por outré, et fet semblant qu'il li voile la teste couper. Et cil voit le branc drecié sor son chief, si a poor de morir, et por ce crie merci et dit: "Ha! frans chevaliers, por Dieu aies de moi merci et ne m'oci mie!".[38] (And when Bors saw he was tired, he redoubled his attack and came at him from all sides and had his adversary turning hither and thither so that he fell over. Bors seized him by the helmet and tugged it right off his head and threw it a great distance from him; then he struck him with the point of his sword on the head so that the blood flowed and the links of his hauberk went in; crying that he would slay him, if he did not yield and making as if to cut off his head. His victim saw the blade poised over his head and was afraid to die, and cried for mercy, saying 'Oh noble knight, for God's sake have mercy on me and don't kill me.') Pisanello's beautiful image (Plate XII) may well represent the instant in which Priadam is kneeeling on the ground in front of Bors, who raises his sword as if to decapitate him. The gesture is calm and solemn, without any of the gratuitous bragging of the declaration made by Angoires li Fel; and its cruel significance is modified, if seen in the context of the Bors episode of the *Queste*, into a threatened decapitation, which would also explain that sense of pity towards the defeated which seems to restrain the winner's sword.

The chivalric duel, a subject common in Breton narrative, also takes on a more specific meaning if it is seen in the context of the Quest, as suggested by the setting of all these illustrations. The meaning of the scene is rendered more obscure by the almost total loss of the figure of the knight at the bottom right. Just a few lines remain of his horse climbing up the steep bank, and of the lance aimed at the other knight, shown on the left without his lance while he lingers on the high ground overlooking the river, as though taken by surprise by that attack (Figs. 27, 54). However, the elements still visible suggest that this may be the episode in which Lancelot, deep in thought while riding along the banks of the river Marcoise, trying to find a way to cross the deep and dangerous waters, is suddenly assailed by a mysterious knight who has come out of the river and who, with a blow of his lance, kills Lancelot's horse, leaving him unwounded, and making off as quickly as he had come: 'Tandis qu'il estoit en cel penser li avint une aventure merveilleuse; car il vit de l'eve issir un chevalier armé d'unes armes plus noires que meure, et sist sus un grant cheval noir. Et la ou il voit Lancelot, si li adrece le glaive sanz lui mot dire et fiert le cheval si durement qu'il l'ocit, mes lui ne touche; si s'en vet si grant erre que Lancelot n'en pot en poi d'ore point veoir.'.. (While he was musing thus, a strange adventure befell him. He saw a knight come forth from the water clad in armour blacker than the mulberry, mounted on a great black horse. When he saw Lancelot, he pointed his sword at him and, without saying a word, struck the horse so hard a blow that he slew it, but did not touch Lancelot. Then he rode off so fast that Lancelot soon lost sight of him.)[39]

On the opposite side of the room, facing those evocative figures of knights errant in a deserted mountain landscape reflecting the mystical spirituality of the Quest, the great fresco of the Battle (Fig. 15) was spread over the whole wall, symbolizing the skill

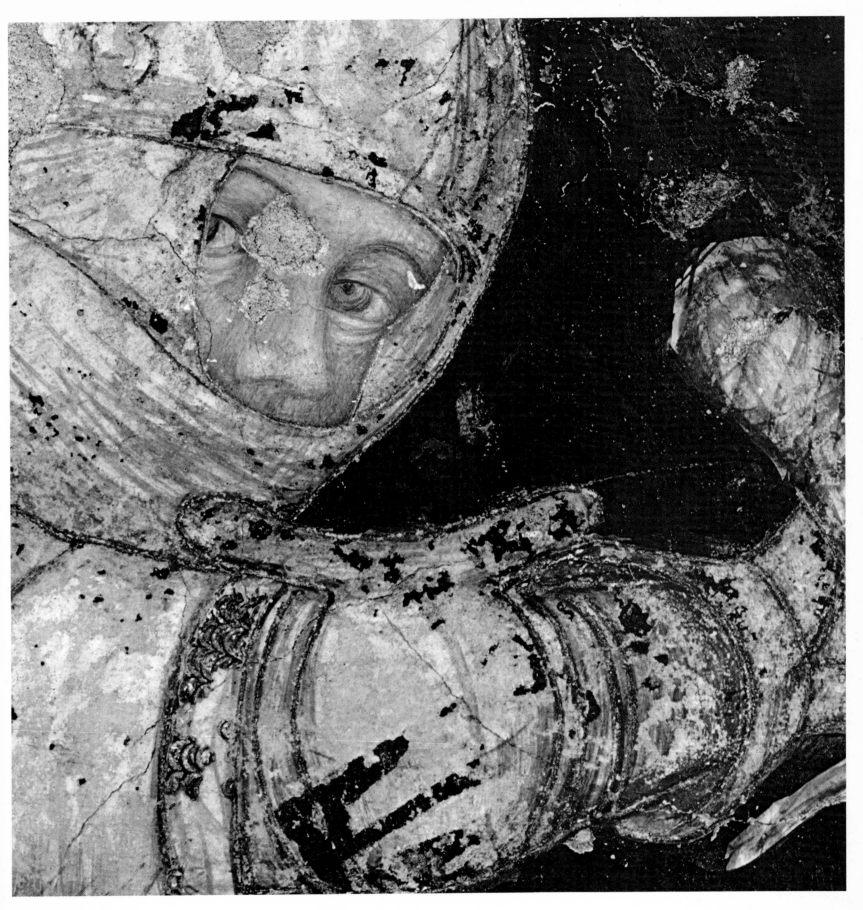

XI. *Arthurian chivalric cycle: warrior, detail of fresco. Mantua, Ducal Palace.*

and valour of these gentlemen of war: here was represented one of those chivalric battles where the opposing lines of Arthurian heroes wound and cut down and kill each other in order to put to the test their virtues as valiant warriors. There are no inscriptions or other hints in the fresco which might indicate which of the many tourneys described in the Arthurian romances is referred to by this grandiose picture of war, displayed on the wall like an immense heraldic escutcheon. But the symbolism linking its iconography with the military activities of the Gonzagas as *condottieri* of armies which continually clashed in the Po Valley during that troubled period of history, suggests that the tourney can be identified with the one which, according to the version in *Tristan*, took place in front of the castle of Louverzep a short time before the search for the Grail began.[40] In a court like that of the Gonzagas, where *Tristan* was the most widely read of the many French romances in the library, the representation of a great, bitterly fought contest would almost certainly have recalled the tourney of Louverzep, in which Tristram asserted himself as leading protagonist, prevailing over all the other knights. In *Tristan* and in the popular Italian text of the *Tavola Ritonda* which derived from it, that tourney is considered to be the most important and bloody of all those proclaimed at the time of King Arthur: on the one side were the great knights of King Arthur's Round Table, together with the warriors of two other kingdoms, and on the other side were the forces of twelve 'foreign' kingdoms.[41] But the tourney of Louverzep is above all the exaltation of the valour of Tristram, who during the three battles of that tourney demonstrates his invincible superiority, passing alternately from one side to the other; and each time the side for whom he is fighting gains the upper hand, so that finally he is proclaimed the absolute winner. Lancelot himself is obliged to yield when faced with the valour of Tristram, who beats him in this battle, and also in other duels brought about by the rivalry which suddenly fires with mortal hatred the spirits of the two great knights previously bound in fraternal friendship.

These are particularly significant themes for a family of *condottieri*, which is how the Gonzagas saw themselves first and foremost, involved as they were in military and political struggles which led them to change sides more than once. There was also the violent rivalry between Marchese Ludovico and his brother Carlo, which might have found an emblematic model in the enmity which arose between Tristram and Lancelot, and which occasioned between them 'the greatest and most mortal battle there had ever been between two knights'.[42] The bitter quarrel which split the two rival brothers, as a result of which they were often fighting in opposing camps, and which finally ended with the decisive defeat of Carlo at Valeggio, might perhaps have been better symbolized by the 'grant haine' which led Tristram and Lancelot to declare 'mortel bataille' on each other in the war between the King of Ireland and the King of Norgalles.[43] In this contest the two Arthurian heroes clashed ferociously, fighting on opposing sides. But the symbolic nature of Pisanello's battle scene was much more complex and it was not confined to the theme of family rivalry. Indeed it merely alluded discreetly to this feud, channelling the wave of rancour into the conventions of chivalry, according to which the knights aimed at establishing a fair trial between themselves in the contests of a tourney, which is implied here by the warriors' dress, the horses' trappings, the balcony from which the ladies are watching the event, and other details. In any case the tourney of Louverzep

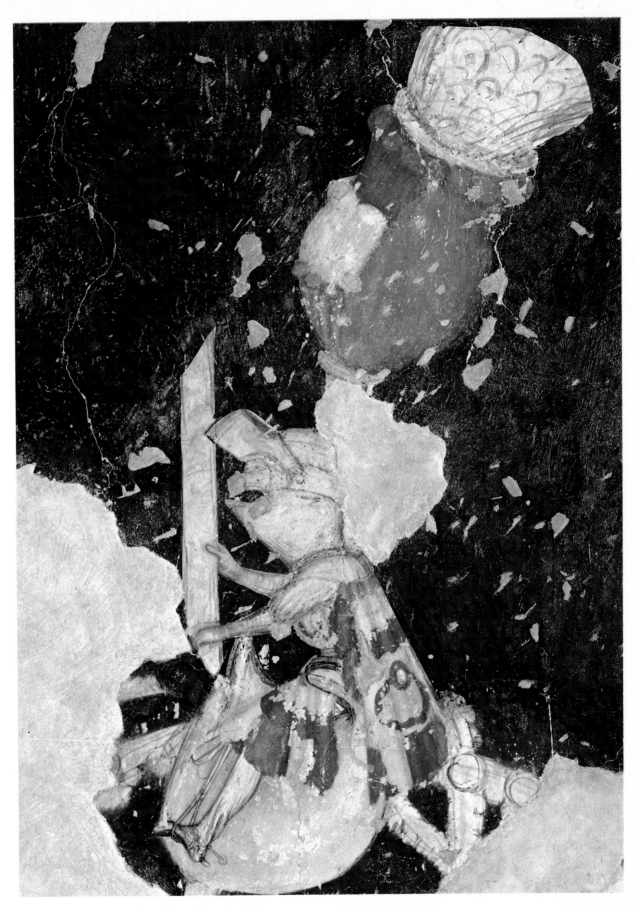

XII. *Arthurian chivalric cycle: The Battle; the dwarf, detail of fresco. Mantua, Ducal Palace.*

does not differ substantially from the battles which were unleashed by the hatred between the knights of King Arthur and those of the other kingdoms at the time when Arthurian chivalric society was breaking up. The author of the *Tavola Ritonda*, drawing his material from *Tristan*, devotes a long description to this tourney, in which he gives a vivid picture of the violent contests which for three days scattered the battlefield with the dead and wounded. Here are the most relevant passages in relation to Pisanello's *Battle*, referring to the decisive engagements of the last day, in which Tristram triumphs, defeating King Arthur's side in the morning and finally bringing the tourney to a close at nightfall, with the defeat of the opposite side led by King Amoroldo:

'And Sir Tristram and his company adorn themselves in black colours; and Tristram, very secretly (for no one knew it, except Queen Iseult, Sir Lantris and also Sir Dinaden) he put on underneath the colours you have already heard about, vermilion colours and his own coat-of-arms, with the azure field and a bend argent, and two gold devices on the side of the said bend; and then they mounted the queen on her horse and led her to the foreign ladies' balconies. And when they were at the field they found King Arthur and Lancelot, and five large formations of knights errant and their friends; and on the other side King Amoroldo and the King of Scotland, and ten large formations of foreign knights. Now, when the trumpets sounded, as was the custom, all the formations went into battle; and as the knights fought, Tristram took off the black colours and gave them to one of his equerries, and continued to wear the colours of Queen Iseult, that is with the vermilion field and a crown of gold; then he went forward and began to fight. He first slew the great King of Norgalles and sent the mighty Sir Gawain to the ground in a heap; then he slew Sir Saigremors and the King Agalon and Sir Sacis; and at the tenth blow, he struck Lancelot. And Lancelot struck him; and their blows were so strong that they both broke their lances and their horses went down on their knees; then they took their swords in their hands. And first Lancelot struck Tristram with such force that he made him knock his chin on the bow of his saddle; and Tristram took a firm grip of his sword and viciously struck Lancelot with such force over the helmet, that he knocked him off his horse quite helpless on to the ground. At this blow, Queen Guinevere was very sad; but she was not more sad than Queen Iseult was happy; for both had given their love, one to Tristram and the other to Lancelot. When Lancelot remounted, Dinaden hit him sideways so as to send him to the ground again. The manner in which Sir Tristram continued to fight his way through the tournament was wonderful to see. The battle was fierce and dangerous, and many barons and knights on both sides died: there were many horses going around the field with empty saddles. On the grass there was a great quantity of hands, heads and legs which had been cut off, and dead horses; and almost all the barons' swords were covered in blood. So great was the noise of the horses and the rattling of weapons and the loud shouting of the knights, that it seemed the world was coming to an end. Sir Tristram went around the field knocking horses and riders to the ground; and every one shouted: "Here is the falcon who harries the whole camp." And in a short time, Tristram had brought King Arthur's side to defeat....

'...And Tristram, having thus crushed the men of King Arthur and given esteem and honour to King Amoroldo's side, quietly withdrew and took off the vermilion colours with the crown of gold, and gave them to one of his equerries, and continued to

wear only his own colours: that is with the azure field, and a bend argent, and two gold devices in the middle. And as it was midday and the sun was already high in the sky, Tristram went over to King Arthur's side, and began to fight against King Amoroldo's warriors and the foreign knights. Firstly he struck King Amoroldo with the shaft of his lance and sent him to the ground; and then he slew the mighty King of Scotland, and the King of the Hundred Knights, and Palamides; and before his lance was broken, twenty-two knights he knocked to the ground. And then he put his hand to his sharp sword and began to strike vigorously...

'...And Sir Tristram went around the field like a lion, and the knights errant followed him, and especially the kinsmen of King Ban; and when Tristram clashed with the King of Gascony, he gave him such a blow that he struck him dead on the ground; and then he killed the King of Sobois and many other knights. And before the sun went down behind the hills, Tristram had defeated King Amoroldo's side: although he was very weary and his arms were swollen, especially his sword arm....

'...And when Tristram had defeated both sides as he pleased, and fought so much that no knight had ever done half as much; at that point, Sir Anselerin came forward, saying to Tristram: "Knight, as the moon glows more brightly than the stars and the rose is above all other flowers and the lion above all the beasts, so you are above all other knights. And now, I command you to take the standard which is stuck in the middle of the field, and carry it wherever you desire; for you have made both sides win at your will." Therefore, Tristram took the standard and carried it across the meadow. And when he was in front of Queen Iseult, he kneeled before her and placed it in her hand; and then he took it and went with it to the castle of Verzeppe and gave it to Queen Guinevere; and she had it set up on the great tower so high that all the people could see it.'[44]

If, as I believe, it is possible to establish a connection between Pisanello's Battle and the tourney of Louverzep—since that tourney, out of all those described in the Arthurian romances, is the one which most closely resembles the historical and cultural background against which the chivalric decoration at Mantua was planned—then the events related in that story must also have some connection with the fragmentary figures at the end of the long inside wall. These include the group of armed knights (Plates II, III; Fig. 18) who are moving away from the Battle scene and filing in front of the decorated balcony where the beautiful ladies are looking out, the great castle to the left of the balcony (Figs. 14, 19), and other details. If this assumption is correct, then in fact the knight at the centre of the group (Plate III) can be none other than Tristram, who at the end of the tourney—as recounted in the *Tavola Ritonda*—is setting off with the standard of victory towards the balcony where Iseult sits, among the foreign ladies. And in that enchanting row of feminine figures, who better to represent the blonde Iseult than the pensive young woman (Plate I; Fig. 17) whose hair, with its soft golden lights, dims even the fair hair of the other lovely damsel at her side? That veil of sadness which marks her pure face gives the image the poetic atmosphere of the *Tristan* of Thomas and yet at the same time it is a very modern interpretation of that figure who 'lived and died' for her love.[45] The two splendid figures of women placed side by side recall the description given by Tristram to his young brother-in-law Ghedin of the unsurpassable beauty

of Iseult and her companion Brengwain: Ghedin has a convincing demonstration of their beauty when he sees the two ladies together.[46] Brengwain, Iseult's faithful maid-servant, is indeed worthy of being portrayed at Iseult's side among the ladies of the foreign kings taking part in the tourney, not only because her affairs were bound up with those of Iseult, but because she too became a queen on her marriage to Gouvernayl, the devoted friend whom Tristram made king of his kingdom and who fought at his side at the tourney of Louverzep.[47]

We can also identify the great castle (Figs. 14, 19) flanked by a river and surrounded by a moat filled with water—similar in structure to the Gonzagas' castle of S. Giorgio on the banks of the Mincio, which shortly after the middle of the century was to become the residence of Marchese Ludovico—as the castle of Louverzep, near which Tristram and Iseult had established their temporary residence at Joyous Gard, not far from Camelot.[48] Thus the hilly skyline of the fantasy landscape which forms the theatre for this *geste* leads back to Camelot, the capital of the kingdom of King Arthur which is the hub of that world and its adventures of chivalry.

This interpretation of the subject matter portrayed in the Mantuan decoration suggests that most of the themes were taken from the *Roman de Tristan*. A large area of the long internal wall and the whole of the adjacent wall to the right is devoted to them, with images representing the castle of Louverzep, the ladies' balcony, the group of knights beside the balcony, and the tourney contests of the great Battle. Moreover, there were certainly other scenes in addition to the ones which survive since, according to the scheme for the composition which I have already mentioned, the most significant episodes were to have been represented with lifesize figures on the bottom parts of the walls. Nevertheless, great importance was undoubtedly given to the adventures of Lancelot and the other heroes of the Round Table; and probably also to the deeds of knights of earlier times. To the left, in the middle area of the large *sinopia* and in the corresponding area on the contiguous wall, the search for the Grail was represented. The part of this which has come down to us is the picture of the knights who have emerged from the walls of Camelot and are riding forth into that 'dubious country', each going his own way ('por ce que a honte lor seroit a torné se il aloient tuit ensamble') in that dangerous undertaking, which was intended as an individual test of moral and physical strength.[49] The large foreground scenes depicting a chivalric duel and the decapitation of a warrior were dedicated to the exploits of some of the great protagonists of the Arthurian cycle and, although according to this interpretation they are connected with the search for the Grail, they are to be considered as episodes from the whole of *L'Estoire de Lancelot*, covering the stories of Lancelot, of the Quest and of the *Mort Artu*;[50] there must have been a great many of these episodes illustrated on the lower parts of the walls, on the side of the room opposite the scenes relating to Tristram.

Although all these hypotheses about the subject matter of the Sala del Pisanello are the result of fairly detailed research, they are not intended as evidence of any definite philological links between the literary text and the figurative representation, but rather to make it easier to understand the particular cultural climate reflected in the mural cycle.

The nature of the decoration confirms that it was not a narration intended to illustrate the deeds of one great Arthurian hero alone, as had been the case with the mural painting dedicated to Lancelot in the previous century. Marchese Ludovico instead wanted to create within his palace a Hall of the Round Table suitable for the currently fashionable chivalric ceremonies, so the decorations were to comprise a selection of episodes which overall would give a worthy representation of the Arthurian world. This plan for a large pictorial decoration in a room dedicated to the Round Table concurs with the fashion in favour at many more courts and artistic centres in western Europe than would appear from the scanty evidence which has come down to us in the form of works of art—apart from miniatures—of dedicating to the Round Table and its heroes all kinds of plastic, pictorial and even architectural works as visual representations of tourneys and feasts recalling the world of chivalry, to 'contrefaire les aventures de Bretaigne et de la Table Ronde, contrefaire Lanselot et Tristan et Pilamides'.[51]

The Marchese and his learned advisers, in selecting from the romances of chivalry in the Gonzaga library the 'aventures de Bretaigne' to be represented in the planned Hall of the Round Table, must have followed the same criteria as Rustichello da Pisa when preparing his popular work *Meliadus*.[52] This book, also in the Gonzaga library, 'n'est mie proprement d'une seule personne fait, ne il n'est tout de Lancelot du lac, ne il n'est tout de Tristan ne tout du roy Meliadus'; but, as the author declares in the preamble, it tells of 'toutes les grans aventures qui advindrent entre les chevaliers errans du temps du roy Uterpendragon jusques au temps au roy Artus, son fils, et des compaignons de la Table Ronde'.[53] ('It is in no way written about one single person, neither all devoted to Lancelot du Lac, nor to Tristan nor to King Meliadus', but recounts 'all the great adventures which befell the knights errant from the time of King Utherpendragon to the time of Arthur his son and the companions of the Round Table'.) Although a long and disjointed narration it enjoyed much popularity, and is proof that the readers of those tales of chivalry demanded more and more romances of this kind, and that their enthusiasm, though still particularly roused by the adventures of Tristram and Lancelot, was not limited to the best-known episodes of the knights of the Round Table and of King Arthur. They were eager for any tales about the deeds of those strong and legendary heroes, like those for example in the *Roman de Palamides*, written after the *Roman de Tristan*, in the thirteenth century.[54] It was this kind of interest which was stimulated by the romances of the Round Table included in the Gonzaga library (*Meliadus, Gyron le courtois, Febus li fort*). Rustichello da Pisa also included in his compilation a long passage from *Palamides*, precisely because it was new and different.[55] And the novelty of *Palamides*, which is of interest to us here because it seems to have some bearing on the subject matter used in the Sala del Pisanello, lies, according to Löseth, in its original formula which consists, in the words of Limentani, 'in setting the characters and their exploits in an era which was somewhat earlier than the Arthurian epoch, in creating an age of chivalry which was already past history and steeped in glory, in relation to that epoch which was so widely known and already over-used and jaded.'[56]

Given this context of a culture imbued with chivalric literature, it was inevitable that the illustrations of Breton material which were to decorate the Hall of the Round Table in Mantua should have included, in addition to the basic tales of Tristram and Lancelot,

other deeds and characters which were part of the overall picture of that world, from its origins to its end.[57] The *sinopie* and the frescoes which have been rediscovered, and a number of drawings by Pisanello and his school, which I shall return to later, all seem to suggest that it was along these lines that a programme was drawn up for this extraordinary, largely unfinished chivalric representation, which came to be known by the name of its great author and whose elegiac tone evokes an imaginary age and the spirit of a past era.

NOTES

1. The name 'Sala del Pianello' used in the documents of 1480 is, in my opinion, further proof that the decoration was left unfinished; had it been concluded the room would not have assumed the name of the artist, which would have been most unusual, but that of the story or decorative theme represented.

2. GEROLA, G., *Vecchie insegne*, etc., cit., pp. 98–101; MARANI and PERINA, *Mantova. Le Arti*, cit., II, p. 6; PACCAGNINI, *Il Palazzo Ducale*, cit., p. 18.

3. BRAGHIROLLI, W., MEYER, P., and PARIS, G., 'Inventaire des manuscrits en langue française, possédés par Francesco Gonzaga, Ier Capitaine de Mantoue, mort en 1407', in *Romania*, 1880, pp. 497–514; NOVATI, F., 'I codici francesi dei Gonzaga, secondo nuovi documenti', in *Romania*, 1890, pp. 161–200; GIROLLA, P., 'La biblioteca di Francesco Gonzaga secondo l'inventario del 1407', in *Atti e Memorie della R. Accademia Virgiliana di Mantova*, vols. XIV–XVII, 1923, pp. 30–72; SANTORO, C., 'La biblioteca dei Gonzaga e cinque suoi codici nella Trivulziana di Milano', in *Arte, pensiero e cultura a Mantova nel primo Rinascimento*, Florence, 1965, pp. 87–94; MERONI, U., *Catalogo della Mostra dei Codici Gonzagheschi*, Mantua, 1966. Some of these codices in the Gonzaga library had formerly belonged to the Bonacolsi, as shown by the will of Filippone Bonacolsi in 1325 (MERONI, op. cit., p. 43).

4. NOVATI, F., op. cit., pp. 164, 171, 186.

5. OSIO, I., *Documenti diplomatici tratti dagli archivi milanesi*, Vol. I, Milan, 1864, p. 197; SANTORO, op. cit., p. 89. The 'beautiful and delightful' books in the Gonzaga library were so much in demand that Marchese Gianfrancesco was obliged to threaten severe sanctions against 'unscrupulous' people reluctant to return the valuable codices they had borrowed, or even stolen, from his library (LUZIO-RENIER, A., 'La cultura e le relazioni letterarie di Isabella d'Este Gonzaga. Appendici', in *Giornale St. della Lett. Ital.*, 1903, p. 76).

6. The inventory of 1407 recalls only one, *L'Infantia Lanzalotti* (BRAGHIROLLI, MEYER and PARIS, op. cit., no. 33, p. 510). However there are others listed among the French books *in folio* in the inventory relating to the library of Duke Federico Gonzaga, compiled in 1542: '...Three copies of Lancelot del lac in French, unbound... Two copies of the first volume of Lancelot - Two copies of the second volume of Lancelot. One copy of the third volume of Lancelot' (NOVATI, op. cit., pp. 195, 196 note 3). In all probability these last named copies of the romance of Lancelot were added to the Gonzaga library at the time of Gianfrancesco (1407–44).

7. DAVARI, S., *Notizie storiche topographiche della città di Mantova nei secoli XIII-XIV-XV*, Mantua, 1903, pp. 38-9. PACCAGNINI, *Il Palazzo Ducale*, cit., p. 18.

8. For the success in Italy of the legend of Tristram, see: SOMMER, E., 'La leggenda di Tristano in Italia', in *Rivista d'Italia*, XIII, 1910, II, pp. 73–127; BRANCA, D., *I romanzi italiani di Tristano e la Tavola Ritonda*, Florence, 1968, pp. 13-23.

9. In the 1407 inventory the nine volumes of *Domini Tristani* are listed under Nos. 35 and 60–67 (BRAGHIROLLI, MEYER and PARIS, op. cit., pp. 510, 514). For a description of the contents of the *Roman de Tristan* and variants contained in the numerous codices relating to this material which are preserved in the Bibliothèque Nationale of Paris, the following work is still of fundamental importance: LÖSETH, E., *Le roman en prose de Tristan, le roman de Palamède et la compilation de Rusticien de Pise, Analyse critique d'après les manuscrits de Paris*, Paris, 1890.

10. The innumerable and continuous links between the political aims of Renaissance princes and the artistic activity at their courts were particularly marked in the case of the Gonzagas who, between the fourteenth and seventeenth centuries, had one of the most sumptuous palaces in Europe built at Mantua and put together an outstanding collection of works of art, following carefully thought-out programmes, which contributed in no small measure to the political successes of the family.

11. PACCAGNINI, G., 'Il ritrovamento del Pisanello nel Palazzo Ducale di Mantova', in *Bollettino d'Arte*, January-March 1967 (1969 article), pp. 17–19; id., 'Il Pisanello ritrovato a Mantova', in *Commentari*, fasc. IV, 1968 (1969 article), pp. 253-8; id., *Il Palazzo Ducale*, cit., pp. 29–42.

12. VENTURI (1896, pp. 44-8) dated the Mantua decoration between 1441 and 1443; HILL (1905, p. 123) between 1439 and 1443; MANTEUFFEL (1912, p. 12) between 1438 and 1442; BRENZONI (1952, p. 130) the end of the fourth decade; COLETTI (1953, p. 32) the beginning of the fifth decade; MAGAGNATO (1958, p. 92 note 99) the end of the fourth decade; and DEGENHART, in his last monograph on Pisanello (1969, p. 613) between 1439 and 1444. MISS FOSSI TODOROW on the other hand pointed out that some of the drawings relating to the Sala del Pisanello display characteristics of his later period and consequently she considered that the decoration was probably done between 1445 and 1447 (FOSSI TODOROW, op. cit., 1966, p. 35).

13. SANUTO, M., 'Vitae ducum venetorum, etc.' in *Rerum Italicarum Scriptores*, XXII, cc. 1060–1074.

14. BIADEGO, G., 'Pisanus Pictor, nota prima' in *Atti del R. Istituto Veneto di Scienze, Lettere ed Arti*, 1908, LXVII, p. II, p. 842, Document of 21 Nov. 1442.

15. VENTURI, A., *Gentile da Fabriano e il Pisanello*, Florence, 1896 (critical ed. of Vasari's *Lives*), pp. 48-9.

16. On the subject of this chivalrous humanism or civilization, see Ruggieri, R.M., *L'Umanesimo cavalleresco italiano: da Dante al Pulci*, Rome, 1962; Folena, G., 'La cultura volgare e l'"umanesimo cavalleresco" nel Veneto', in *Umanesimo Europeo e Umanesimo veneziano*, Florence, 1963, pp. 141–58; De Robertis, D., 'Ferrara e la cultura cavalleresca', in *Storia della Letterat. Ital.*, Vol. III, Milan, 1966, pp. 570–4.

17. Girolla, P., *Pittori e miniatori*, cit., pp. 7–17; Braghirolli, W., *Sulle manifatture di arazzi in Mantova*, Mantua, 1879, pp. 18–24.

18. Venturi, A., op. cit., 1896, pp. 40-1. The poem, as Venturi observes, must have been composed after 1438; I consider that it might have been written during the period in which Pisanello was working in Ferrara, after 1441.

19. Venturi, A., op. cit., 1896, pp. 55–7.

20. De Robertis, D., op. cit., p. 572.

21. Venturi, A., op. cit., 1896, p. 56.

22. Mazzoldi, L., *Mantova. La Storia. II*, Mantua, 1961, pp. 52–3 note 37. (Arch. di Stato di Mantova, Gonzaga, busta 2884, copial. n. 21, c.58 v.).

23. *L'Intelligenza*, ed. by Mistruzzi, V., Bologna, 1928, stanze 287–8. On the subject of figurative representations of chivalric material decorating rooms and palaces see: Loomis, R.S., and Loomis, L.H., *Arthurian Legends in Medieval Art*, London and New York, 1938, part I.

24. The names of the knights undergo considerable variations in the different romances, as indicated in the work by Flütre, L., *Table des noms propres avec toutes leurs variantes figurant dans les romans du Moyen Age écrits en français ou en provençal*, Poitiers, 1962.
I am grateful to Bernhard Degenhart who first helped me to decipher the names of Malies de l'Espine and Arfassart li gros; to Silvio Pellegrini and to Valeria Pizzorusso of the Institute of Romance Philology at the University of Pisa, who kindly confirmed my reading of the knights' names, and who also provided information which was of great assistance in reading the serial numbers beside the names and in interpreting a number of puzzling features of the inscriptions.

25. *Le livre de Lancelot del Lac*, ed. by H. Oskar Sommer, Vol. IV, London, 1911, pp. 266–7.

26. Löseth, op. cit., pp. 283–4, para. 395a.

27. *Gyron le courtois*, published in Paris at the beginning of the sixteenth century. The text I have consulted is that of the edition of 1519 by Petit, J., and Le Noir, M., a copy of which is kept in St. Mark's Library in Venice.

28. *Lancelot del Lac*, ed. by H. Oskar Sommer, cit., pp. 266–7.

29. *Talibor* in the London MSS, *Cabilor* in those in *Paris*, cf. Flütre cit., pp. 38, 40, 176.

30. *Malies* in Gyron, *Melior* in the London MSS, *Maillot* in the Paris MSS, cf. Flütre, cit., pp. 127, 128, 136.

31. Flütre, op. cit., p. 135. In *Tristan*, however, *Mandin l'envoisié* appears among the list of knights quoted; cf. Löseth, cit., p. 284.

32. Chrétien de Troyes, *Le Roman de Perceval ou le Conte du Graal*, according to MS. 12576 in the Bibl. Nat. of Paris edited by W. Roach, 1956.

33. For this text see *La Queste del Saint Graal, roman du XIII siècle*, ed. by A. Pauphilet, Paris, 1923.

34. Braghirolli, Meyer and Paris, op. cit., p. 511, note 40, *Questa Sancti Gradalis*.

35. Cf. Löseth, op. cit., p. XVI.

36. Most of the knights listed in this late text of the *Queste*, incorporated in *Tristan*, did not figure in the older Lancelot Quest. Tristram too was included in order to increase the glory of this personage who for the compilers of the *Roman de Tristan* was the greatest knight of the time of King Arthur, with whom not even Lancelot could compete.

37. The knights in *Tristan* were given the following names, in this order: (I) Kalaart le petit, (II) Sibilias aux dures mains, (III) Aplasat le gros, (IIII) Sadoc le blond, (V) Malyos (or Melios) de l'espine, (VI) Argoier le fel, (VII) Patrides au cercle d'or, (VIII) Mandin l'envoisié, (IX) Gringalos le fort, (X) Malaguin de Gallois, (XI) Acricor le bel. The laid Hardi, who is the twelfth knight in the Lancelot legend, is here instead among the group of the most important knights and comes before Meliadus, a hero well known to the readers of the romances in the Gonzaga library. Even if there are sometimes considerable variations in the names, the relationship between this series and that of the Lancelot episode is significant.

38. *La Queste del Saint Graal*, cit., p. 174.

39. *La Queste del Saint Graal*, cit., p. 146.

40. On the subject of the tourney of Louverzep in the *Roman de Tristan* see Löseth, cit., XVI, pp. 262–74. A long and lively description of that tourney which lasted three days can be found in the *Tavola Ritonda*, the fine Italian text which derives from the *Roman de Tristan* (*La Tavola Ritonda o l'Istoria di Tristano*, ed. by F.L. Palidori, I-II, Bologna, 1864–5). For an analysis of the *Tavola Ritonda* and of the Italian versions of the romance of *Tristan*, see: Branca, D., *I romanzi italiani di Tristano e la Tavola Ritonda*, cit.

41. The definition of 'foreign' is given in the *Tavola Ritonda*, cit., pp. 348–72, 379–85. The arrangement of the two sides taking part in the tourney as they appear in *Tristan* is summarized by Löseth as follows: 'Le royaume de Logres sera d'un côté, avec ceux d'Orcanie et de Norgalles; de l'autre seront l'Irlande, l'Ecosse, le pays de Galles, ceux de Gorre, ceux de Sorelois, ceux de Listenois, ceux de Nohoberlande et tous les autres qui relèvent du roi Arthur en deça de la mer.' (Löseth, op. cit., p. 263).

42. *La Tavola Ritonda*, cit., p. 402.

43. Löseth, op. cit., pp. 342–5; *La Tavola Ritonda*, cit., pp. 402–9.

44. *La Tavola Ritonda*, cit., pp. 385–8.

45. The words in quotes are reproduced from *La Tavola Ritonda*, cit., p. 203.

46. Sommer-Tolomei, O., op. cit., 1910, p. 79; Bédier, J., *Le roman de Tristan par Thomas*, Paris, 1902; *La Tavola Ritonda*, cit., p. 204.

47. *La Tavola Ritonda*, cit., pp. 235, 375; Löseth, op. cit., pp. 204, 206.

48. '...le château de Louverzep, situé sur l'Hombre, à une *demie journée* de la Joyeuse Garde'. (Löseth, op. cit., p. 262). 'The king (Arthur) decided to organize a large tournament in front of the fine castle of Verzeppe, which was on a very beautiful plain, encircled by a stretch of water, which was called the Syrian Lake, and that castle was twenty leagues from the Joyous Gard and forty leagues from Camelot' (*La Tavola Ritonda*, cit., p. 347). The castle of Louverzep, as all the other castles and the town of Camelot itself, are represented along the ridge of the hilly landscape which winds all round the horizon, and many of the palaces, churches and castles are made to appear as though rising from behind the mountains as a result of the use of aerial perspective which had been developed by the Flemish painters, on the subject of which see the important essay by Meiss, M., '"Highlands" in the Lowlands. Jan Van Eyck, The Master of Flémalle and the Franco-Italian tradition', in *Gazette des Beaux-Arts*, June 1961, pp. 273–314. It must also be pointed out that on the fragments of undecorated *arriccio* which were left on the bottom part of the wall, there are some letters (Fig. 260) relating to the castle, traced in black with a thick brush in rather a sketchy manner. In my opinion these letters are part of two words, the first of which ending in ...*or* and the second beginning with capital *L* followed by another, fragmentary letter, probably an *o* (*Lo...*). If this is the case, one may suppose that the two words indeed referred to the castle of Louverzep and that they were therefore to be read as (Man)or. Lo(uverzep).

49. *La Queste del Saint Graal*, cit., p. 26. As Pauphilet notes, in this ascetic and mystical romance of Cistercian inspiration, the search for the Grail 'n'est, sous le voile de l'allégorie, que la recherche de Dieu' (*Queste*, p. IX). Pellegrini remarks that the lance dripping with blood in the castle of the *Roi Pêcheur*, was the 'same one with which Longinus pierced the side of Jesus', while the Grail, it seems 'must be identified with the cup in which Jesus celebrated Easter with Simon, and which was used to collect the blood which streamed from the Saviour's side' (PELLEGRINI, D., *Nota introduttiva al Perceval (o Romanzo del Graal) di Chrétien de Troyes*, Florence, 1963, p. 484). It may therefore be said that the intention here was to establish a relationship between this legend and that—for the Mantuans no less important—of Longinus and the sacred vessels containing the blood of Christ preserved in the Benedictine monastery of S. Andrea, and now in the crypt of the Albertian church of S. Andrea.

50. The whole of this Arthurian narrative cycle was reproduced by SOMMER, O., in *The Vulgate Version of the Arthurian Romances*, Vols. I-VII, London, 1909–13.

51. For these representations and activities recalling the Arthurian world, see: LOOMIS, R.S., 'Chivalrie and dramatic imitations of Arthurian romance', in *Medieval Studies in Memory of A. Kingsley Porter*, Harvard University Press, Cambridge, 1939, pp. 79–97; LOOMIS, R.S., and LOOMIS, H., *Arthurian Legend in Medieval Art*, op. cit.

52. BRAGHIROLLI, MEYER and PARIS, op. cit., pp. 501, 510.

53. LÖSETH, op. cit., pp. 423-7.

54. ZUMTHOR, P., *Histoire littéraire de la France Médiévale*, Paris, 1954, p. 277; LIMENTANI, A., *Dal Roman de Palamedès ai cantari di Febus-el-fort*, Bologna, 1962, p. VII.

55. LÖSETH, op. cit., pp. 432-65.

56. LIMENTANI, op. cit., p. IX; LÖSETH, op. cit., p. 438.

57. In Italy this is the overall picture which the Breton material assumes in the very popular text of the *Tavola Ritonda*: a picture which is mentioned in the prologue by the unknown author: 'Gentlemen, this book recounts and describes fine adventures, great deeds of chivalry and noble tournaments which took place at the time of King Uther Pendragon and of the barons of the Old Table, in the indiction beginning one hundred years after the death of Our Lord Jesus Christ, Son of the One True God. And it also recounts and describes other deeds of chivalry which took place at the time of King Arthur and the valiant knights of the New Table, and especially Sir Tristram and Sir Lancelot and Sir Galahad and Sir Palamides, and in general of all other knights errant belonging to the Table, and foreign knights, some from faraway lands, who at that time were proving themselves in battle. And also we shall show the destruction of the Table, as a result of the undertaking to search for the Holy Grail.' (*La Tavola Ritonda*, cit., p. 1)

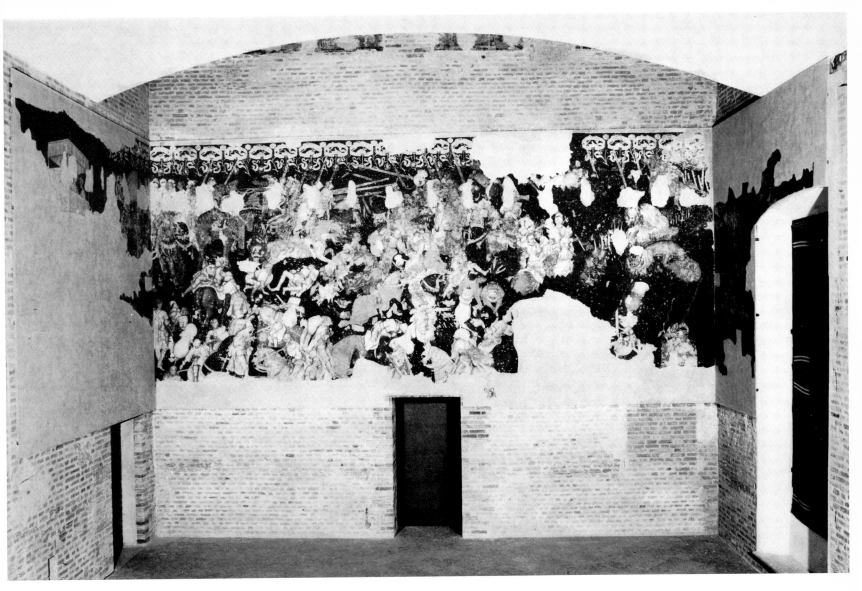

15. Overall view of the frescoes, with the Battle in the centre.

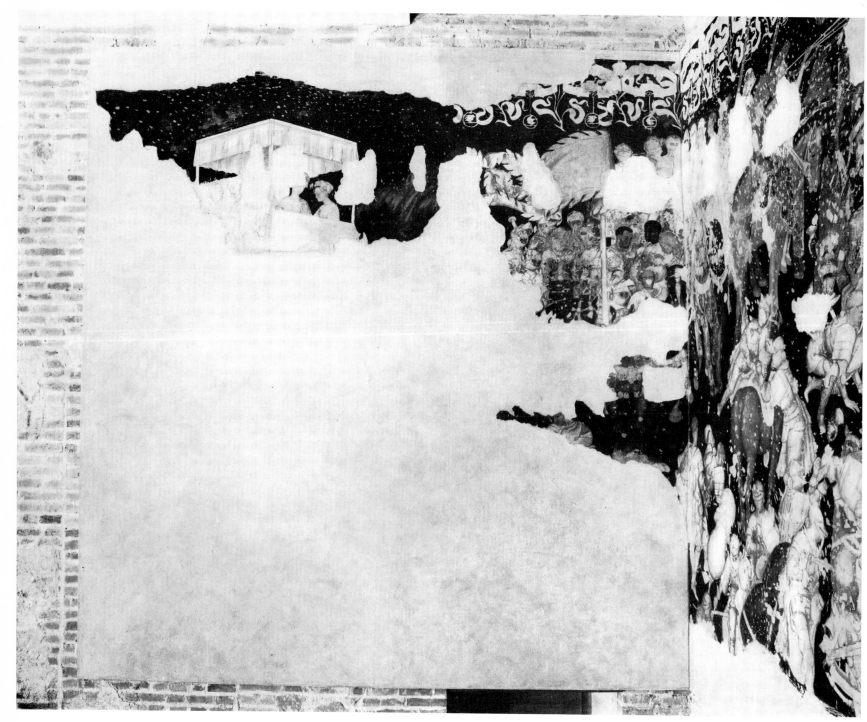

16. Continuation of the frescoes on the long inside wall adjacent to the wall with the Battle.

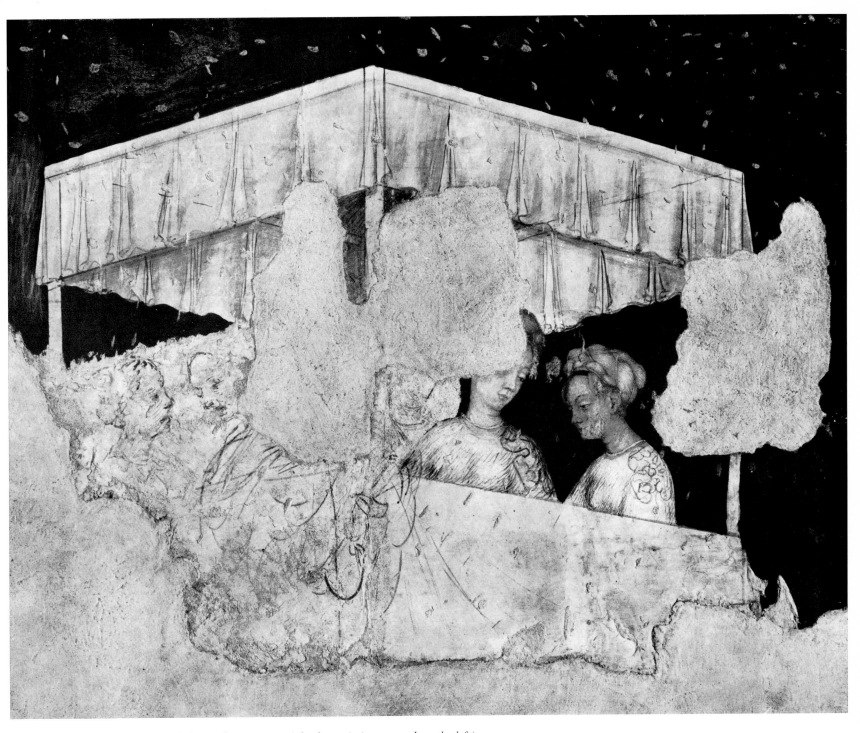

17. Fragment of fresco showing ladies under a canopy (the fresco is interrupted on the left).

18. Group of knights, detail of fresco. ▷

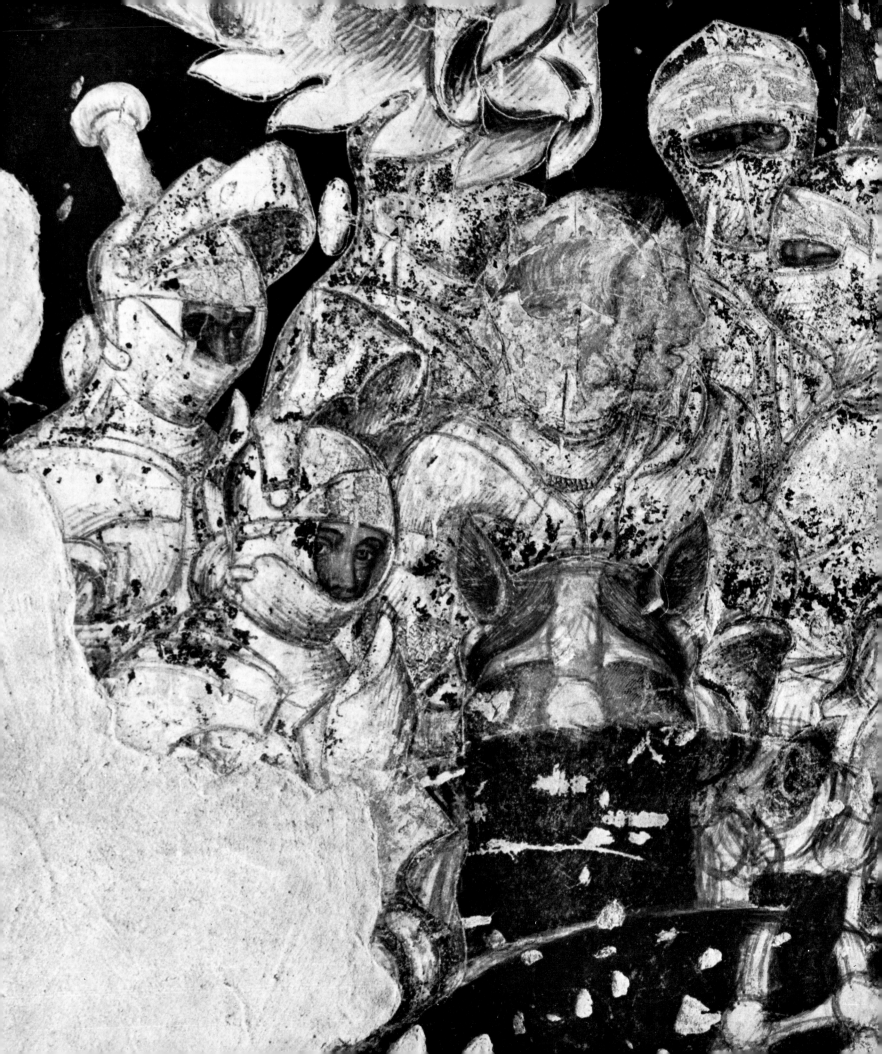

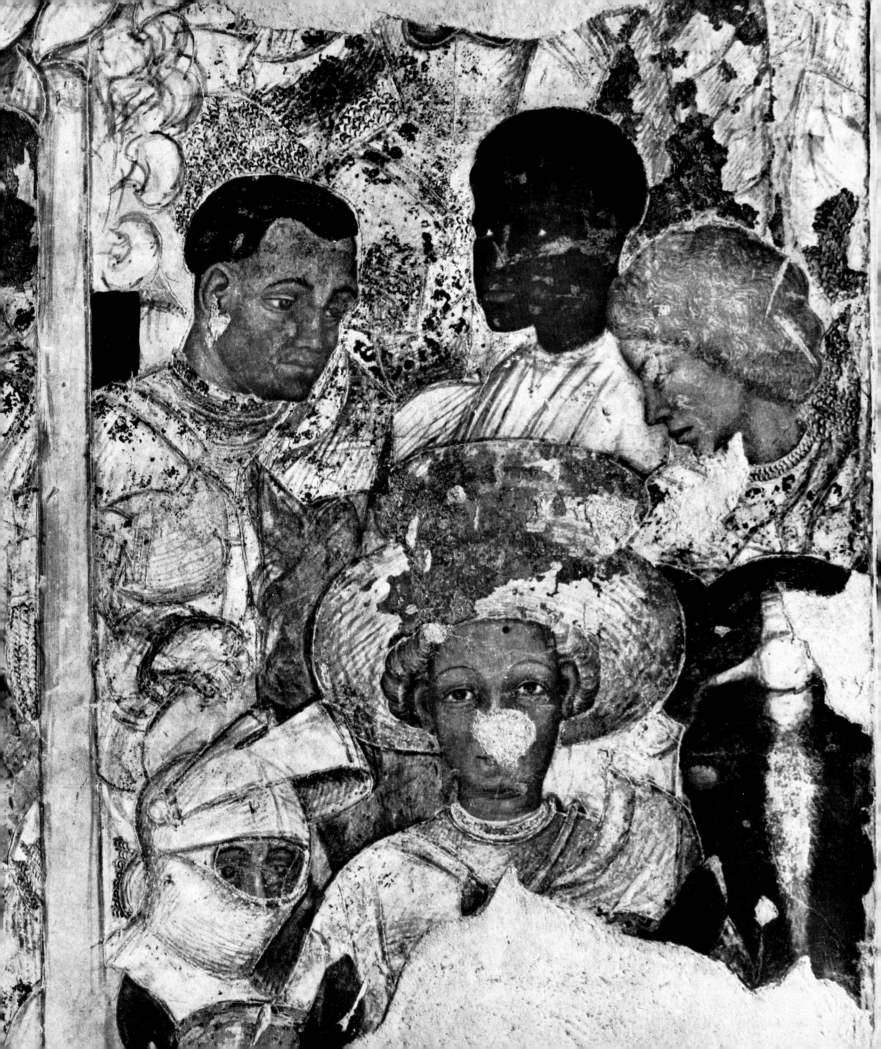

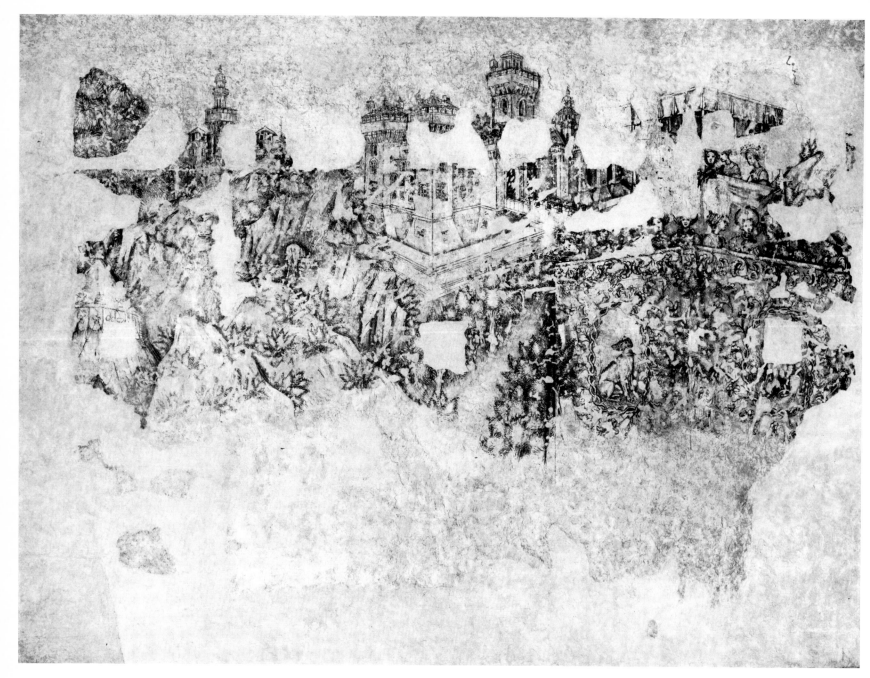

19. Right hand side of sinopia *on the inside wall.*

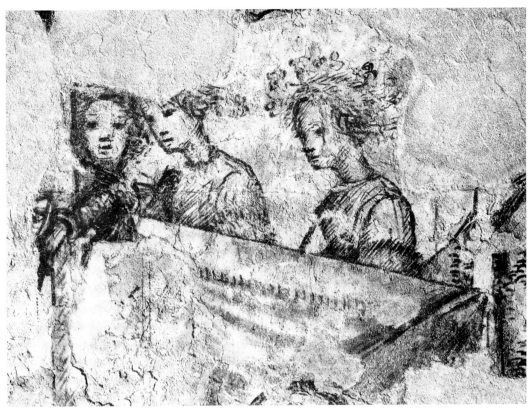

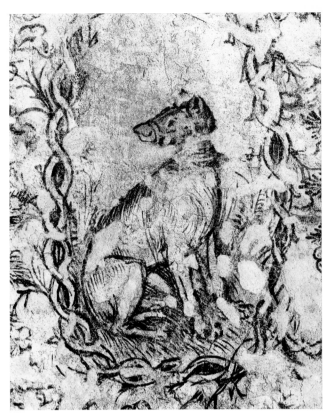

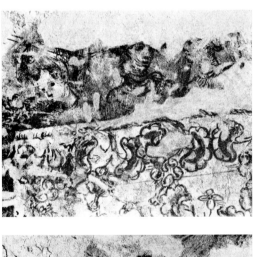

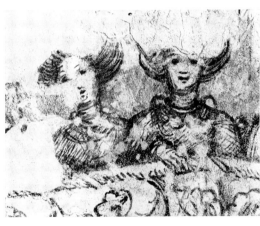

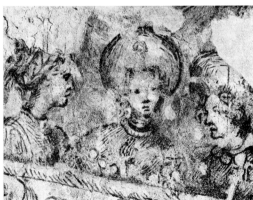

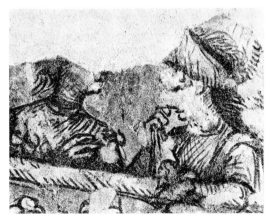

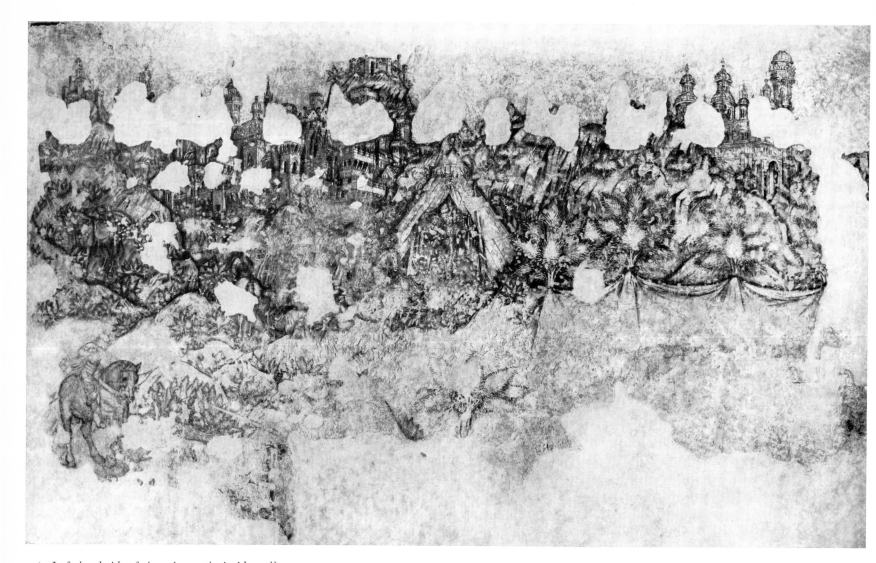

26. Left hand side of sinopia *on the inside wall.*

27. Knights errant in a landscape, detail of sinopia.

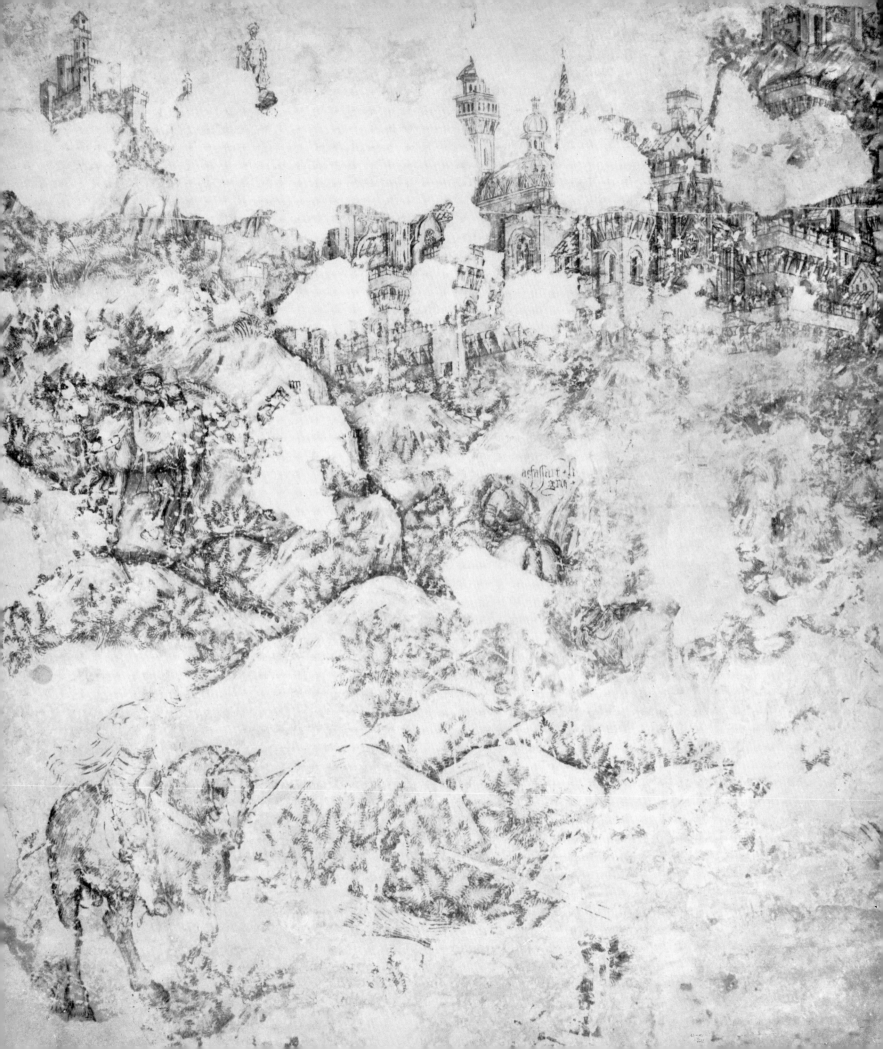

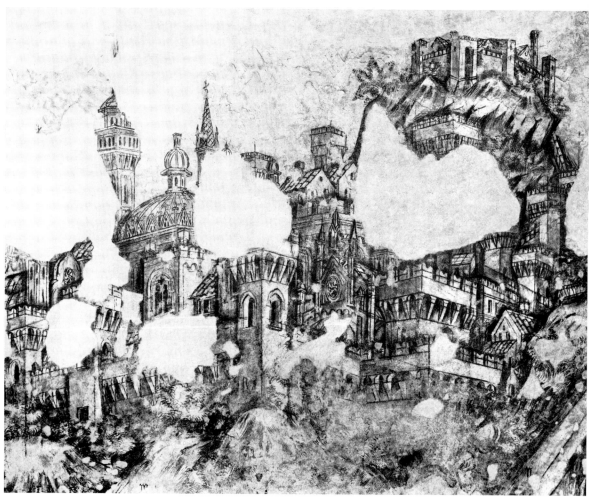

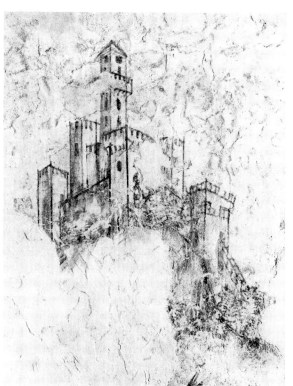

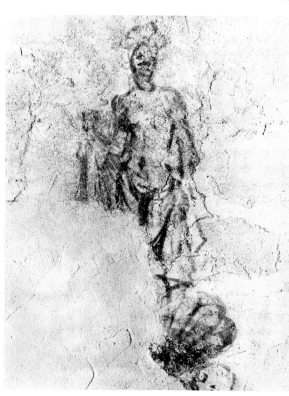

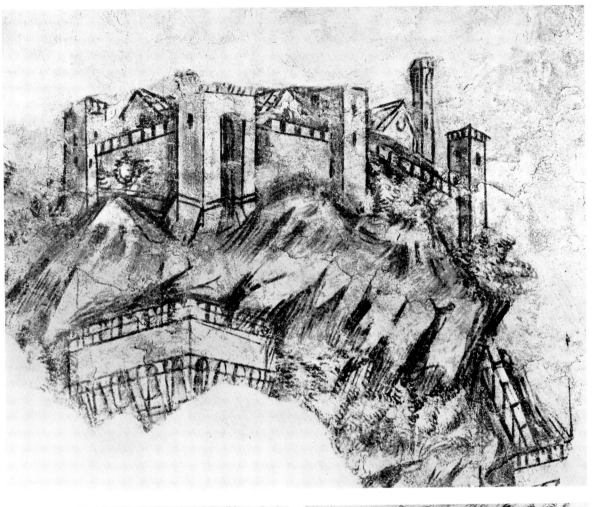

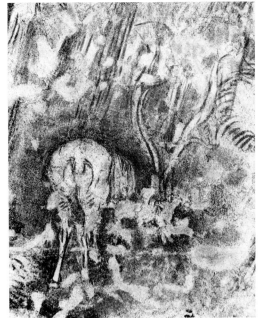

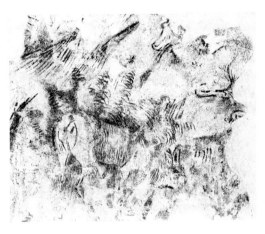

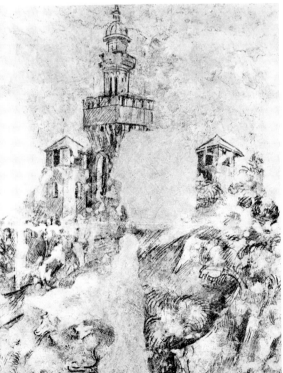

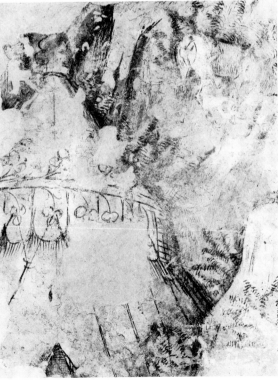

31. *Fortifications of a castle, detail of* sinopia.
32. *A castle, detail of* sinopia.
33. *A pavilion and a deer, detail of* sinopia.
34. *A deer, detail of* sinopia.
35. *Two deer, detail of* sinopia.

36. *Part of a large church, detail of* sinopia.

37. *A fox, detail of* sinopia.

38. *A bear, detail of* sinopia.

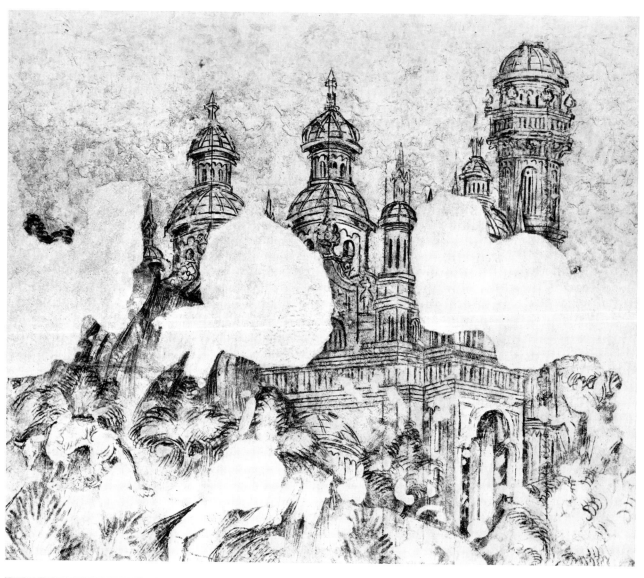

On the opposite page:

39. 'II-...lor. as. dures. mains.' (Ca-*bilor as dures mains), detail of* sinopia.

40. 'III- arfassart. li gros' (Arfas-*sart li gros), detail of* sinopia.

41. 'IV-...rot' (Calarot le petit?), *detail of* sinopia.

42. 'V-...Malies. de. lespine.' (Ma-*lies de l'Espine), detail of* sinopia.

43. 'VIII-...ons. li. envoissiez' (Mel-*dons li envoissiez), detail of* sinopia.

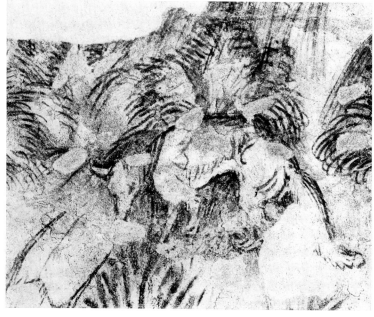

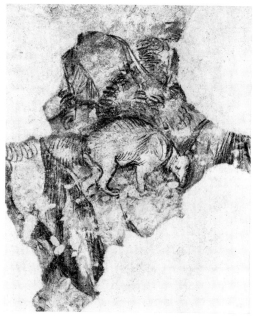

44. Knight putting on his armour (Cabilor as dures mains), detail of sinopia.

45. Knight errant, detail of sinopia.

46. Knight errant with a page (Arfassart li gros), detail of sinopia.

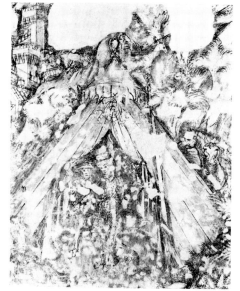

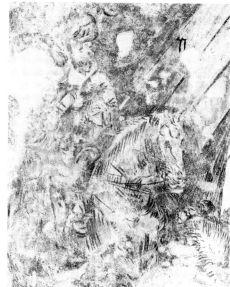

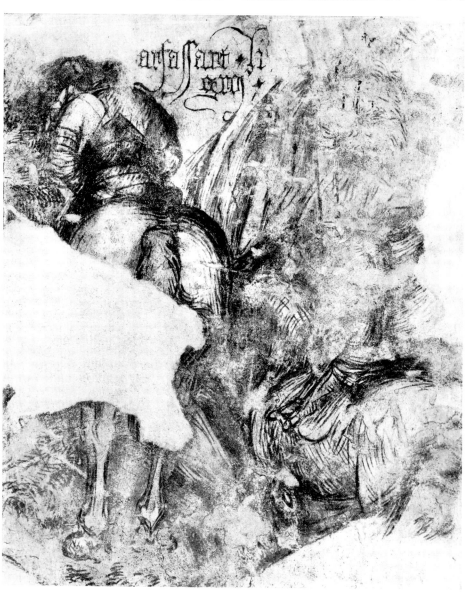

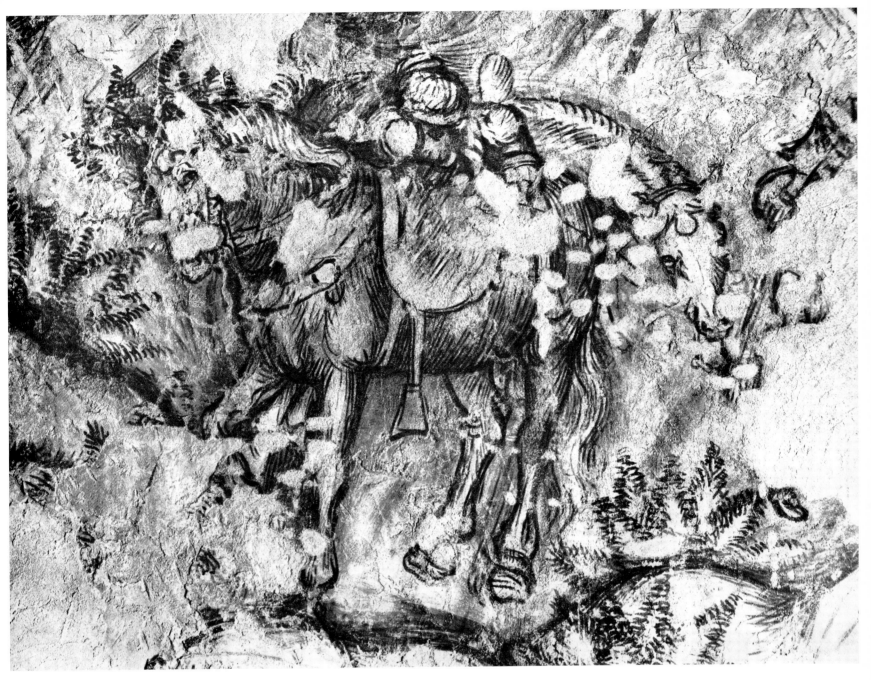

47. *Two horses and a dwarf knight (Calarot le petit?), detail of* sinopia.

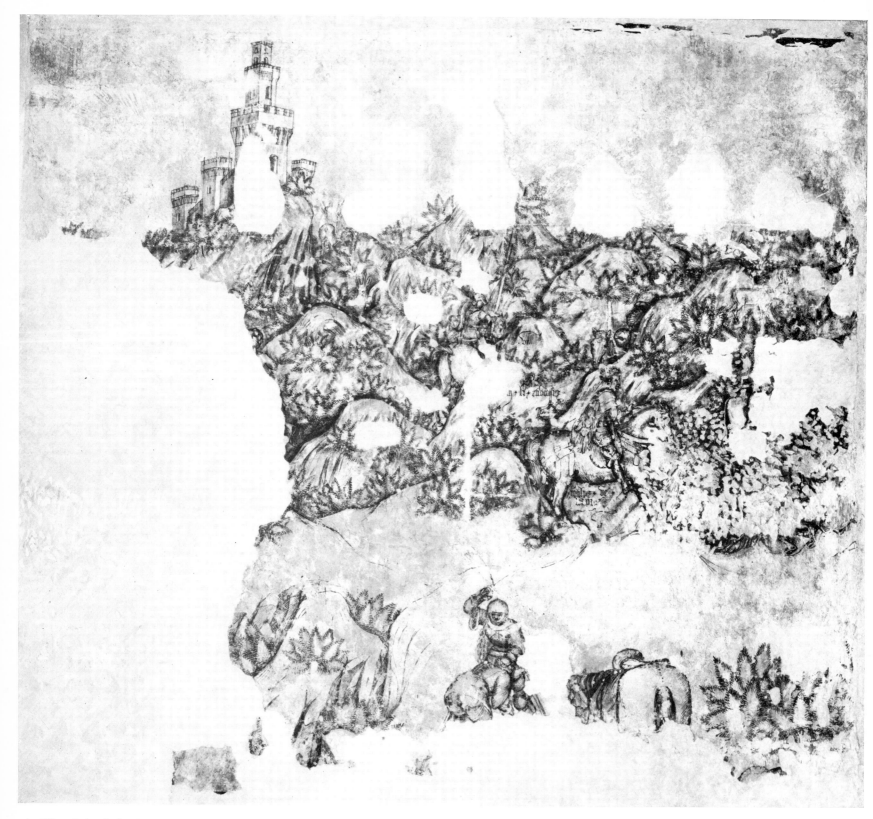

48. The whole of the sinopia *on the short left hand wall.*

49. A castle, deer and fragment of the figure of a lady, detail of sinopia.

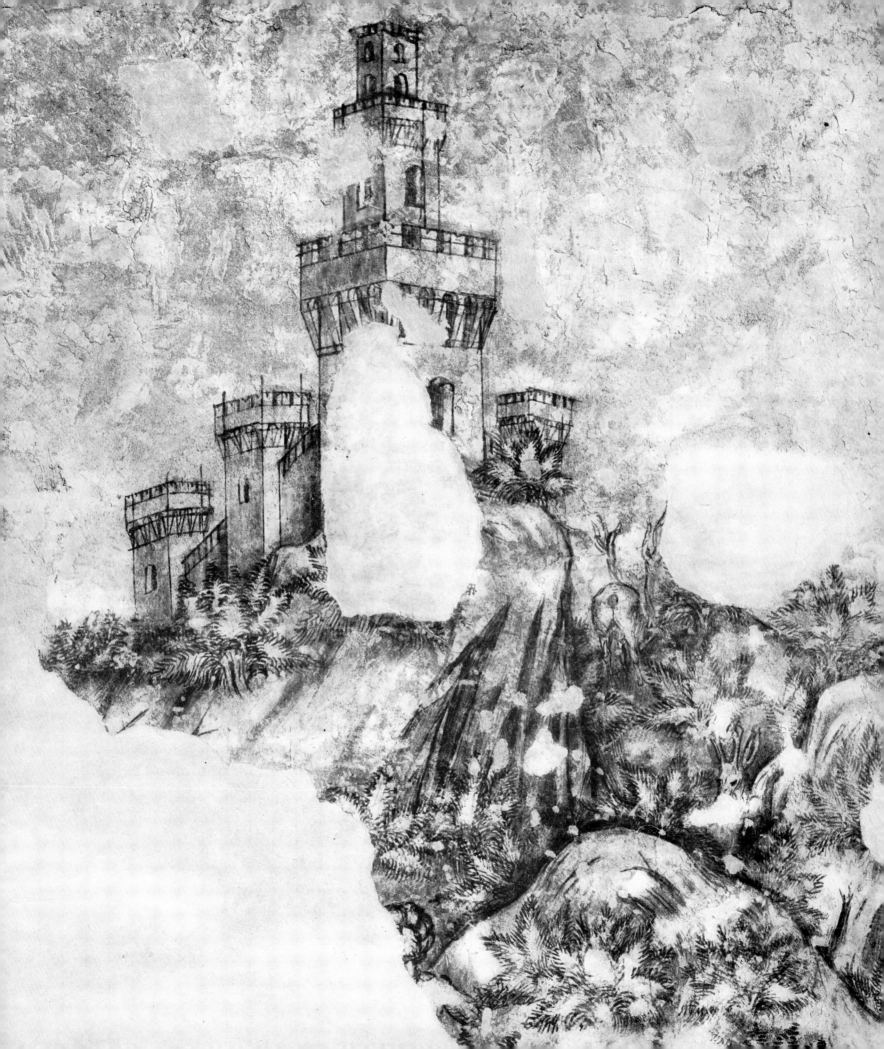

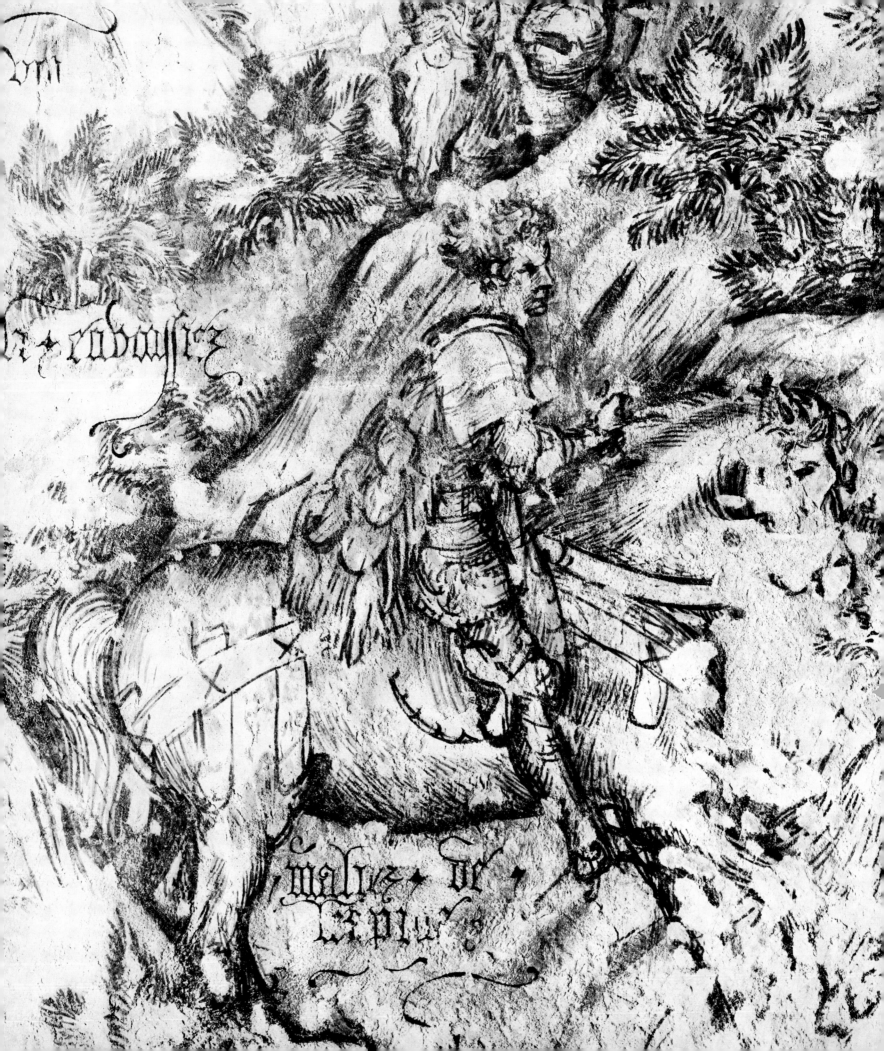

50. *Knight errant (Malies de l'Espine), detail of* sinopia.
51. *Deer and fragments of other images, detail of* sinopia.
52. *Knight errant (Meldons li envoissiez), detail of* sinopia.
53. *Horse seen from behind, detail of* sinopia.

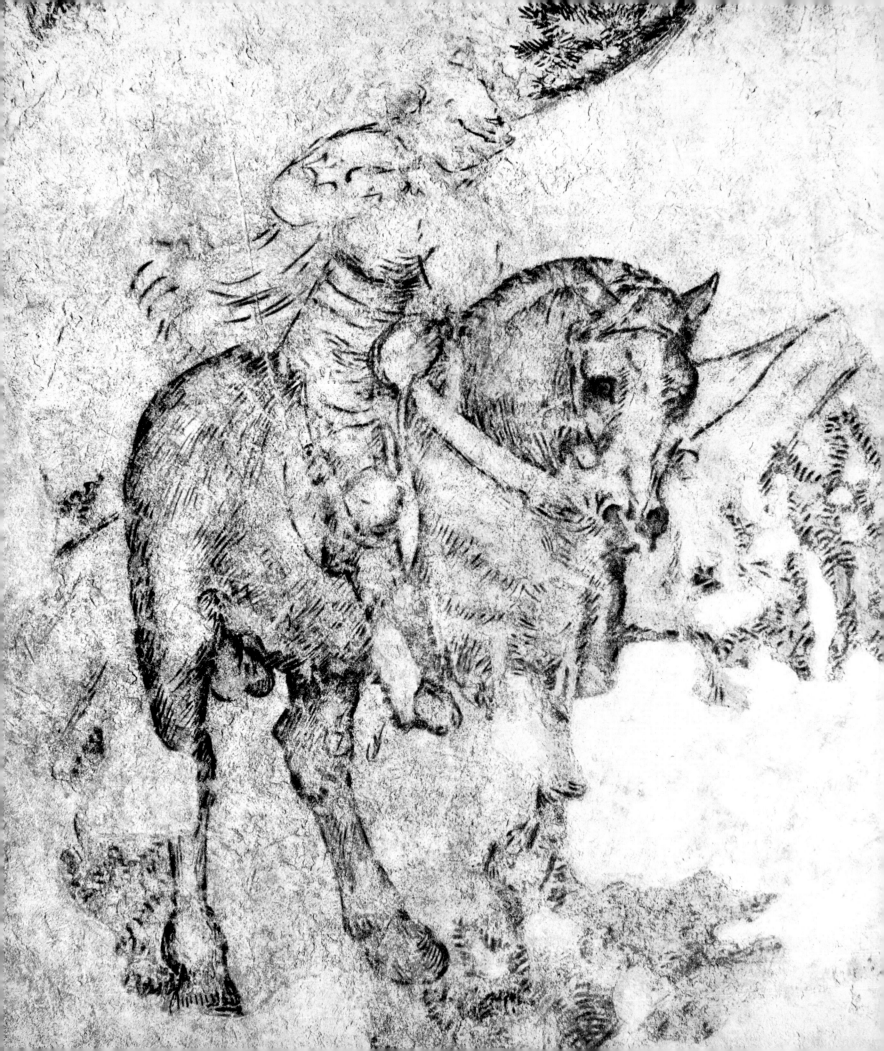

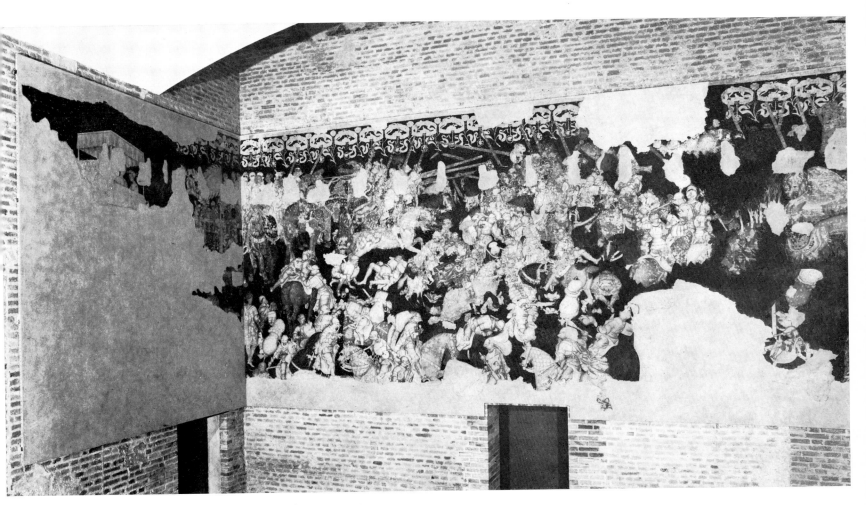

55, 56. Overall view of the Battle, and detail of the knights in combat.

54. Knight errant (Lancelot beside the river Marcoise?), detail of sinopia.

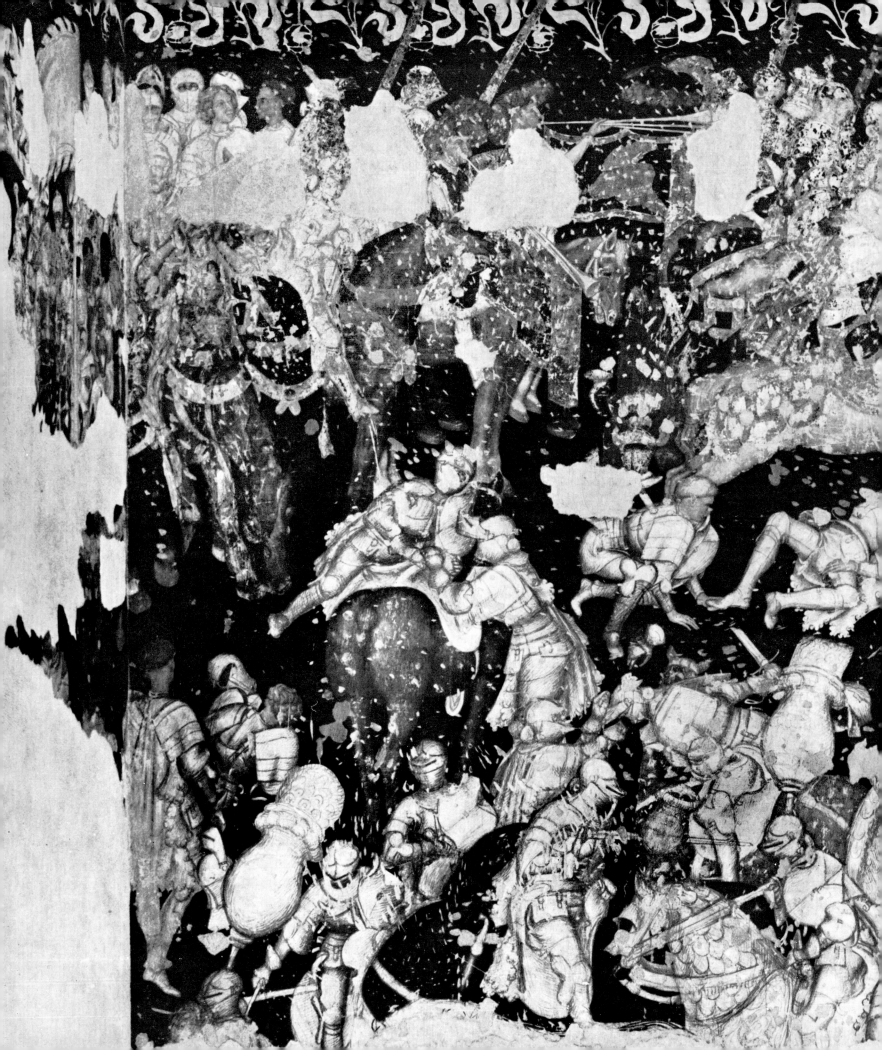

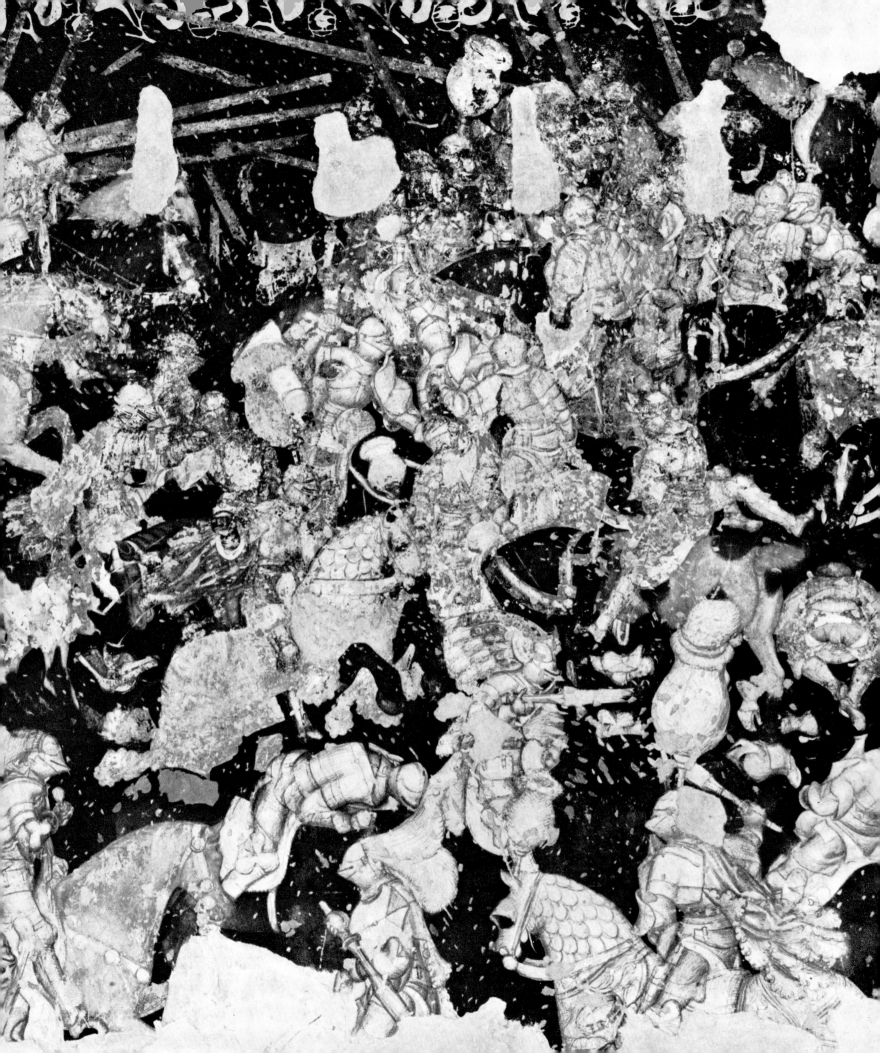

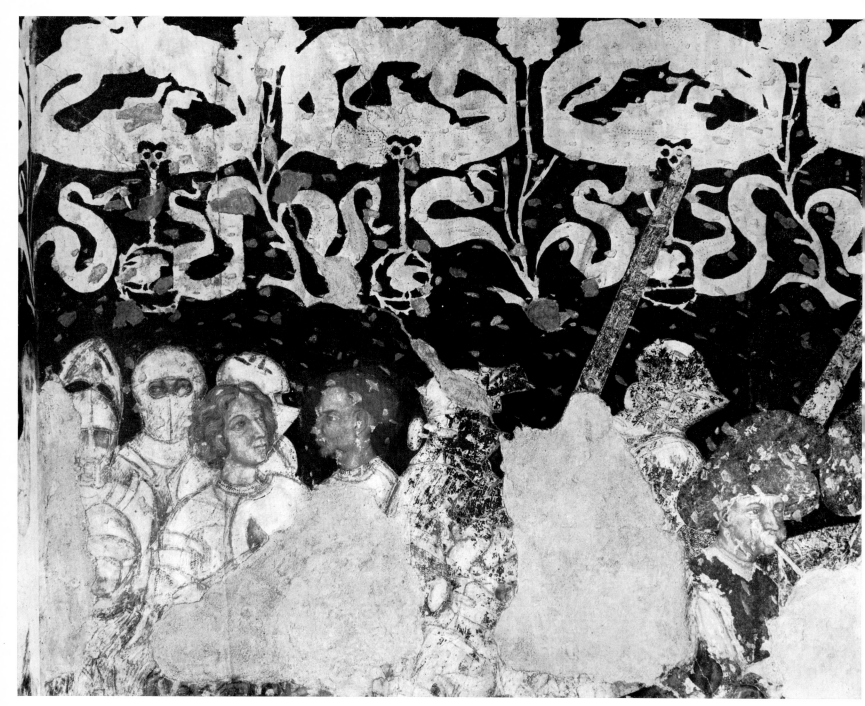

57, 58. The Battle, details of fresco.

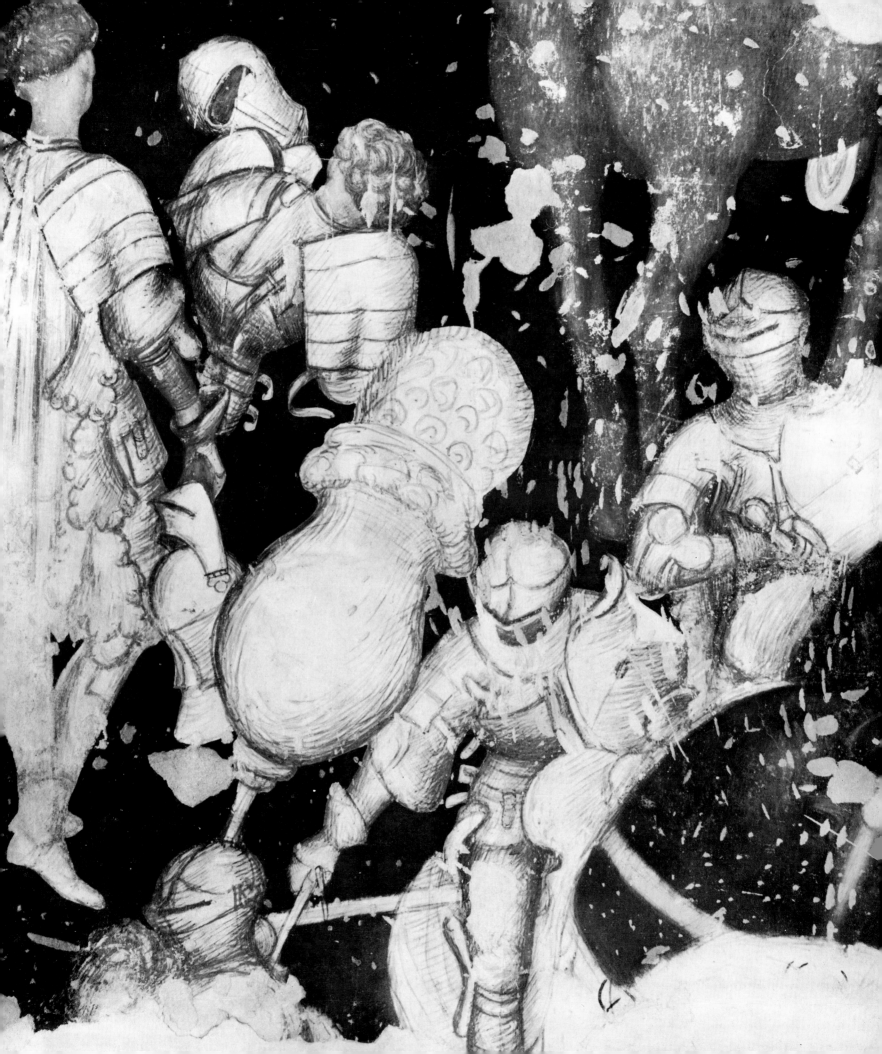

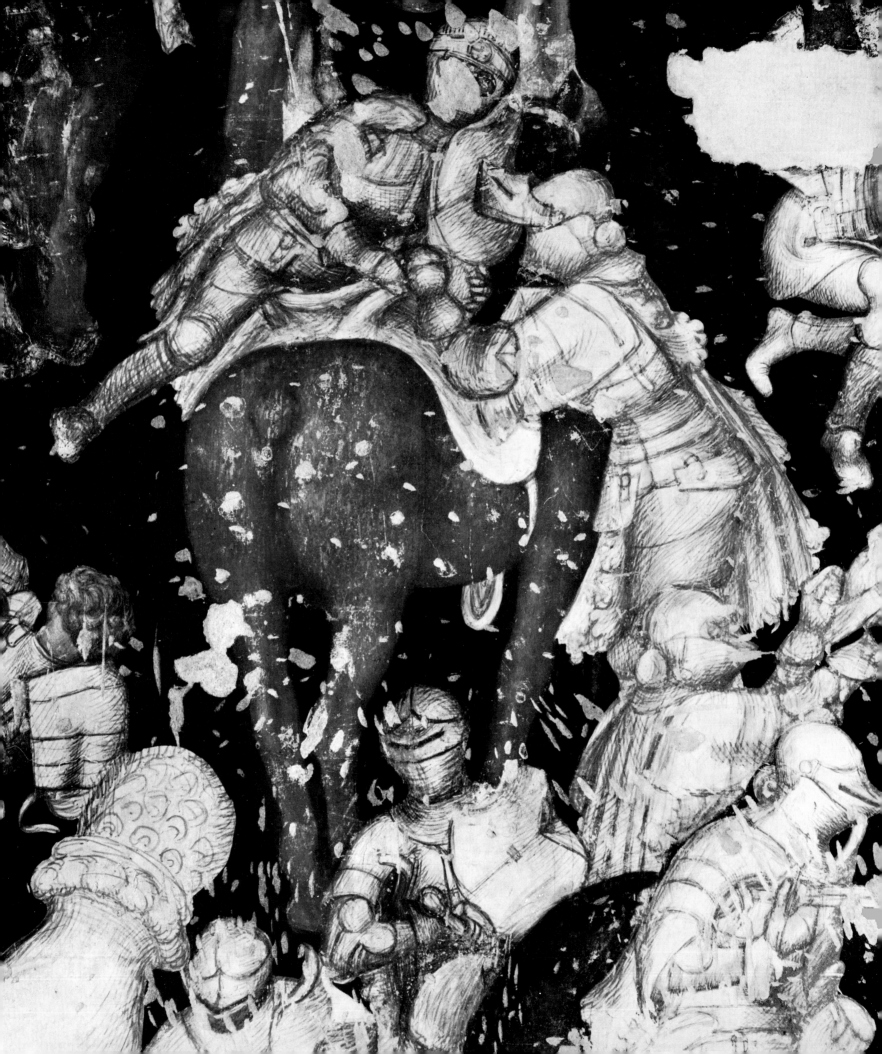

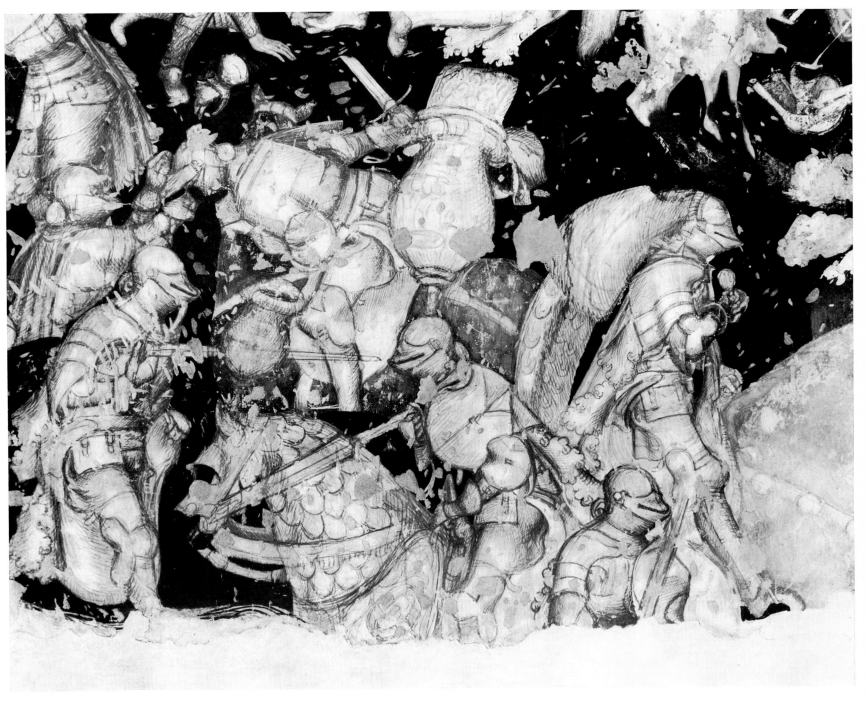

59, 60. *Knights in combat, details of the Battle fresco.*

61. *Group of warriors on bottom part of the Battle fresco (the horse of the warrior on the right has only been sketched in and the work has been left unfinished).* ▷

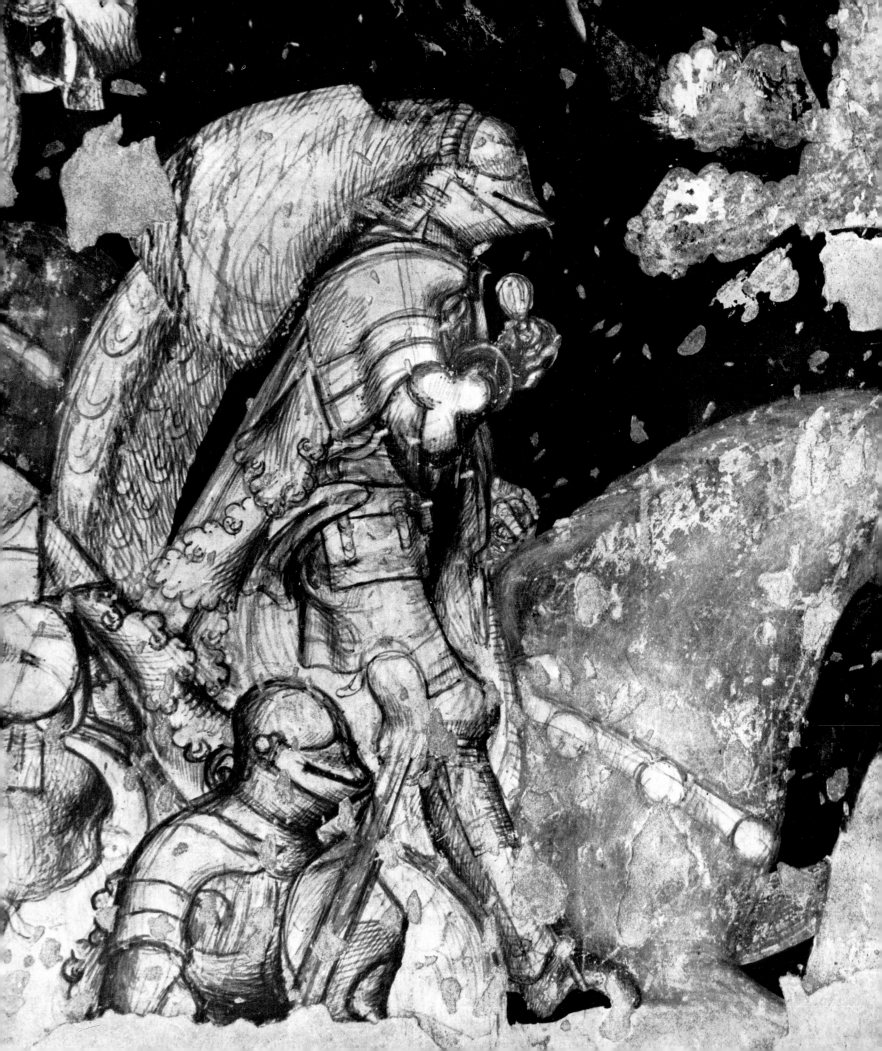

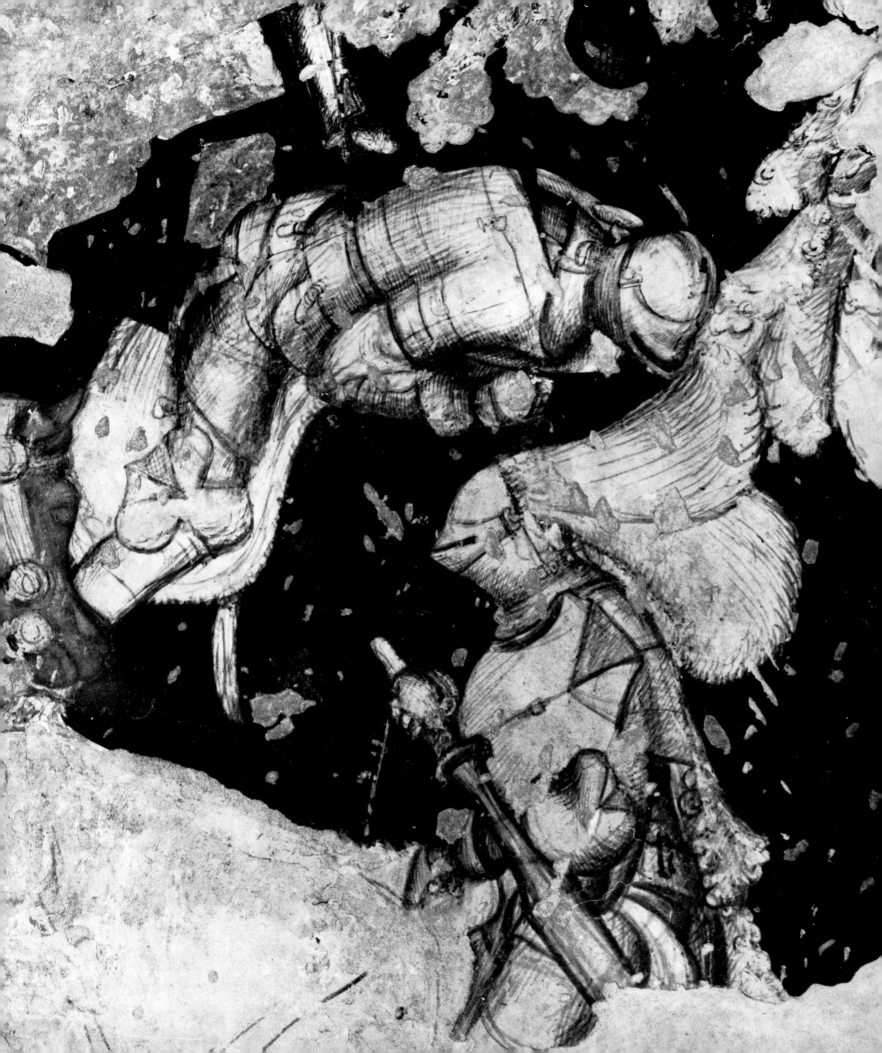

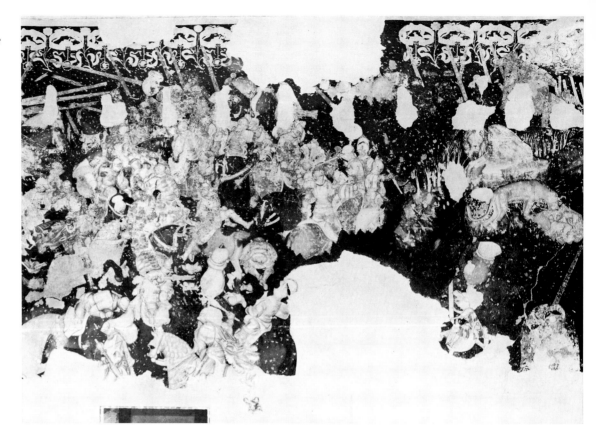

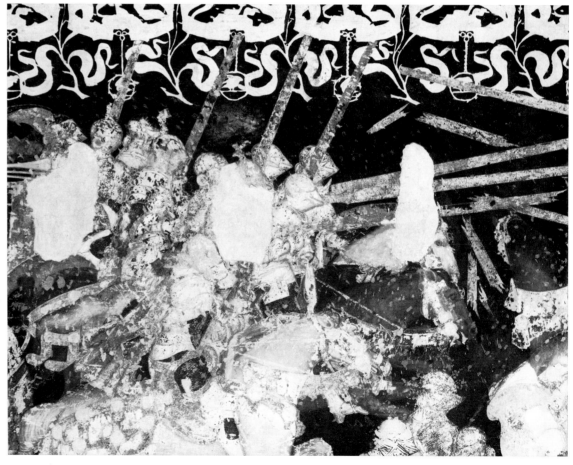

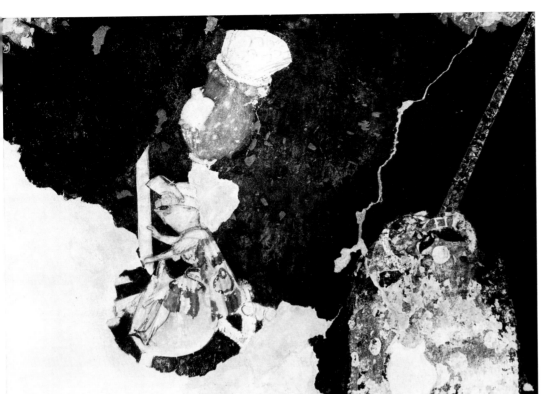

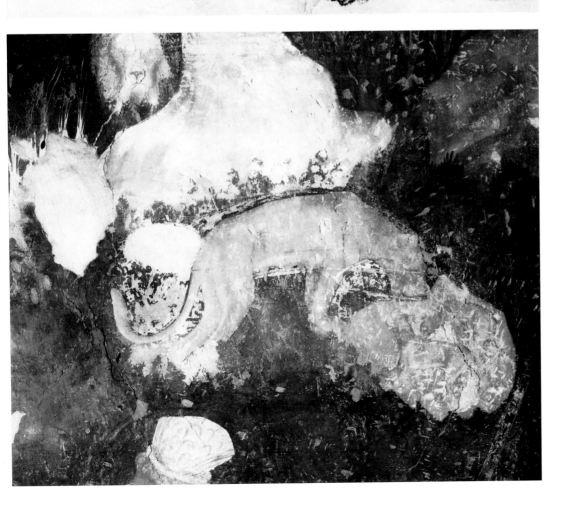

64. *The dwarf, detail of the Battle fresco.*
65. *The lioness and cubs, detail of the Battle fresco.*

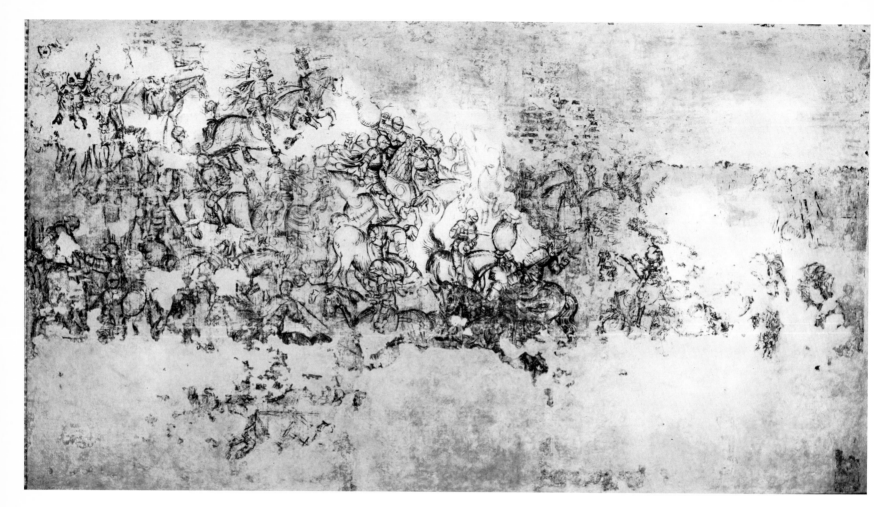

66. The Battle, the whole of the sinopia.

67. The Battle, detail of the sinopia *on the left hand side.*

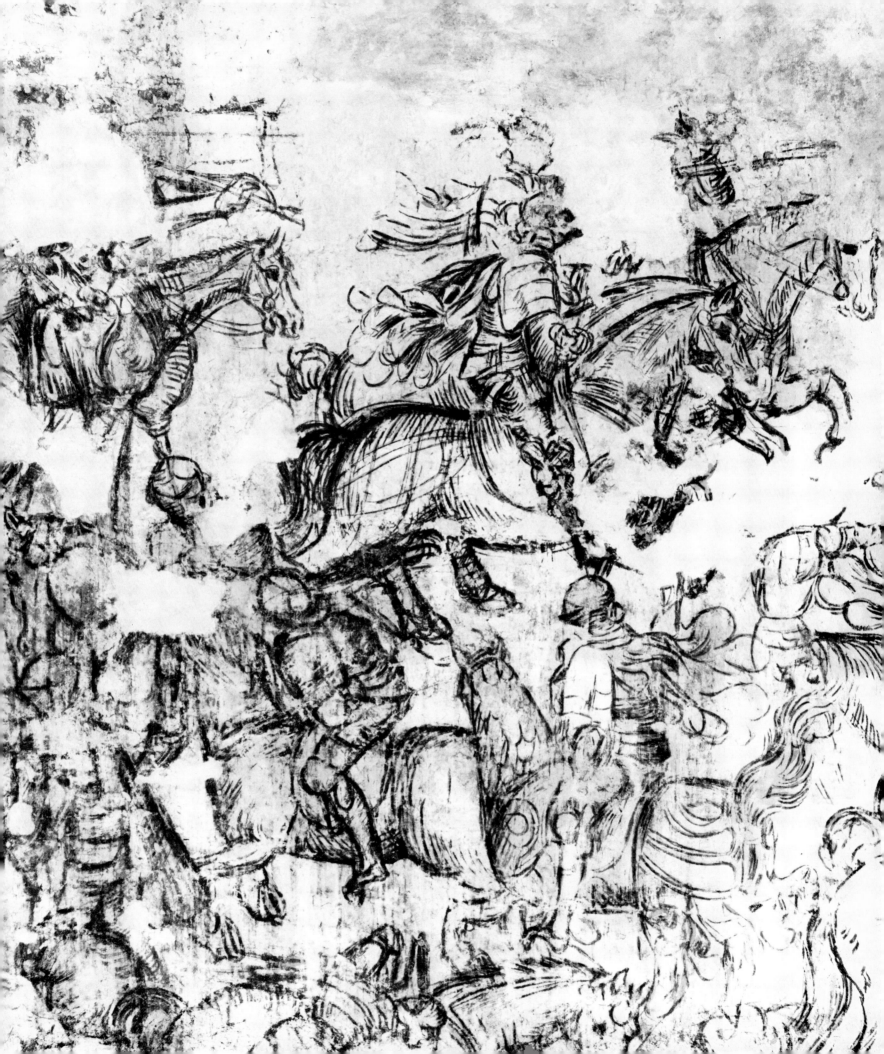

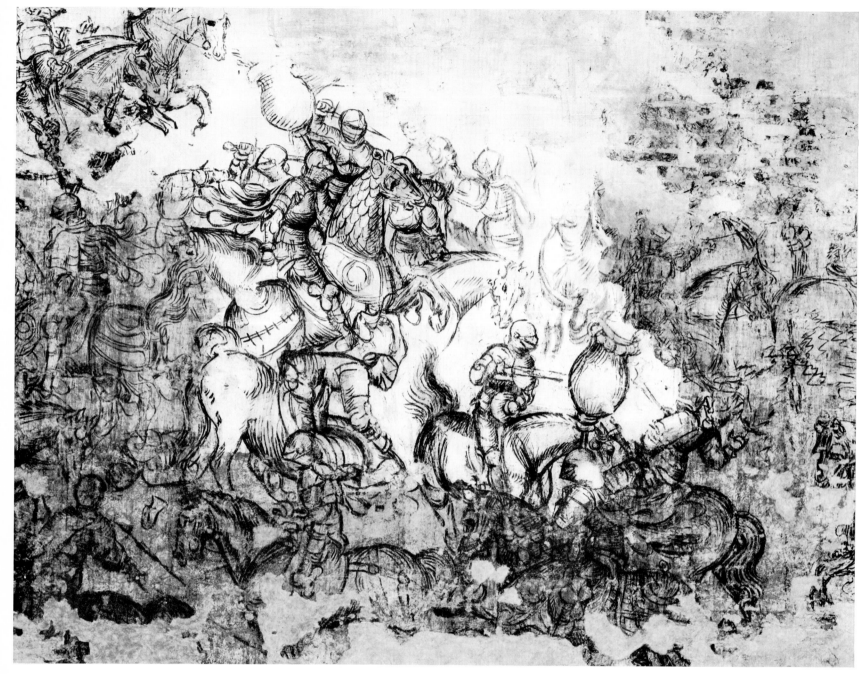

68. *Detail of the central part of the Battle* sinopia *(the second version on light-coloured* intonaco *can be seen in the centre)*.

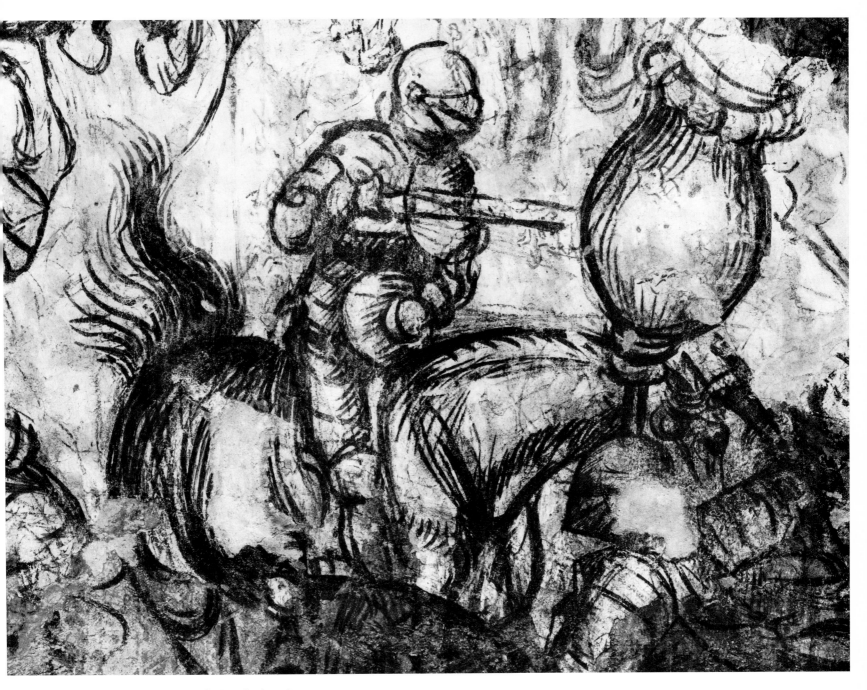

69. Detail from the central part of the Battle sinopia.

70, 71. *Knight in combat*, *details of the Battle* sinopia.

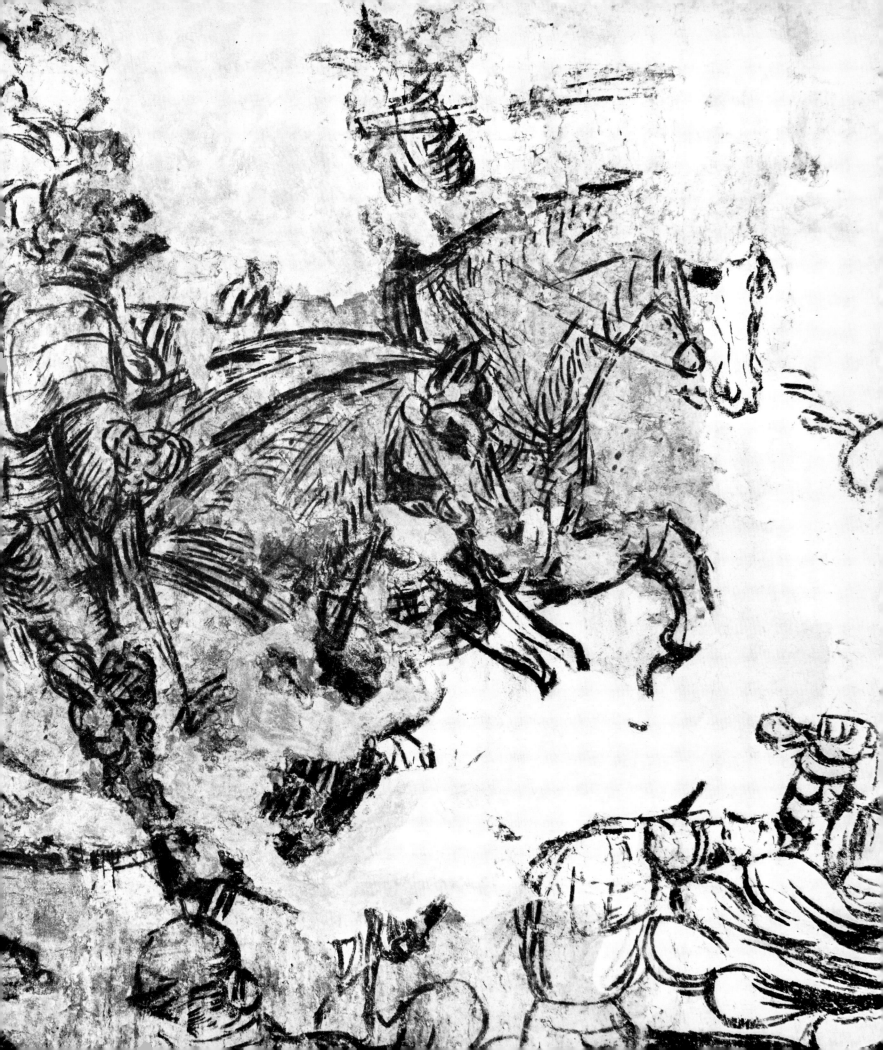

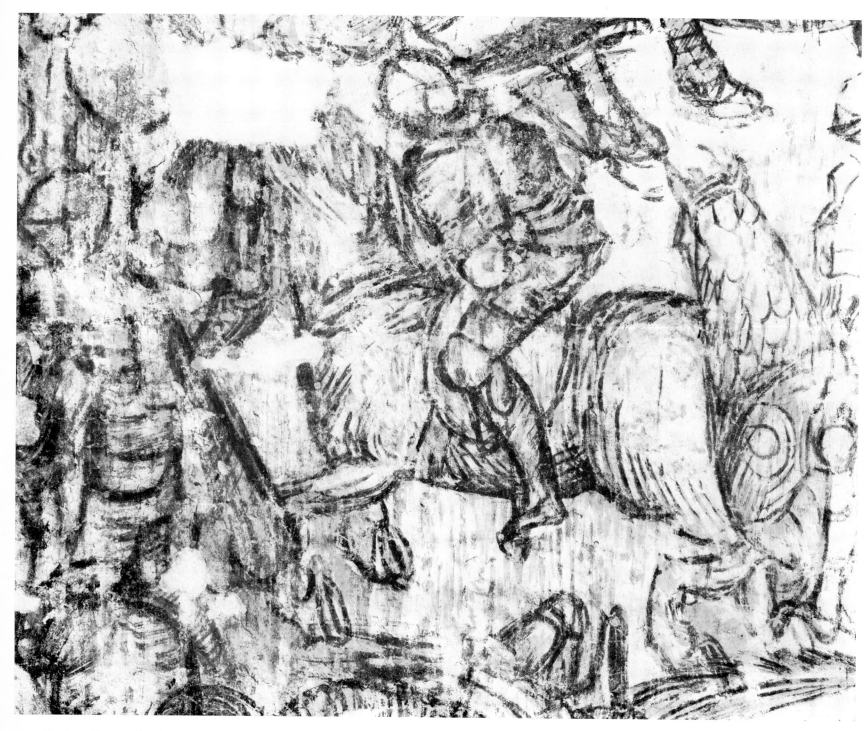

72. *Knight galloping*, *detail of the Battle* sinopia.

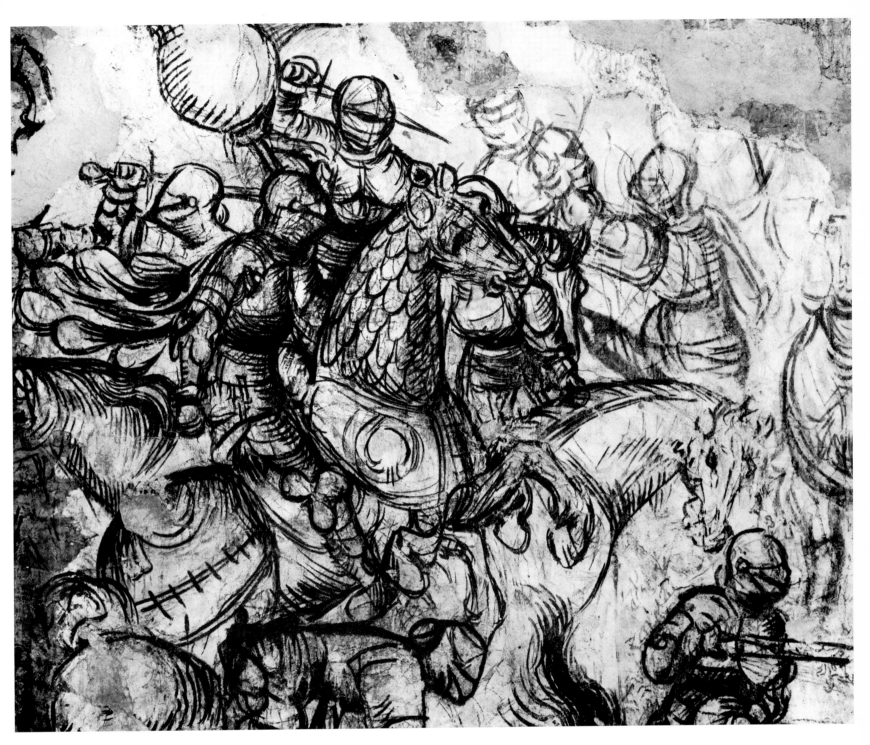

73. *Group of Knights, detail of the Battle* sinopia.

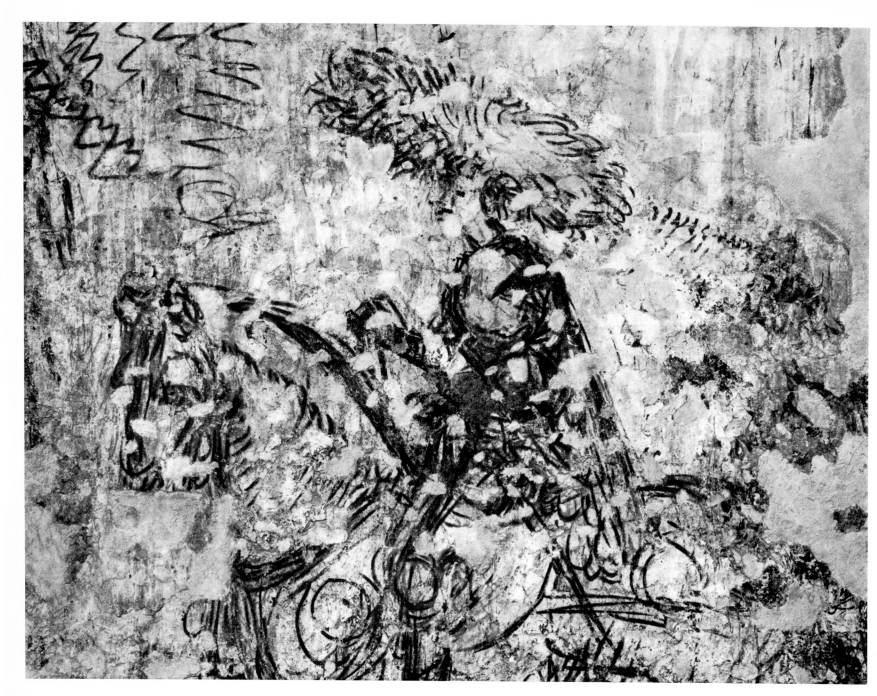

74. Plumed Knight, detail of the Battle sinopia.

PISANELLO'S ACTIVITY AND THE PROBLEMS IT POSES

The recovery of such an important pictorial cycle as this, executed during the last period of Pisanello's activity and comprising, in spite of its unfinished state, a remarkable finale to his artistic career, raises a series of questions which also have some bearing on the earlier stages of his development. But quite apart from this, I believe that the information relating to the youth of Antonio Pisano needs to be re-examined, beginning with the year in which the artist was born. This new analysis will I hope clear up some of the mystery surrounding his origins and early training.

First of all there is the question of the artist's date of birth. It used to be put at about 1380, but was brought forward almost twenty years by Biadego and finally was settled as *circa* 1395, as a result of documentary evidence produced by Biadego. The belief that the painter was born around 1380 had been founded on two main points. One of these seemed to have the objective validity of a documentary piece of information, since it concerned an inscription bearing the name of Vittore Pisano and the date, incorrectly read as 1406, on a painting of the *Madonna and Child with St. Catherine, St. John the Baptist and St. Clare*. In the early eighteenth century this painting was in the possession of Bartolomeo dal Pozzo from Verona but in the last century it passed to the Berlin Museum.[1] The other argument was Vasari's statement that Pisano 'assai ben vecchio passò a miglior vita' ('when very old departed to a better life')[2] and since it was known that the artist died not earlier than 1450 and not later than 1455—and in view of the date on the Berlin painting read as 1406—it was necessary to go back as far as 1380 to justify Vasari's statement. But these arguments began to wear rather thin when it was ascertained that the inscription was apocryphal and that the painting in Berlin had nothing to do with Pisanello at all.[3] Yet the name and the birth date of about 1380 assigned to Pisanello remained unchanged, on the basis of Vasari's undocumented information alone, until Biadego published the results of his research among the archives in six fundamental essays on Pisanello written between 1908 and 1913.[4] In the first Biadego proved that Pisanello was not called Vittore but Antonio and, referring to information contained in an official register of 1433 and to other documents he discovered in the Verona Archives, he maintained that the painter was born in 1397, son of a Pisan cloth merchant called Bartolomeo and a woman from Verona called Isabetta who, on becoming a widow, entered into a second marriage with a draper named Filippo di Ostiglia.[5] Although most of this new documentary information was favourably received by the majority of Pisa-

nello scholars, the conclusions drawn in Biadego's essay were so unexpected that they did give rise to quite strong reactions and a considerable number of reservations and doubts,[6] which are still far from dispelled.

It is easy to understand why 1397 as the date of Pisanello's birth should have caused some bewilderment, since it rendered even more unclear the already mysterious early period of his activity. Biadego, in his second essay on Pisanello, had taken to task those historians who had been unwilling to accept without reservations the results he had set out in his previous work, and reaffirmed his certainty of 'having demonstrated, with a contemporary document in my hands, that Pisano was born in the year 1397'.[7] But he was to change his mind a short time later when he found new documents which considerably modified his earlier claim. It transpired that Isabetta had had three husbands, the first two of whom were Pisan and only the third, Filippo, was a Veronese, from Ostiglia; that Pisanello was not the son of Bartolomeo, but of Isabetta's first husband, the cloth merchant from Pisa, Puccio or Puccino di Giovanni da Cerreto; and finally that Puccino died at Pisa, where he had lived in Campo S. Silvestro, after having left his son Antonio as his sole heir in a will received on 22 November 1395 by the notary Fanuccio di Jacopo da Pisa.[8] The exact terms regarding this legacy were later recorded by the notary Andrea di Monzambano (who declared he had seen and read the will of Puccino in the presence of the interested parties) in the deed drawn up on 8 July 1424. In this Isabetta acknowledged a debt in favour of her son Antonio to the notable sum of six hundred ducats, corresponding to the value of the property bequeathed to him by his father.[9] Biadego immediately published these new findings which corrected his previous ones, acknowledging the fact that it was clear that Antonio Pisano was born in Pisa 'at any rate in 1395' and that the official who had made the entry in the Verona register of 1433 had made an error by relying on uncertain verbal information.[10] Yet Biadego never managed to free himself entirely of his initial theories and he declared he was convinced that the new documents led to no more than a 'slight adjustment' of the painter's birth date and the situation was otherwise unchanged. In his opinion historical and stylistic considerations supported his theory.[11]

Yet it was these very considerations which were the greatest cause of perplexity. At the same time, the new documents had not actually proved the birth date of 1395, but had merely pointed to the unreliability of the registrar's entry of 1433. Certainly it was impossible to establish the real margin of error by making use, as Biadego did, of information from one partly erroneous document, together with information from another one which was accurate, namely the declaration made by Isabetta acknowledging her debt in the presence of Andrea da Monzambano (and there can be no doubts about its authenticity since it is a legal document). The latter document mentions only the date when the testator, Puccino di Giovanni da Cerreto, died at Pisa, and not that of the birth of his son Antonio, to whom Puccino was making his bequest.

The information which emerged from the new documents contrasted so sharply with that which had hitherto formed the basis of the artist's biography that Testi, most dogged opponent of Biadego's theories, was even led to believe that two different painters had been active at Verona during the same period, both called Pisanello, the younger one being Antonio di Puccio, the other, older one, Vittore.[12] This however was an un-

realistic supposition, for it was clear that both old and new information related to one and the same painter, Antonio Pisano called Pisanello. Nevertheless, Pisanello's date of birth which Biadego had initially placed at 1397, and then at about 1395, meant that the artist's early training period would have been very short in realtion to the overall pattern of his work, as established by the art historians, so Biadego felt it necessary to adjust a few dates. Thus he brought forward as far as possible, to between 1422 and 1427, the execution of Pisanello's lost mural paintings in the Sala del Maggior Consiglio in the Doge's Palace in Venice, which in view of the importance of the task would not have been entrusted to a young and inexperienced man but to a painter whose skill was already well known; and he deferred by a decade the date of the decoration of the Brenzoni monument in the Verona church of S. Fermo, which he considered to be of the period 1435–40,[14] contrary to the evidence of the original plaque on the monument which was dated 1425. Finally he moved to about 1446 the date of the frescoes in the Pellegrini chapel in the church of S. Anastasia.[15]

The date for the decoration of S. Fermo was unacceptable, but it meant that Biadego obviously did not consider this masterpiece of Pisanello's to be a juvenile work. This mural decoration is of very high quality, even though it is not immediately impressive, mainly because of the irreversible decay suffered by the pigments, but also because of the apparently secondary function of Pisanello's pictorial background, which seems almost like a tapestry backcloth for the plastic structure of the monument, sculpted by Il Rosso. It shows Pisanello as an artist endowed with a fully mature and autonomous personality, formed through the assimilation of a wide-ranging artistic culture which was international in the real sense of the word, and which in no way relied entirely on elements derived from Stefano da Verona and Gentile da Fabriano. It would therefore be quite logical to assume that Pisanello was at that time older than the birth date of 1395 implies. He would then fit more clearly into the development of that cosmopolitan trend of which he and Gentile da Fabriano were the major representatives in Italy.

Furthermore, an objective examination of the documents relating to Pisanello's family will shows that it is very unlikely that Antonio was born in about 1395: his mother was at least thirty-two years old when her first husband died and it would be surprising if Isabetta, an attractive and marriageable woman, had not already been married for several years to Puccino da Cerreto, especially since in those days girls were usually married very young. Her son Antonio would probably have been born before 1395, unless he was a very late issue of that marriage; indeed, the last, if he was born in the same year as his father's death.[16]

This would be a good moment to ponder on why and when Antonio was called Pisanello, the name by which the artist was to be known all his life; even the diplomatic document issued by Alfonso of Aragon in 1449, when the painter moved to his court, is headed 'Pisanelli de Pisis pictoris'. The description 'de Pisis', which seems pleonastic when added to the name Pisanello, was certainly accepted by Antonio for he always signed himself Pisano, and all his friends and admirers, including the Veronese Guarino, knew him as this. It is possible that the name Pisano chosen by Antonio was the proud declaration of an artist who wanted to underline his Tuscan origins, which set him apart from the Veronese environment and its late Gothic culture, even though his early train-

ing had been partly based on that culture. The name Pisanello could not have pleased him for he never used it, but it stuck to him even when he was an old man at the court of Aragon in Naples, so we may presume that this was a nickname which derived from his shorter than normal stature, as well as from his Pisan accent which would have stood out against the fluid, sing-song cadence of the Veronese dialect. He must have been saddled with that half-affectionate, half-ironical diminutive by his contemporaries in Verona from the moment he arrived from Pisa, still very young but no longer a child.

We do not know when the young Antonio's family left Pisa for Verona; but it is unlikely that it was before Isabetta married her second husband Bartolomeo, who was from Pisa. (This marriage took place a few years after the death in 1395 of her first husband Puccino.) In fact, the first documentary references in Verona to Bartolomeo and Isabetta occur in the first decade of the fifteenth century;[17] it can therefore be inferred that the well-off family of Pisan drapers which Pisanello belonged to, transferred their residence during the period when there was a great deal of migratory movement between Pisa and Verona,[18] and the two cities shared the common fate of being incorporated for several years between the end of the fourteenth and the beginning of the fifteenth century, in the territory owned by the duchy of the Visconti.[19] The ambitious project conceived by Gian Galeazzo Visconti of uniting under his dominion a large part of northern and central Italy came to an end with his death in 1402. Venice and Florence, the two largest powers whose vital interests had been threatened by that expansion, took advantage of the situation to bring about the disintegration of the duchy of the Visconti. As a result of this, Verona passed into the hands of Venice in 1405, while Pisa was conquered by the Florentines in 1406. It was probably just before these military and political events— events which were of fundamental importance to the future destiny of those cities—that Antonio's family left Pisa for Isabetta's native city, where economic conditions were more flourishing. At that time Antonio, even if he really had been born just before 1395, would have had his eyes wide open to what was going on around him; and he would have been even more receptive to his new Veronese environment if he had been born several years before the death of his father. In that case he would have been a young man of about twenty or just under, when he gained his first experience of art in the Veneto and in particular of Gentile da Fabriano's activity in Venice. It must not be forgotten that the first document testifying Pisanello's presence in Verona is dated 1422. This related not to a permanent but to a temporary stay, in connection with the purchase of property in the district of S. Paolo, as we learn from the document, which specifies that the artist lived during that period in Mantua; he was therefore already engaged in some work for the Gonzagas.[20] It does not seem then that Pisanello stayed in Verona for the whole period of his youth, when he was receiving his artistic training—probably under a great and famous master, as Cennini advised.[21] This master may well have been, perhaps just after the beginning of the century, Gentile da Fabriano himself.

However that may be, an explanation must be found for the fact that the ingredients and style of Pisanello's art display not only his indisputable links with the Venetian art of his time, but also a special accent of their own. I am not referring here to the important Lombard elements in his artistic background, nor to the influence of painting from abroad, nor to the firm bond which Pisanello established right from his early youth with Gentile

da Fabriano, but to what one might call the inborn nature of his vision of the world, as a result of which his images are given that intense, restless and sharp characterization, and objects are brought into close and relentless focus so that the details of their individual aspects are multiplied to infinity. This way of representing visual experiences was a far cry from the melodious linear elegance of Stefano da Verona which, some claim, was the starting point for Pisanello's art. According to those who hold this view Pisanello received his early training in Verona in the ambiance of Stefano. All this suggests that Antonio was by no means lacking in artistic knowledge when he began his activity in the north and that he had already had some kind of early guidance in his native city, which may have been sketchy but nevertheless, like most impressions gained in youth, probably influenced his development.

Pisa at that time was undergoing its own cultural crisis. In the Romanesque and Gothic period Pisa had reached the heights of artistic expression in every field—architecture, sculpture and painting—through the activity of outstanding Pisans of the Duecento and of the first half of the Trecento. Giotto and above all Simone Martini had both worked for Pisa in the early part of the Trecento, and the Sienese had continued over a long period to exert their influence there. Both Gentile da Fabriano and Pisanello must have been interested in the exquisite naturalistic observation of these painters. The young Antonio must have looked with pride at the glorious past of his city, whose vital energy seemed to exhaust itself just after the middle of the fourteenth century, with the death of the last great artists, the sculptors Andrea Pisano and his son Nino, and the painter Francesco Traini. This was the moment when the situation was altering radically, with the increasing activity in Pisa of painters from many different places, among them Taddeo di Bartolo, Barnaba da Modena and Giovanni da Milano. But the outstanding lesson which could have been learned by a young man with a strong inclination towards painting, was that provided by the vast walls of the Gothic Camposanto created by Giovanni di Simone. These were decorated from top to bottom with one of the most extensive and varied series of mural paintings of the second half of the century. It must indeed have been an impressive and exciting sight, this succession of vast painted cycles over those immense interior surfaces of the spacious building, with the light coming in through the large quadripartite openings. It displayed some of the most important developments which had taken place in late Gothic mural painting. The frescoes were clear evidence that Pisa lacked good local painters in the second half of the century since apart from the first scenes, which were perhaps executed by Traini or more probably by his followers, all the illustrations covering the walls of the Camposanto had been entrusted to outsiders: the delicate *Assumption* attributed to Giottino, works by the famous Master of the Triumph of Death, the *Story of Job* by Taddeo Gaddi, the *Scenes from the Life of S. Ranieri* begun by Andrea da Firenze and continued by Antonio Veneziano, the *Stories from the Old Testament* by Piero di Puccio, and finally the *Story of the Holy Martyrs St. Ephysius and St. Potitus* by Spinello Aretino. When Pisanello found himself among those frescoed walls which provided such an inexhaustible fund of figures and compositions, he must have felt the vocation for painting grow within him. He would have become familiar with the realistic force of representation displayed by the Master of the Triumph of Death; with the problems of architectural composition and of the

organization of space by means of series of planes receding into the distance, in the panoramic views of Taddeo Gaddi (Fig. 75); and with the vivid naturalism of this artist's landscape backgrounds so rich in plants and animals. The more recent mural paintings executed between 1384 and 1392 by Antonio Veneziano, Piero di Puccio and Spinello Aretino, must have been of particular interest to him, since these were modern works open to the influence of the International Gothic style. It is also possible, if Pisanello's birth date is to be put back more reasonably to the 1380s, that the young Pisanello might have been able to see the painters Piero di Puccio and Spinello Aretino—active in the Pisan Camposanto between 1390 and 1392—actually at work on the scaffolding. He must have learned from the work of Piero di Puccio and from his gift for keen, attentive observation, and noticed his strong naturalism, his plastic sense, his arrangement of space in relation to one figure or group of figures, which gave a peculiarly modern accent to the Gothicism of this artist from Orvieto. These qualities were noticed by Toesca who, almost fearing a trick of the imagination, cautiously stated that the frescoes of Piero di Puccio's *Genesis* 'in a few places, and for a brief moment, might seem to be the work of a precursor'.[22] In fact, Piero di Puccio has only recently been rediscovered by the art historians;[23] but it was Longhi who really called attention to him, dispelling Toesca's cautious reservation when he pointed to the painters Ugolino di Prete Ilario, Cola Petruccioli and Piero di Puccio as the representatives of the 'specifically Orvietan culture in the second half of the Trecento'.[24] Longhi also demonstrated the relationship between this culture and the later activities of the great Lombard painters and also Gentile da Fabriano's own enigmatical training. Unfortunately, fate ordained that Piero di Puccio, who painted the first stories from *Genesis* in the Camposanto between 1389 and 1391,[25] was to be appreciated only after the cycle had suffered serious damage during the last war, when most of the frescoes were scorched by a fire in the roof of the gallery of mural paintings comprising the four imposing corridors of the Pisan Camposanto. The removal of the painted surface, unfortunately in bad condition (though there were still some very effective details), has brought to light the beautiful and powerful *sinopie*. These give a more obvious and more immediate idea of the painter's sharp portrayal of reality, the numerous and carefully detailed images of animals in his landscapes, the elementary, essential quality of his drawn line, his studied search for an illusion of space arranged in 'superimposed but perspicuous planes'. The complex and meditated formal structure of Piero di Puccio's images seemed to Longhi to be sufficiently important to have influenced Paolo Uccello in his first frescoed cycles in the Chiostro Verde.[26] These new trends could not have escaped Pisanello, observing them with the unclouded eyes of youth. He must have been struck by the forceful line and the roughness of naturalistic observation shown in those scenes (Figs. 77, 78), and by the repetitive rhythm of hills which, in the scene of the death of Abel, creates the landscape space where the restless progeny of Adam and Eve live among the plants and animals of a primeval world (Fig. 79). If I am not mistaken, these landscape compositions of medieval descent—but which contain signs of a new sense of space—remained in Pisanello's mind, for even his landscape in the Mantuan decoration, with its steep crags cleaving through the wood in zigzag fashion like a mountain stream rushing headlong to the valley, still seems to conserve a memory of that powerful, vertical landscape in Piero di Puccio's *End of the Flood* (Fig. 80).

122

The frescoes by Spinello Aretino must also have had great influence on Pisanello who probably knew the *Scenes from the Life of St. Benedict* in the church of S. Miniato in Florence, in addition to the frescoes in Pisa with their symbolic *Battle of St. Ephysius against the Pagans in Sardinia*, which is the most lively episode from the *Scenes from the Lives of St. Ephysius and St. Potitus* executed in 1391–2.[27] Indeed, this heraldic construction of space with rapid, radiating lines and patches of colour creating strong chromatic and chiaroscuro contrasts (Fig. 76), already had the courtly and chivalrous air of an International Gothic decoration; and it is worth noting how it anticipates the developments which this theme was to undergo in the battle scenes by Pisanello and by Paolo Uccello.

Further comments could be made on the interest which may have been roused in the young Antonio by other painters who were working in the Camposanto of Pisa: the Master of the Triumph of Death, the Florentines Taddeo Gaddi and Andrea da Firenze, the Tuscan-trained Venetian, Antonio Veneziano, whose *Scenes from the Life of S. Ranieri*, spread over a wide architectural backcloth, provided perhaps the most effective prelude for Pisanello's later experience of the art of Altichiero and of Avanzo. However, the intention here is above all to point out that the extraordinary ability to assimilate a vast and complex late Gothic culture, which Pisanello shared with Gentile da Fabriano, was partly due to these first direct impressions, which were to influence his development. This start, I believe, must have been given to him in his earliest youth, for all the most significant works painted in Pisa in the second half of the century were by painters from outside the Pisan environment, and they expressed some new and lively trends in late Gothic art. What Pisanello saw in his native city—which together with Verona now came under the political domination of the Visconti—and in the other Tuscan, Venetian and Lombard centres, with which his family of cloth merchants must have been in close touch, helped to turn his attention to the north. It was here where the cosmopolitan style was in full flower and this, in his opinion, was the right direction for modern art to follow. The removal of his family to Verona would not in itself have been a determining factor in the development of the young artist; he must have deliberately chosen to be in northern Italy, since the comfortable financial circumstances of his family would certainly have enabled him to go elsewhere, for example to Florence where in fact Vasari claimed he received his early artistic education. Moreover, it is well known that Pisanello maintained and developed his contacts with Florentine late Gothic circles, possibly collaborating with Gentile da Fabriano during the period in which the latter was working in Florence.

Another source of international influence on Pisanello which may have been of particular significance was the presence in Pisa towards the end of the Trecento of two young painters, Parri, son of Spinello Aretino, and Zanino di Pietro, pupil and assistant of Antonio Veneziano, both of whom later played an important part in the development of the International Gothic trend in central Italy and in the Veneto. The decadent Ghibertian elegance of Parri Spinelli's drawings matches the gentle, undulating rhythm of Stefano da Verona so well that many drawings by Stefano were for a long time attributed to Parri.[28] The similarity of linear rhythms in the graphic art of both painters is certainly not merely casual. It suggests that, as well as links with the activity of international artists working in Florence in the first quarter of the Quattrocento, Stefano's style, though so

northern in feeling, has a close affinity with the 'international decadentism' of Lorenzo Monaco and Ghiberti.[29] With regard to Zanino di Pietro, the connection between the only signed painting by this rare painter, the Triptych of the Crucifixion in the Pinacoteca of Rieti, and the Pisan works of Antonio Veneziano, has been explained by Salmi, who identified Zanino as the Giovanni who is quoted in Pisan documents as disciple and assistant of Antonio Veneziano in the Camposanto frescoes.[30] The style of this refined painter, who may have come from Verona, presents complex links with painting from abroad: Bohemian, Rhenish and French.[31] This background, a similarity of style and their modern international culture, places him side by side with Niccolò di Pietro, the Venetian 'friend of Gentile da Fabriano and of the painters of Prague and Cologne'.[32] Longhi originally attributed to Niccolò the exquisite *Scenes from the Life of St. Benedict*, which were later assigned by Degenhart and subsequently by Longhi himself, to the young Pisanello.[33]

The attribution of these small panel paintings is one of the most controversial points in the history of Venetian painting of the first decades of the Quattrocento. But there are also still some doubts about the very few other works on which the various theories about Pisanello's early activity have had to be based. The formative period of a young artist is often obscure and elusive, but Pisanello retains his enigmatical nature even in the clearly identified masterpieces of his maturity. Apart from the difficulties which arise from the secretive nature of Pisanello's art, there are many other factors which limit our chances of knowing more about this painter. One of these is the almost total disappearance of the numerous pictorial cycles which he executed during his lifetime. From the beginning to the end of his activity, these works were the most highly esteemed by contemporary humanists, who praised their beauty, and by the princes who owed to them the increased fame and splendour of their courts. The loss of the frescoes painted by the young Pisanello and Gentile da Fabriano in the Doge's Palace in Venice makes it very difficult to reconstruct the artist's early activity in the Veneto. Certainly if any part of those mural decorations, which were so influential in the development of Venetian painting in the first decades of the Quattrocento,[34] should come to light this would settle the complex question of the *Scenes from the Life of St. Benedict* (Figs. 84–6).

In my opinion these four very delicate panels, divided between the Uffizi and the Poldi Pezzoli Museum, are the first known work of Pisanello, but they have been variously ascribed to Stefano da Verona or to his circle, to Gentile da Fabriano, Niccolò di Pietro, Pisanello, the hypothetical Master Wenceslaus, the Maestro degli Innocenti, alias Teodorico d'Ivano d'Alemagna, the young Giambono and to the circle of Jacopo Bellini.[35] The different critical angles taken in examining these small but important works, which were presumably part of a sizeable series covering the main events in the life of St. Benedict, have meant that they have been investigated in all their aspects and the various stylistic elements clearly pointed out. However, widely different conclusions have been drawn. As far as I can see, this was inevitable, since the fascinating question of Pisanello's early training and activity is not, at the present stage of research, one which can be resolved with categorical affirmative or negative replies to the various theories put forward. Degenhart himself, who has always been a staunch supporter of the theory which ascribes the St. Benedict scenes to Pisanello, acknowledges that it is not easy to prove this

attribution, since the paintings represent the point when the young artist was closest to Gentile; and thus their style is not readily distinguishable from that of Gentile's own works.[36] This close link with the painter from Fabriano caused Longhi to suspend judgement for a long time following his first recognition in 1940 of the exceptional quality of the three Scenes of St. Benedict in the Uffizi: 'of such quality', he wrote then, 'that one hesitates to ascribe them to Niccolò and one is tempted to see in them Gentile's Venetian period.'[37] Longhi's later attribution of the three panels to Niccolò di Pietro partly took into account the Venetian nature of the buildings depicted, though this was really more an acquired than an innate characteristic; but he also underlined the formal analogies and similarity of poetic tone with the work of Gentile, and pointed to traces in these three paintings of Bohemian and Rhenish influence.[38] Yet it was precisely because of their close affinity with Gentile's work that the three Scenes in the Uffizi appeared to belong to Gentile's companion, Pisanello, whose personality revealed itself clearly in the more obviously Pisanellian nature of the fourth of these Scenes, *St. Benedict the Hermit*, in the Poldi Pezzoli Museum (Fig. 86), identified by G.M. Richter, Degenhart and by Coletti.[39] Since it was by now clear that the four panels were part of a single group and that they were all by the same hand, Degenhart attributed them, in my opinion correctly, to the young Pisanello.[40] The fact that Longhi, after the Verona Exhibition of 1958, accepted Degenhart's attribution[41] was the logical conclusion of a critical process and I do not see how any other conclusion could have been reached. These panels were included, as being particularly significant works of Pisanello's youth, in the excellent study on International Gothic art in Italy recently published by Miss Castelfranchi Vegas,[42] and the controversy seemed to be settled once and for all. Yet there continues to be hostility in many quarters to the attribution to Pisanello.

Those who reject the theory that Pisanello was the author of the St. Benedict scenes naturally lay emphasis on the characteristics which differentiate them from the other works ascribed to the period of the painter's youth. Among various hypotheses the most acceptable is that put forward by Volpe,[43] who attributes the Scenes to the young Giambono. The undoubted relationship that these paintings have with the decoration ascribed to Giambono which was executed in about 1432 around the Serego monument in the Verona church of S. Anastasia, confirms the ties between Pisanello and Giambono and their frequent contacts. But this does not seem to provide sufficient grounds for assigning the *Scenes from the Life of St. Benedict* to the period of Giambono's youth. Because of their quality and their particular accent which is so close to that of Gentile, although it is not by any means identical to his, they must be seen at the very epicentre of the movement which was started in Venice by the activity of Gentile and Pisanello between the first and second decades of the century. I would also add that, although the frescoes on the Serego monument are among the most important Venetian pictorial creations in the International style, I do not believe that it has yet been clearly demonstrated that they are the work of Giambono. The first comparison to be drawn between the St. Benedict scenes and the frescoes on the Serego monument resulted from J.P. Richter's attribution of both these works to a Veronese master of Stefano's circle of the early Quattrocento.[44] This was in 1914. In 1952 Fiocco took up the suggestion again. In the interim the four panels had been attributed to a number of different painters.

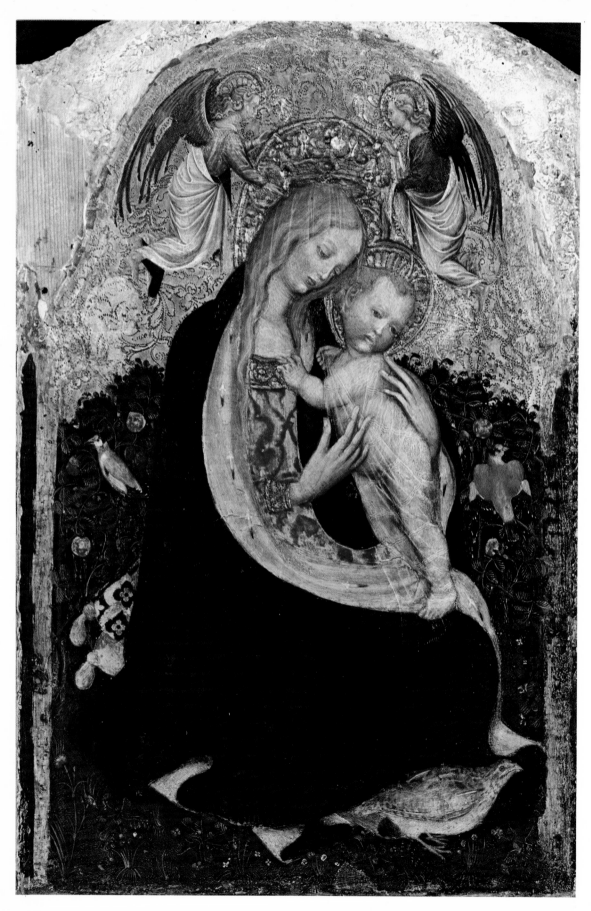

XIII. Madonna of the Quail. Verona, Museo di Castelvecchio.

Fiocco proposed that the Stefanesque author of the St. Benedict scenes and the Serego frescoes was a Bohemian painter by the name of Wenceslaus, who followed his master Stefano to Italy when the latter returned to Verona from his supposed journey to Vienna in 1404. This painter, who was also credited with the cycle of the *Months* at Torre Aquila in Trento, was apparently the same as the Master Wenceslaus responsible for the frescoes, signed and dated in 1415, in the cemetery chapel at Riffiano in the Merano district.[45] This was a far-fetched and somewhat contrived attempt to explain the convergence of various cultural trends in the Veronese world of painting during the first decade of the Quattrocento, by assigning everything to a single artist. In any case it was a conjecture built upon the unsound basis of a group of works which were similar in some aspects, but basically heterogeneous. This was immediately noticed by Rasmo[46] and by Degenhart,[47] who arrived by different routes at the same conclusions regarding some of the problems relating to the various works gathered under the name of the pseudo-Bohemian Master Wenceslaus, but gave however completely contrasting verdicts on the St. Benedict scenes. Degenhart confirmed his attribution of these to Pisanello while Rasmo—though he did not exclude the possibility suggested by Degenhart of identifying the author of the scenes with the painter responsible for the frescoes of the *Legend of S. Eligio*[48] in the nave of the church of S. Caterina at Treviso—denied that the hand of Pisanello could be seen in all of these works.[49] The fresco depicting the *Legend of S. Eligio* (Fig. 27) had first been ascribed to Pisanello by Coletti who, on re-examining the question of the artist's early activity, also accepted Degenhart's attribution to the young Antonio of the *St. Benedict the Hermit* in the Poldi Pezzoli Museum.[50] However, shortly afterwards he assigned the other three panels in the Uffizi to a painter who had decorated the Cappella degli Innocenti in the church of S. Caterina at Treviso, and whom he therefore called the 'Maestro degli Innocenti'.[51] Coletti then returned to the argument, inclining to Degenhart's point of view. He accounted for the affinity which he noted between the Uffizi panels and the frescoes in the Cappella degli Innocenti with the hypothesis that Pisanello and the Maestro degli Innocenti had collaborated in the St. Benedict polyptych.[52] Rasmo however took up a more radical stand. In an article on the portrait of the Emperor Sigismund in the Kunsthistorisches Museum in Vienna, which Degenhart had attributed to Pisanello,[53] he reinforced the negative judgement he had already expressed on the *Scenes from the Life of St. Benedict*.[54] He maintained that they were works of modest quality which could be ascribed to the author of the Treviso frescoes—Coletti's 'Maestro degli Innocenti'—whose characteristics as an Austro-Bohemian painter could be seen in the crudely drawn features and in the 'mediocre architecture, the result of taking on themes which were extraneous to his own background'.[55] Coletti resumed the argument after the Verona Exhibition of 1958, finally abandoning all his reservations on the much discussed *Scenes from the Life of St. Benedict*. He accepted *toto corde* Pisanello's authorship and enthusiastically acknowledged their very great quality and their subtle poetic accent in the interpretation of a reality reproduced 'in a climate of affectionate cordiality, of simplicity and of virginal freshness, of touching intimacy, so that every nuance of expression is disclosed'.[56] And yet how secret the world of these Scenes really is, in their apparent guilelessness, rich in shrewd psychological details and sometimes with a subtle humour. Coletti found inexplicable, for instance, some of the contrasts lurking

in the harmonious simplicity of the composition, such as St. Benedict's rather exaggerated gestures, and above all he was puzzled by the arbitrary nature of some of the architectural structures. Rasmo was puzzled by the architecture too, though for different reasons.[57]

But, as we know from the description left to us by Facio of the lost *Scenes from the Life of Federico Barbarossa*, which were once in the Doge's Palace in Venice,[58] the marked individuality of facial features and the use of emphatic gestures was the distinguishing characteristic of the works which Pisanello executed during those years. It points to the contact he had with the 'sharply Grotesque' style of Zanino di Pietro and his Rhenish-Bohemian culture,[59] and suggests that Pisanello's early education, already influenced by central and northern Italian art and by Gentile's work, must have been extended in an international direction. One has only to think of the strikingly realistic accents of the Crucifixion triptych in the Rieti Museum, which Zanino di Pietro executed in the early years of the century, whose figures on the reverse of the side doors (Fig. 88) show notable similarities with those in the St. Benedict scenes, or the face of St. Benedict, which resembles the strongly accentuated face of Christ bearing the Cross in one of the tapestries in St. Mark's Museum, which according to Longhi were executed from cartoons by Zanino di Pietro.[60] With regard to the supposed arbitrary nature of the architecture, it is true that the morphological elements which have been borrowed from Venetian architecture are not put together in any logical structure, and that the way in which they are arranged, while intended to be illusory, is in fact unrealistic. However, it is their very fairy-tale unreality, which seems moreover to recall something of the harmonious simplicity of luminous planes which make up the architectural structure of fourteenth-century Sienese painting, which gives the interiors a magic atmosphere, suspended and immobile, a tone which is half-fabulous, half-exotic, and which gives these Scenes their particular fascination. It is quite possible that Pisanello saw the *Scenes from the Life of St. Benedict* frescoed by Spinello Aretino in the church of San Miniato al Monte, and that he retained in his memory the melodious, rhythmic clarity of the compositions and some of the details of faces and figures, as for example the profile of St. Benedict, the monastic table in the *Miracle of the Poisoned Glass* (Fig. 85), and other details. In the Scene of *St. Benedict Exorcizing a Monk* (Fig. 84), the interior space of the small chapel, reduced to the measure of the figures, is reminiscent of Tuscan compositions, and perhaps dates back to the time when the artist saw in Pisa the Gothic shrines of some of the *Scenes from the Life of S. Ranieri* such as the *Temptation of the Saint* and the *Saint Putting on the Hermit's Habit*, which were painted in the Camposanto by Andrea Bonaiuti. But what is typically Pisanellian in this scene of the exorcism is the penetrating attention with which every detail is examined, the emphatic gestures and expressions which define the characters so clearly, and give to their simple and ritualistic gestures played out within the small area of the chapel, the tone of a softly-murmured liturgy. The gold of the Venetian altarpiece shines through the penumbra with the same intimacy which can be felt in the colours of the gentle interior in the Scene of *St. Benedict and the Miracle of the Broken Salver* (Fig. 83), where a delicate Gentilesque light filters through, almost Flemish in quality. These in my opinion are clearly Pisanellian accents; but even if there is still uncertainty about the three panels in the Uffizi, all doubts must be dispelled by the *St. Benedict the Hermit* castigating him-

self with thorns (Fig. 86), in the Poldi Pezzoli Museum, which belongs to the same series and whose authorship appears to be much more obvious. The Pisanellian nature of this work lies not only in the pictorial richness but also in the graphic structure of the image and in the very individualistic way in which the artist arranges the various parts of the scene. The profane nude of St. Benedict has a classically proportioned harmony in keeping with that taste which must have been fostered by the classical studies made by Gentile and Pisanello,[61] probably even before the journey of the two artists to Rome. But one can sense Pisanello's observant spirit in the lucid way in which the model has been drawn from life; and furthermore the clear-cut lines of the beautiful limbs are obviously related to the vigorous drawings of nudes which were done not much later and which are now in Rotterdam and Vienna (Figs. 105, 106). Such a worldly representation of the saint, not so much punished by the sharp thorns which are the central theme of this story of penitence, as adorned with elegant fronds which are traced against the flesh like a delicate floral embroidery, fits well into the refined and restless world of this artist. The figure of the young nude who is listening intently to the words of the angel, but who feels equally attracted by the prompting of the sinister demoniac raven, is like a symbolic image, poised between good and evil, of the uneasiness of existence; it seems to me that this is one of the images which reveal the most hidden meaning of Pisanello's art.

Whatever the verdict regarding the *Scenes from the Life of St. Benedict*, they are without a doubt connected with those frescoes in Treviso attributed to Gentile da Fabriano, to Pisanello and to other painters influenced by them.[62] These frescoes constitute the most direct demonstration of the effect which the intervention of Gentile and Pisanello in the Sala Nuova of the Doge's Palace had on Venetian mural painting. The great room in this most important Venetian palace was decorated with a series of mural paintings executed and partially renewed between the second half of the fourteenth century and the first decades of the fifteenth. The series began with the fresco depicting the *Coronation of the Virgin*, painted by Guariento between 1365 and 1368 on the wall above the dais where the Doge's throne stood. On the other three walls were represented the story of Alexander III and Federico Barbarossa, composed it seems of thirty-six episodes, but these were probably fitted into a smaller number of scenes, the inscriptions to which were described by Sanuto in 1425 and published by Lorenzi.[63] This cycle illustrating the long struggle between the Pope and the Emperor was of such fundamental and symbolic significance to the Venetians that its theme, already used between the thirteenth and the fourteenth century in other rooms in the same palace, was used again for the decoration of the Sala Nuova and preserved for over two more centuries. Finally the subject was treated by the great Venetian artists of the fifteenth and sixteenth centuries but these paintings were lost in the fire of 1577. The fire also destroyed Guariento's *Coronation of the Virgin* and the mural cycle of Alexander and Barbarossa which was initially carried out by late Gothic painters in the second half of the Trecento. It may be that this whole series of frescoes had already been completed in 1382, since it was in that year that the Procurators of St. Mark were entrusted with the task of arranging for the maintenance of the room 'ne tam solennissimum opus devastetur in picturis vel aliis rebus'.[64]

Documents relating to the work carried out between the first and second decade of the fifteenth century by Gentile da Fabriano and Pisanello in the Sala Nuova suggest that it consisted of more than just the two scenes described by Facio. According to the latter, Gentile painted the Naval Battle in which Ottone, son of Federico Barbarossa, was taken prisoner by the Venetians,[65] and Pisanello executed the story depicting a suppliant Ottone begging his father to negotiate peace with Venice.[66] It seems however that the task of the two artists was a much wider one and that it was connected with the measures taken by the Maggior Consiglio between 1409 and 1411 for the repair and partial repainting of the pictorial cycle which had been seriously damaged by damp and salt-petre.[67] The loss of this vast mural decoration, which covered most of the three walls of the imposing hall where the Grand Council met, has deprived us of many precious examples of Venetian late Gothic mural painting. The loss of the frescoes by Gentile da Fabriano and by Pisanello is particularly serious for the history of the artistic developments which took place in the Veneto during the first two decades of the fifteenth century, and it also leaves us in the dark about the relationship between the two artists and the degree of collaboration, which must have dated back to the first decade of the century. The bond was one of friendship even more than one of work, and lasted for twenty years, until Gentile died in 1427 in Rome, bequeathing to Pisanello the tools of his workshop and the task of completing the interrupted *Scenes from the Life of St. John the Baptist* in the basilica of St. John Lateran.

Another far from resolved problem concerns the years in which the frescoes were painted. Opinions vary quite widely: between 1409 and 1419 for Gentile and between 1409 and 1427 for Pisanello.[68] It is however certain that Gentile spent several years in Venice, and probably so did Pisanello: the task they were engaged in was therefore long and complex. The huge work of restoration which was started in 1409 in the Sala Nuova of the Doge's Palace had in fact been undertaken, according to the documents, 'pro faciendo reparare et aptari picturas Sale Nove'; thus the part played by Gentile and Pisanello must have included not only the two Scenes mentioned, which were probably in replacement of earlier ones of the same subject which had been destroyed following the damage suffered by the wall paintings in the room, but also the complete restoration, or rather reconstitution of the many parts which had been lost of the whole pictorial cycle of Alexander and Barbarossa. As for the two Scenes painted by Gentile and by Pisanello, I believe that the documents I have quoted contain information which can be used to establish with sufficient accuracy their period of execution. If we take it that the start of the work in the Sala Nuova coincides with the allocation of funds in 1409, then the decision of 1411 which authorized further expenditure in order to complete the works, must mean that there was still a great deal to be done but that work was proceeding at a fast pace. We know moreover from those documents that in September 1415 it was decided to construct a new marble staircase, to replace the previous one, so that a more worthy access to the Sala Nuova should be created, since 'omnes dominj ac notabiles persone proficiscentes ad terram nostram desiderant illam summe videre propter ipsius maxime pulcritudinis famam'.[69]

It would seem then that the works begun in 1409 for the restoration of the damaged pictorial cycle in the Sala Nuova were completed in 1415. Keen curiosity to see this

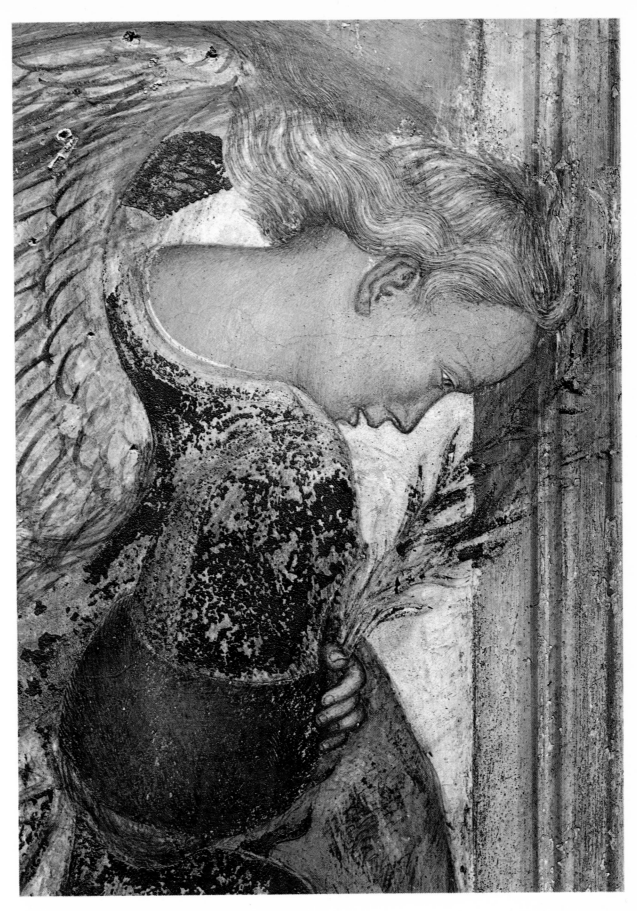

XIV. Brenzoni Monument: Angel of the Annunciation, detail. Verona, Church of S. Fermo Maggiore.

room was expressed by Venetian noblemen and by those who were friendly with Venice including, among the most important of these, Gianfrancesco Gonzaga,[70] following the news of the magnificent, renovated appearance of the room and the beauty of the works carried out there by Gentile and Pisanello.[71] In 1414 Gentile da Fabriano was engaged in painting a chapel for Pandolfo Malatesta at Brescia, where the painter stayed until he left northern Italy for good in 1419 when he went to Rome at the invitation of Pope Martin V.[72] Thus by this date he must have completed his work in the Doge's Palace; otherwise he could hardly have wanted or been able to leave Venice in 1414 and nor would it have been easy for him to obtain a safeconduct for Brescia. There does not seem to be any valid reason for assuming that he returned from time to time to Venice between 1414 and 1419 to finish work he had left interrupted; or vice versa, that he made frequent journeys to Brescia from Venice, where he presumably continued to work up to 1419.[73] This idea was obviously put forward with the intention of justifying the theory that Pisanello received his first youthful training in Verona, as an apprentice to Stefano da Verona, after which he followed Gentile to Venice as his assistant, or else succeeded him in the work in the Sala Nuova after Gentile's departure from Venice. Assuming he was born in around 1395, this would leave enough time for the young artist to be in a position to receive the commission for the Scene described by Facio, which he executed on his own no later than 1422.

But this chronology is not convincing enough to explain the development of the work in the Doge's Palace in Venice. First of all, as far as one can gather from the existing documents, the restoration of the decorations in the Sala Nuova, in which, as was noted in 1409, 'multum destruitur in picturis',[74] was a very complex task but it must have continued without interruption from 1409 to about 1414. And it was precisely because of the complex nature of this work that Gentile and Pisanello must have collaborated in its execution, though not of course in the two Scenes already mentioned. Naturally it was the older artist, Gentile da Fabriano, who directed the work; but Pisanello's exceptional gifts of characterization—clearly indicated by Facio—which led Gentile to choose him as his collaborator in this undertaking, were very well suited to the restoration of the missing or damaged parts of the various figures and images of the great cycle. At most it could be supposed that Pisanello executed his Scene after Gentile's departure in 1414; but it is likely that the work was already completed when the noblemen and officials asked to visit the room, which had immediately become famous for its beauty.

If Pisanello carried out these works in Venice as late as 1419 to *circa* 1422, then this would imply, as we have seen, that the young artist had earlier been trained at Verona under Stefano. Though in the period in which he painted the *Madonna of the Quail*, in about 1420, it might seem that this indeed is what his early training had been, it is not at all the case in the *Scenes from the Life of St. Benedict* or in the Treviso fresco of the *Legend of S. Eligio*, which reflect his earlier Venetian activity. If Pisanello had indeed learned the art of painting at Verona under the guidance of Stefano, he could not have completely ignored the great Veronese master, as he did in these works. Bettini, firm believer in the theory of his initial training under Stefano, therefore rejects the attribution to Pisanello of the St. Benedict scenes and of the *Legend of S. Eligio*. While recognizing a certain consonance between some of the facial features and those painted

by the young Pisanello, Bettini sees a hardness of line and a dense, rigid plasticity which, if true, would repudiate his earlier experience gained from Stefano's lesson in lyricism of line.[76] This is a subtle observation but in my opinion it means only that this experience of Stefano's linear style came after and not before the works of Pisanello's Venetian period. In fact, there is certainly no Stefanesque accent in the first works attributed to Pisanello which were executed at the time of the Venice decoration, while one can perceive a very strong influence from Gentile. It is also true that there is something about their Venetianism which, though one could not in any way define it as foreign, and quite apart from Bohemian and Rhenish influences, is certainly not local. But these formal characteristics of Pisanello's juvenile works seem to reveal his origins, his primitive naturalism, his pure use of plastic forms which still bore traces of Tuscan influence gained early in his life, in addition to those of his initial artistic training under Gentile. And the delicate quality of the St. Benedict scenes suggests that the apparently incoherent aspects of the work are not the defects of a mature and mediocre painter, but rather the marvellous disproportions to be found in the youthful work of a great artist during his formative period.

The *Scenes from the Life of St. Benedict* and the frescoes by Pisanello and Gentile in Treviso offer some idea of the pictorial culture which these two artists had in common during the period of their Venetian activity. This culture appears to be composed of initial experiences of central Italian art which took on a certain refinement when combined with the rich, formal elegance and the naturalistic sensitivity of the *ouvraige de Lombardie* and of its major representatives, Giovannino de' Grassi and Michelino da Besozzo. It was also enriched by new trends from abroad through contacts with International painters, including Niccolò di Pietro and Zanino di Pietro; and these contacts must have already been taking place before the Venetian period of Gentile and Pisanello. It is possible that Gentile and Pisanello knew these two painters, as well as other Venetian and Lombard artists, in the early years of the century when Niccolò painted a panel at Verona and Zanino did the triptych now in the Rieti Museum. This work revealed the influence of an International culture which also attracted the interest of Gentile and Pisanello, and suggests that the question of Pisanello's early training is linked with the equally mysterious one of the artistic origins of Gentile da Fabriano and of where he was working before 1408.

Gentile's affinities with Taddeo di Bartolo and with other Sienese artists, noted by Lanzi and by Cavalcaselle, were again referred to by Longhi when in 1941 he suggested that the Sienese influences came through the Orvietan element in Gentile's complex central and northern background. More recently Longhi distinguished in Orvietan painting of the second half of the Trecento a certain foretaste of the art of Gentile and even of the methods later developed by the great Lombard illuminators.[78] The repercussions of this central Italian culture seem to be present in the plastic fullness of the soft forms and in the rational and balanced structure of the composition of the *Madonna and Child between Saints Nicholas and Catherine* in the Berlin Museum, which is the oldest of Gentile's known works and the most Lombard in style. It can therefore be assumed that Gentile gained this experience even before his first contacts with Lombardy. In the Valle Romita polyptych, painted at the beginning of the Quattrocento and now

in the Brera Gallery, Gentile's style, deriving from his central-northern background and clearly displaying Sienese and Emilian elements,[79] reaches full maturity, several years before the period of his Venetian activity which, as Magagnato noted,[80] was firmly based on that background; and this has a bearing on Pisanello's art as well. But these two particularly indicative works were painted at Fabriano, so it is difficult to say whether the Lombard tendency of this earlier activity of Gentile's was indeed the result of a journey he made to Lombardy before the beginning of the century.[81] It may have been a result of the spread of the *ouvraige de Lombardie* in central Italy and of the diffusion of Lombard culture during the last years of the fourteenth and early years of the fifteenth century into a number of areas and cities of central Italy, such as Pisa, Siena and Perugia, which were conquered by Gian Galeazzo Visconti.

It is possible that it was in this early but already fully mature period of Gentile's activity that Pisanello met the older artist and became his pupil for a few years around the beginning of the fifteenth century. But the initial master-disciple relationship must have very soon been transformed into one of free collaboration and friendship, giving rise to their fruitful sharing of experience which lasted until Gentile's death. In spite of the substantial difference between the two artists, a community of ideals and of artistic culture was established between them, as between travelling companions, which seems to indicate that their association began in central Italy, before they worked together in the Doge's Palace. It would be difficult to explain the feeling of plasticity, the organic, modelled compactness which the images assume in the first of their works known to us, compared with the fluid mobility and naturalistic accents displayed by the painting of northern Italy, unless there had been contact between them at an early stage. Vasari seems to be partially aware of this contact when he mentions that Pisanello had been trained in Florence. Even if Vasari's assertion that Pisanello's master was Andrea del Castagno is completely unfounded, it is however significant that this historian from Arezzo should have felt the need to explain the realism of Pisanello's style as being the result of the artist's education under a great Tuscan master. Yet it would have been more logical if he had shown Pisanello to be a pupil of Gentile da Fabriano, given the obvious formal resemblance of their works; a resemblance which Vasari, so observant of manner and stylistic similarities between artists, had clearly grasped in the works of another great pupil of Gentile, Jacopo Bellini.[82] In fact, by grouping together the lives of Gentile da Fabriano and of Vittore Pisanello from Verona,[83] Vasari did show that he had sensed the inner cultural relationship which placed the two artists side by side in a particular stylistic current. Gentile, whose 'hand was like his name',[83] represented the sensitivity and aristocratic fineness of this current and Pisanello was the spearhead of the most advanced International and Tuscan ideas of the early Quattrocento.

Gentile da Fabriano must certainly have known Pisanello well for some time and have appreciated his gifts and skills if they worked together in Venice between the first and second decade of the fifteenth century on the complex work of restoration and partial *rifacimento* of the damaged scenes of Alexander and Barbarossa. The members of the Maggior Consiglio presumably had a high regard for Pisanello as well as for the fa-

mous painter from Fabriano, if they granted him the privilege of executing *ex novo* an entire story in that mural cycle, which was so important to the Venetians. Yet there was no lack of excellent painters in Venice; and working not far away, at Verona, was Stefano, one of the greatest Venetian masters of the International Gothic style, while in 1410 there was also an outstanding Lombard painter in Venice, Michelino da Besozzo, celebrated as 'pictor excellentissimus inter omnes pictores mundi' by that seeker of new artists and new painting techniques, the Gallicized Milanese Giovanni Alcherio.

If Pisanello enjoyed such esteem at that time as to be placed on a level with the greatest and most famous painters of the north, he must certainly have been an artist who was already trained and well known, even if the work he was doing in Venice was in collaboration with Gentile, as was probably the case with other work in Florence and certainly in Rome. However, even when he was following the forms and poetic style of Gentile during the Venetian period, Pisanello's independent personality makes itself clearly felt in the lucid way in which his penetrating eye examines and defines his figures with a firm and precise line, which almost tends to over-accentuate their characteristics. This is what distinguishes him from Gentile, even though he borrows from the latter some of his technical, graphic and pictorial procedures, and often uses the same iconography for heads and figures, which were probably modelled on examples contained in a repertory which the painters both used for their work. Pisanello's skill, referred to by Facio, in creating such expressive figures by a combination of strongly accentuated gestures and facial features, is found in the St. Benedict scenes, in the *S. Eligio* fresco at Treviso and also in some of Pisanello's large drawings of heads, done on red paper, which were probably models for mural decorations. It may be that some of these drawings were connected with the works which Gentile and Pisanello did in the Sala Nuova in Venice.

These drawings constitute one of the many question marks surrounding the activity of the artist and his workshop for, apart from the fact that a very small number of them show some iconographical resemblance to other known works by Pisanello, there is still no satisfactory explanation as to what purpose they served. Moreover, their graphic structure has greatly bewildered the critics and has led them to widely differing conclusions. According to those who deny that Pisanello himself was responsible for the drawings,[85] they are done with an academic, mechanical line and, according to Miss Fossi Todorow—the latest and most convinced exponent of this theory—the style suggests that 'this series of drawings on red paper is a collection executed within Pisanello's workshop as a notebook for reference purposes'.[86] Other scholars are less rigid in their opinion, believing that the drawings were originally done by Pisanello in charcoal or in sanguine, but later gone over again with a pen, or else copied, by the artist's pupils. One supporter of the theory that the drawings were entirely the work of Pisanello is Degenhart, who places them in the Neapolitan period[87] and accepts the theory advanced by Burger and by Planiscig, that they may relate to the Triumphal Arch of Castelnuovo in Naples and to its bronze door;[88] another is Keller who accepts Degenhart's attribution to Pisanello and explains the special form of the drawings by suggesting that they were intended for use by the stonemasons working on the sculptures of this triumphal arch.[89] Sindona too accepts many of the drawings as original, but thinks that they were

done at different times, while others he believes to be the work of a heavier hand.[90] Coletti considers the drawings very uneven in quality but he links two of them, both representing the head of a bearded man, with the Treviso fresco which he attributes to the young Pisanello.[91]

One might also accept the opinion that some of these drawings were the work of several hands or were retraced more than once. However, to deny Pisanello's authorship of any of the drawings is to fail to understand their significance, since there is a danger of forgetting altogether their principal function, which I maintain was that of serving as models for certain particularly important works, such as the great mural cycles painted by Pisanello. Moreover, any study which focuses exclusively on the formal aspects of the drawings inevitably overlooks the extraordinarily vigorous characterization and the individuality of the faces, which can only have been achieved by a great master with exceptional powers of invention and observation, as Pisanello was, and not by the assistants in his workshop. Degenhart has fully understood the importance of this series even though, in my opinion, his judgement is encumbered by the theory that the drawings were all connected with the Castelnuovo arch in Naples.

Degenhart has analysed the graphic structure of these drawings more closely than anyone else, and he has been able to define the procedure followed. The first stage was a charcoal drawing from life; this was then finished with a network of minute but strong lines done in pen, which shows the artist's deep interest in 'penetrating the human face' whose individual features he often accentuated in order to achieve a vivid representation of the personality of his model.[92] My opinion is that some of these models, which I shall return to later, should be seen in relation to the decoration in the Gonzaga palace; and this does not conflict with Degenhart's attribution of them to Pisanello's Neapolitan period, which is closely linked with his last work at Mantua. But there are others among these models which, for iconographic and stylistic reasons, seem to belong to Pisanello's most Gentilesque period, at the beginning of his activity, and therefore they could be seen as reflecting the work of the two artists in the Sala Nuova of the Doge's Palace. The strongly expressive and gesticulatory figures in which the artist has accentuated the irregular plasticity and the facial features so as to disclose every psychological reflex is, I believe, an aspect of Pisanello's youthful works and not of his advanced maturity. In his later works the artist no longer seeks to convey feelings in narrative form, but to capture their lasting essence. There is the mysterious sense that one is seeing the interior image of his subjects whose faces display their absorption in secret, disquieting thoughts. Consequently I find significant the comparison which Coletti makes between the beautiful drawing in the Louvre, No. 2621, representing the head of a bearded, curly-haired man, and the juvenile fresco by Pisanello at Treviso of the *Life of S. Eligio* (Figs. 81, 93). Coletti notes the Gentilesque derivation of the drawing and of the fresco, comparing it to the St. Dominic in the Valle Romita polyptych now in the Brera Gallery (and the derivation is even more obvious, as Degenhart states,[93] when we look at the figure of Christ in the *Coronation* of that polyptych); moreover he points out that the drawing seems to follow the same pattern as the head of the kneeling king in the *Adoration of the Magi*, which Gentile painted in Florence in 1423 for Palla Strozzi, and the head of the ermine-clad knight in the *St. George and the Princess*, painted by Pisanello between 1433 and 1438

136

in the Verona church of S. Anastasia. According to Coletti, the careful, meticulous drawing of the man's head was a preparatory drawing for the Treviso fresco, which was then used for the Verona fresco as well; or else it was drawn from the Treviso fresco and then used as a preparatory drawing for that in Verona. The relationship of these works to those of Gentile confirms the close bonds already existing between the two artists in Pisanello's juvenile period; but even here the accentuated features of Pisanello's figures and their penetrating gaze reveal the difference in 'vital tone' which clearly distinguishes his artistic temperament from that of Gentile.[94]

The drawing in the Louvre also has features which are similar to others in this series of heads on red paper. As I have already said, I believe these heads served as models for the faces portrayed in Pisanello's great mural decorations rather than for the sculptures of the Castelnuovo arch, whose iconography does not seem to bear any precise resemblance to the drawings. The only evidence of the Gothic prehistory of Alfonso of Aragon's triumphal arch at Naples is to be found in the drawing for the first plan for the monument, now in the Boymans Museum in Rotterdam, bearing the inscription 'Bononu de Ravena', which is very probably apocryphal.[95] It is however likely that this plan, as Degenhart noted,[96] refers to some idea of Pisanello's. This is suggested by the architectural composition which is of an elegant late Gothic style (though with some classical tendencies), and in the overall Pisanellian graphic quality of the drawing. However, the Castelnuovo arch was eventually constructed in a very different manner from that envisaged in this drawing,[97] and the sculptures which were realized later bear no resemblance to the series of heads. As Degenhart pointed out, these large drawings on red paper were made as preparatory studies and were 'all done for a definite commission'.[98] Certainly Pisanello, with the help of his workshop, would not have produced such a large and varied series of heads, studied in every minute detail, unless they were for use in executing important details in the work he had on hand. The drawings are not sketches jotted down in order to capture sudden ideas for compositions, nor records of things seen, nor observations taken from works of other artists. They are true studies in which the patient retracing in pen of the initial pencil line was an operation indispensable to the procedure followed in the workshop. Their purpose was to assist in the exact realization of the rich and varied iconography needed for projects as complex as Pisanello's mural cycles. They indicated the precise structure of the extremely well defined aspect which was to be given to all the details of the fresco, the way in which they were to be modelled, the shading, the individual characteristics of the faces; even the movement of the minute brush strokes in the pictorial fabric was already studied in the pen strokes of the graphic models. These studies make it easier to understand the fundamental importance in Pisanello's art of drawing as the structure which bears the image; and this confirms that his basic education in drawing was the one I have repeatedly referred to.[99]

This, I maintain, was the procedure invariably followed by Pisanello and his workshop in carrying out the various mural decorations, for which the artist and his pupils prepared the necessary models during the course of the work. Although a number of the large drawings of heads seem intended for the Mantuan decoration (the fact that some of these heads were executed on the back of Neapolitan drawings does not mean that they were not for the cycle—left interrupted when Pisanello went to Naples—for

he certainly planned to complete the decoration as soon as possible); others are so close-ly connected with the works executed by Gentile da Fabriano and by Pisanello in the first decades of the century, that they do appear to belong to that period. It is not possible to pick out any of the Venetian and Lombard stylistic influences which from the end of the second decade onwards were to considerably alter Pisanello's manner, which then assumed a flowing and harmonious linearity, absent from these graphic models. Their realistic, plastic structure might be explained by the early experience of central Italian art shared by both artists. Perhaps even more significant is the fact that the iconography of the drawings often reflects Venetian painting of the second half of the fourteenth cen-tury: this could mean that they were intended for the *rifacimento* of the damaged parts of the stories of Alexander and Barbarossa. The physical types represented in the draw-ings, the fashion of their clothes, their hats and hoods, their hairstyles, ornaments and various other elements portrayed, are in fact the same as those found in works of painters active in the Veneto and elsewhere during the last decades of the Trecento. It is there-fore understandable why some of the figures portrayed have also been considered to be copies from works by Altichiero. An Altichierian element is also to be seen in the iconography of the two drawings in the British Museum (Sloane Coll., 5226–57) repre-senting a person kneeling in front of an emperor on a throne, and a conflict between armed men (Figs. 90, 91). These drawings have been linked in various ways with the lost frescoes of the Doge's Palace.[99] Guariento was certainly among the Gothic painters who executed the pictorial cycle of Alexander and Barbarossa: he also painted the *Coronation of the Virgin* in the Sala Nuova and the *War of Spoleto*.[100] Vasari moreover states that An-tonio Veneziano, after having learned his art in Florence as pupil of Agnolo Gaddi, re-turned to Venice where 'as he had made himself known with many works done in fresco and in tempera, the Signoria commissioned him to paint one of the walls of the Sala del Consiglio, which he carried out so excellently and with such majesty that, as he deserved, he should have been awarded a prize for it; but the emulation or rather envy of other craftsmen, and the favour which certain gentlemen showed towards foreign painters, was the reason why the affair went differently. And so poor Antonio, finding himself beaten and dejected, decided that the best thing was to return to Florence, with the intention of never again returning to Venice, completely convinced that Florence was his home.'[101]

The part which Vasari claims was played in the pictorial decoration of the Sala Nuo-va by Veneziano, who was probably a fellow-student rather than a pupil of Agnolo Gad-di,[102] was not rejected by Toesca, and recently the same theory has been presented by Pignatti.[103] The suggestions which I have made accord with this view. However, unlike Pignatti who believes that only part of the Alexander and Barbarossa cycle had been executed before Gentile da Fabriano and Pisanello painted the scenes in the Sala Nuova described by Facio,[104] I consider that the entire pictorial decoration of the room had al-ready been completed by then and that in 1409 the two painters were given the important and difficult task of repairing the whole of the pictorial cycle for, as the documents already quoted relate, a large part of the decoration was in a very bad condition.[105]

There seems to me, however, to be no valid reason for supposing that Pisanello was able to execute three scenes of that cycle.[106] Facio, a close friend of the painter, would

not have failed to describe the other scenes as well as the one concerning Ottone, if indeed Pisanello had painted them. But the task of renovating the damaged parts of the vast decoration of this room was in itself a very demanding one, in view of the quantity and variety of details which had been destroyed. Of paramount importance, naturally, was the *rifacimento* of the faces and expressions of the characters, and Pisanello's skill at representing these vividly and with such strong characterization was admired by everyone and was particularly remarked upon by Facio. This was the aspect which distinguished Pisanello most strikingly from Gentile—for his actual painting technique was not dissimilar—and his collaboration was particularly useful in the partial *rifacimento* of the lost facial details from the scenes which had been painted in the Sala Nuova by so many different late Gothic artists. Their varied iconography would have required the great powers of observation and the versatility which are displayed so well in the drawings of heads on red paper. The descriptions given by Facio and by Sansovino, and the references contained in various documents, are proof of the great admiration aroused in the Venetians by the renovation of the Sala Nuova. In 1409 the room had still been in disrepair but by 1415 it was already famous for the beauty conferred on it by the works of Gentile and Pisanello.[107]

The pictorial work in the Sala del Maggior Consiglio had perhaps already been completed when Gentile left for Brescia in 1414, called there by Pandolfo Malatesta to carry out the mural decoration, since lost, of a chapel in the old 'Broletto' (court of justice). It may well be that at the same time Pisanello too had finished his task in the Sala Nuova, since he must have worked on it very closely with Gentile. On the other hand one is tempted to believe that in 1415 he was still in Venice and that it was here that he met for the first time Gianfrancesco Gonzaga, who in April of that year took part in a large chivalric tournament held in Piazza San Marco, in which he jousted against the Marchese di Ferrara.[108] It is likely that Gianfrancesco, having seen and admired the work that Pisanello and Gentile had done in the Sala Nuova, decided either to take with him, or to invite to Mantua, the young artist who a few years later was to become his court painter. At any rate it is significant that the first documented date which refers to Pisanello is that which shows him as an inhabitant of Mantua in 1422;[109] and it would not be at all surprising if he had gone to the court of Gianfrancesco immediately after his success in Venice.

At this point it is interesting to note the unusual iconography of one of the St. Benedict scenes, that of the *Miracle of the Poisoned Glass* (Fig. 85), which departs from the traditional illustration in which it is the monks themselves who, in order to rid themselves of the inconvenient presence of this abbot, offer him the glass containing the poison. St. Benedict blesses the glass with a sign of the cross and it falls to the ground, smashed. This is the scene which Spinello Aretino represented in the *Scenes from the Life of St. Benedict* in San Miniato al Monte.[110] In the scene attributed to Pisanello an elegant young man, his head adorned with leaves in French style, is holding the poisoned glass in his hand and examining it suspiciously, while at his side St. Benedict, guessing the plan to poison him, is grimacing in indignation. To the left of the saint a young monk, unaware of what is going on, is deep in prayer, but the other monk, probably the one responsible for the plot, watches the glass in suspense, and with an imperceptible gesture of irritation

reveals his reaction to the failure of his scheme. A subtle range of psychological expressions holds the story together in a network of emotions, which only an artist of genius could capture. What is particularly important here is that the young man holding the glass so mistrustfully, seems to represent the patron, for the elegant clothes he is wearing—made from a bright cloth which recalls that of the garments worn by some of the noblemen depicted by the Salimbeni in the frescoes they painted at Urbino in 1416—are of red, white and green in a pattern which is clearly of heraldic significance, indicating the colours of the Gonzagas. The comparison with the emblematic dwarf warrior, wearing a tunic of the same colours, in the Battle scene which Pisanello painted in Mantua (Plate XI), needs no further comment. The conclusion to be drawn is that the polyptych—which included other panels, since lost—of the four *Scenes from the Life of St. Benedict* ascribed to Pisanello, was probably commissioned by the Gonzagas, perhaps shortly after the artist's departure from Venice, and in a period which one can assume to have been between 1415 and 1420.[111]

Towards the beginning of the third decade of the century Pisanello discovered the art of Stefano. Of course, this does not mean that up to then he had not known about the Veronese painter's activity. Nevertheless it was at this time that he established more intense contacts not only with the Verona environment but also with the Venetian and Lombard artistic culture which provided him with many elements which were to influence the further development of his style. If, as I believe, Pisanello was not a pupil of Stefano da Verona before going to Venice, neither would he have become his pupil on his return, when the fame of the works he had carried out with Gentile da Fabriano at the Doge's Palace would have been sufficient for him to be assured of esteem and fame wherever he went.

Pisanello's attitude to the artistic tradition of northern Italy was not very different from that of Gentile da Fabriano, who was not bound to any particular place or school, but was interested in all kinds of artistic experiences. These accumulated within him in a 'slow but perpetual process, as a vast quantity of figurative impressions were added layer upon layer, interacting and merging with one another and in some cases taken from contrasting sources'.[112] With equal curiosity Pisanello drew on the most modern sources of Venetian and Lombard art. His training could not have been limited to a predominantly Veronese cultural environment, even though Verona was at that time one of the most lively centres of international contacts. Moreover, even if Veronese late Gothic art was of a somewhat different nature from that typical of other historical centres in the Po Valley, it is nevertheless possible to distinguish the outlines of a civilization common to the Po Valley as a whole. This civilization was called Lombard in order to describe that sense, which undoubtedly existed, of unity of customs and taste, which overrode local factions. This feeling of cultural unity was also a motivating force behind the political and military actions of Cangrande della Scala and Mastino II who wanted to unite under the dominion of the Della Scala family the whole 'Lombard' region. It also lay behind the actions of Gian Galeazzo Visconti who, at the end of the fourteenth century, almost succeeded in accomplishing the same political plan. The belief that the people

of Verona belonged to what was broadly speaking a Lombard civilization, divided by political struggles but united in the ideals and customs of a common chivalric society, was widespread among all social classes. Dante referred to the hospitality of Cangrande della Scala as 'la cortesia del gran lombardo' and the poem composed for the death of the great head of the Della Scala family laments the loss of the 'fior di tutta Lombardia'.[113] And 'lombardo paese' continued to be the name given to the territory of which Verona was part, even when the city had passed into Venetian control. The sense of a single culture in the Po Valley was even more alive during that period in which political divisions by no means prevented artists and works of art from circulating freely between states.

It does not seem, then, that in such an open situation as this, we are bound to accept that Pisanello must, of historical necessity, have been a disciple of Stefano da Verona. There is no trace of Stefano's influence in his early works, while in those probably executed in the third decade of the century, before the decoration of the Brenzoni monument (1426), Stefano's influence is inseparable from that of the *ouvraige de Lombardie*. Certainly, after the Venetian years, the effect of new experiences is apparent in Pisanello's already very International style. There are clear indications of direct contact with Stefano, which probably first occurred at Verona, but may have continued at Mantua where Stefano is known to have painted many frescoes.[114] Pisanello immediately felt the linear musicality of Stefano's works. To his very observant eye, as International painter of Tuscan origin, this must have recalled the decadent graphic elegance of Parri Spinelli, and he would have noticed that this musicality was similar to the 'feeling of Attic pliability' of Ghiberti's first door and to the rhythmic tension of Lorenzo Monaco. At the same time he could not have failed to notice the Lombard elements of Stefano's style, recalling the refined naturalism of Giovannino de' Grassi and the imaginative, warm humanity of Michelino da Besozzo.

Because of the sharp attention which Pisanello paid to everything in the world of art which stimulated his interest, the notebook in which he collected a large quantity of studies together with drawings done by Gentile da Fabriano and other artists, has the vital quality of a diary. The fact that some of these graphic memoirs may sometimes be the work of another hand does not alter their importance for Pisanello's art. The studies reveal a steadily growing interest in Altichiero, the most significant effects of which were to become apparent in the large mural compositions of the artist's maturity; they also display a marked tendency during the artist's youth towards the style of Stefano da Verona and that of Michelino da Besozzo. Probably Pisanello knew Michelino da Besozzo when the Lombard painter was in Venice in 1410 with Giovanni Alcherio.[115] It must therefore be remembered that Pisanello's contacts with Stefano da Verona towards the end of the second decade of the century were preceded by a series of important artistic experiences. His activity at that time showed him to be an autonomous artist and indicated that this early phase of technical and stylistic research was intense and fruitful, terminating towards the middle of the third decade with the decoration of the Brenzoni monument.

Pisanello's style in about 1420 is sometimes considered so Stefanesque that it would seem that only then had he begun his activity, under the guidance of the Veronese master.

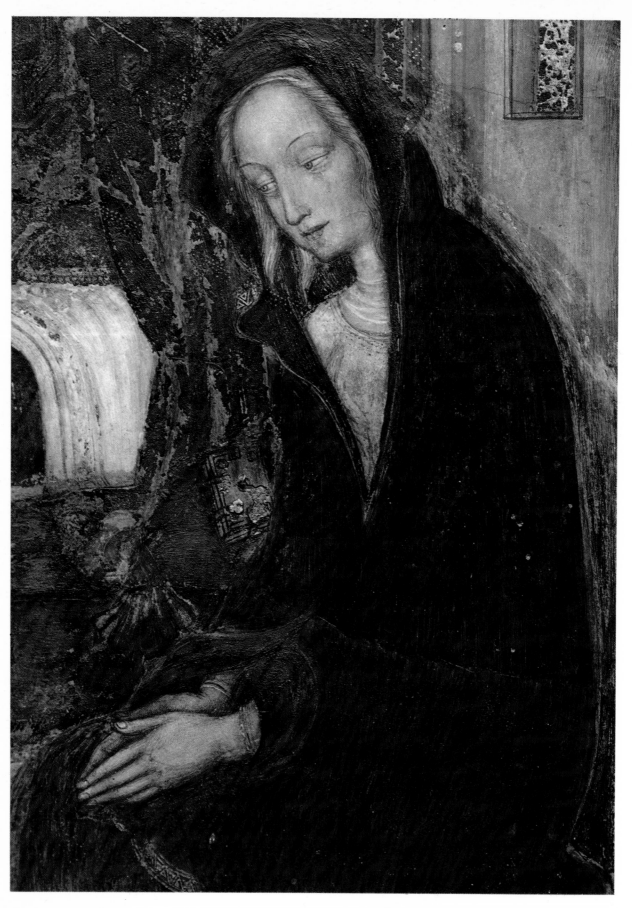

XV. *Brenzoni Monument: Virgin of the Annunciation, detail. Verona, Church of S. Fermo Maggiore.*

For certain historians this style is represented most clearly by two panel paintings, the *Madonna of the Quail* in the Verona Castelvecchio Museum (Figs. 94-7) and the *Madonna and Child Enthroned* in the Palazzo Venezia Museum in Rome (Fig. 98). These two works, however, are surrounded by controversy and both present different problems. In my opinion the formal characteristics of the painter in that period are more easily recognizable in the *Madonna of the Quail*. Its attribution to Pisanello is the subject of a certain amount of discussion, even though the majority of critics now favour his authorship.[116] The earlier attribution to Stefano has been definitely rejected. But, although the question is now regarded as no longer important by those who maintain that Pisanello was the author of both paintings, it is impossible to ignore the 'dominant Lombard affinity' of the two Madonnas. Longhi tried to explain this by seeing in their formal characteristics a correspondence with the works of the artist from Cremona, Cristoforo Moretti.[117] The attribution of the Madonnas to Moretti implied a basic analogy or even identity of style in the two works, which was also pointed out by those who later agreed that they were the work of Pisanello. Yet the two paintings, while they are both of outstanding quality, appear to be stylistically different, and not contemporary. Each time I have re-examined the *Madonna of the Quail* I have become more firmly convinced that it is by the hand of Pisanello. It also seems to me that this small masterpiece fits naturally into Pisanello's artistic career, for it links up with his first experiences under Gentile da Fabriano, which constitute the structural foundation of the work, and at the same time it anticipates that interior, inquisitive analysis of nature, which is typical of the works of Pisanello's full maturity. By now, however, those new, directly experienced impressions of the work of Michelino da Besozzo and of Stefano da Verona had been grafted on to the original Gentilesque stem, which already included a certain Lombard element. Those who believe that Pisanello's education was substantially Veronese, think that the component of his culture derived from Michelino was at this point absorbed by the Stefanesque element. Indeed the sharing of stylistic and technical elements and even of physical types portrayed, which can be observed in the most representative works of Michelino da Besozzo and Stefano da Verona—the *Marriage of St. Catherine* (Fig. 81) in the Pinacoteca at Siena and the *Madonna of the Rose Garden* in the Castelvecchio Museum (Fig. 82)—is so obvious that Coletti finally concluded that the 'spatial abstractness' of the *Marriage of St. Catherine* was the 'perfect equivalent of the spatial irrationality' of the *Madonna of the Rose Garden*, and this conviction led him to ascribe the latter work to Michelino. I do not share this opinion because the style of the two artists is very different, notwithstanding their obvious points of cultural contact which do not modify in any way the poetic individuality and the entirely distinctive feel of these two masterpieces. Coletti rightly pointed out that familiarity with the art of Michelino da Besozzo is noticeable in Pisanello's works of around the beginning of the third decade of the century. Nevertheless, Michelino's influence was never as strong as Stefano's. The historical importance and the very stature of this great artist from Verona, who had already suffered an attempt to demote him to a lesser position,[118] was compromised further when authorship of the *Madonna of the Rose Garden* was transferred from him to Michelino da Besozzo, and when it was denied not only that Pisanello had been a pupil of Stefano's before the Venetian period—which was unlikely anyway—but also that Stefano's work had any stylistic influence

on the younger artist at any later date.[119]

Pisanello must have been impressed by the skilful painting technique of Michelino da Besozzo, by his subtly expressed sentiments, his warm Lombard nature which is displayed in certain strongly realistic motives, all wrought in free-flowing, supple lines. He would have realized the usefulness of experimenting with the idiom of this painter to further his own researches into modes of artistic expression. Nevertheless, there can be no doubt that the broad, undulating rhythm of the *Madonna of the Quail* is derived from the style of Stefano, which for Pisanello, as I have mentioned, must have had Ghibertian echoes and perhaps reawakened in him the memory of the balanced rhythms of Andrea and Nino Pisano. The influence of Michelino however is noticeable in certain details, as for example the Lombard, elliptical shape of the haloes and the way in which their plastic form is attained by means of *pastiglia*.[120] Pisanello uses this technique to detach the almost statuesque group of the Madonna and Child from the gold background. The background itself gives a feeling of space vibrating with light softly reflected on the Gentilesque angels, the Madonna and the Child, the curved garden swarming with life. Michelino's influence is also seen in Pisanello's exaggerated handling of the physical structure of the central group: but Pisanello goes even further in representing the plumpness of the Child[121] who sits heavily across the Madonna's knee. She holds Him lovingly, with a maternal gesture superbly expressed by the long fingers tenderly spread out like a corolla around the body of the Child. This is a truly modern kind of expressive distortion, which perfectly renders the tender, intimate bond which unites Madonna and Child. The way in which the wide curve of the Madonna's cloak is wrapped around the central image—the plastic nucleus of the composition—to provide an element of synthesis to the whole composition, shows the originality of a great and already fully mature artist. The various ingredients of his cultural background have here been absorbed into the organic individuality of the whole work.

Opinion is still very divided on the *Madonna and Child Enthroned* in the Palazzo Venezia (Fig. 98). Some see this as a Veronese work and attribute it either to Stefano or to the young Pisanello;[122] others consider it to be a Lombard work. Each side lays stress on what they believe to be the prevalent stylistic elements. However, while it does not seem possible to place this Madonna among Pisanello's juvenile works alongside the *Madonna of the Quail*, the undoubted links it has with mid-century Lombard painting do not on the other hand appear to be so definite as to establish it as the creation of a Lombard artist. Certainly the Palazzo Venezia Madonna is a work of very great quality and its Veronese-Lombard style does also have certain Gentilesque and Tuscan accents, which suggest the possibility that there was renewed contact between Pisanello and Gentile da Fabriano during the time in which the latter was working in Florence. Longhi was the first to point out its relationship with mid-century Lombard painting, and in particular with Cristoforo Moretti whose only remaining works are the panels depicting the *Madonna and Child and two Saints*, in the Poldi Pezzoli Museum. Others have also noted certain similarities to the polyptych depicting the *Enthroned Madonna with Child, Angels and Saints* by the Zavattari in the Castel Sant'Angelo Museum in Rome.[124] Another, very delicate Lombard work, a polyptych with the Madonna and Child in the centre and eight saints at the sides, now in the Waldenstein Gallery in New York, shows a sur-

prising affinity with the Palazzo Venezia Madonna, and this was pointed out by Meiss.[125] In view of its high quality and its stylistic and iconographical characteristics, Meiss thought that the work could have been executed between the first and second decade of the century by the Lombard painter who illuminated the Ciceronian Codex *De Natura Deorum* in the Bibliothèque Nationale in Paris. The Madonna in the central panel of the polyptych might, according to Meiss, have inspired the Veronese painter of the Palazzo Venezia Madonna, and the stylistic relationship between the two works would suggest that the Lombard author of the polyptych was active at Verona.[126] Subsequent research carried out by Panazza established that this polyptych was painted in a later period, in about 1447, for the church of S. Siro at Cemmo, by the Lombard painter Maestro Paroto, of whom there is no other known work.[127] Moretti's polyptych in the Poldi Pezzoli Museum and the one in the Museum of Castel Sant'Angelo attributed to the Zavattari, fit in with this mid-century dating. What then is the significance of their relationship with the Palazzo Venezia Madonna? Magagnato, who attributes the latter work to Pisanello, believing it to have been executed around 1420 during the artist's Stefanesque period, explains the Veronese vein in Lombard art towards the middle of the century as being due to 'the influential effect which Pisanello's art had in Lombardy through his stays in Pavia, Mantua and Milan'.[128] I share this view, partly because I believe that Cristoforo Moretti was a pupil of Pisanello and that his art contributed notably to the spread of Pisanello's style in Lombardy. But there are direct iconographical links between the three polyptychs I have mentioned, all executed towards the middle of the century, and the Palazzo Venezia Madonna, which indicate that the latter work too was painted in Lombardy. Indeed, analogies which exist between these works lead one to suppose that they had a common origin in some important work, perhaps a polyptych, for they all seem to reflect the style favoured in the Lombard environment. The outstanding quality and Pisanellian character of the Palazzo Venezia Madonna could then perhaps be explained by assuming that it originally formed the central panel of that polyptych, which Pisanello may have painted when he was in Milan and Pavia, where in the castle of the Visconti he carried out the lost mural decorations mentioned by Cesariano.[129]

In fact, if in the *Madonna of the Quail* the influence of Stefano da Verona is easily recognizable, though contained within certain limits as already described, the style of the Palazzo Venezia Madonna on the other hand seems to indicate a more complex relationship with the International style: this may have developed during Pisanello's renewed contact with Gentile da Fabriano in the years between 1422 and 1425, when the latter was in Florence, painting the *Adoration of the Magi* for Palla Strozzi, and the polyptych of the *Madonna and Child and Four Saints* for the Quaratesi family. Also belonging to that period are some of Pisanello's graphic studies which reveal among other things how much attention he paid to the works of the 'Maestro del Bambino Vispo'.[130] This International painter seems to be identifiable as the Italianized Spaniard Miguel Alcañiz,[131] who also caught the attention of Gentile da Fabriano.[132] It is from him that the richness and strong colours of the fabrics, and the elegant, vertical rhythm of the Palazzo Venezia Madonna seem to derive, recalling the upward movement displayed in the refined *Madonna Enthroned* by that artist (Fig. 99) identified by Berenson (1932) and now in the Rothermere Collection in London. It could therefore be maintained that the Madonna

of Palazzo Venezia as well as the *Madonna of the Quail* are the work of Pisanello. However, the works should not both be dated around 1420 in the supposed Stefanesque period of the artist, for it is important to recognize that they display different cultural substrata, indicating that the two paintings were executed at a distance of time and under the influence of different experiences.

The Brenzoni monument in the church of S. Fermo at Verona, sculpted by the Florentine Nanni di Bartolo, called Il Rosso, and painted by Pisanello (Figs. 107, 108), was already finished when the plaque dated 1426 was added.[133] Since Nanni di Bartolo did not leave Florence until 1424, the architectural and plastic structure of the monument could not have been begun before that year; the pictorial decoration would have been carried out after Il Rosso's sculptures had been installed, perhaps between 1425 and 1426. What Pisanello did in those five years or so between the *Madonna of the Quail* and the Brenzoni monument is a matter for conjecture, since we do not know any works which could be attributed to him for that period, apart from a few drawings. Documents show that the painter, who was already enjoying fame as *magister egregius*, was in Mantua between 1424 and 1425, employed by the Gonzaga family as court painter.[134] Pisanello must have kept this position for the rest of his life, judging by the medals and frescoes which he executed in Mantua during the later years of his activity. Indeed, although Pisanello frequented many courts his closest and most constant links were with the Gonzagas, although this did not limit his personal freedom as a restless, wandering artist. Furthermore, the friendship and collaboration which bound Pisanello to Gentile da Fabriano in Venice were not interrupted by the different turn of events in the lives of the two artists after 1415.[135] Certain references in the pictorial decoration of the Brenzoni tomb to works painted by Gentile in Florence between 1422 and 1425 suggest that Pisanello was sporadically in Florence in the company of the artist from Fabriano. Degenhart noted a correspondence, at least of an iconographical nature, between some of the figures in the *Adoration of the Magi* which Gentile completed in 1423 and those in the Brenzoni monument decoration; for example, the head of the Archangel Michael at S. Fermo (Fig. 115) is similar to that of the youngest of the kings in the *Adoration* (Fig. 101), the horses in the *Adoration* resemble certain drawings ascribed to Pisanello, and so on.[136] It seems to me that the two very beautiful handmaidens behind the Virgin (Fig. 100) provide the most significant analogy; so much so that one is led to believe that perhaps the facing figure who is devoid of all ornaments and in whom the freshness of youth is expressed by the use of luminous colour and of pure, simple volumes, might be a Pisanellian contribution, or at least a reflection in Gentile's art of Pisanello's skill in portraiture. Certainly this beautiful figure is closer to Pisanello's portraits of women, such as the one of Margherita Gonzaga in the Louvre (Fig. 124), or of the two damsels in the room in Mantua (Fig. 17), than it is to the refined late Gothic elegance, full of early Trecento reminiscences, of the handmaiden at her side who represents in the highest degree the 'sumptuous melancholy' of Gentile's style.

The decoration of the Brenzoni tomb, even though not as late as 1435-40, a date which Biadego proposed,[137] is nevertheless another work of Pisanello's maturity, in

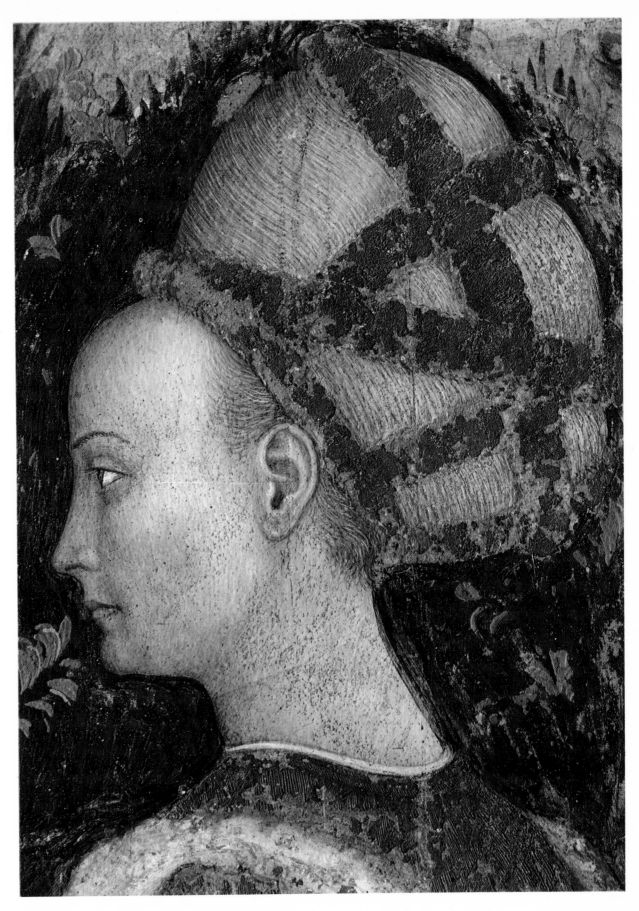

XVI. St. George and the Princess, detail of the Princess. Verona, Church of S. Anastasia.

which the most important ingredients of his culture converge. These ingredients, briefly, came from the experiences gained through his collaboration with Gentile da Fabriano in Florence and from the Tuscan late Gothic environment, which were woven into the pattern of relations he had established in the north some time earlier with Lombard and Venetian painters. One of these of course was Stefano da Verona, whose lyrical accents are reflected in the Angel of the Annunciation. But perhaps the most vivid lessons which Pisanello had learned during those years and which helped him to give new life to the Venetian late Gothic style of the Brenzoni tomb, came from the awareness he developed of the austere and monumental quality of Altichiero's art, which now became a truly integral part of his artistic expression, and from his new contacts with French and Flemish art. Two drawings ascribed to Pisanello by Degenhart (Figs. 103, 104), one an 'architectural study' which is now in the Boymans Museum in Rotterdam (No. I, 526), and another in the Louvre (No. 423) representing St. Jerome, may derive, like the *St. Jerome in his Study* (Fig. 102) at the beginning of the *Bible moralisée* (Paris, Bibliothèque Nationale, Ms. fr. 166), from some lost work by the Limbourg brothers.[139] Degenhart also noticed a resemblance between architectural details painted by Pisanello on the Brenzoni monument (the tabernacles at the top, on either side of the Archangels and God the Father) and details in the drawing of St. Jerome in the Paris *Bible*.[140] The drawing in the Boymans Museum depicting some nude women standing or bathing (No. 1,520) (Fig. 106) and the *Luxuria* (Fig. 105) in the Vienna Albertina (No. 24018 r.), also bear some relation to Flemish and French painting. A number of French and Flemish artists were working at the court of the Gonzagas in Mantua and it would be logical to suppose that their activity helped to transmit the stylistic and iconographical manners adopted by the great painters of those European centres, from the Limbourgs to the Van Eycks.[141] In the Boymans Museum drawing Degenhart rightly pointed out the extraordinary likeness between the face of the nude woman on the right, who is tying up her hair, and that of the Madonna of the *Annunciation* (Plate XV; Fig. 12), painted by Pisanello at S. Fermo:[142] it is clear that this graphic work, like the *Luxuria* in the Albertina, reflects deeply-felt experiences of those years in which Pisanello conceived and realized the pictorial decoration on the Brenzoni monument.

I shall not dwell on the beauty of the best known and best preserved details of that monument (Plates XIV, XV; Figs. 111–116): the doves, the heads of the archangels Michael and Gabriel, the fabulous Angel of the Annunciation (so different from the art of Stefano, even though it does evoke that painter's rhythms) and the less appreciated but nevertheless very beautiful Virgin of the Annunciation, whose descent from Gentile da Fabriano has been perhaps over-emphasized; then there are other accents to be discovered in the florid architecture, illuminated by a soft glimmering light never before seen in any fresco in Italy, but which was to be found in Flemish small paintings and miniatures, as for example in the interior of the Gothic church in the *Mass for the Dead*, illuminated by Jan van Eyck in the *Hours of Milan* (Fig. 117). These details are an intimation of the modernity and very high quality of this decoration; but the loss or deterioration of most of the pictorial surface, which originally covered the sculptures as well, makes it difficult to appreciate the importance and the significance that it once had. It was not just an 'ornament' as Vasari states,[143] for in this case its purpose would

have been to provide no more than a decorative background for Nanni di Bartolo's sculpted monument. Instead, it also included the plastic parts of the tomb, which thus became internal elements of a single decorative composition.

In order to analyse the various values in the monument one must distinguish what remains of Pisanello's pictorial decoration from the plastic structure carried out by the Florentine sculptor Il Rosso, which moreover was done with the assistance of other hands, as can be seen especially in the two candle-bearing angels.[144] However, first of all, it is important to understand that the Brenzoni tomb was conceived as a whole. One has only to compare the Brenzoni monument with the later Serego monument in the Verona church of S. Anastasia (Figs. 108, 109) which is fully Venetian in inspiration even if the plastic work was done by a Tuscan sculptor and the pictorial work by a great Venetian artist, possibly Giambono, though there is still some doubt about this. In the Serego monument there is no relation indeed there is a contrast, between the monument suspended in mid-air and apparently nailed on to the vast wall surface, and the very beautiful but totally extraneous pictorial decoration which surrounds it.

In the Brenzoni tomb on the other hand everything is linked; the various elements are all connected with one another in an organic composition which seems to be the result of an initial overall plan, which would have indicated the relationships between the various architectural, plastic and pictorial parts.[145] This initial plan helped to give the monument its sense of spatial development, receding into the distance in a succession of planes: first the plastic group sculpted by Il Rosso, then the plane behind it, formed by the surrounding Gothic trellis painted by Pisanello, and finally the landscape background which contains the Annunciation. The delicate structure of the Gothic tabernacles and of the rose garden trellis which stood out on the tapestry depicting a sky thickly studded with bright stars, is preserved in the engraved reproduction (Fig. 110) done by Nanin in 1864.[146] A large rectangular frame in relief marked the inside edge of the geometrical pattern of the painted background architecture. This frame was like a huge window opening on to the space of a daytime landscape receding into the distance, with a very Flemish effect of aerial perspective, towards the hills and castles along the skyline. The canopy, of Venetian Trecento style, was thus transformed into a kind of large pavilion in the foreground, with its curtains lifted up by the angels on both sides to reveal the tomb and the risen Christ; at the bottom, the group of sleeping soldiers lies on the rocks which extend without a break to the hills of the landscape painted at the top, behind the pavilion. Pisanello may well have planned the complex relationships between the various elements in a preliminary study and perhaps also planned some of the plastic details, such as the two candle-bearing angels (Fig. 120). Certainly the figurative unity which the monument originally had could not have been arrived at casually. Il Rosso and Pisanello must have agreed on a plan for realizing the work as a whole. One can imagine the original appearance of this monument: the painted sculptures[147] formed the foreground, projecting from the elegant, flowery backcloth and from the richly ornate tabernacles; the archangels stood guard like knights before a castle, dressed in gold and silver armour, standing out against a night sky lit by the splendour of the stars; and in the centre, a view of that gentle country, the place of man's birth and his death. Clearly, there was a symbolic relationship between light and darkness, life and death, within the

central theme of the resurrection: Pisanello's rendering of this theme could be compared to a page from a *livre d'heures*, depicted on monumental scale on the wall of the church.

Towards the end of 1426 Gentile da Fabriano was in Rome engaged in painting the *Scenes from the Life of St. John the Baptist* and the figures of the Prophets in the basilica of St. John Lateran, left unfinished because of his death in 1427. The scenes were completed in 1432 by Pisanello; but when Degenhart learned from some Roman documents that Gentile had bequeathed to Pisanello the tools of his workshop,[148] he came to the conclusion that Antonio not only finished the scenes left uncompleted, but that he worked on the pictorial cycle together with Gentile. The decoration, considered by Roger van der Weyden when he saw it in 1450 to be one of the most important Italian pictorial works,[149] has disappeared and only one or two memories of it remain, preserved in the drawing of some figures of Prophets, done by Borromini before he started on the transformation of the basilica, and in other drawings from Pisanello's notebook.[150]

Included in the equipment of Gentile's workshop bequeathed to Pisanello were a number of those drawings described as a 'Roman sketchbook' or 'travelling notebook' respectively by Degenhart and Miss Fossi Todorow, who have discussed at length the problems they present. The drawings are of considerable importance to the study of Pisanello's graphic work,[151] but what is of interest here is that this collection brought together very many drawings not only by Pisanello and Gentile but by several other artists from northern and central Italy. As Degenhart stated, it constituted 'a systematic collection of *exempla*, typical of those made by a workshop of medieval artistic outlook. Drawings by various artists and copies from all kinds of models were collected for the use of all members of the workshop, and were put together in the form of study manuals or notebooks.'[152] Among the many experiences which this collection records are those derived from Venetian and Lombard painters, and in particular Pisanello's growing interest in Altichiero and Avanzo; but above all Pisanello's interest in the new Tuscan elements is proclaimed by copies of works by Fra Angelico, the 'Maestro del Bambino Vispo', Luca della Robbia and Donatello.[153] Studies in perspective, such as drawing No. 2520 in the Louvre (Fig. 118), testify Pisanello's interest in that fundamental problem which the Florentines had been exploring, and in the solution which Brunelleschi and Alberti had found for it.[154] But a comparison between this drawing and Masaccio's *Trinity* with its centrally arranged perspective, demonstrates that, despite the strict geometric pattern of Pisanello's drawing, he was still turned towards 'the objectives of the imagination or towards the breathtaking subtlety of refinement' which, as Ragghianti noted, form the basis of his vision of things.[155] The relationship which he established with the most Gothic of the modern Tuscan painters, Paolo Uccello—a relationship which was reciprocal, as can be seen most clearly in the Mantuan mural cycle—confirms that for Pisanello, perspective was a useful means of refining his style as International Gothic painter and not, as it was for the Florentine innovators, a new conception of reality. His study of antiquity, which he and Gentile had made in Rome,[156] was of the same nature and gave him that sense of volume typical of the works of his full maturity and his late period, and taught him a great deal which was to serve him in his future activity as

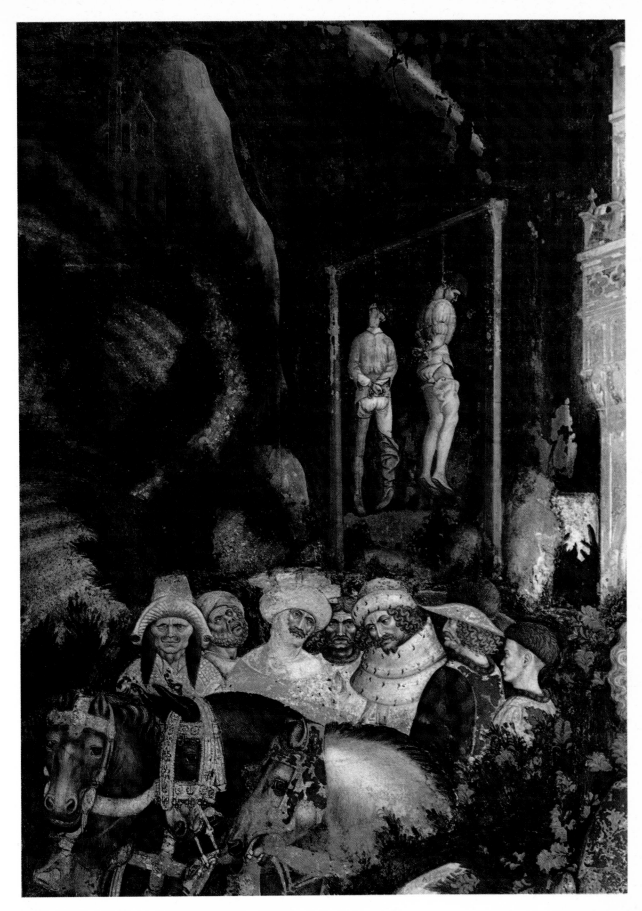

XVII. St. George and the Princess, detail of hanged men. Verona, Church of S. Anastasia.

medallist. However, for this activity he was to receive a very different kind of impetus from French exponents of late Gothic plastic arts and from his contact with Ghiberti.

With regard to the Roman activity of Gentile and Pisanello, it must also be noted that in the period in which the two artists were executing the lost cycle in the basilica of St. John Lateran (1426–32), another important cycle was being carried out by Masolino, in the basilica of S. Clemente, between 1427 and 1431. The large Crucifixion on the back wall of the chapel of S. Caterina in S. Clemente reveals the intervention of a collaborator whom Toesca and Longhi, with different degrees of conviction, identified as Masaccio,[157] while Brandi put forward the name of Domenico Veneziano.[158] Domenico's early Pisanellian and Gentilesque education could explain his presence in the Papal See while those two masters were working in St. John Lateran, and also his subsequent collaboration with Masolino, after Gentile's death in 1427 and Masaccio's in 1428. Pisanello must at any rate have been very impressed by the frescoes in S. Clemente, and especially by the Crucifixion, whose landscape structure, which is by Masolino, he was to recall in his subsequent mural decorations, and particularly in the one in Mantua. The landscape (Fig. 119) viewed from above, evokes the kind of research being carried out at that time by Jan van Eyck.[159] Masolino's collaborator executed the figures of the warriors at the foot of the crosses. If this collaborator was indeed Domenico Veneziano, there could be no better explanation for the way in which, from that moment onwards, the course of his artistic career diverged from that of Pisanello, who together with Gentile, was probably his master. While Domenico Veneziano's destiny was in fact to be that of being placed firmly among the innovators of Florentine Renaissance painting, Pisanello was to continue as representative of the courtly tradition, of whose splendours and pathetic decline, he was the greatest interpreter and poet in Italy.

When the frescoes in St. John Lateran were completed, Antonio Pisano left Rome in 1432 and, after a short stay in Ferrara, returned to Verona in 1433, where he decorated the Pellegrini chapel in the church of S. Anastasia. Although opinions differ as to the period in which these mural paintings were executed, the dating generally accepted is the one proposed by Degenhart, who holds that this decoration and the numerous related drawings were done between 1433 and 1438.[160] But at that time Pisanello was also working for the Gonzagas and the Este, for whom he made a number of portraits in addition to the effigy, probably a miniature, of Julius Caesar, which in 1435 he sent as a gift to Lionello d'Este on the occasion of his marriage to Margherita Gonzaga.[161]

It was perhaps in Mantua that he executed the portrait of the Emperor Sigismund (Fig. 122) which Gianfrancesco Gonzaga may have wanted for presentation to the Emperor who had conferred on him the title of Marchese in 1433. Degenhart's attribution to Pisanello of this portrait was contradicted by Rasmo who maintained that its style betrayed it as a Bohemian work.[162] Indeed, a close examination of this portrait does not immediately confirm Degenhart's attribution, partly because of the calligraphic emphasis of certain details, and the arguments followed by Rasmo in his careful investigation certainly carry considerable weight. However, when I re-examined the painting at the Vienna exhibition in 1962, I felt that its quality and tone were undeniably Pisanellian, even if it represented one of the less attractive aspects of Pisanello's art: aspects which do occur in the work of this artist who is often a cold and severe classifier, as he appears

to be in many of his drawings. What is bewildering about the portrait of the Emperor Sigismund is that it does not correspond to the two drawings in profile of the Emperor (Figs. 121 ,123) executed from life (Louvre Nos. 2479 and 2339); and equally puzzling is the Bohemian nature of the image, rightly noted by Rasmo, who saw it in relation to the works of the Master of the Apostles in the Capuchin monastery in Prague.[163] It is in fact rare to find drawings in Pisanello's graphic repertoire which correspond exactly to his paintings or medals, but nevertheless there could be other possible explanations for these obvious differences. For example, the Emperor may not have liked being portrayed in profile and he may have given the artist a portrait of himself done by a Bohemian artist, to serve as a model for the new painting. It must be remembered too that the technique used for this painting on parchment, possibly following a model as I have suggested, is that of a miniature, and thus it has a different feel from that of the other portraits by Pisanello. There is in any case a marked difference in quality between this work and those of the Bohemian Master of the Apostles and, as Degenhart has noted, it is much closer to the drawings and paintings executed by Pisanello for the church of S. Anastasia. On the whole, and in spite of its various puzzling features, I believe one can consider Pisanello to be the author of this work.

That penetrating power of observation which often led Pisanello to scrutinize human beings with the eye of a 'zoographer',[164] almost as though they were some refined species of animal, is also noticeable in the S. Anastasia fresco (Plate XVI) and in the very expressive portrait of Margherita Gonzaga (Fig. 124) preserved in the Louvre, which Pisanello painted during her brief marriage with Lionello d'Este (1345–9). It has been suggested that the portrait represents Ginevra d'Este and not Margherita Gonzaga, but this is unlikely since the Gonzaga heraldic colours of red, white and green are shown in the plaited cord adorning her dress, and there is a distinct resemblance to Margherita's sister Cecilia, who was later depicted in a medal.[165] This very fine female portrait reflects the artist's familiarity with the paintings of the Limbourg brothers, whose own training in turn owed much to the circulation in France of the *ouvraige de Lombardie*. Antonio's links with French painting, and in particular with that of the Limbourgs, so noticeable in this portrait[166] and in the one which he did a few years later of Lionello d'Este, is also evident in his last works. In his *St. George and the Princess* (Plates XVI, XVII; Figs. 125–39), painted over the arch of the Pellegrini chapel in the church of S. Anastasia, this influence, together with Venetian and Tuscan elements, is apparent in the composition, the physical types and the style. This was Pisanello's last work in Verona, probably executed in 1437–8, shortly before he had to leave the city as a result of the military clash with Venice in which he sided with Marchese Gianfrancesco Gonzaga.

The present state of the *St. George and the Princess* is far removed from its original splendour: the colour values are now partly lost or spoiled because of the deterioration of the pigments which, as in the Mantuan cycle, were applied with the *secco* technique. However, there is still a vivid impression of light which makes the strong, luminous colours stand out against the dark plane of the background, giving an effect of depth. The perspective values created by foreshortening some of the images are organized through a succession of planes in the form of wings, as on a stage, following the shape of the arch. On the right hand side the main figures of St. George and the Princess and

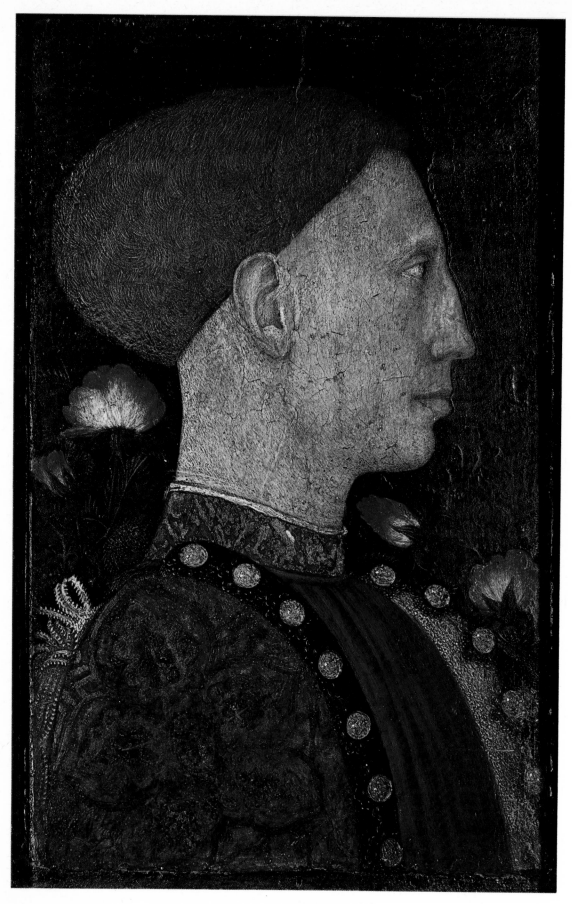

XVIII. Portrait of Lionello d'Este. Bergamo, Accademia Carrara.

the two beautiful horses are brought forward (Fig. 125); the centre opens out into the short horizon of the sea, deserted and unfathomable; and on the left, the rough terrain along the edge of the arch extends to the shores of the fearful kingdom of the dragon. But this is the unreal space of Pisanello's imagination, where the images loom larger than life as though in a dream. In the background the light-coloured buildings of the townscape rise against the sky, and recede beyond the ridge of the hills (Fig. 128) in an incommensurable space, as in the luminous landscapes of the Limbourgs.

The fascination of this masterpiece lies in the sense of mystery which expresses Pisanello's taste for the fabulous and for chivalry,[167] and in the sense of 'adventure' typical of the courtly romances. Bettini has defined this chivalric element as the fundamental dimension of Pisanello's poetic world.[168] However, that world embraced all of Pisanello's experiences as man and artist, and these were expressed through his penetrating contemplation of nature and its 'organism',[169] in which life and death are felt to be fatally united as two aspects of a single destiny.

The pictorial decoration of the Pellegrini chapel, in addition to this splendid scene painted over the entrance together with the Pellegrini coat of arms, also included, according to Vasari, the figures of St. George and of St. Eustace, now lost.[170] These must have been situated in the small area between the earlier decorations and the terracotta tiles depicting scenes from the life of Christ, executed in 1436 by the Ghibertian sculptor Michele da Firenze.[171] There is no iconographical or formal connection between these plastic works and the pictorial decoration which Pisanello must certainly have started after the tiles had been put in position, and before he left Verona in 1438. It is impossible to understand why the patrons wanted their chapel painted with a completely profane theme of chivalry as this story is, unless perhaps its subject bore some relation to John VIII Palaeologus, Emperor of Constantinople, who came to Italy together with his retinue and representatives of the Greek church to attend the Council of Florence. This might explain the inclusion in the middle ground of the fresco, underneath the corpses on the gallows, of the group of figures, some of whom, like the Kalmuck, are oriental-looking.[172] It would also justify the traditional title of the scene, 'St. George freeing the Princess of Trebizond', which, according to Bryer, implies that the Princess can be identified as Maria Komnena of Trebizond, wife of the Emperor John Palaeologus, for whom Pisanello made his first medal.[173]

The year 1438, in which Antonio Pisano left Verona after completing the decoration of the Pellegrini chapel, is of particular importance, since it marks the beginning of that period during which, in little more than a decade, he created his famous medals. I cannot dwell here upon all the many problems surrounding these medals, since I must concentrate on those which have some bearing on the pictorial decoration in Mantua.[174] Nevertheless it will be necessary to try and discover why this form of artistic expression should have revealed itself so unexpectedly in Pisanello's work, and at such an advanced phase of his activity. In Florence he had already come into contact with Donatello and Ghiberti and the sculptors of Ghiberti's circle, both before and after the journey to Rome, where he had studied at length the plastic arts of antiquity; and in Verona, between the

third and fourth decade, he had kept in touch with the Ghibertian sculptors who had worked on the monuments which he himself had decorated. Moreover, during his frequent stays at the courts of Ferrara and Mantua, he must have seen some of those late Trecento and early Quattrocento ivories and medals in chivalric style which influenced the formal structure of his own commemorative medals. For this reason it is impossible to establish his medals as either Gothic or Renaissance, since they originated from his experiences of these complex International elements, within that climate of chivalric taste and humanistic culture, typical of the environment of the northern Italian courts in the first half of the fifteenth century.

Why then did Pisanello begin to create his commemorative medals only in about 1438–9 when he left Verona, and not before? It cannot be said that until then he had never turned to the problems of sculpture, for his graphic and pictorial productions reflect his concern with plasticity, and some figures in his paintings derive from his experience in the plastic arts. The arrangement of the circular composition in the fresco of *St. George and the Princess* in the church of S. Anastasia also seems to have been conceived within the imaginary circumference of a medal.[175] The origins of this activity of Pisanello's, which Martinie links with the works of certain Tuscan sculptors and in particular with Ghiberti's doors,[176] are related by Salmi to Pisanello's contacts with the Ghibertian circle and the great Florentine Gothic sculptor for whom he expressed such admiration.[177] The question still remains, however, as to why it was not until 1438–9 that these influences, which Pisanello had been exposed to for some time, suddenly spurred him to create his medals. Although the first medal may have been prompted by the historical importance of the presence at the Council of Florence of the Emperor John Palaeologus,[178] the real answer might lie in the deep impression the panels of Ghiberti's second door made on the artist during a journey he probably made to Florence between 1438 and 1439. In 1437 the panels had already been cast[179] and to be able to examine them at close hand in Ghiberti's workshop as individual works of art, must certainly have been a memorable experience for Antonio Pisano. The effect of this experience can be discerned in the medal depicting Palaeologus 'with that strange, Greek-looking hat, which the emperors used to wear', and according to Giovio the medal 'was made by Pisano in Florence, at the time of the Council of Eugenius which was attended by the aforesaid emperor'.[180] It is generally considered however that the Palaeologus medal was executed in Ferrara in 1438; only Fasanelli has claimed that it 'was cast in Florence in 1439, rather than in Ferrara when the drawings were made'.[181] The drawings comprise those sketches of the Emperor and his retinue, now preserved in the Louvre (Fig. 140) and at the Art Institute of Chicago, and show a more strongly contrasted pictorial effect penetrating the graphic forms of Pisanello's last period of activity.[182] If they really were done in Ferrara towards the end of 1438, as Fasanelli and most other historians maintain, then Antonio must have already renewed his contact with Ghiberti in Florence, for the intense light and shade relations in the free-flowing lines of Pisanello's sketches imply, as does the medal, familiarity with the pictorial relief in the panels of Ghiberti's second door, and with his drawings such as the *Flagellation of Christ* (Fig. 143) in the Vienna Albertina (No. 24409), with its frayed, quivering lines.

With his medal of the Emperor, Pisanello evoked a classical manner of representation

which was very popular during the Renaissance; but this did not mean that his world and his humanism were to cease being permeated by that chivalric spirit of the courtly world which continued to characterize his art up to the last phase of his activity. His last works, together with their relative graphic studies, include the great mural decoration in Mantua, the two small paintings in the National Gallery in London, one depicting the *Vision of St. Eustace*, the other the *Madonna and Child with Saints*, the medals he made for the courts of the Gonzagas and Alfonso of Aragon, and the one for Iñigo di Avalos with its fabulous landscape on the reverse so closely resembling the chivalric landscapes of the room in Mantua. Certainly the example provided by Ghiberti, as Salmi has noted,[183] was of considerable importance to Pisanello as medallist (Figs. 141, 187), since the influence of Ghibertian pictorial relief, already apparent in the first and most Gothic medals of Palaeologus, Filippo Maria Visconti, Niccolò Piccinino and Francesco Sforza, is accentuated in the 'Hellenic pictorialism'[184] of those made for Lionello d'Este. It is still noticeable together with other Florentine influences in the late medals: the medal of Lionello created for his marriage with Maria of Aragon in 1444, and the others made for the Malatestas, the Gonzagas, Alfonso of Aragon and for a number of humanists and noblemen belonging to those courts. In these late medals the organic and architectonic relationship of the image and inscription to the background plane gives these works a more definitely 'Renaissance' character.[185]

It was not only the example of Ghiberti however which helped to give this new aspect to the last works of Antonio, who to the end considered himself a painter, even when creating his medals which he invariably signed *Pisanus pictor*; he was at all times very aware of what other early Quattrocento Tuscan artists were doing, and above all of the activity of Paolo Uccello with whom he may have been in frequent contact, both during his journeys to Florence and when the Florentine painter was in Venice between 1425 and 1430. Furthermore, he would certainly have known the treatise *De pictura*, the Latin version of which was dedicated by Alberti to Marchese Gianfrancesco Gonzaga and the vernacular edition of 1436 to 'Filippo di Ser Brunellesco'.[186] This treatise must have confirmed his own conviction that perfection in the art of painting could not be attained by following only the researches of Florentine artists. At any rate he was in touch with Alberti (even if he had not already met him in Rome, which is likely), when both of them were in Ferrara in 1443; and it is possible that the portrait of Lionello d'Este now in the Accademia Carrara in Bergamo (Plate XVIII), was executed during this time. According to the sonnet by the poet Ulisse, the portrait is presumed to have been executed in 1441 in competition with Jacopo Bellini; the contest was apparently won by Jacopo.[187] The luminescent colours of the wild roses glowing against the dark background of this superb portrait recall those of the columbines and butterflies, though somewhat colder and more pearly, in the portrait of Margherita Gonzaga. Yet there is a stylistic gap between the two works which indicates a corresponding distance in time between them. The portrait of Lionello, in my opinion, is the first important outcome of the contacts which the artist had, not only with French painting, but with Flemish painting as well. These contacts were developed more intensely by Pisanello during the last decade of his activity. The painted portrait of Lionello and the medal dated 1444, which it so closely resembles, are the greatest works realized by Pisanello

in Ferrara in the fifth decade of the century, in that climate of 'courtly humanism' inspired by Guarino and stimulated by the presence of Alberti.

NOTES

1. The incorrect version of the inscription OPERA DI VETTOR PISANELLO DE SAN VI VERONESE MCCCCVI, transcribed by Dal Pozzo and repeated by Maffei (DAL POZZO. B., *Le vite dei pittori, degli scultori ed architetti veronesi*, Verona, 1718, p. 9; MAFFEI, S., *Studi sopra la storia della pittura italiana dei secoli XIV e XV e della scuola pittorica veronese dai medi tempi a tutto il secolo XVIII*, Verona, 1865), was correctly read as OPERA D. VETTORE PISANELLO DE SAN vi VERONE MCCCCXI by Bode and Tschudi who judged the painting to be a work from Padua or Squarcione of around 1450 (BODE, W., AND VON TSCHUDI, H., 'Ambetung der Könige von Vittore Pisano und die Madonna mit Heiligen aus dem Besitz des Cav. Dal Pozzo', in *Jarbuch der Königl. preussisch. Kunstsamml. VI*, 1885, p. 18 et seqq.).

2. VASARI, G., *Le Vite de' più eccellenti pittori, scultori e architettori*, edited by MILANESI, G., Florence, 1878-85, III, p. 13.

3. BODE and TSCHUDI, op. cit., p. 18 et seqq.; VENTURI, A., *Gentile da Fabriano e il Pisanello*, cit., XIII: 'Della pretesa data più antica nella cronologia del Pisanello', p. 28; HILL, G.F., *Pisanello*, London, 1905, pp. 4-5; SINDONA, op. cit., 1961, p. 109, note 14.

4. BIADEGO, G., 'Pisanus Pictor, nota prima' in *Atti del R. Istituto Veneto di Scienze, Lettere ed Arti*, 1908, t. LXVII, p. II, pp. 837-59; id.; 'Pisano Pictor, nota seconda', 1909, t. LXVIII, p. II, pp. 229-48; id., 'Pisanus Pictor, nota terza', 1909, t.LXIX, p. I, pp. 183-8; id., 'Pisanus Pictor, nota quarta', 1910, t.LXIX, p. II, pp. 797-813; id., 'Pisanus Pictor, nota quinta', 1910, t.LXIX, p. II, pp. 1047-54; id., 'Pisanus Pictor, nota sesta', 1913, t.LXXII, p. II, pp. 1315-29.

5. BIADEGO, 'nota prima', cit., 1908, pp. 837-59. With regard to the name Vittore, Biadego returned to a tentative suggestion made by Hill (HILL, *Pisanello*, cit., p. 77 note) that the Dominican friar Marco de Medici, who supplied Vasari with information about Veronese artists, must have known the painting from the collection of Bartolomeo da Pozzo and that its apocryphal inscription was therefore the origin of the incorrect name given to Pisanello by Vasari. But Testi pointed out that the name of Vittore appeared already in the first edition of the *Lives*, in which Vasari had not yet made use of the information given by Marco de Medici, which he was to use in the second edition (TESTI, L., 'Vittore Pisanello o Pisanus Pictor', in *Rassegna d'Arte*, 1910, p. 191, note 6). The real name of Antonio Pisano, which appears unequivocally in the documents reproduced by Biadego, had however already appeared, as Sindona rightly stated (op. cit., p. 109, note 13), in a document which was reproduced in 1902 by Zippel, where the painter *Antonius Pisanus*, author of the famous portrait of Lionello d'Este, is remembered in an oration by Ludovico Carbone (ZIPPEL, G., 'Artisti alla corte degli Estensi nel Quattrocento', in *L'Arte*, 1902, pp. 405-9). Zippel's information and his theory that the painter might be identified with Vittore Pisano passed unnoticed, until Biadego found the Veronese documents already quoted (VENTURI, A., 'Giuseppe Biadego: Pisanus Pictor' (review), in *L'Arte*, 1908, pp. 467-9); BIADEGO, 'nota quarta', cit., 1910, pp. 797-8).

6. See TESTI, L., *Storia della pittura veneziana*, Bergamo, 1909, note 1; VENTURI, *L'Arte*, 1908, cit., id., *L'Arte*, 1910,

pp. 74-5; TESTI, *Rassegna d'Arte*, 1910, cit.; MARTINIE, A., *Pisanello*, 1930, pp. 6-12.

7. BIADEGO, 'Pisanus Pictor, nota seconda', cit., 1909, p. 246.

8. BIADEGO, 'Pisanus Pictor, nota quarta', cit., 1910, pp. 797-813 and 'nota quinta', 1910, pp. 1047-54.

9. BIADEGO, 'Pisanus Pictor, nota quinta', cit., 1910, pp. 1052-4.

10. BIADEGO, 'Pisanus Pictor, nota quinta', cit., 1910, p. 1049. Brenzoni, commenting on this information in the register, remarked that the entry regarding Pisanello had been twice crossed out, as though these family details were supplied by people uncertain of the facts and who were therefore 'probably not members of Pisanello's immediate family'. (BRENZONI, R., *Pisanello*, Florence, 1952, p. 15)

11. In fact Biadego wrote '...even with this slight alteration, I still attach great importance to the year of birth, which one might say is of recent discovery, compared with the traditional date of 1380; it affects any comments and resulting conclusions regarding the history of this painter's work: the way in which it developed, the chronology of his various vorks, the inspiration he received from the work of contemporary artists and the influence which he himself had on other painters' (BIADEGO, 'Pisanus Pictor, nota quinta', cit., 1910, p. 1049).

12. TESTI, *Rassegna d'Arte*, cit., 1910, p. 135.

13. BIADEGO, 'Pisanus Pictor, nota seconda', cit., 1909, p. 241.

14. BIADEGO, 'Pisanus Pictor, nota sesta', cit., 1913, p. 1327.

15. BIADEGO, 'Pisanus Pictor, nota seconda', cit., 1909, p. 242. Biadego based this late dating of the S. Anastasia frescoes on the opinions expressed by Gruyer and de Foville. (GRUYER, G., 'Vittore Pisano appelé aussi le Pisanello', in *Gazette des Beaux-Arts*, X, 1893 and XI-XII, 1894; DE FOVILLE, J., 'Pisanello d'après des découvertes récentes', in *Revue de l'art ancien et moderne*, 1908, pp. 315-17.)

16. The Registrar's note of 1433 was, as we have seen, incorrect with regard to Antonio and may have also been wrong regarding his mother. At any rate Isabetta who according to this note was born in 1363, could well have had a son, Antonio, around the year 1380, which was the opinion of nineteenth-century historians and fiercely contested by Biadego.

17. A *Bartolomeo de pisis condam domini Zoli* resident in the S. Paolo district is mentioned in a legal document of September 1404 (BIADEGO, 'Pisanus Pictor, nota prima', cit., 1908, p. 847; BRENZONI, *Pisanello*, cit., p. 16 and p. 33, note 5).

18. Brenzoni, though inclined to believe that Pisanello was born in Verona, gives some interesting information on that movement, documented in a list of Pisans who were living in Verona in the first half of the fifteenth century (BRENZONI, *Pisanello*, cit., pp. 43-5).

19. When the domination of the Della Scala family came to an end in 1387, Verona passed into the hands of the Visconti; Pisa was ceded to Gian Galeazzo Visconti in 1399.

20. BIADEGO, 'Pisanus Pictor, nota quarta', cit., 1910, p. 805; BRENZONI, *Pisanello*, cit., p. 65. Pisanello paid for that property the considerable sum of 170 gold ducats, between 1422 and 1423; this was money he must have earned by his activity as an artist, since the legal document in which his mother Elisabetta declared that she still owed her son all of the money which his father had left to him, was dated 1424.

21. CENNINI, op. cit., p. 15.

22. TOESCA, P., *Il Trecento*, Turin, 1951, pp. 379–80.

23. LONGHI, R., 'Tracciato orvietano', in *Paragone*, XIII, No. 149, May 1962, pp. 3–14; DONATI, P.P., 'Inediti orvietani del Trecento', in *Paragone*, XX, No. 223, March 1969, pp. 5–17.

24. LONGHI, 'Tracciato orvietano', cit., p. 11.

25. BUCCI, M., and BERTOLINI, L., *Camposanto monumentale di Pisa. Affreschi e sinopie*, Milan, 1960, pp. 103–10.

26. LONGHI, 'Tracciato orvietano', cit., p. 13.

27. On Spinello Aretino see the recent monograph by BELLOSI, L., 'Da Spinello Aretino a Lorenzo Monaco', in *Paragone*, XVI, No. 187, September 1965, pp. 18–43; LONGHI, R., 'Ancora su Spinello Aretino', ibid., pp. 52–3.

28. FERRI, P.N., *Catalogo della raccolta dei disegni antichi e moderni degli Uffizi*, Rome, 1890; DEGENHART, B., under 'Stefano da Verona' (with a list of drawings by Stefano) in Thieme-Becker, XXXI, Leipzig, 1937, pp. 526-30; FIOCCO, G., 'Disegni di Stefano da Verona', in *Proporzioni*, III, 1950, p. 58.

29. LONGHI, R., 'Una mostra a Verona (Altichiero, Stefano e Pisanello)', in *L'Approdo Letterario*, 1958, p. 7.

30. SALMI, M., 'Antonio Veneziano', in *Bollettino d'Arte*, 1928–9, pp. 448–51.

31. LONGHI, R., *Viatico per cinque secoli di pittura veneziana*, Florence, 1946, p. 8. For other studies on Zanino di Pietro see also: ZERI, F., 'Aggiunte a Zanino di Pietro', in *Paragone*, XIII, No. 153, September 1962, pp. 56–60; LONGHI, R., 'Ancora un pannello di Zanino di Pietro', ibid., p. 60.

32. LONGHI, *Viatico*, cit., pp. 48–9.

33. DEGENHART, B., 'Le quattro tavole della leggenda di S. Benedetto, opere giovanili del Pisanello', in *Arte Veneta*, 1949, pp. 6–22; LONGHI, R., 'Sul catalogo della Mostra di Verona', in *Paragone*, IX, No. 107, November 1958, p. 76.

34. Careful research in Venice as well, and in other places where Pisanello worked, might possibly reveal parts of painted mural cycles by the artist which today are considered to be totally lost, but may nevertheless survive in part, as has been the case in Mantua.

35. The four small panels represent: *The Miracle of the Broken Salver, St. Benedict Exorcizing a Monk, The Miracle of the Poisoned Glass, St. Benedict the Hermit in Penance* (Figs. 83–6). I give here a summary of the various attributions which have been put forward. In 1880 Morelli and in 1884 Frizzoni ascribed the three panels, formerly in the Cannon collection and now in the Uffizi, to Stefano da Verona; Berenson (1907) and Van Marle (1926) made the same attribution. In 1914 J. P. Richter linked the Poldi Pezzoli panel with those of the Uffizi, ascribing them to the author of the frescoes of the Serego monument in S. Anastasia. Miss Sandberg Vavalà (1926) linked the *St. Benedict the Hermit* with the school of Jacopo Bellini, while G.M. Richter (1931) related it to the last period of Pisanello; Berenson (1932) attributed it to Gentile da Fabriano, followed by Morassi (1936) and by Miss Wittgens (1937). Longhi (1940) initially thought that one of the Uffizi St. Benedict scenes was by Gentile and the other by Niccolò di Pietro; subsequently (1946) that they were both the work of Niccolò di Pietro, to whom Bologna (1952), Ferrari (1953) and Grassi (1953) also ascribed them. Degenhart (1941) held that the Poldi Pezzoli *St. Benedict the Hermit* was a juvenile work of Pisanello, and subsequently (1949) ascribed all four scenes to the young Pisanello. Coletti (1947) proposed Pisanello for the Milan St. Benedict, attributing (1948) the three Uffizi panels to the 'Master of the Innocents' and then (1953) decided that this artist had

collaborated with Pisanello. Fiocco (1952) attributed the scenes to Master Wenceslaus (Waczlaw Pehm), author of the frescoes at Riffiano, and he was followed by Brenzoni (1955 and 1959); Rasmo (1955) linked them with the 'Master of the Innocents', whom he identified with Teodorico d'Ivano d'Alemagna; Pallucchini (*La Pittura veneta del Quattrocento*, 1956) considered that Degenhart's attribution to the young Pisanello might be correct, but he did not think the problem was yet settled (*Arte Veneta*, 1956); Volpe (1955 and 1958) thought they were the work of the young Giambono, and was followed by Cuppini in 1969; Russoli (1955) judged the Milan St. Benedict to be a Venetian work influenced by Gentile; Magagnato (1958) assigned the panels to a 'Master of the Life of St. Benedict'. Longhi, after the Verona Exhibition (1958) agreed with the attribution to the young Pisanello, which was confirmed by Coletti (1958), Sindona (1961) and by Miss Castelfranchi Vegas (1966). This was rejected by Bettini (1959), who assigned the scenes to a colleague of Niccolò di Pietro, and Miss Fossi Todorow (1959) who considered them to have been done by more than one artist, in the ambiance of Gentile-Niccolò-Pisanello. Chiarelli too (1966) regarded the attribution of the St. Benedict scenes to Pisanello as being far from definite.

36. DEGENHART, B., under 'Pisanello', in *Enciclopedia Universale dell'Arte*, Vol. X, Venice and Rome, 1963, p. 614.

37. LONGHI, R., 'Fatti di Masolino e di Masaccio', in *La Critica d'Arte*, fasc. XXVI-XXVI, 1940, p. 190.

37. LONGHI, *Viatico*, cit., pp. 48–9.

39. RICHTER, G.M., 'Pisanello again', in *The Burlington Magazine*, 1931, p. 235; DEGENHART, B., *Pisanello*, Vienna, 1941, p. 29; COLETTI, L., 'Pittura veneta dal Tre al Quattrocento', Part II, in *Arte Veneta*, 1947, pp. 257–8.

40. DEGENHART, *Arte Veneta*, cit., 1949, pp. 6–22.

41. LONGHI, 'Sul catalogo della Mostra di Verona'; cit., p. 76; id., 'Una mostra a Verona', cit., p. 10.

42. CASTELFRANCHI VEGAS, L., *Il gotico internazionale in Italia*, Rome, 1966,. pp. 28–9.

43. VOLPE, C., 'Donato Bragadin ultimo gotico', in *Arte Veneta*, 1955, p. 20, note 4; id., 'Da Altichiero a Pisanello' in *Arte Antica e Moderna*, No. 4, October-December 1958, p. 412.

44. RICHTER, J.P., *A Descriptive Catalogue of Old Masters of the Italian School*, Florence, 1914.

45. FIOCCO, 'Disegni di Stefano da Verona', cit., p. 57; id., 'Niccolò di Pietro, Pisanello, Venceslao', in *Bollettino d'Arte*, 1952, p. 16, note 12 and p. 20. Fiocco holds that Master Wenceslaus was the same as 'Waczlaw Pehm', struck off the register of the Prague *Malerzeche* in 1405.

46. RASMO, N., 'Note sui rapporti fra Verona e l'Alto Adige nella pittura del tardo Trecento', in *Cultura Atesina*, 1952, V, pp. 57–82.

47. DEGENHART, B., 'Di una pubblicazione su Pisanello e di altri fatti', p. II, in *Arte Veneta*, 1954, pp. 96–118.

48. DEGENHART, *Arte Veneta*, cit., 1949, pp. 7–22.

49. RASMO, op. cit., p. 76.

50. COLETTI, *Arte Veneta*, cit., 1947, pp. 251-62.

51. COLETTI, L., 'Il Maestro degli Innocenti', in *Arte Veneta*, 1948, pp. 30–40.

52. COLETTI, L., *Pittura veneta del Quattrocento*, Novara, 1953, p. XVII; id., *Il Pisanello*, Milan, 1953, p. 30, n. 4.

53. DEGENHART, B., 'Das Wiener Bildnis Kaiser Sigismunds, ein Werk Pisanellos', in *Jahrb. d. Kunsthistor, Sammlungen in Wien*, XIII, 1944, p. 359 et seqq.; id., *Pisanello*, cit., 1945, p. 81; id., 'Un'opera di Pisanello: il ritratto dell'imperatore Sigismondo a Vienna', in *Arti figurative*, II, 1946, pp. 166 et seqq.

54. RASMO, N., 'Il Pisanello e il ritratto dell'imperatore Sigismondo a Vienna', in *Cultura Atesina*, IX, 1955, pp. 11–16.

55. The 'Master of the Innocents' to whom Rasmo ascribes this whole group of works, is in his opinion 'perhaps identifiable with the painter Teodorico d'Ivano d'Alemagna who was certainly working in 1436 in S. Caterina at Treviso'

(Rasmo, op. cit., 1955, p. 13 note 2). Previously however Rasmo had acknowledged that the panels illustrating the *Scenes from the Life of St. Benedict* 'are of greater quality than the work of the Master of the Innocents, while they are on a level with the *S. Eligio* fresco' (RASMO, op. cit., 1952, p. 76). Coletti also took up the question of the identity of the artist whom he had named 'Maestro degli Innocenti'. He noted that on 24 December 1436 a *Magister Theodoricus pictor qu. ser Ivani de Alemania* had been present at S. Caterina, but considered it was impossible to demonstrate that this was the same artist, and he limited himself to expressing the opinion that the 'Maestro degli Innocenti' was a Venetian painter, trained in the Marches (Coletti, *Arte Veneta*, cit., 1948, pp. 33, 36–4).

56. COLETTI, L., 'La Mostra da Altichiero a Pisanello', in *Arte Veneta*, 1958, pp. 239–50.

57. RASMO, op. cit., 1955, p. 13 note 3; COLETTI, *Arte Veneta*, cit., 1958, p. 247.

58. FACIO, BARTOLOMEO, *De viris illustribus liber*, edited by Mahus, Florence, 1745, pp. 47–8.

59. ZERI, F., 'Aggiunte a Zanino di Pietro', cit., p. 59.

60. LONGHI, *Viatico*, cit., p. 49.

61. DEGENHART, *Arte Veneta*, cit., 1949, p. 11; DEGENHART and SCHMITT, *Münchner Jahrbuch*, cit., 1960.

62. COLETTI, *Arte Veneta*, cit., 1947, pp. 251–62; DEGENHART, *Arte Veneta*, cit., 1949, pp. 7–22; RASMO, op. cit., 1955, pp. 11–16; HUNTER, G., 'Gentile da Fabriano and the Madonna of Humility', in *Arte Veneta*, 1970, pp. 26–43.

63. LORENZI, G.B., *Monumenti per servire alla storia del Palazzo Ducale di Venezia, Part I: dal 1253 al 1600*, Venice, 1868, pp. 61–4. For the history of the decorations in the Doge's Palace in Venice, see also WOLTERS, W., 'Der Programmentwurf zur Dekoration des Dogenpalastes', in *Mitteilungen der Kunsthist. Instit. in Florenz*, 1966; *Il Palazzo Ducale di Venezia* (edited by Zorzi, A.. Bassi, E., Pignatti, T., Semenzato, C.), Turin, 1971.

64. LORENZI, op. cit., doc. no. 107; VENTURI, A., op. cit., 1899, pp. 5–6.

65. The inscription on the scene painted by Gentile was; 'Pugnant viriliter partes tandem clarissimi Dux et probissimi Veneti, Deo assistente, obtinent victoriam et triumphum, capto Ottone filio Imperatoris, et omnibus galeis Imperialibus devictis et positis in conflictum, de quibus LX capte fuerunt, reliquis consumptis unda vel igne, exceptis pauces que rapuerunt fugam.' (LORENZI, op. cit., p. 63.) Facio referred to the scene as follows: 'Friderici Imperatoris filium a Venetis pro summo Pontifice susceptum, gestumque, quod tamen parietis vitio paene totum excidit'. (FACIO, op. cit., p. 45.)

66. The inscription on the scene painted by Pisanello was: 'Imperator viso filio valde letatur, sed pacem omnino recusat: longa diseptatione habita inter eos, tandem considerata filiali constantia dat pater filio potestatem tractande pacis.' (LORENZI, op. cit., p. 63.) Facio describes it as follows: 'Pinxit Venetiis in Palatio Fridericum Barbarussam Romanorum Imperatorem, et eiusdem filium supplicem: magnum quoque ibidem Comitum coetum germanico corporis cultu, orisque habitu: Sacerdotem digitis os distorquentem, et ob id ridentes pueros tanta suavitate, ut aspicientes ad hilaritatem excitent.' (FACIO, op. cit., pp. 47–8)

67. LORENZI, op. cit., document nos. 137, 140, 145.

68. Wickhoff (1883, p. 20) and Venturi (1896, p. 29) date the execution of the works in the Doge's Palace around 1422; Biadego (1909, p. 241) between 1422 and 1427; Hill (1905, pp. 27–9) between 1409 and 1414; Degenhart (1945, p. 14), followed by Dell'Acqua (1952, p. 14) and Miss Fossi Todorow (1966, p. 6) between 1415 and 1422, Coletti (1953, p. 30) between 1419 and 1422, Pignatti (1971, p. 109) between 1408 and 1414.

69. LORENZI, op. cit., document no. 145, p. 56.

70. SANUTO, M., 'Vitae Ducum Venetorum etc.', in *Rerum Italicarum Scriptores*, Vol. XXII, c. 1060–1074; TARDUCCI,

F., 'Gianfrancesco Gonzaga Signore di Mantova', in *Archivio Storico Lombardo*, Vol. XVII, fasc. XXXIV; Vol. XVIII, fasc. XXV, 1902, p. 48.

71. Grassi accepts the traditional date of 1409 for the execution of the Naval Battle painted by Gentile in the Sala del Maggior Consiglio. Although in 1408 Gentile was already in Venice, where he was working on the now lost altarpiece for Francesco Amadi, the documents quoted show that in 1409 work in the Sala had only just begun; but at the end of 1413, or at the beginning of 1414, Gentile's work must have been completed, if by April 1414 the artist was in Brescia (GRASSI, *Gentile da Fabriano*, Milan, 1953, p. 50).

72. It is possible that after Pisanello's successful collaboration on the decorations in the Doge's Palace, Gentile da Fabriano came to an agreement with the younger artist, before leaving Brescia in 1419, and arranged to have him as his collaborator for the execution of the *Scenes from the Life of St. John the Baptist* in St. John Lateran. He had probably been invited to Rome to do these, when Pope Martin V was in Brescia in 1418. The situation of the papal court following the Council of Constance obliged Martin V to change his plans, however, and he remained for several months between 1418 and 1419 in Mantua, then in Florence where he stayed until September 1420. Gentile returned to Fabriano and it appears that he was still there in 1420, before moving to Tuscany, where he worked between 1421 and about 1426. By the end of that year he must have been in Rome, since in January 1427 payments began for the frescoes of St. John Lateran. He was to leave these unfinished, since he died in the autumn of that year, and they were completed by Pisanello in 1432.

73. COLETTI, *Storia della pittura veneta*, cit., p. X; DEGENHART, *Arte Veneta*, cit., 1949, p. 22.

74. LORENZI, op. cit., document no. 137.

75. COLETTI, *Pisanello*, cit., p. 30.

76. BETTINI, S., *La pittura gotica internazionale a Verona*, University lecture notes, 1958–59, pp. 92–4.

77. LONGHI, 'Fatti di Masolino e di Masaccio', cit., p. 189, note 29.

78. LONGHI, 'Tracciato orvietano', cit., p. 7.

79. The Sienese ancestry of the Valle Romita polyptych was pointed out by Longhi ('Fatti di Masolino e di Masaccio', cit., p. 190). Grassi claimed that the Sienese and Emilian influences which are noticeable in the Brera polyptych derived from Taddeo di Bartolo and Barnaba da Modena (GRASSI, *Gentile da Fabriano*, cit., pp. 12–16).

80. MAGAGNATO, L., *Da Altichiero a Pisanello*, exhibition catalogue, 1958, pp. 75–6.

81. For this journey and Gentile's early Lombard training see GRASSI, *Gentile da Fabriano*, cit., p. 8.

82. VASARI, *Le Vite*, cit., III, p. 149.

83. VASARI, *Le Vite*, cit., III, pp. 5–14. However, one cannot help noticing the historical inversion made by Vasari when he claims that Pisanello's more modern outlook was the result of the teaching he had received from a Florentine artist, Andrea del Castagno, whose birth date and style in fact place him in a later generation.

84. This, according to Vasari, was how the 'divine Michelangelo' assessed the art of Gentile da Fabriano (*Vite*, cit., III, p. 7).

85. Here is a brief summary of the various opinions which have been expressed on the subject: Hill (1905), school copies from original sheets by Pisanello; Burger (1907), copies from Pisanello's workshop partly deriving from a project, now lost, for the Castelnuovo arch at Naples; Manteuffel (1909), a series of drawings by Pisanello, or by his pupils from sketches by the master himself, originally done in sanguine and intended for use in connection with the execution of frescoes; Krasceninnikowa (1920), copies from Altichiero, from other Trecento artists from Verona, and from Pisanello himself; Van Marle (1927), copies done by the school of Pisanello, taken from the master's sketchbook; Planiscig (1933), drawings by Pisanello's workshop, to be seen in relation to the Castelnuovo arch in Naples;

Degenhart (1945), autograph drawings by Pisanello during his Neapolitan period, in connection with the Castelnuovo arch; Popham (1946), drawings whose quality is not that of Pisanello; Coletti (1947), drawings of uneven quality, two ascribable to Pisanello's juvenile period; Middeldorf (1947), Arslan (1948), Dell'Acqua (1952), mostly copies by pupils; Keller (1957) autograph drawings by Pisanello, models to be used by the stonemasons working on the Castlnuovo arch; Magagnato (1958), circle of Pisanello, but gone over again by another hand; Sindona (1961), many original drawings but executed in different periods, some by another hand; Fossi Todorow (1966), denies that any of this series were by Pisanello himself.

86. Fossi Todorow, op. cit., 1966, p. 50.

87. Degenhart, *Pisanello*, cit., pp. 45–52.

88. Burger, F., *Francesco Laurana*, Strasburg 1907, p. 68; Planiscig, L., *Disegni per l'arco trionfale di Castel Nuovo di Napoli*, 1933.

89. Keller, H., 'Bildhauerzeichnungen Pisanellos', in *Festschrift Kurt Bauch*, Berlin and Munich, 1957.

90. Sindona, *Pisanello*, cit., pp. 53–86.

91. Coletti, *Arte Veneta*, cit., 1947, p. 258.

92. Degenhart, *Pisanello*, cit., pp. 45–50.

93. Degenhart, *Arte Veneta*, cit., 1949, p. 16 et seqq.

94. Coletti, *Arte Veneta*, cit., 1947, pp. 258–9.

95. Planiscig, L., 'Ein Entwurf für die Triumphbogen am Castelnuovo zu Neapel', in *Jahrbuch der Königlich. Preussisch. Kunstsamml.*, LIV, 1933.

96. Degenhart, *Pisanello*, cit., p. 50.

97. Cf. the thorough enquiry into the history of the construction of the Castelnuovo arch reported in the study by Causa, R., 'Sagrera, Laurana e l'Arco di Castelnuovo', in *Paragone*, 1954, No. 55, pp. 3–23.

98. Degenhart, *Pisanello*, cit., p. 45; the Italian edition contains the following wording: 'per l'incarico del giorno', which alters the original phrase 'für den vorliegen den Auftrag geschaffen' of the German, meaning roughly: 'for a certain work ordered from the artist'.

99. Popham, A.E. and Pouncey, P., *Italian Drawings in the Dept. of Prints and Drawings in the Brit. Mus.*, London, 1950, No. 299, pp. 189–90. Colvin (*Academy*, XXVII, 1864, p. 338 et seqq.) at first regarded them as drawings done by Pisanello for the frescoes in Venice; subsequently, in 1895 (id., *Guide to an Exhibition of Drawings*, etc.) he thought they might be works by Antonio Veneziano or by Guariento; Hill (1905) agreed with the proposal regarding the iconography of the subjects, but not with the attributions; Degenhart (1945) judged the drawing on the verso to be a copy of the fresco by Pisanello in the Doge's Palace, and the scene represented on the recto he thought might also be from a painting by Pisanello and that the drawing was the work of an artist from central-northern Italy, made between 1430 and 1460. For Mellini (*Altichiero e Jacopo Avanzi*, Milan, 1965, p. 80) however, the drawings belong to the circle of Altichiero. Drawing No. 2432r in the Louvre, undoubtedly by Pisanello, depicting some dogs and on the right the sketch of a scene taking place in a large covered blacony, which stands against the background of a palace with Ghibelline battlements (Fig. 22) was also considered by Wickhoff to be an idea for the scene in the Doge's Palace described by Facio (Wickhoff, F., 'Der Saal des grossen Rathes zu Venedig in seinem alten Schmucke', in *Repertorium für Kunstwissenschaft*, VI, 1883, pp. 21-2). This opinion is shared by various critics, including Gruyer (1894), Müntz (1897), Krasceninnikowa (1920), Degenhart (1945), Pignatti (1971); it was not accepted by Hill (1905) nor by Manteuffel (1909), who believed that the scene sketched on the right was executed later than the drawings of dogs. Miss Fossi Todorow (1966) also disagrees that the sketch is related to the Doge's Palace and she regards it, together with the greyhounds at bottom left, as belonging stylistically to the fourth decade, that is to the S. Anastasia period. In my opinion all the

drawings on folio 2432r are of the fourth decade and the scene sketched on the right might depict the ceremony in September 1433 during which the Emperor Sigismund conferred the title of Marchese on Gianfrancesco Gonzaga. The ceremony did in fact take place in the open air, in front of the Gonzaga palace in the Piazza di S. Pietro, where a balcony was set up for the Emperor's throne. Gianfrancesco, kneeling at the Emperor's feet, swore allegiance to him and received from his hands the insignia of Marchese (Possevino, A., *Gonzagae*, Mantua, 1617, p. 538 et seqq.; Amadei, F., *Cronaca Universale della città di Mantova*, Vol. II, Mantua, 1955, p. 7 et seqq.). It is likely that Pisanello was present at this ceremony and that he made a number of sketches for decorations which he might have had to execute to commemorate this event which was so important for the Gonzagas. The ceremony was the first of the subjects represented in the sixteenth century by Tintoretto on the large canvases of the *Fasti Gonzagheschi*, now preserved in the Alte Pinakothek in Munich.

100. Sansovino, F., *Venetia città nobilissima e singolare, descritta in XIII libri*, Venice, 1581.

101. Vasari, *Le Vite*, cit., I, p. 662.

102. Salmi, M., 'Antonio Veneziano', in *Bollettino d'Arte*, 1929, pp. 433–52; Coletti, L., *I Primitivi*, II, Novara, 1946, pp. LVII–LVIII; Pallucchini, R., *La pittura veneziana del Trecento*, Venice, 1964, pp. 210–11.

103. Toesca, P., *Il Trecento*, Turin, 1951, p. 668; Pignatti, T., *Il Palazzo Ducale di Venezia* (edited by Zorzi, A., Pignatti, T., Semenzato, C.), Turin, 1971, p. 100.

104. Pignatti, op. cit., p. 100.

105. Lorenzi, op. cit., Nos. 137–140.

106. Pignatti, op. cit., p. 109.

107. Lorenzi, op. cit., No. 145. The dense crowd of people portrayed from life, forming a ring round the figure of St. John the Baptist in the lively Scenes frescoed by Lorenzo and Jacopo Salimbeni in 1416 in the oratory of S. Giovanni in Urbino, must also have been an immediate echo of the works carried out in the Sala Nuova in Venice by Gentile and Pisanello. The Salimbeni, rightly considered by Zampetti to be among the major artists from the Marches in the early Quattrocento (Zampetti, P., *La pittura marchigiana da Gentile a Raffaello*, Milan, n.d., pp. 133-44) were ready to accept and develop new currents in the International Gothic style, for which they had been prepared by their contacts with Niccolò di Pietro and Zanino di Pietro, active in the Marches. But this is not sufficient explanation for the confident way in which the characters are portrayed (Fig. 89) nor for the use of foreshortening and the powerful plastic quality of the group of the Madonna and the Pious Women, which shows links with the researches carried out by Gentile and Pisanello and their manner of painting in the first decades of the century.

108. Sanuto, op. cit., cc. 894-5; Tarducci, op. cit., p. 48.

109. It appears that in January 1425 Pisanello was already receiving regular maintenance from the Gonzaga family (Biadego, 'Pisanus Pictor, nota terza', cit., 1909, p. 185).

110. Kaftal, G., *Iconography of the Saints in Tuscan Painting*, Florence, 1952, pp. 151-5.

111. According to J.P. Richter, two of the panels once in the Cannon collection and now in the Uffizi—those representing the *Miracle of the Poisoned Glass* and *St. Benedict Exorcizing a Monk*—came from the Portalupi palace in Verona; the third showing the *Miracle of the Broken Salver*, already assigned to Pisanello, came from the Milanese collection of Rodolfo Sessa, who had acquired it in an unidentified village near Mantua. Richter also pointed out that *St. Benedict the Hermit* in the Poldi Pezzoli was part of the same series (Richter, op. cit., 1914; Fiocco, op. cit., in *Bollettino d'Arte*, 1952, pp. 15–16). This provenance fully accords with what I have suggested regarding these panels. In the territory of the marquisate of Mantua there were many Benedictine monasteries, one of which probably originally contained the polyptych of the St. Benedict scenes:

to mention only two, the monastery of S. Benedetto in Polirone (today S. Benedetto Po) which was one of the most important Benedictine monasteries in northern Italy, and the monastery of S. Andrea in Mantua.

112. GRASSI, *Gentile da Fabriano*, cit., p. 8.

113. 'Mort'è la fonte de la cortesia; / Mort'è l'onor de la cavalleria; / Mort'è il fior di tutta Lombardia, / Cioè Messer Can Grande, / Che 'l suo gran core e la sua valoria / Per tutto'l mondo / spande'. ('Dead is the source of all courtesy; / Dead is the honour of chivalry; / Dead is the flower of all Lombardy, / Sir Can Grande, / whose great heart and whose valour / Spread throughout the world'.) (RIVA, F., 'Il Trecento volgare' in *Verona e il suo territorio*, Vol. III, p. II, Verona, 1969, p. 95.)

114. VASARI, *Le Vite*, cit., III, pp. 631–2.

115. VENTURI, A., *Storia dell'Arte Ital.*, Vol. VI: *La sculture del Quattrocento*, Milan, 1908, p. 36 note 1; SALMI, M., 'La pittura e la miniatura tardo gotiche', in *Storia di Milano*, VI, 1955, pp. 800–1.

116. The following agree with the attribution to Pisanello: Venturi (1908), Van Marle (1927), Martinie (1930), Coletti (uncertain in 1947 and 1953, certain in 1958), Degenhart (1945), Pallucchini (1946 and 1956), Avena (1947), Fiocco (1952), Brenzoni (1952), Magagnato (1958), Mazzini (1958), Volpe (1958), Bettini (1959), Sindona (1961), Chiarelli (1966), Castelfranchi Vegas (1966 with some reservations). It is ascribed to Stefano da Verona by Biadego (1908), Vavalà (1926, with some doubts) and Berenson (1932); Fossi Todorow (1959 and 1966) thinks it was probably the result of collaboration between Stefano and Pisanello, while Longhi (1928 and 1958) considers it to be the work of a Lombard artist, perhaps Cristoforo Moretti.

117. LONGHI, R., '"Me pinxit", op. II, I resti del polittico di Cristoforo Moretti', in *Pinacoteca*, I, 1928–9.

118. ARSLAN, W., 'Un affresco di Stefano di Verona', in *Le Arti*, 1943; COLETTI, *Arte Veneta*, cit., 1947, p. 261.

119. COLETTI, *Arte Veneta*, op. cit., p. 247.

120. The use of *pastiglia* and other materials in relief, such as molten wax, was to become a technical procedure frequently applied by Pisanello in his mural works as well, to give plastic and spatial modulations to his painting.

121. The plastic accentuation of the figure of the Child might descend from the tradition of Pisan sculpture which abounds in well-nourished *putti;* one has only to think of the stupendous *Madonna of the Milk* by Nino Pisano. Pisanello must also have seen, during his stay in Venice, the very beautiful *Madonna and Child* of the Cornaro monument in the church of SS. Giovanni e Paolo.

122. The panel is attributed to Stefano da Verona by Berenson (1907), Hermanin (1923), Van Marle (1926 with some reservations), Sandberg Vavalà (1926), Arslan (1943), Santangelo (1948 with some reservations in favour of Pisanello), Pallucchini (1956), Mazzini (1958). The following are inclined to recognize it as the work of Pisanello: Coletti (1953), Magagnato (1958), Bettini (1959), Sindona (1961), Fiocco (1969); according to Volpe (1958) it is definitely Pisanello's work; Cuppini considers that like the *Madonna of the Quail* it cannot be included in Pisanello's paintings (1969).

123. It was ascribed to Cristoforo Moretti or at any rate to a Lombard artist by Longhi (1928), Ragghianti (1930), Morassi (1930), Filippini (1932), Chiarelli (1966), Gengaro (1967). Brenzoni (1959) thought it the work of a Lombard artist who had some contacts with Veronese artists; for Fossi Todorow (1959) it is a Veronese work of Stefano's circle with Lombard reminiscences of the Zavattari of or Moretti.

124. MAZZINI, F., *Catalogo della Mostra d'Arte Lombarda dai Visconti agli Sforza*, Milan, 1958, p. 70.

125. MEISS, M., 'An Early Lombard Altarpiece', in *Arte Antica e Moderna*, 1961, pp. 125–33, Fig. 42.

126. MEISS, op. cit., 1961, p. 130.

127. PANAZZA, G., 'La pittura nei secoli XV e XVI', in *Storia di Brescia*, Vol. II, p. VII, Brescia, 1963, pp. 914–16. The polyptych is described in one of the files compiled by G. Brunati towards the middle of the last century which are preserved in the library of the University of Salò. In the nineteenth century it was transferred from the church of S. Siro at Cemmo to the Cavallari Museum in Milan, and this museum was later transferred to Paris. The works belonging to the museum were apparently sold in Paris at the beginning of this century on the antiques market. At the top of the polyptych by Maestro Paroto there was also a *Calvary* in the middle and an *Annunciation* at the sides. The work was signed *Parotus pinxit* and dated 1446 or 1447.

128. MAGAGNATO, *Catalogo Mostra*, cit., p. 87. Mazzini also holds that the 'particular stylistic manner of Moretti, with hints of Veronese influence showing through, is more sensitive than that of other typical followers of the late Gothic style' (*Arte Lombarda dai Visconti agli Sforza*, cit., p. 72).

129. CESARIANO, C., *Lucius Pollio Vitruvius De Architectura, Liber X*. Translated from Latin into the vernacular, Como, 1521, Ch. XV.

130. DEGENHART, B., and SCHMITT, A., *Italienische Zeichnungen der Frührenaissance*, Munich, 1966; id., *Disegni del Pisanello e di maestri del suo tempo*, cit., pp. 14, 37–8. SCHMITT, A., 'Ein Musterblatt des Pisanello' in *Festschrift Ulrich Middeldorf*, Berlin, 1958, p. 119–23.

131. LONGHI, R., 'Un'aggiunta al "Maestro del bambino vispo"', in *Paragone*, 185, July 1965, pp. 38–40; CASTELFRANCHI VEGAS, L., *Il gotico internazionale in Italia*, Rome, 1966, p. 48.

132. In the Washington *Madonna and Child* and in the *Coronation of the Virgin* in the Louvre, both by Gentile, in addition to the Sienese influences mentioned, a certain rapport with the Master of the Bambino Vispo can be noticed, which moreover was reciprocal.

133. The plaque, conserved in the Castelvecchio Museum, was recognized by Brenzoni and published by him. The inscription it bears reads as follows: 'Hic tumulatus est Nicolaus Brenzonarius vir nobilis civis optimus et assiduus pater familias. - Cuius devotionis et Franciscus filius homo primarius satisfacere et hunc locum pie adornandum curavit 1426' (BRENZONI, op. cit., 1952, No. 1, pp. 141–3).

134. BIADEGO, 'Pisanus Pictor, nota terza', cit., 1909, p. 185.

135. See note 72.

136. DEGENHART, *Pisanello*, cit., pp. 23–5. The following accepted Degenhart's theory that Pisanello may have collaborated in the painting of the *Adoration of the Magi*, which Gentile da Fabriano executed in 1423: COLETTI (*Arte Veneta*, 1947, p. 58), id. (*Pisanello*, 1953, p. 29); CHIARELLI (*Pisanello*, 1958, p. 11), id. (*Due questioni pisanelliane*, 1965–6, p. 2); PALLUCCHINI (*Pittura veneta del Quattrocento*, 1956, p. 138); MAGAGNATO (1958, p. 77); Sindona (1961, p. 31). Grassi, while acknowledging 'the striking similarity' between certain drawings by Pisanello and the figures in the *Adoration*, which was 'the most enigmatic aspect of the relationship between the two painters', eventually saw this relationship to be no more than the utilization by Gentile of drawings by Lombard artists and by Pisanello for the many figures of animals in the *Adoration* (GRASSI, *Gentile da Fabriano*, cit., p. 24). Many statements made by Chiarelli in the above-mentioned essays were inspired by his conviction that during this period Pisanello underwent Gentilesque and Florentine influence.

137. See note 14.

138. DEGENHART, B., 'Di una pubblicazione su Pisanello e di altri fatti,' in *Arte Veneta*, 1954, pp. 109–12.

139. Wescher ('Eine Modellzeichnung des Paul von Limbourg', in *Phoebus*, I 1946, p. 33 et seqq.) ascribed the Rotterdam drawing to Pol de Limbourg and considered it to be a preparatory drawing for the figure of St. Jerome in the *Bible Moralisée* (RING, G., *A Century of French Painting. 1400–1500*, London, 1949, p. 200 n. 67). DEGENHART (*Arte Veneta*, cit., 1954) and Meiss (MEISS, M., 'French

and Italian Variations on an Early Fifteenth-Century Theme: St. Jerome and his Study,' in *Gazette des Beaux-Arts*, 1963, pp. 147–70) denied that these two drawings belonged to Pol de Limbourg, although Meiss believed that the St. Jerome in the Paris Codex might be the work of an artist whom he calls the 'Master of St. Jerome', who was in direct contact with the Limbourgs (op. cit., p. 170). Pächt on the other hand agreed with the attribution to Pisanello of the Rotterdam drawing and considered that the St. Jerome in the Bibliothèque Nationale in Paris might be, if not by Pol, then by another of the three Limbourg brothers (PÄCHT, O., 'Zur Enstehung des "Hieronimus in Gehäus"', in *Pantheon*, 1963, pp. 131 et seqq.). In the catalogue of the Exhibition of International Gothic Art held in Vienna in 1962 the attribution to Pol of the St. Jerome in the Bibliothèque Nationale in Paris was accepted again, and also that of the Rotterdam drawing to Pisanello (Exhibition Catalogue, 1962, Nos. 105 and 284). Miss Fossi Todorow however disagreed that these drawings belonged either to Pisanello or to the Limbourgs (FOSSI TODOROW, op. cit., pp. 133, 139).

140. DEGENHART, *Arte Veneta*, 1954 cit., p. 114 note 7.

141. See p. 49 and note 17, Chapter III. It is interesting to note that among the great quantity of objets d'art in the International Gothic style—codices, tapestries, panel paintings, niches, tabernacles, richly decorated caskets and chests, some of which came from abroad, and which comprised the elegant furnishings of the Gonzaga court—there was also a chest painted '*ad dominas nudas se balneantes*' (GIROLLA, P., *Pittori e miniatori*, cit., p. 18 note 1).

142. DEGENHART, *Pisanello*, cit., p. 21.

143. VASARI, *Le Vite*, cit., III, p. 10.

144. Venturi considered that only the figure on top of the canopy fully represented the style of Il Rosso. He detected the intervention of a local assistant, particularly in the figure of the Risen Christ and in the 'angels inspired by German models' (VENTURI, A., *Storia dell'Arte Italiana*, VI, Milan, 1908, pp. 213, 216).

145. Longhi had already remarked in the *Lettere pittoriche* he exchanged with Fiocco that the 'sensitively pictorial sculpture' of Il Rosso constituted a 'perfect accompaniment to Pisanello's paintings surrounding it' (*Vita artistica*, 1926, p. 128). Fiocco, too, later acknowledged in the new edition of his *Arte di Andra Mantegna* (FIOCCO, G., *L'Arte di Andrea Mantegna*, 1959, p. 20) a Pisanellian influence on Il Rosso noticeable in the Brenzoni monument. Del Bravo, on re-examining the activity of Nanni di Bartolo in the Veneto, referred to the possibility that perhaps some graphic notes had been drawn for the monument as a whole (DEL BRAVO. C., 'Proposte e appunti per Nanni di Bartolo', in *Paragone*, 1961, 137, p. 29). Since the opinion I am expressing here dates back to the exhibition in Verona in 1958, as my friend Magagnato will confirm, on recalling our conversations on this problem at that time, the fact that Del Bravo's viewpoint agrees with mine gives the hypothesis greater objective validity. I do not think it likely, however, as Del Bravo does, that the two candle-bearing angels are extraneous; that is that they are the outcome of 'a relatively modern contamination with the stylistic characteristics of a late Gothic monument' (op. cit., p. 28).

146. NANIN, P., *Disegni di varie dipinture a fresco che sono in Verona*, Verona, 1864.

147. Today nothing remains of the original polychrome other than a few traces of the imprimitura, which came to light during the restoration of this work which was completed in 1968 by the Istituto Centrale del Restauro of Rome.

148. COLASANTI, A., *Gentile da Fabriano*, Bergamo, 1909, pp. 18–19, note 2.

149. FACIO, op. cit., p. 45. 'De hoc Viro ferunt, quum Rogerius Gallicus insignis Pictor, de quo post dicemus, Jubilaei anno in ipsum Joannis Baptistae Templum accessisset, eamque picturam contemplatus esset, admiratione operis captum auctore requisito eum multa laude cumulatum ceteris Italicis pictoribus antep_osuisse.'

150. DEGENHART, *Pisanello*, cit., pp. 28–30; id., *Arte Veneta*, cit., 1949, p. 17; id., *Münchner Jahrbuch*, cit., 1960, I, p. 59 et seqq.; FOSSI TODOROW, M., 'Un taccuino di viaggi del Pisanello e della sua bottega', in *Studi in onore di Mario Salmi*, Florence, 1962, II, pp. 146–8.

151. DEGENHART and SCHMITT. *Münchner Jahrbuch*, cit., 1960; FOSSI TODOROW, op. cit., 1962.

152. SCHMITT, A., and DEGENHART, B., *Disegni del Pisanello e di altri maestri del suo tempo*, Vicenza, 1966, p. 13.

153. DEGENHART and SCHMITT, *Münchner Jahrbuch*, cit. 1960; id., op. cit., 1966.

154. DEGENHART and SCHMITT, op. cit., 1960, p. 86; id., *Corpus der italienischen Zeichnungen, 1300–1400*, Berlin, 1968, I, pp. XXXV–XXXVI. For a further bibliography on this drawing, see FOSSI TODOROW, op. cit., 1966, No. 99, who places it among Jacopo Bellini's studies in perspective. Since Alberti was secretary to the Papal Chancellery from 1431 to 1434, it is not unlikely that Pisanello met him in Rome.

155. RAGGHIANTI, C.L., *Commenti di critica d'arte*, Bari, 1946, p. 234.

156. DEGENHART and SCHMITT, op. cit., 1960; id., op. cit., 1966.

157. TOESCA, P., under 'Masaccio', in *Enciclopedia Italiana*, Vol. XXII, Rome, 1934, p. 475; LONGHI, 'Fatti di Masolino e di Masaccio', cit., pp. 163–5.

158. BRANDI, C., 'I cinque anni cruciali per la pittura fiorentina del '400', in *Studi in onore di Matteo Marangoni*, Florence, 1957, pp. 167–75.

159. MEISS, M., '"Highlands" in the Lowlands: Jan van Eyck, the Master of Flémalle and the Franco-Italian Tradition', in *Gazette des Beaux-Arts*, 1961, p. 295.

160. Apart from Brenzoni (1952) who considers the decoration to have been executed between 1429 and 1430, that is before the artist's stay in Rome, Biadego (1909) who, on the basis of opinions expressed by Gruyer and by de Foville (see note 15), places them in about 1445 and Arslan (1948) who confirms this late dating, the other critics all agree in placing the decoration between 1433 and 1438.

161. CAMPORI, G., *Raccolta di cataloghi ed inventari inediti*, Modena, 1870; VENTURI, op. cit., 1896, pp. 38–9; SALMI, M., 'La "Divi Julii Caesaris effigies" del Pisanello', in *Commentari*, 1957, pp. 91–5.

162. DEGENHART, B., 'Das Wiener Bildnis Kaiser Sigismunds ein Werk Pisanellos', cit., 1944, p. 359 et seqq; id., 'Un'opera di Pisanello. Il ritratto dell'imperatore Sigismondo a Vienna', cit., 1945, p. 165 et seqq., RASMO, cit., 1955, pp. 11–15. Degenhart's attribution to Pisanello was accepted by Middeldorf (1947), Coletti (1953), Ragghianti (1954), Gnudi (1959), Marcenaro (1959), Sindona (1961), the Catalogue of the Vienna Exhibition (1962), Vayer (1962), Genthon (1965); the attribution was rejected, as well as by Rasmo, by Brenzoni (1959), who had previously accepted it (1952), Magagnato (1958), Bettini (1959), Fossi Todorow (1959 and 1966), Chiarelli (1966).

163. RASMO, op. cit., 1955, p. 15.

164. LONGHI, *Una mostra a Verona*, cit., 1958, p. 11.

165. Venturi (1889) who referred to the painting as the work of Pisanello, thought he could identify it as the portrait of one of the daughters of Niccolò d'Este; Gruyer (1893), however, thought it was Margherita Gonzaga, and Ravaisson (1895) identified it as Cecilia Gonzaga. In the catalogue of the Exhibition of Portraits of the Gonzagas (1937) the painting was stated to be a portrait of Margherita Gonzaga, and this was also the opinion of Degenhart (1945), Hentzen (1948), Pallucchini (1956), Keller (1957), Longhi (1958), Salmi (1958), and Gnudi (1959). Hill (1905) instead proposed the name of Ginevra d'Este, which was accepted by Brenzoni (1952), Coletti (1953), Bettini (1959), Fossi Todorow (1966) and Chiarelli (1966). Martinie (1930), Magagnato (1958), Sindona (1961), Castelfranchi Vegas (1966) referred only to a princess of the Este family.

166. In this connection it is significant, as Degenhart and Meiss both commented, that the beautiful portrait of a

woman in the National Gallery of Washington, painted by a French painter stylistically similar to the Limbourgs, should for a long time have been ascribed to Pisanello (DE-GENHART, op. cit., 1945, p. 39; MEISS, *French and Italian Variations*, cit., 1963, p. 104 and p. 169 note 53).

167. COLETTI, *Pisanello*, cit., 1953, p. 12.

168. BETTINI, op. cit., 1959, pp. 120–9. In his analysis Bettini reached the conclusion that 'the works of Pisanello are romances of chivalry, courtly romances, "told in pictures"' (p. 126). This is a perceptive judgement which captures one of the essential aspects of Pisanellian expression, provided of course one interprets it not as implying a direct relationship between the structure of Pisanello's works and the narrative technique of the old romances of chivalry, but as meaning that the literature of chivalry is an active ingredient in Antonio Pisano's poetic imagination.

169. MAGAGNATO, *Catal. Mostra*, cit., 1958, p. 94; id., *Arte e civiltà del Medioevo veronese*, Turin, 1962, p. 130.

170. 'In the church of S. Anastasia in Verona, in the chapel of the Pellegrini family, he painted a St. Eustace caressing a tan and white dog; the dog, whose front legs are raised so that they rest against the Saint's leg, is turning its head right round, almost as if it had heard a noise; this movement is portrayed so vividly that it seems to be real. Underneath the figure the name Pisano is written; ...On the other side, a St. George bearing sidearms made in silver; as not only he but all the other painters used to do in that period. This St. George has killed the dragon and is about to replace his sword in its sheath; his right hand is holding the sword with its point already in the sheath is raised, and his left hand is lowered, in order to achieve the stretch which is necessary in order to sheathe his long sword; this is done with such grace and in so fine a manner that there is nothing finer to be seen... Over the arch of this chapel is painted the scene where St. George, having killed the dragon, is freeing the king's daughter; she is shown near the Saint, in a long dress of the kind worn in those times: in this part the figure of St. George is still wonderful. The Saint, armed as I have described, is about to remount his horse, and he stands facing the crowd, with one foot placed in the stirrup and his left hand on the saddle, as though in the process of getting on to his horse. The horse's hindquarters are turned towards the crowd, and as it is shown in foreshortening, it is all contained very well in a small space. To sum up, it is impossible to gaze upon this work which is executed with good design, grace and exceptional judgement, without the utmost wonder, and indeed astonishment.' (VASARI, *Le Vite* cit., III, pp. 8–10)

171. Mellini quite reasonably supposed that the paintings of St. George and of St. Eustace inside the chapel were not scenes from the Lives of the saints but individual figures of a votive nature (MELLINI, L., 'Problemi di archeologia pisanelliana', in *Critica d'Arte*, 1961, p. 54). It is not easy to decide where they could have been placed in the small amount of space available, and Chiarelli for this reason eventually proposed that the St. Eustace must be identified as the small panel painting now in the National Gallery in London; this theory however is not altogether confirmed by the style of that work, which belongs to Pisanello's last period of activity.

172. COLETTI, *Pisanello*, cit., 1953, No. 18; DEGENHART, B., 'Zu Pisanellos Wandbild in S. Anastasia in Verona', in *Zeitschrift für Kunstwissenschaft*, V. 1951; SINDONA, op. cit., 1961, p. 71. The iconography of the Kalmuck in the fresco in S. Anastasia does not imply however that Pisanello must necessarily have seen and portrayed this figure in Ferrara among the people in the retinue of John Palaeologus, as Miss Fossi Todorow supposed when examining draw-

ing No. 2325 in the Louvre which represents the figure of the Kalmuck together with four other heads (FOSSI TODOROW, op. cit., 1966, pp. 64–5). Coletti, who had already tentatively advanced this theory, also suggested that Pisanello could well have seen oriental types on other occasions. The well-known miniature by the Limbourgs depicting the Meeting of the Magi in the *Très riches heures du Duc de Berry* is an extremely rich collection of oriental types. There are many significant details which suggest that it was known to Pisanello, even though possibly only through a copy. There are other orientals in the Paduan frescoes by Altichiero, which Pisanello studied at length.

173. BRYER, A., 'Pisanello and the Princess of Trebisonda', in *Apollo*, 1961, pp. 601–3.

174. For a classification of Pisanello's medals see HILL, G.F., *A Corpus of Italian Medals of the Renaissance before Cellini*, London, 1930, I, pp. 6–13. For other studies on the subject, see the Bibliography.

175. COLETTI, *Pisanello*, cit., 1953, p. 14.

176. MARTINIE, A.H., *Pisanello*, Paris, 1930, p. 40 et seqq.

177. SALMI, M., 'Riflessioni sul Pisanello medaglista', in *Annali dell'Istituto Italiano di Numismatica*, 1957, p. 23.

178. The Council, which opened in Basle in 1431 and was dissolved in 1437 by Eugene IV, met again in Ferrara in 1438 and then transferred in 1439 to Florence, from which it took its name, then to Rome where it was closed in 1443. The main question dealt with by the Council was the union of the Greek and Latin churches. John Palaeologus was present in Ferrara in 1438 and in Florence in 1439.

179. KRAUTHEIMER, R., *L. Ghiberti*, Princeton, New Jersey, 1st ed. 1956; 2nd ed. 1970, pp. 164–5; id., under 'Ghiberti', in *Enciclopedia Universale dell'Arte*, 1958, pp. 16–24.

180. VASARI, *Le Vite*, cit., III, p. 11. However, according to Vasari, Giovio wrote that the reverse of the Palaeologus medal, which he owned, represented 'the Cross of Christ supported by two hands, that is, the Latin and the Greek'. If this affirmation is not a mistake on Giovio's part, or on Vasari's, then Pisanello must have made two medals for Palaeologus (HILL, cit., 1905, pp. 106–8).

181. FASANELLI, J.A., 'Some notes on Pisanello and the Council of Florence', in *Master Drawings*, Vol. III, No. 1, 1965, p. 40.

182. FOSSI TODOROW, op. cit., 1966, pp. 80–1, plates LXVIII–LXXI. According to Fasanelli the sketches must have been executed during the session of the Council held in Ferrara on 8 October 1438 (op. cit.).

183. SALMI, op. cit., 1957, pp. 13–23.

184. SINDONA, op. cit., 1961, pp. 46–7.

185. DEGENHART, op. cit., 1944, pp. 42–5.

186. BONUCCI, A., *Opere volgari di L.B. Alberti*, Florence, 1843–9; JANITSCHEK, H., 'L.B. Albertis, Kleinere Kunsttheoretische Schriften', in *Eitellberger Quellenschriften*, XI, Vienna, 1887; ALBERTI, L.B., *Della Pittura*, critical ed. by Mallé, L., Florence, 1950. With regard to the influence on contemporary painting exercised by Alberti's artistic tastes, Parronchi notes that 'It was probably thanks to Alberti and the more eclectic nature of his culture, where painting was concerned as well, that he contributed to the formation of a style in the figurative arts which was more Italian than Florentine (which would certainly not have gained him Vasari's sympathy) and which embraced the art of northern as well as central Italian painters' (PARRONCHI, A., 'Leon Battista Alberti pittore', in *Studi su la dolce prospettiva*, Milan, 1966, p. 465).

187. VENTURI, op. cit., 1896, pp. 46–7.

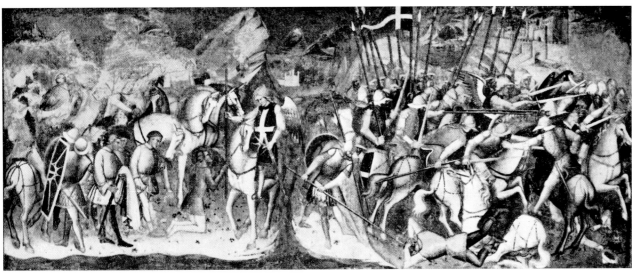

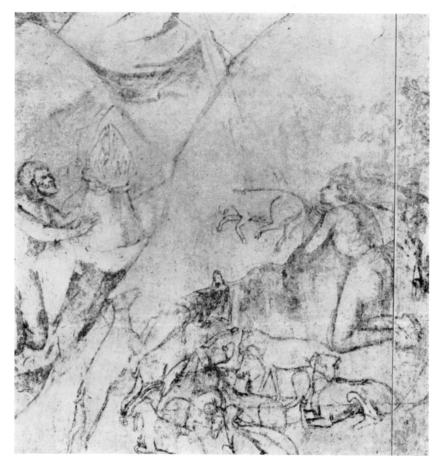

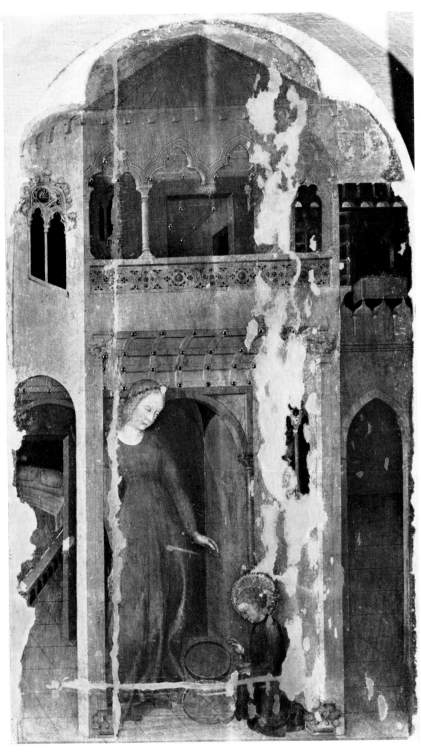

83. Scenes from the Life of St. Benedict: The Miracle of the Broken Salver. Florence, Uffizi.

84. Scenes from the Life of St. Benedict: St. Benedict Exorcizing a Monk. Florence, Uffizi.

85. *Scenes from the Life of St. Benedict: The Miracle of the Poisoned Glass. Florence, Uffizi.*

86. *Scenes from the Life of St. Benedict: St. Benedict the Hermit in Penitence. Milan, Poldi Pezzoli Museum.*

87. *Legend of S. Eligio, detail of fresco. Treviso, Church of S. Caterina.*

88. *Zanino di Pietro: Crucifixion Triptych, reverse of the doors showing Scenes from the Life of St. Francis. Rieti, Pinacoteca.*
89. *Lorenzo and Jacopo Salimbeni: St. John the Baptist preaching. Urbino, Oratorio di S. Giovanni.*

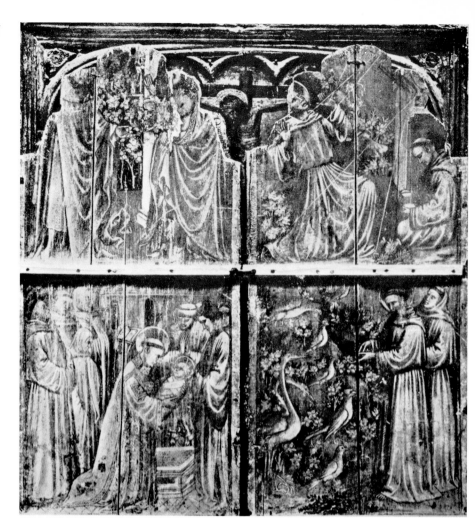

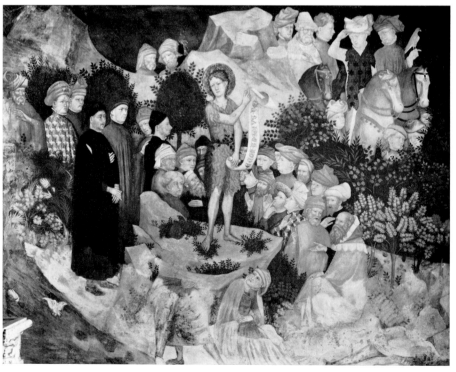

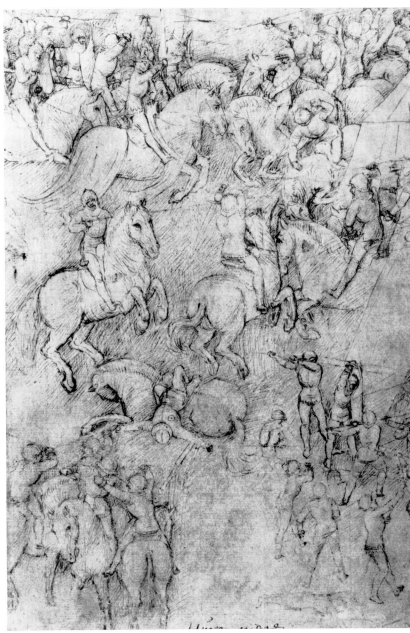

90. *Early fourteenth-century Veronese: Homage to an Enthroned Emperor. London, British Museum, Sloane Collection (Drawing No. 5226–57v).*

91. *Early fourteenth-century Veronese: A Combat. London, British Museum, Sloane Collection (Drawing No. 5226–57r).*

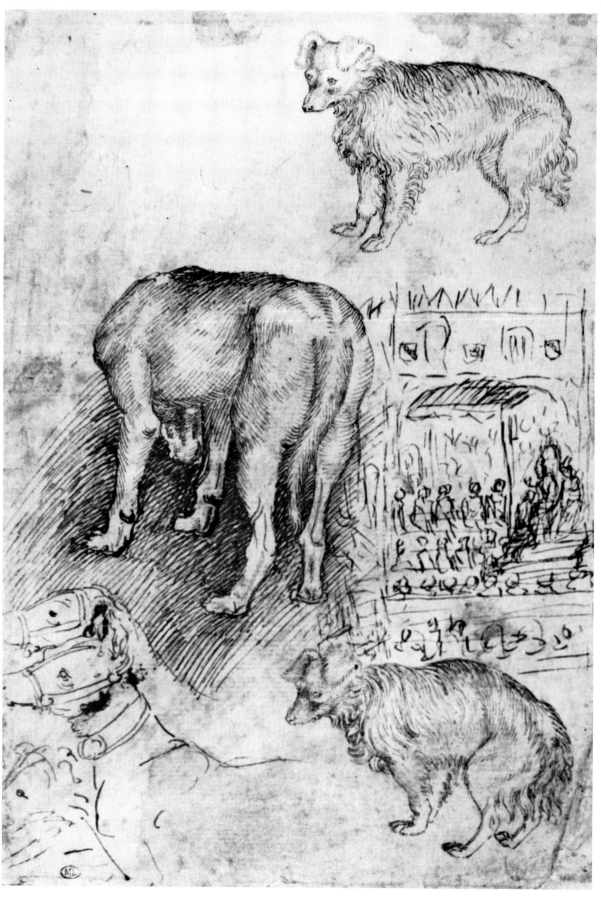

92. *Studies of dogs and sketch of a person kneeling in front of an enthroned emperor. Paris, Louvre (Drawing No. 2432r).*

94. Madonna of the Quail. Verona, Museo di Castelvecchio.

95, 96. Madonna of the Quail, details. Verona, Museo di Castelvecchio.

97. *Madonna of the Quail, detail. Verona, Museo di Castelvecchio.*

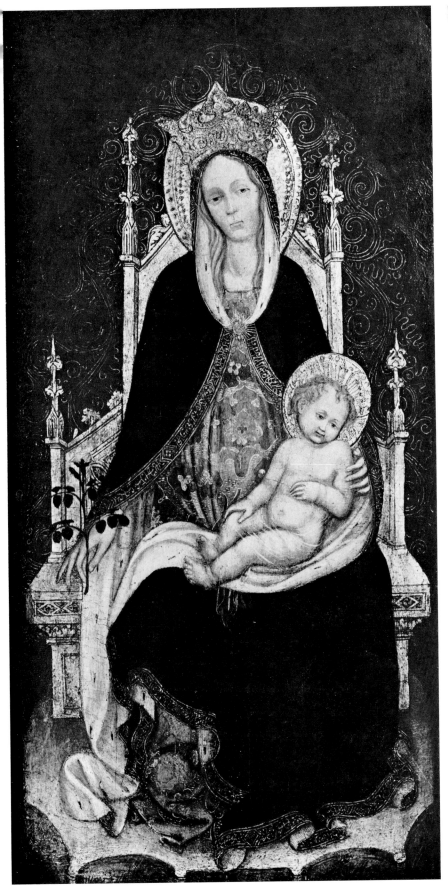

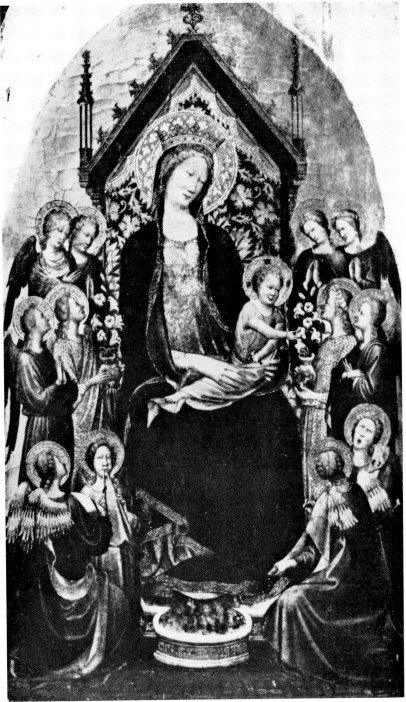

99. *Maestro del Bambino Vispo: Enthroned Madonna with Child and Angels. London, Private Collection.*

◁ 98. *Enthroned Madonna and Child. Rome, Palazzo Venezia Museum.*

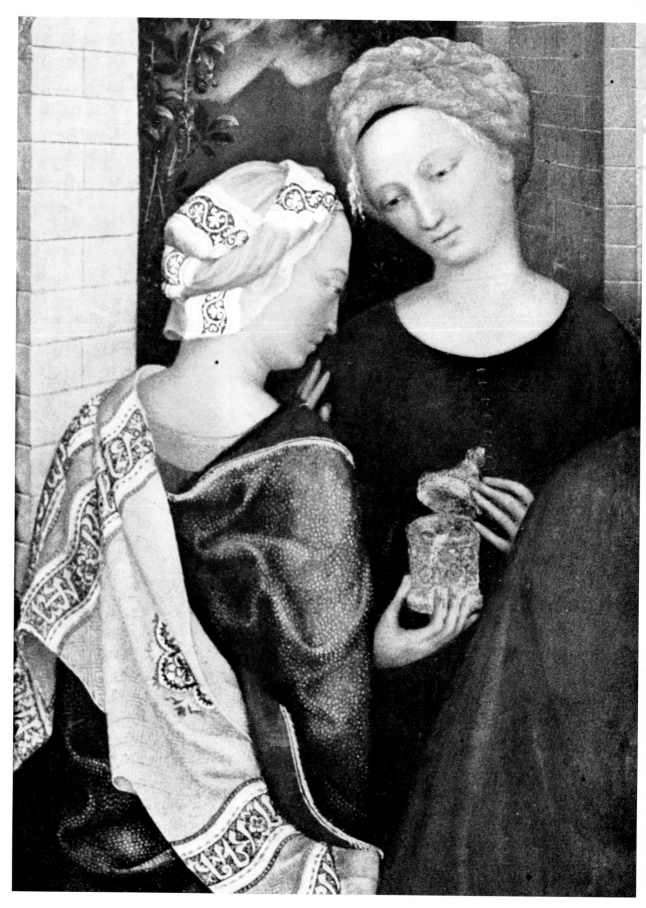

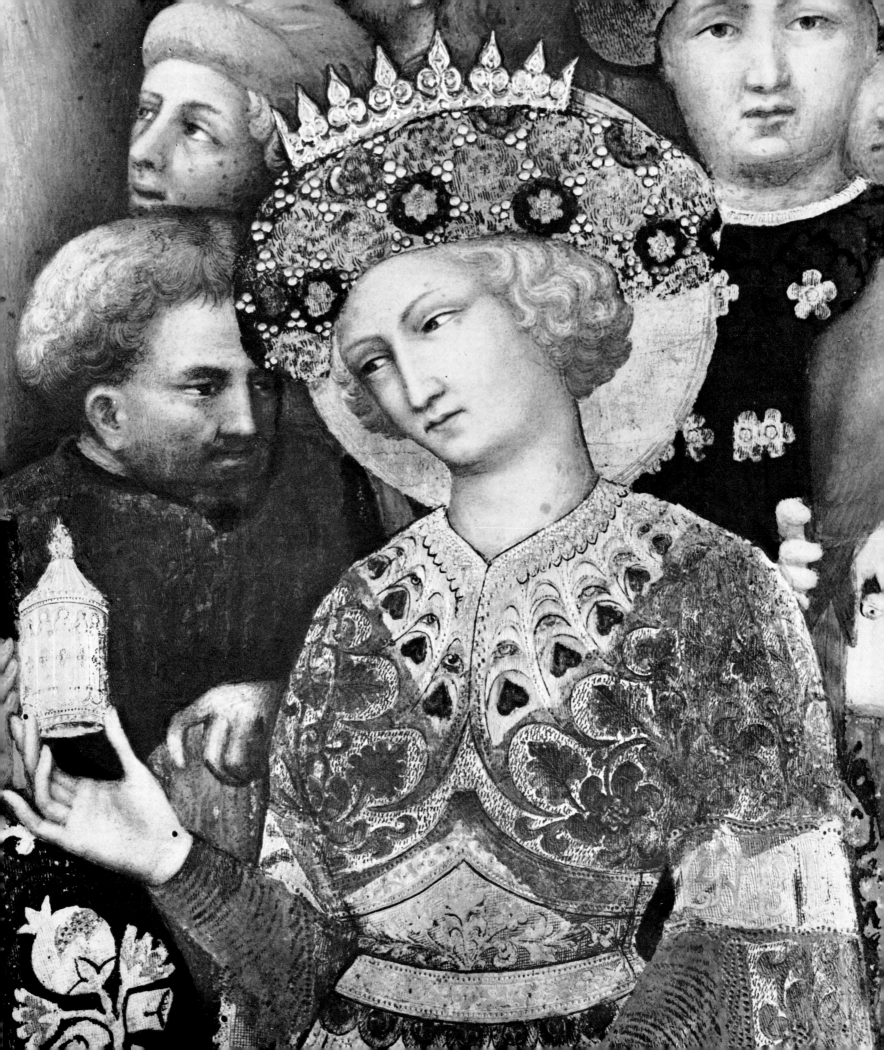

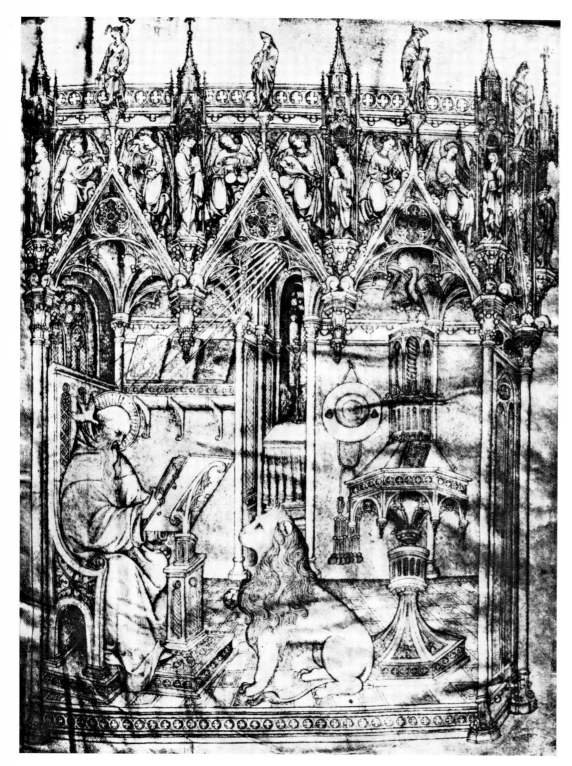

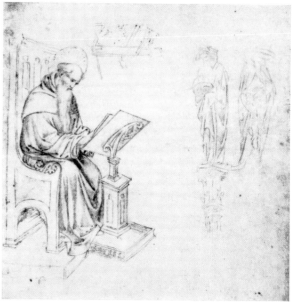

102. *Limbourg Brothers (?): St. Jerome in his Study. Paris, Bibliothèque Nationale (Fr. MS. 166, fol. A).*

103. *Architectural study. Rotterdam, Boymans Museum (Drawing No. I, 526r).*

104. *St. Jerome Reading and Statues of Prophets. Paris, Louvre (Drawing No. RF 423).*

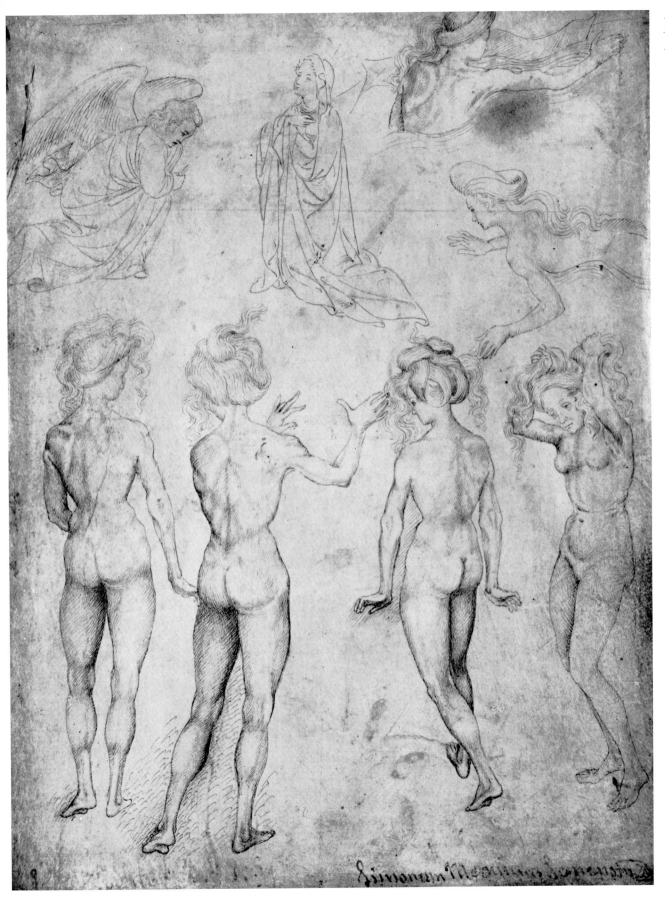

105. *Female Nudes. Rotterdam, Boymans Museum (Drawing No. I, 520r).*

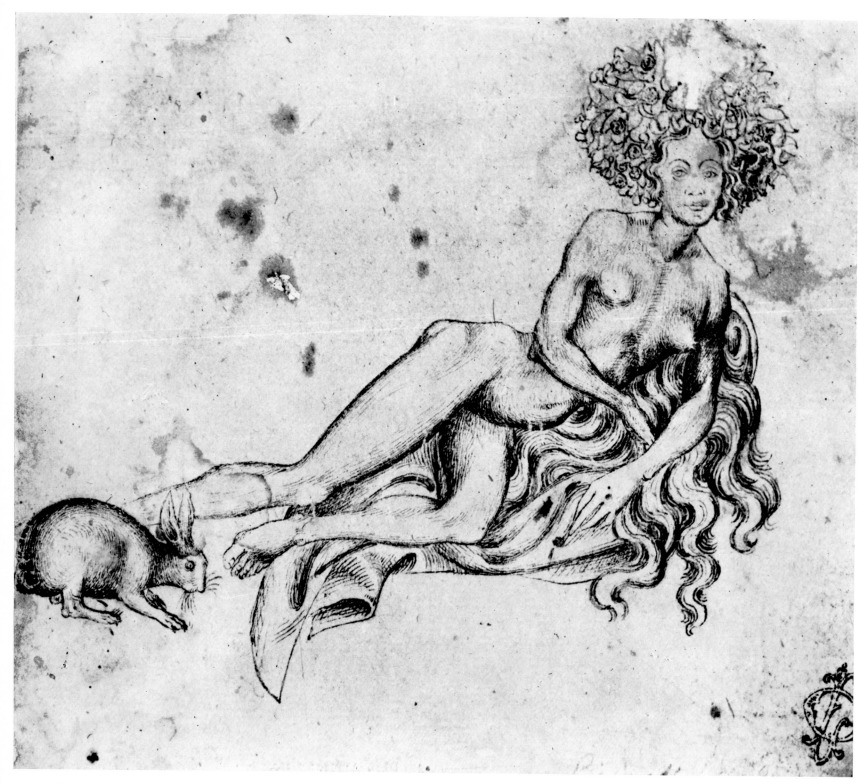

106. *Allegory of Luxuria. Vienna, Albertina (Drawing No. 24018r).*

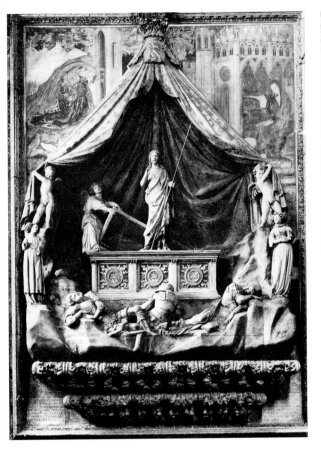

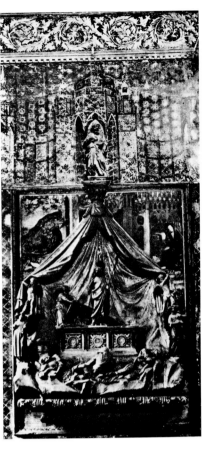

107. *Brenzoni Monument: the plastic composition and the Annunciation, detail. Verona, Church of S. Fermo Maggiore.*
108. *Brenzoni Monument. Verona, Church of S. Fermo Maggiore.*
109. *Serego Monument. Verona, Church of S. Anastasia.*
110. *Brenzoni Monument, engraving by Pietro Nanin made in 1864.*

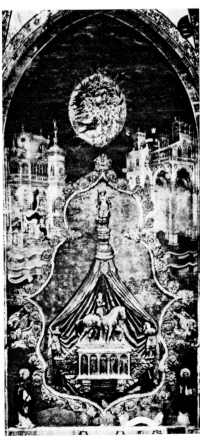

111, 112. *Brenzoni Monument: The Annunciation, details. Verona, Church of S. Fermo Maggiore.*

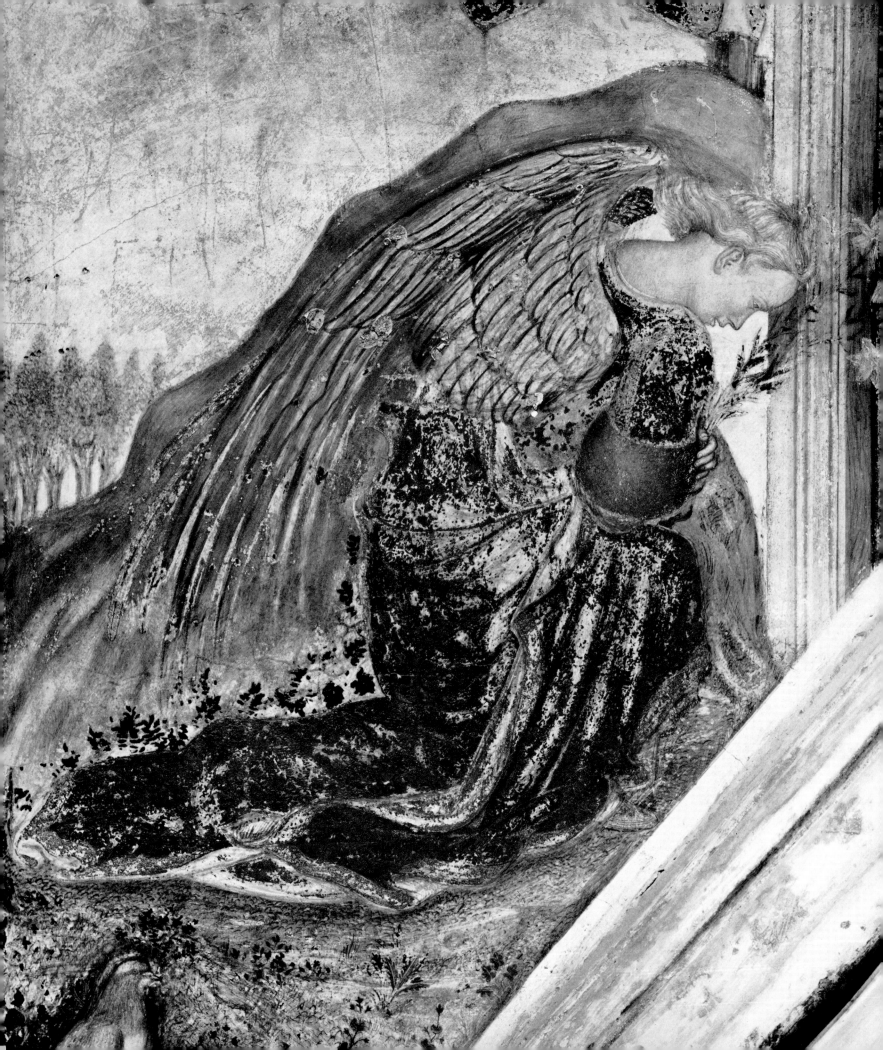

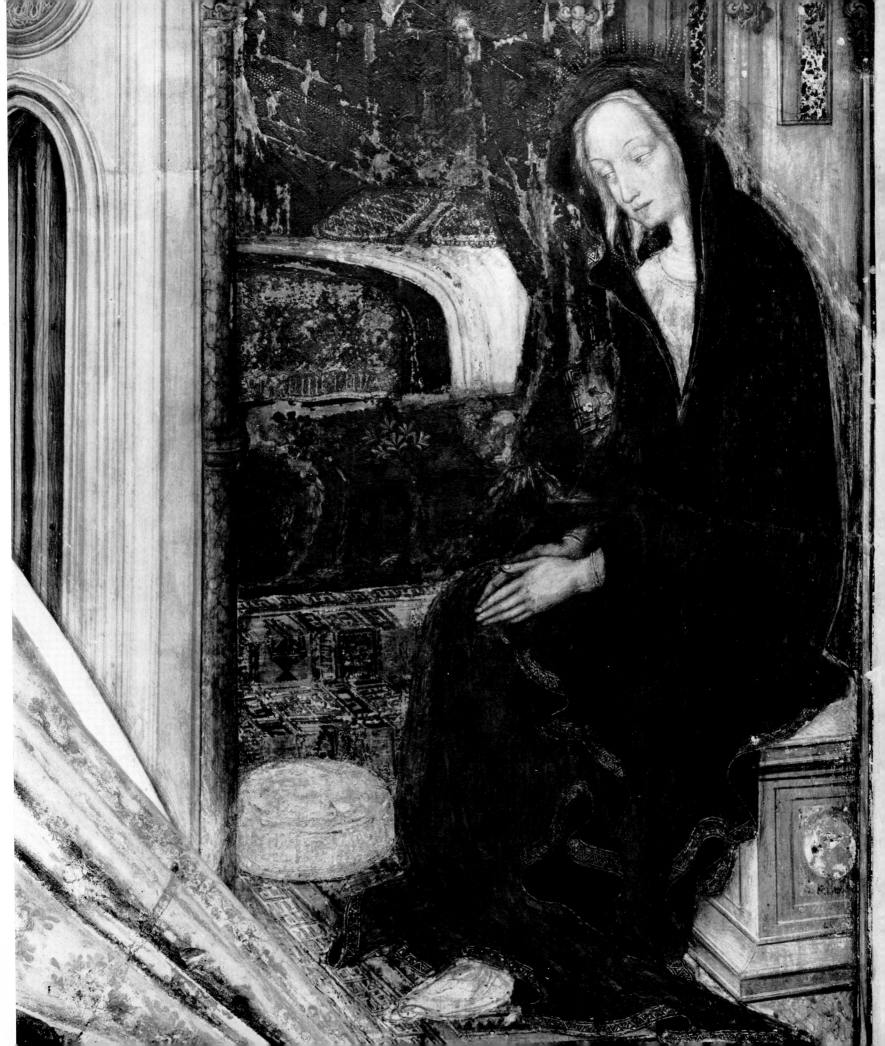

113. Brenzoni Monument: Doves, detail. Verona, Church of S. Fermo Maggiore.

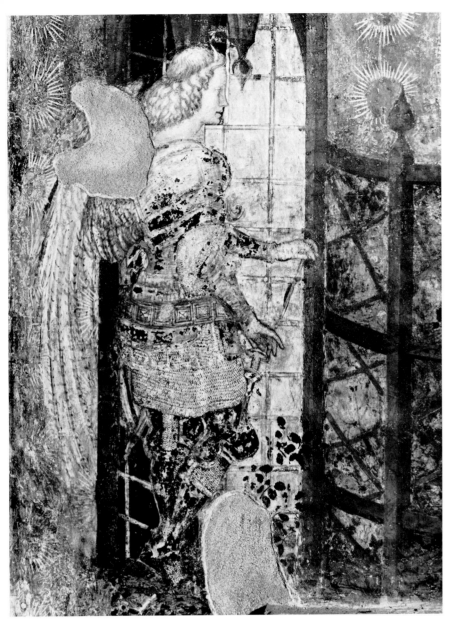

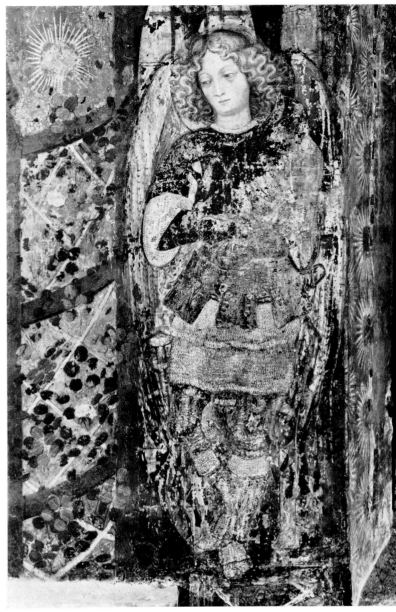

114. *Brenzoni Monument: Archangel Michael. Verona, Church of S. Fermo Maggiore.*

115. *Brenzoni Monument: Archangel Raphael. Verona, Church of S. Fermo Maggiore.*

116. *Brenzoni Monument: Archangel Michael, detail. Verona, Church of S. Fermo Maggiore.* ▷

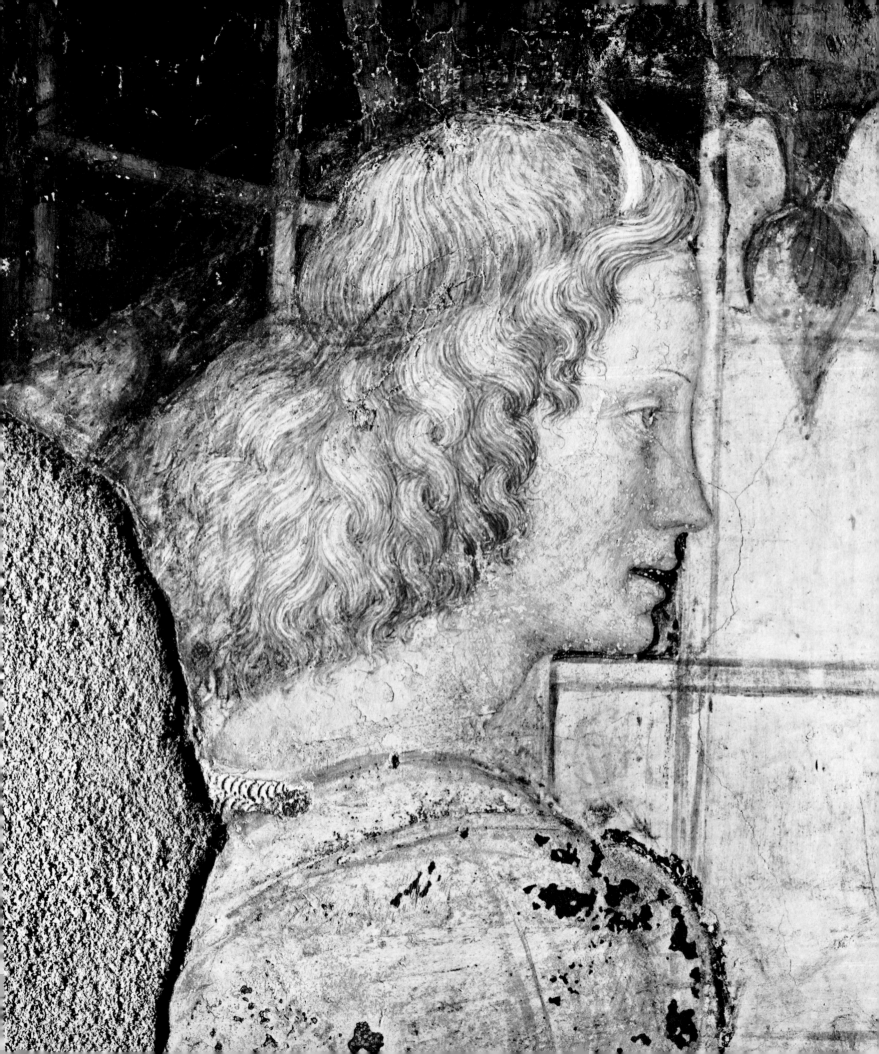

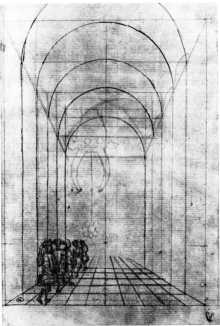

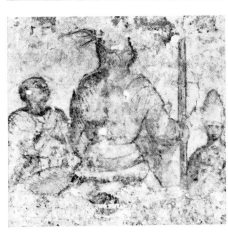

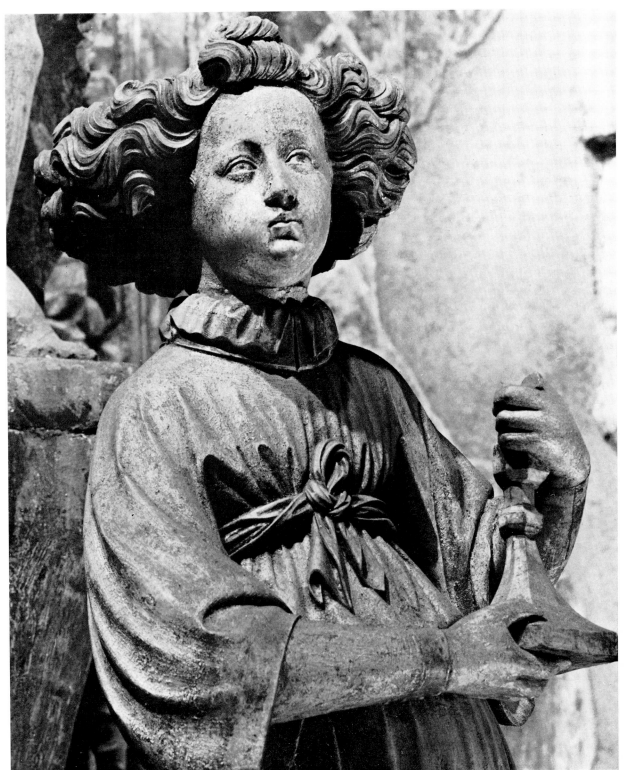

117. *Jan van Eyck: Hours of Milan, Mass for the Dead (c. 1415-17). Turin, Museo Civico.*
118. *Perspective study. Paris, Louvre (Drawing No. 2520).*
119. *Masolino and assistant: Crucifixion, detail of the sinopia. Rome, Church of S. Clemente.*
120. *Brenzoni Monument: Candle-bearing angel, detail. Verona, Church of S. Fermo Maggiore.*

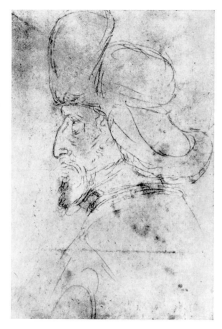

121. *Portrait of the Emperor Sigismund. Paris, Louvre (Drawing No. 2479).*

122. *Portrait of the Emperor Sigismund. Vienna, Kunsthistorisches Museum.*

123. Portrait of the Emperor Sigismund. Paris, Louvre (Drawing No. 2339).

124. Portrait of Margherita Gonzaga. Paris, Louvre.

125. St. George and the Princess, right hand side of the fresco. Verona, Church of S. Anastasia.

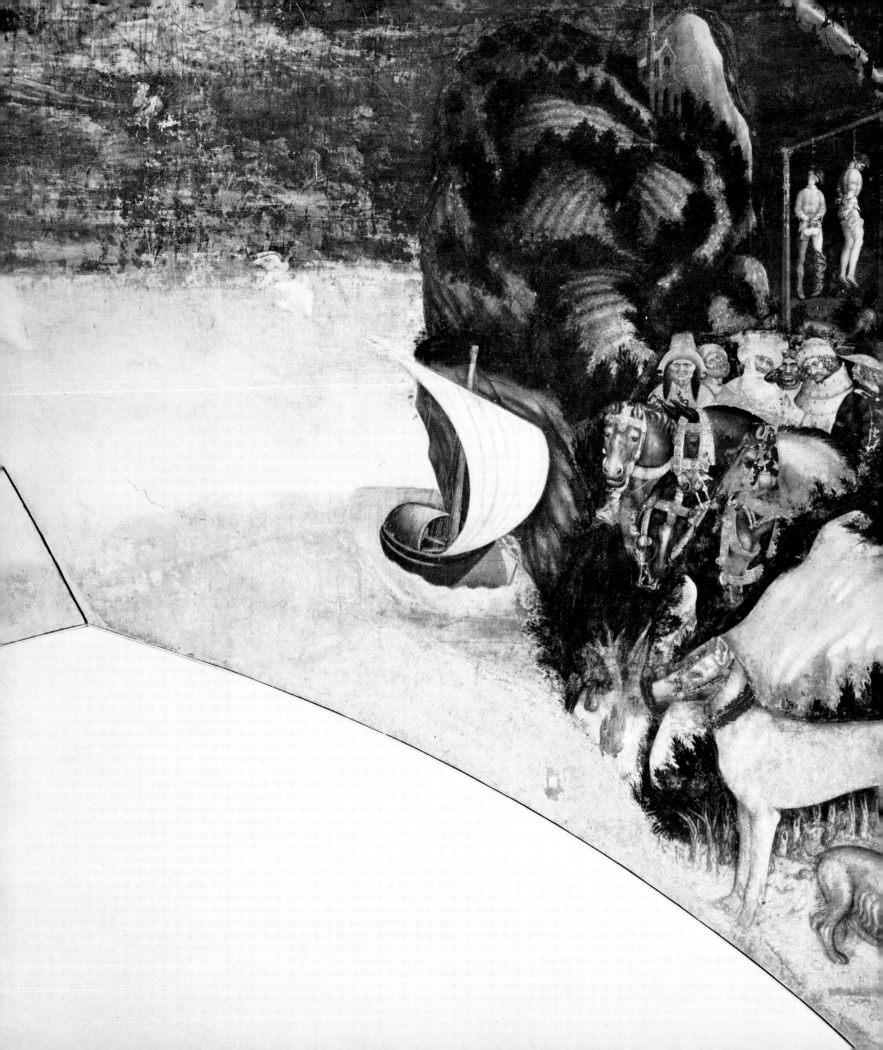

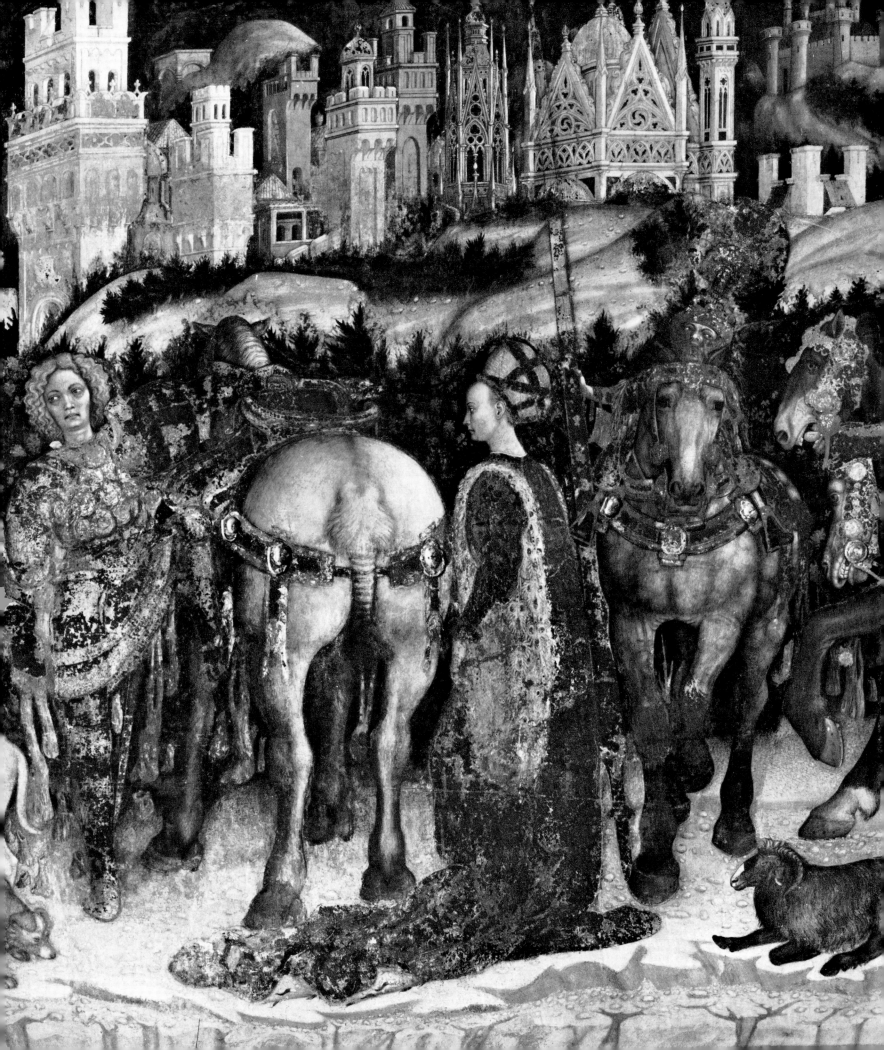

St. George and the Princess, details.
Verona, Church of S. Anastasia. |
126. The kingdom of the monster. |
127. The boat with sail unfurled. |
128. The city of crystal. | 129. Head
of St. George.

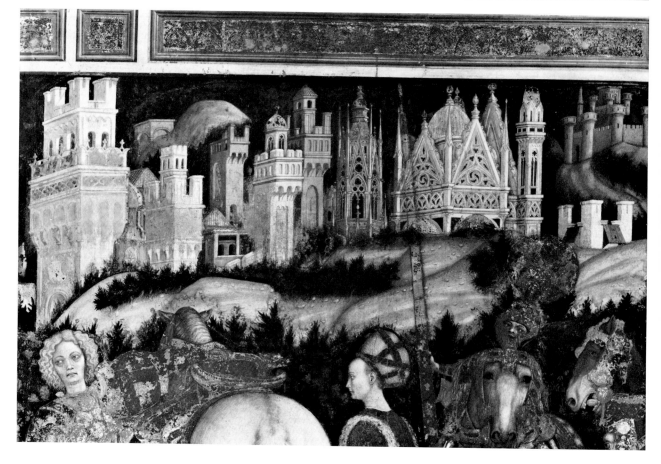

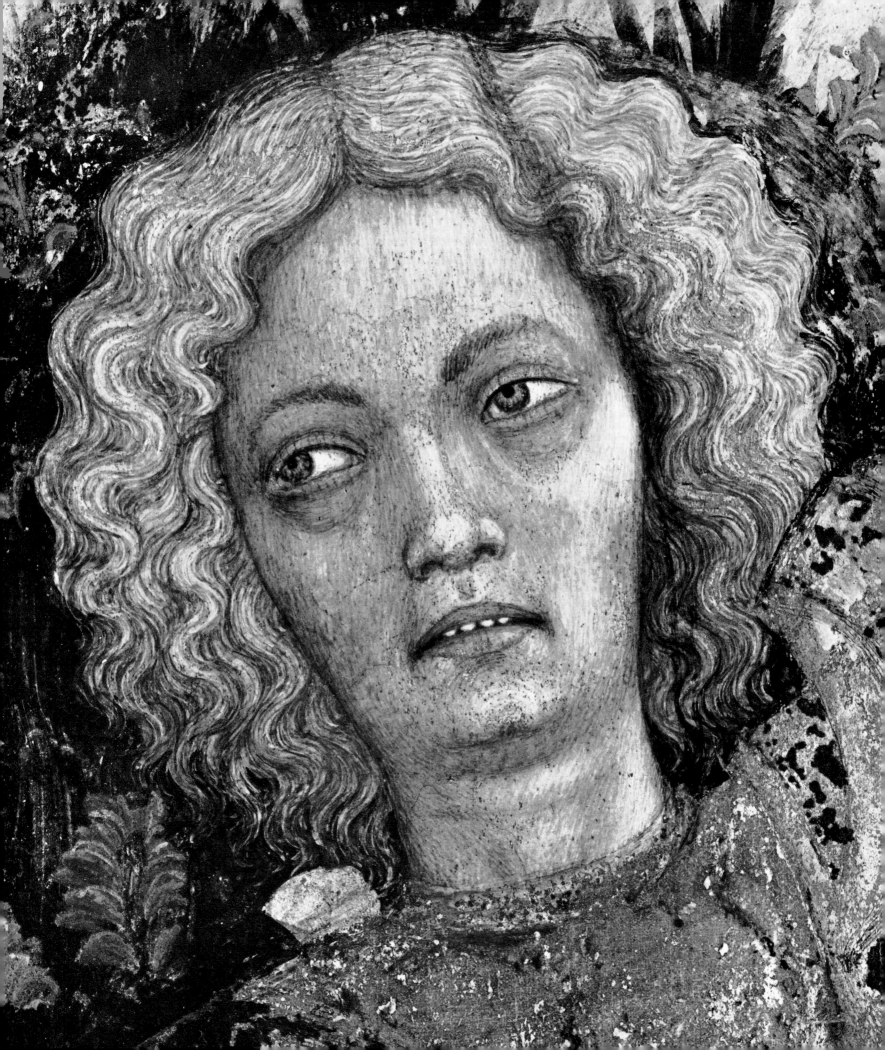

130. *Head of a woman. Paris, Louvre (Drawing No. 2342v).*

131. *St. George and the Princess, detail showing head of the Princess. Verona, Church of S. Anastasia.*

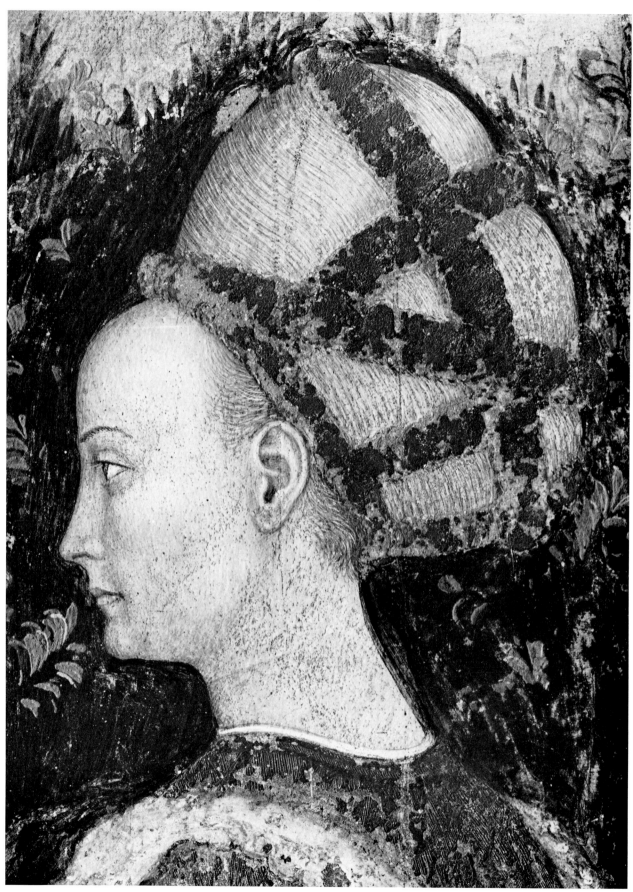

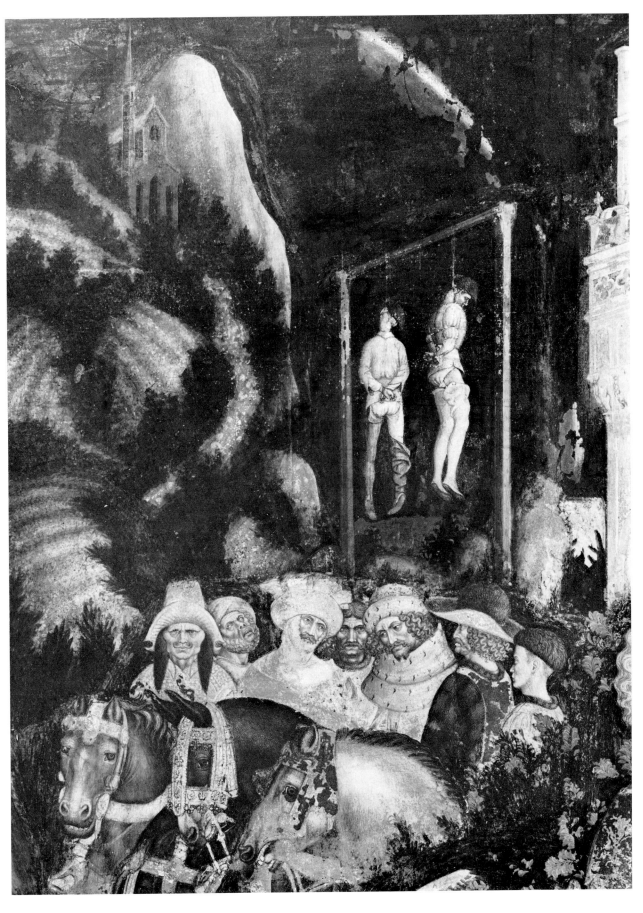

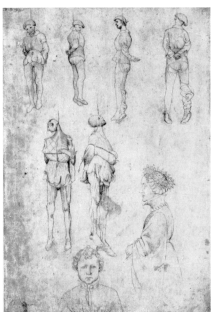

132. *St. George and the Princess, detail of hanged men and merchants. Verona, Church of S. Anastasia.*

133. *Hanged men and two portraits. London, British Museum (Drawing No. 1895.9.15.441).*

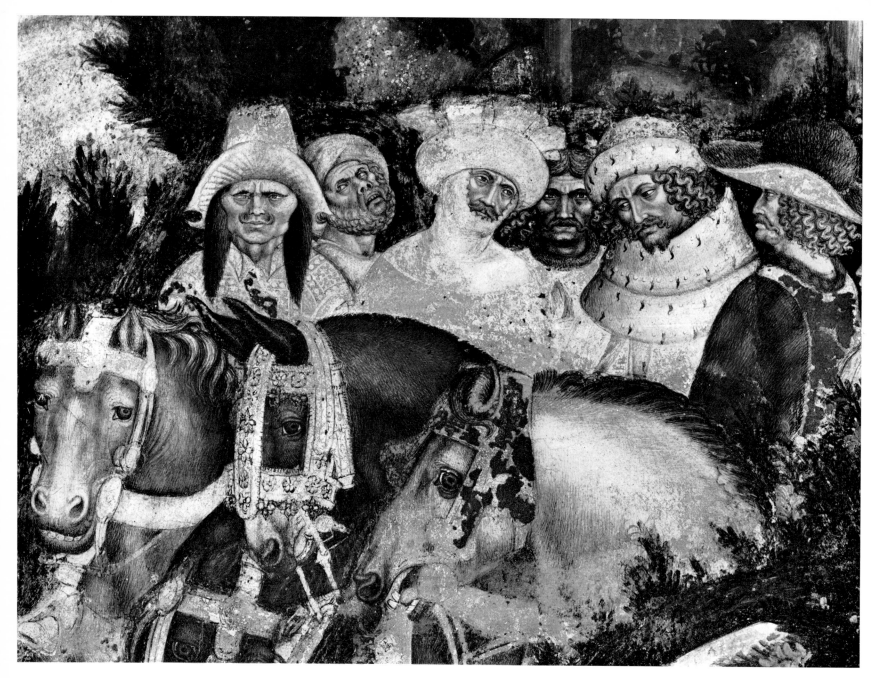

134. St. George and the Princess, detail of merchants. Verona, Church of S. Anastasia.

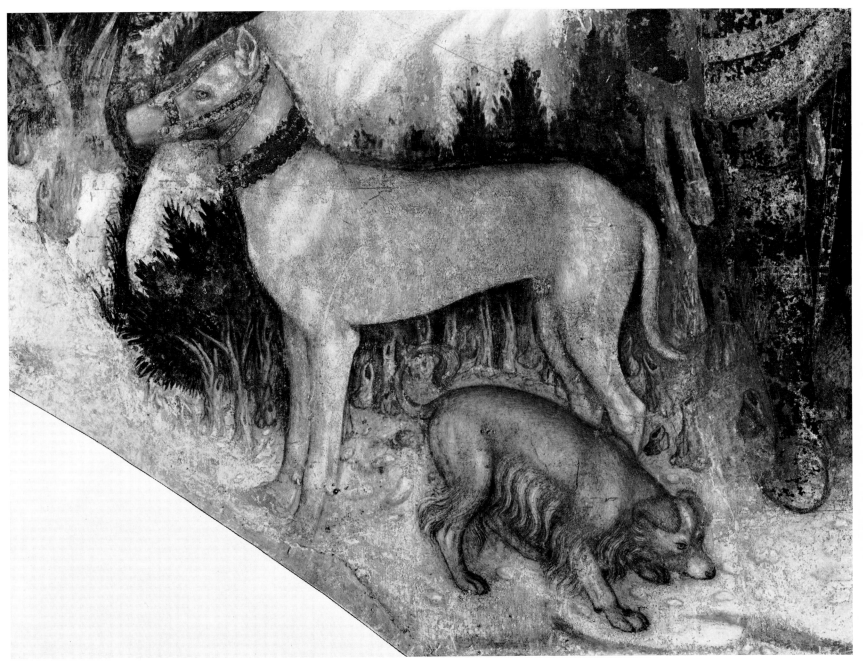

135. St. George and the Princess, detail with dogs. Verona, Church of S. Anastasia.

136. St. George and the Princess, detail with dead fawn. Verona, Church of S. Anastasia.

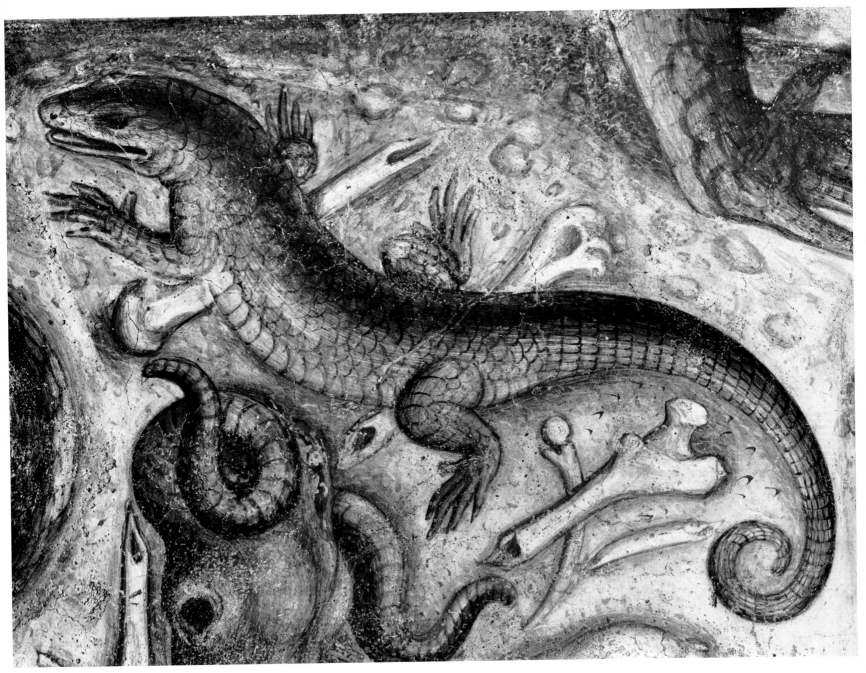

137. *St. George and the Princess, detail of the kingdom of the monster. Verona, Church of S. Anastasia.*

138. *St. George and the Princess, details showing outline of the city and migrating bird. Verona, Church of S. Anastasia.*

139. *St. George and the Princess, detail with birds. Verona, Church of S. Anastasia.*

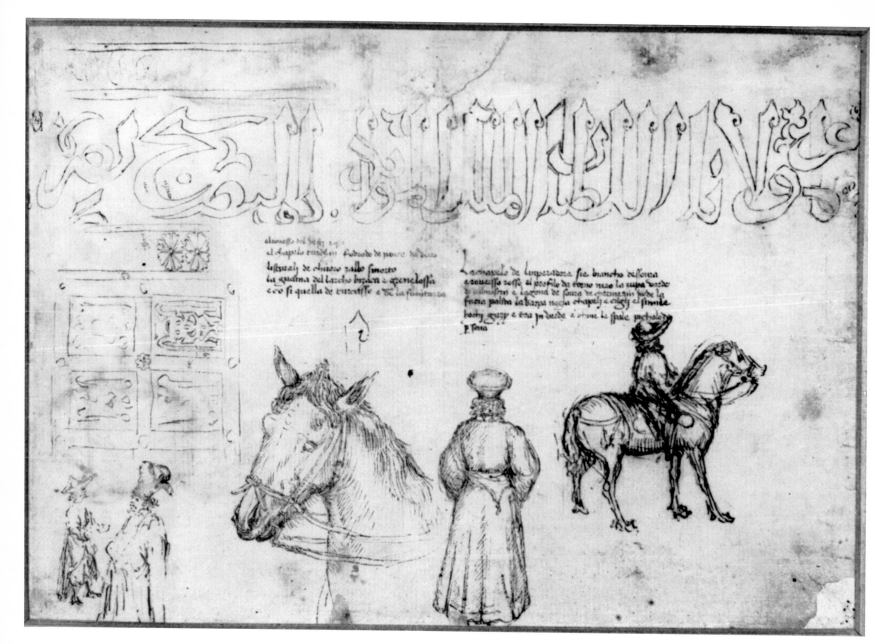

140. A knight, figures of orientals and text in Arabic script. Paris, Louvre (Drawing No. M.I. 1062r).

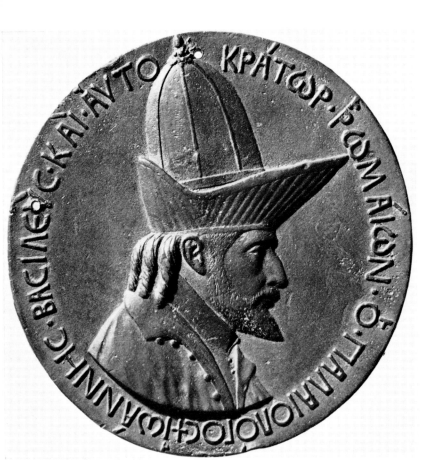

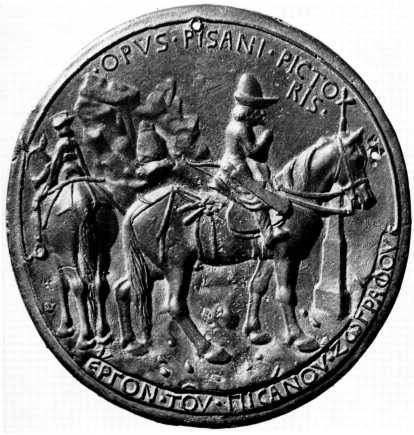

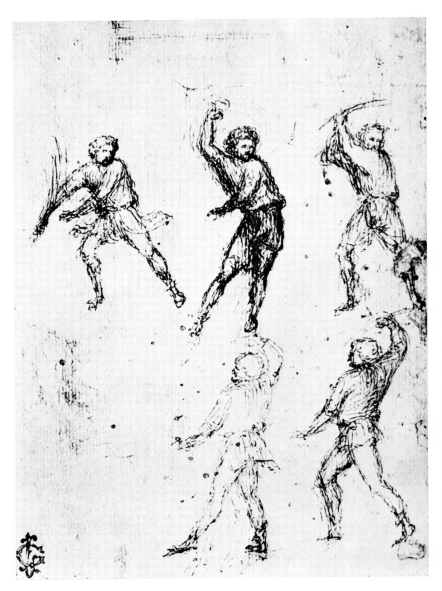

141, 142. Medal of John VIII Palaeologus. Florence, Bargello Museum.
143. Lorenzo Ghiberti: The Flagellation of Christ. Vienna, Albertina (Drawing No. 24409).

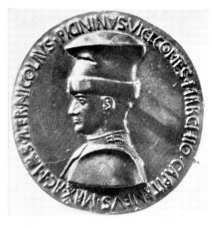

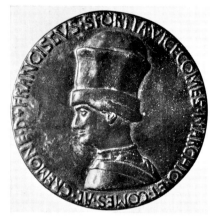

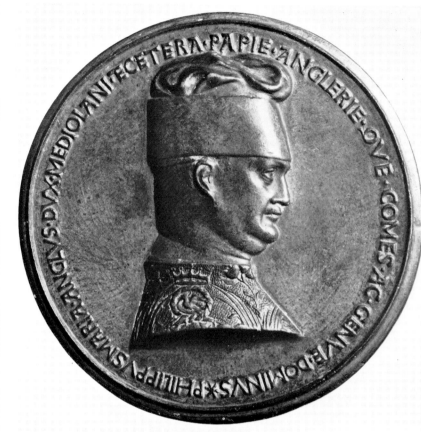

144, 145. *Medal of Niccolò Piccinino. Mantua, Museo del Palazzo Ducale.*

146, 147. *Medal of Francesco Sforza. Milan, Civici Musei del Castello.*

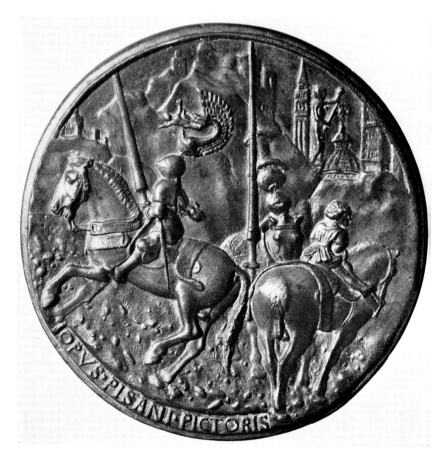

148, 149. *Medal of Filippo Maria Visconti. Milan, Civici Musei del Castello.*

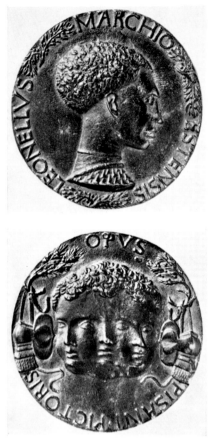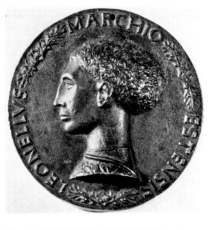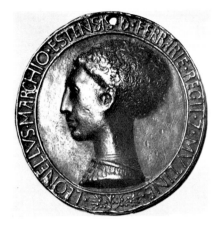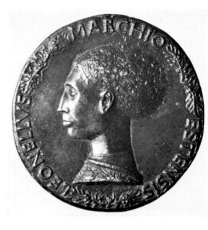

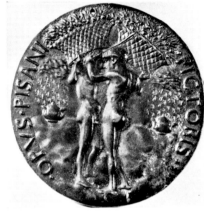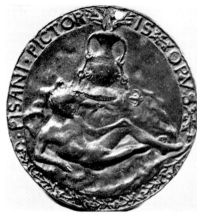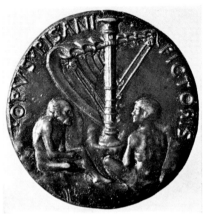

150, 151. Medal of Lionello d'Este. Brescia, Museo Cristiano.

152, 153. Medal of Lionello d'Este. Modena, Galleria Estense.

154, 155. Medal of Lionello d'Este. Modena, Galleria Estense.

156, 157. Medal of Lionello d'Este. Milan, Civici Musei del Castello.

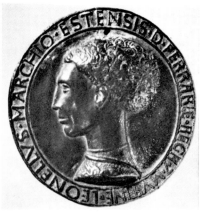

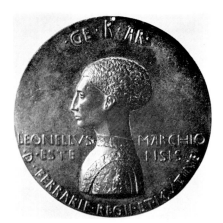

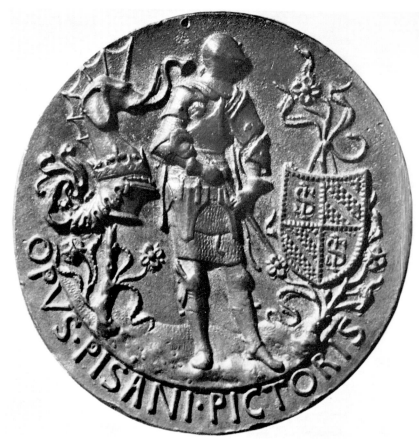

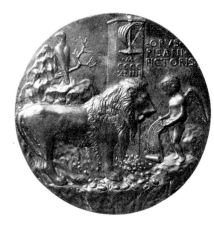

158, 159. Medal of Lionello d'Este.
Brescia, Museo Cristiano.

160, 161. Medal of Lionello d'Este.
Milan, Civici Musei del Castello.

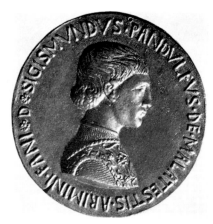

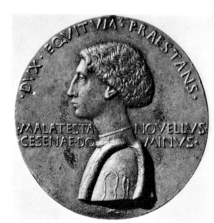

162, 163. Medal of Sigismondo Pan-
dolfo Malatesta. Florence, Bargello
Museum.

164, 165. Medal of Novello Malate-
sta. Florence, Bargello Museum.

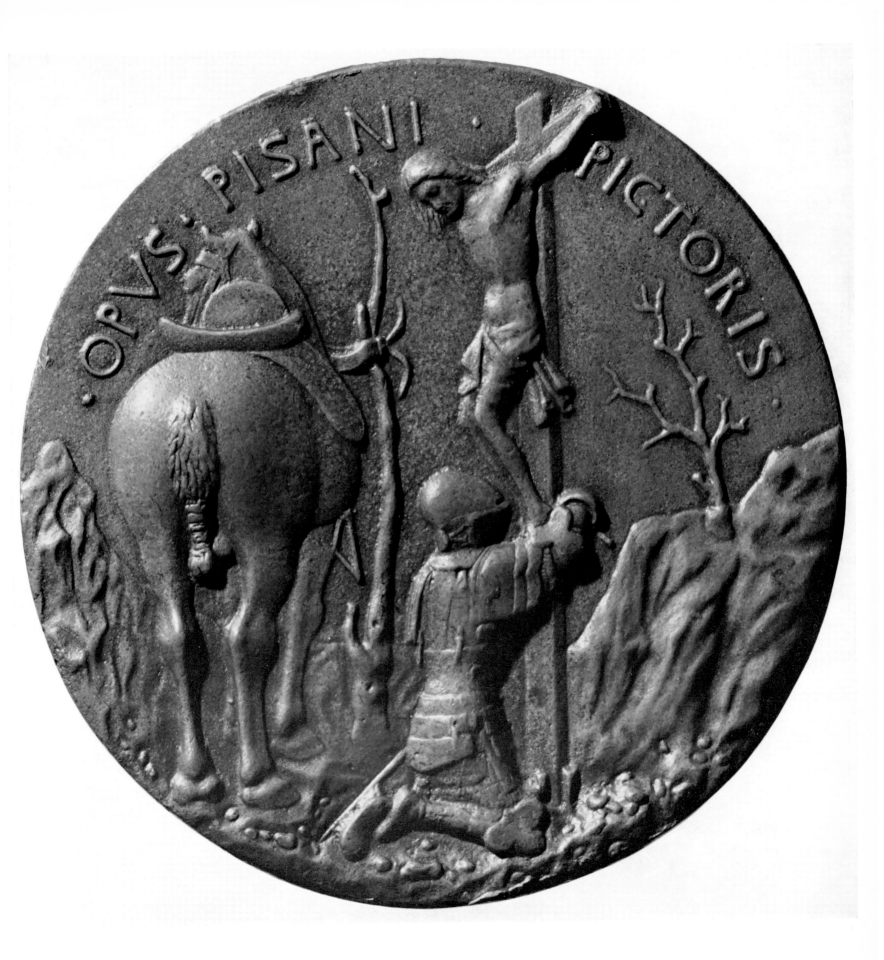

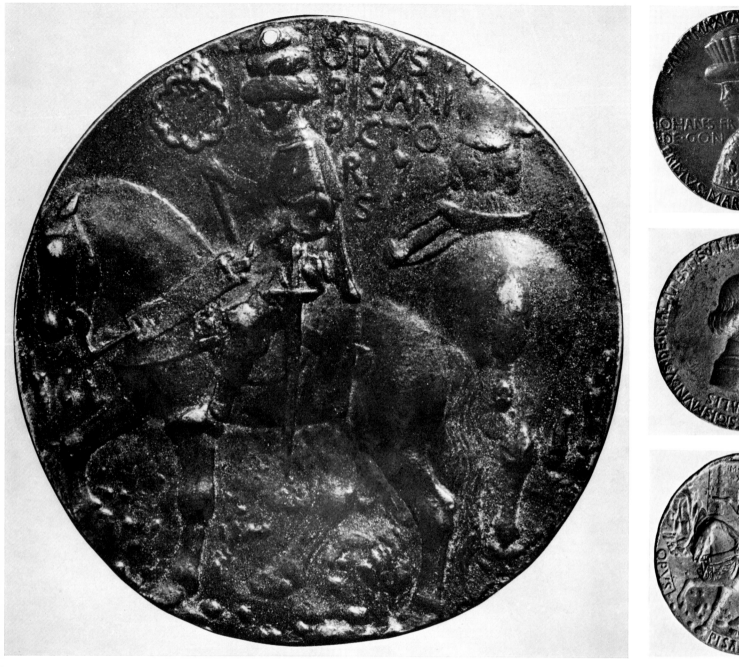

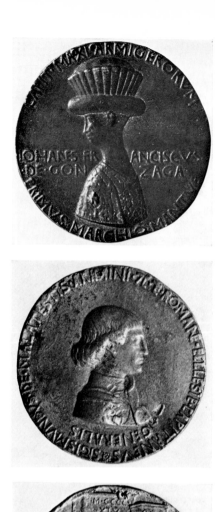

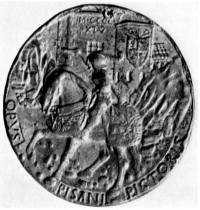

166, 167. Medal of Gianfrancesco Gonzaga. Mantua, Museo del Palazzo Ducale.

168, 169. Medal of Sigismondo Pandolfo Malatesta. Brescia, Museo Cristiano.

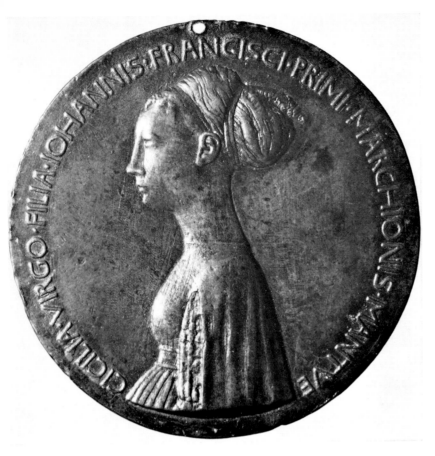
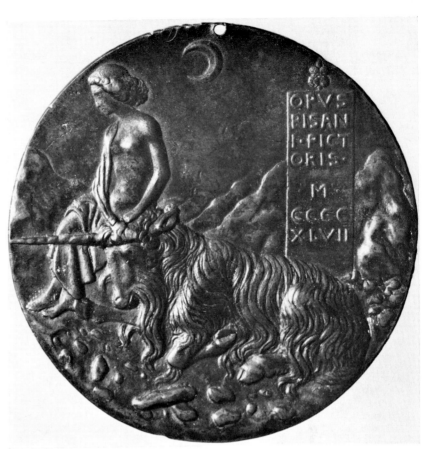

170, 171. Medal of Cecilia Gonzaga. Milan, Civici Musei del Castello.

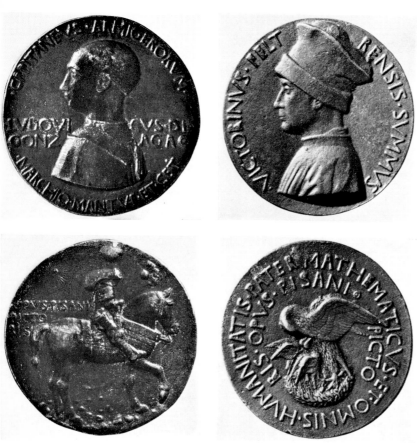

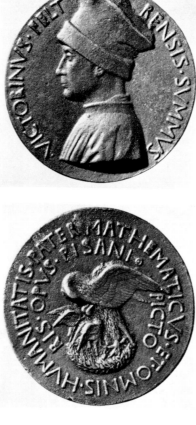

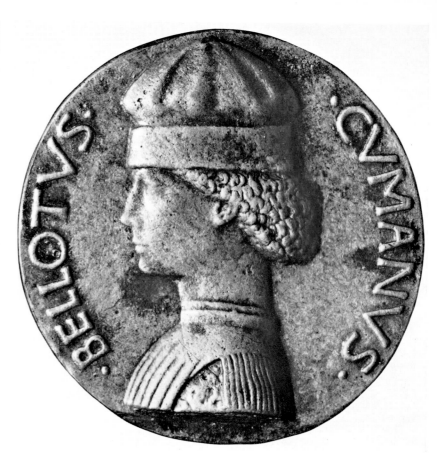

172, 173. *Medal of Ludovico II Gon-zaga. Mantua, Museo del Palazzo Ducale.*

174, 175. *Medal of Vittorino da Fel-tre. Florence, Bargello Museum.*

176, 177. *Medal of Bellotto Cumano. Milan, Civici Musei del Castello.*

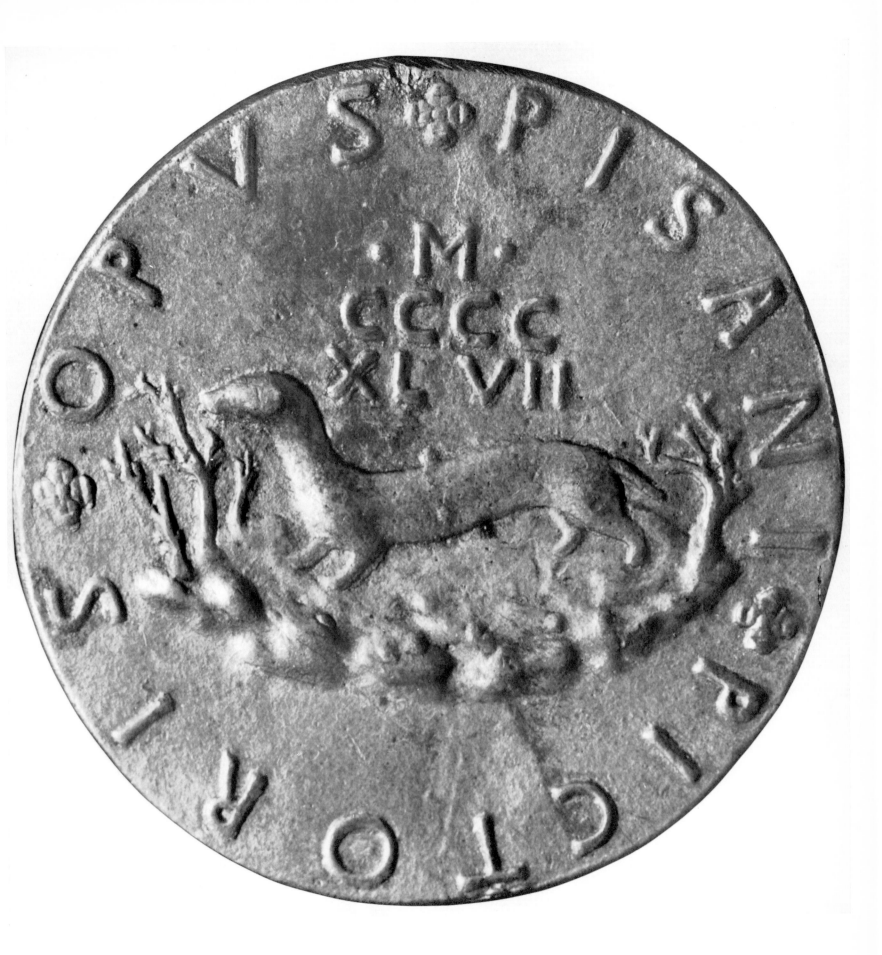

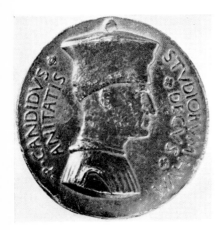

178, 179. Medal of Pier Candido Decembrio. Brescia, Museo Cristiano.

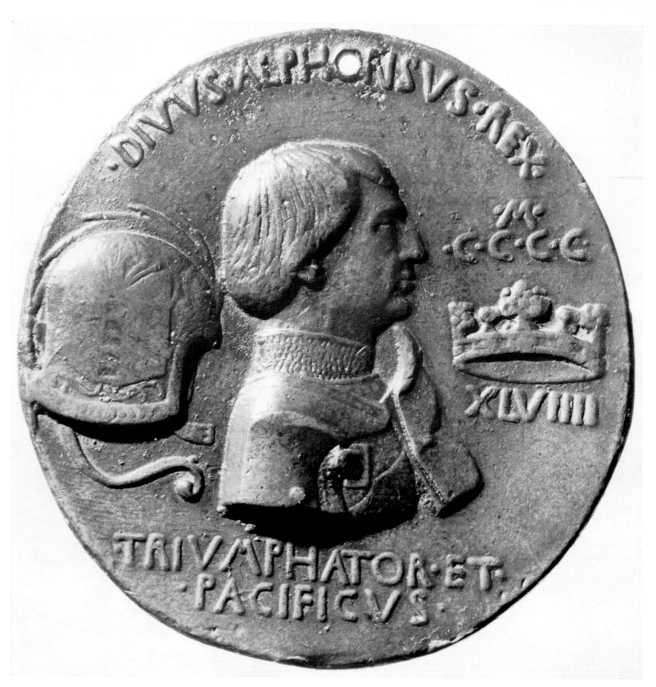

180, 181. Medal of Alfonso V of Aragon (Liberalitas Augusta). Florence, Bargello Museum.

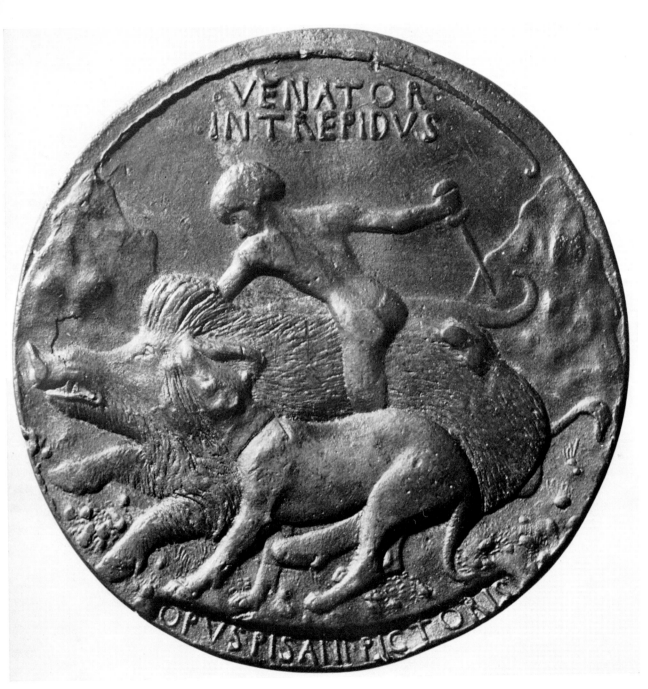

184, 185. Medal of Alfonso V of Aragon. Florence, Bargello Museum (?).

182, 183. Medal of Alfonso V of Aragon (Venator intrepidus). Florence, Bargello Museum.

186, 187. *Medal of Iñigo d'Avalos.*
Florence, Bargello Museum.

Chapter Five
SOME OBSERVATIONS ON PISANELLO'S LATE WORKS

The atmosphere of humanism and chivalry which filled the air at Ferrara in the day of Lionello d'Este, was not unlike that which developed during the same years at Mantua. Here the courtly humanism of Vittorino da Feltre, tutor to Marchese Ludovico Gonzaga, had been grafted on to the fourteenth-century tradition of chivalric fashion and culture.[1] These courts of Mantua and Ferrara, familiar to Pisanello through the long periods he had lived and worked in them, provided an ideal environment for the full development of his poetic world. But so too did the courts of the Visconti, the Sforzas, the Malatestas, and of Alfonso of Aragon, where he was much in demand as an artist, and his work was accorded the favour of princes and the praise of his humanist friends.[2] The courtly environment certainly did not impose a limit on Pisanello's artistic activity. He was the most advanced exponent in Italy of that movement which has been variously classified as International Gothic art, cosmopolitan art and courtly art (höfische Kunst). The term 'autumnal art' is still valid—notwithstanding a growing number of objections to it— in its meaning of decadence and feeling of 'fin de siècle' which it assumes in the evocative but pessimistic account Huizinga gives of the period in his *Waning of the Middle Ages*.[3] An earlier study by Schlosser, dedicated to fourteenth-century courtly art, contains a much more objective and positive picture. He saw the late fourteenth century as a period when medieval forms attained the rich colours and succulence of fruit at the peak of ripeness and just ready for harvesting.[4]

At the end of the fourteenth century and in the first half of the fifteenth, European courts accumulated works of art reflecting fashionable cosmopolitan taste, and emerged as centres where artists from different countries could meet and exchange ideas. This taste for cosmopolitan art was not confined to the court circles in which it had largely developed, but spread to other places at every level of contemporary society, even to Florence where 'cosmopolitan decadentism' was more esteemd than the works of the great innovators, even of Masaccio or Donatello.[5] It was considered to be the most up-to-date approach to the problem of finding new subjects and new forms of expression, the 'modern way of art'.[6] The popularity enjoyed by the 'beautiful and delightful' romances of chivalry was itself the result of an increasingly marked preference for the profane rather than the sacred. One of the best-loved saints at that time was St. George, the purest representative of the ideals of chivalry which had been revived within the environment of the courts and the wealthy bourgeoisie, and his popularity reflected the

literary taste of an era in which the modern heroes of chivalric narrative were esteemed as much as the ancient heroes of the classical world.

However, the unity of artistic language which developed in the western world during that period did not have the uniformity of a common dialect, nor did it have that kind of formal structure which recognizably belongs to a particular place and which, because of its quality and modernity, can extend its cultural domination to European scale. Though interest in the tradition of chivalrous literature and in French artistic fashion was very marked, it did not however hold an exclusive or even predominant position. The so-called 'internationalism' in the figurative arts of the time was actually made up of an extraordinary range of expressions all differing from one other yet all linked in some way. According to Pächt in his most recent study on this unprecedented phenomenon, the great variety of artistic forms was due above all to the multiple and continual exchange of ideas regarding techniques, subject matter and formal concepts; often these ideas were extremely diverse, but that complicated dialogue between artists of differing background and from all over Europe, gave rise to a surprisingly homogeneous result.[7] Much research has been dedicated to that outcome and to the various phases of development of the cosmopolitan style. Scholars have come up with different solutions to the problems raised, but their studies all lead to a single overall view of that complex historical period.[8] Research has shown that the contacts which Italian 'International' artists had with artists of other countries—Bohemian, Rhenish, French and Flemish—were extraordinarily lively between the Trecento and the Quattrocento. It is remarkable, as Panofsky observed, that the art of Gentile da Fabriano and of Pisanello had greater affinity with the Limbourg brothers, than with local artists who preceded or followed them, and this demonstrates how freely and intensively artistic ideas were circulating throughout Europe.[9]

To return to Pisanello, it is important to realize that, if he was not involved in the great movement being activated in the early fifteenth century by Brunelleschi, Masaccio and Donatello—a movement with which he was very familiar and to which he had devoted perhaps as much attention as he had to the study of classical relief in Rome—then this was due to his outlook as a cosmopolitan painter. For him the exquisite naturalism which had spread throughout Europe with the *ouvraige de Lombardie*[10] and the new trends in painting abroad which were equally important to him, particularly the Franco-Flemish painting of the Limbourg brothers, the Van Eycks, the Master of Flémalle and Roger van der Weyden, were in complete accordance with the 'modernity' (understood in the sense which the term had at that time) of the researches carried out by Florentine artists whom he regarded most highly, such as Ghiberti, Paolo Uccello and Masolino. In this connection it is significant that Facio, when writing in the *De viris illustribus* the biographies 'de iis paucis (*sic*) Pictoribus atque Sculptoribus, qui hac aetate nostra claruerunt' includes among the painters only two Italian International artists, Gentile da Fabriano and Pisanello, whom he places deliberately side by side with the two great Flemish artists, Jan van Eyck and Roger van der Weyden. Among the great sculptors he considers the most important to be Lorenzo and Vittore Ghiberti, whom he sees as being, stylistically, a single personality ('Ita enim inter se utriusque videantur'), and after them, Donatello.[11] This assessment, remarkable for the time in which it was written (*c.* 1455–6), has been

taken as evidence of Facio's taste for the International style as well as of his knowledge of Flemish painting.[12] Probably it also reflects the exchanges of ideas on art which he had had in Naples with his friend Antonio Pisano, who in person ('ex eo audivi') informed him of various items, such as for example the poor condition of the *Scenes from the Life of St. John the Baptist*, which Gentile da Fabriano and Pisanello had painted between 1427 and 1432 in the basilica of St. John Lateran. It is in any case clear that the work Pisanello carried out in the last ten years of his activity was considered to be on a level with that of the most important Italian and Franco-Flemish International artists. Also, since Facio's opinions were probably similar to Pisanello's, it is significant that Ghiberti was placed among the sculptors even before Donatello, and above all for his creation of the Door of Paradise, a work which for Antonio too was 'inenarrabilis'.

The very high esteem accorded to Pisanello around the middle of the century is demonstrated by his intense period of activity during the last years of his life at the most important Italian courts, above all those of the Gonzagas, the Este and Alfonso of Aragon. Facio seems to credit Antonio with the extraordinary gift of objective representation of a Jan van Eyck and the subtle interpretation of inner sentiments of a Roger van der Weyden ('in pingendis rerum formis, sensibusque exprimendis ingenio prope poetico putatus est').[13] The position assigned to him among these artists is a reflection of the nature of the more intensely pictorial style of Pisanello's last period and the fundamental cultural relationships apparent in his late works executed in Mantua, Ferrara and Naples. In these, there is a unity of poetic and formal tone which makes it difficult to establish the order in which they were done and in some cases even to decide with any certainty in which of these three courts they were created. But in the masterpieces of the fifth decade which impart a sense of fulfilment to the multiple experiences which had accumulated in the course of this great painter's life as a wandering court artist, it is possible to detect a steadily growing interest in French and Flemish painting, especially in the small paintings and portraits. This interest proceeds *pari passu* with the development of what he learned from Ghiberti, whose influence is discernible in the airy, supple line of the famous medals and in the intense light and shade values of the late drawings. It can also be seen in Pisanello's handling of the problem of organizing the open and unbroken structure of the narration in his last pictorial compositions, above all in the chivalric cycle in Mantua. This work, using modern procedures yet without any substantial departure from the late Gothic style, represented an advance on the tradition of Italian large-scale mural painting, which had played a far from negligible part in Ghiberti's own training.

The characteristics of the two small panel paintings depicting the *Madonna and Child with Saints Anthony and George* (Plate XX; Figs. 199, 203) and the *Vision of St. Eustace* (Plate XIX; Figs. 189, 191) in the National Gallery in London[14] suggest that they belong to the last period of Pisanello's activity and that it was to works of this kind that Facio was referring when he wrote that the artist had painted in Mantua a number of highly esteemed panels.[15] The sketches for a Madonna and Child and for the more complex composition of an altarpiece (Figs. 208, 212), outlined on the top part of some folios in

the Vallardi collection (Louvre Nos. 2278, 2300), may also be regarded as ideas for some of those much-praised panels, executed by Pisanello at the court of the Gonzagas. It is possible that the sketch of the Madonna and Child contained within a bright, radiant mandorla (Fig. 208) was the starting-point for the composition of the *Madonna and Child with Saints Anthony and George* (Fig. 199), whose strange iconography is still not satisfactorily explained. The upper part of the painting showing the Madonna within the circle of the sun corresponds to a drawing from the Pisanellian repertoire (Louvre No. 2623v) depicting a Madonna and Child (Fig. 200), which Glaser recognized as deriving from a composition by the Limbourg brothers.[16] This theme was then analysed in all its aspects in the essay by Pächt which I have already mentioned.[17] The iconography of the Madonna is the result of combining the medieval idea of the Virgin and Child appearing '*in circulum iuxta solem*', revealed to Augustus by the Tiburtine Sibyl on the site of the Aracoeli, with that of the apocalyptical '*Virgo amicta sole*' (Apocalypse XII, 1). The Limbourgs perhaps first used this theme when they adopted the motive of the Virgin *glykophilousa* (the Madonna caressing the child) in the two illustrations of Augustus and the Sibyl illuminated in the *Belles Heures* now in New York and in the *Très Riches Heures de Chantilly*.[18] And since Pisanello's drawing of the Madonna obviously derives from the iconographic invention of the Limbourgs, Pächt infers that the strange halo which Pisanello painted around the sun was also from a lost prototype of the Limbourgs, depicting a third variant of the theme of the Madonna appearing to Augustus and the Sybil.[19] Certainly, when compared to the Limbourgs' composition, this work by Pisanello becomes more comprehensible, since here too the vision of the '*Virgo amicta sole*' has a particular significance in relation to the two figures of St. Anthony and St. George below. But in the Limbourgs' representation, the relationship between the figures of St. Augustus and the Sibyl and the Madonna at whom they are gazing, is quite obvious, while it is much less clear in Pisanello's panel. Here the two saints are not paying any attention to the apocalyptic Virgin who appears in the sky in the great disc of the sun surrounded by an enormous iridescent halo in flames.[20] (This disturbing phenomenon seems both a sudden and mysterious occurrence and at the same time has the value of a refined decorative symbol.) The saints are facing each other on the edge of a wood deep in shadow and staring at one another intently. The hermit St. Anthony, who has a luminous elliptical halo around his cowl, turns his severe gaze on St. George and it almost seems as though he wants to introduce the elegant, worldly knight to a life of penitence like his own. What does all this mean, if the persons represented are indeed the two saints I have named? Instead of a halo, which would have been an iconographic indication of his sanctity, the knight has on his head a large straw hat in the fashion of the time. Pisanello probably did not intend to depict St. George himself, but a knight dressed as St. George, in which case the painting could have had a votive significance and the patron was represented in the clothes of the saint of whom he was a votary. The resemblance of the knight to the idealized, youthful Marchese Ludovico Gonzaga, and to the profile of the same Marchese in Pisanello's medal of about 1447–8, makes it seem likely that Ludovico wished to be portrayed in the clothes of St. George in a painting dedicated to the Madonna, perhaps in gratitude for some important grace received, as in votive pictures which depict the person who is making the offering.[21] The Cross of St. George had for a long time been

an heraldic emblem of the Gonzaga family[22] and Ludovico's devotion to St. George was explicitly declared in the letter of 1453 (the test of which I quoted earlier in order to show the spirit of chivalry it reflects) where the Marchese announced to his wife Barbara that he had defeated in battle his brother Carlo 'cum la gratia de esso Idio, de nostra Donna e di *San Zorzo*'.[23] The portrayal of Marchese Ludovico as St. George therefore seems to be the most logical explanation for the iconographical significance of the elegant figure of the knight in this painting, generally considered to be a late work of Pisanello by almost all scholars, except Van Marle who maintains it is a juvenile work.

The relationship between this small masterpiece and works by the Limbourg brothers, and signs of the influence of the *ouvraige de Lombardie* and of miniatures by foreign painters, are noticeable not only in the iconography but also in the actual formal structure of Pisanello's paintings, composed of a dense fabric of minute brush strokes. These links seem to suggest that among the various forms of expression which he employed to represent his poetic world, he also practised the art of miniature—a hypothesis often put forward by Pisanellian scholars. The very beautiful miniatures contained in a small codex which belonged to the Gonzaga family, are known under the name of Helio Sparciano (*Scriptores Historiae Augustae*; *Vitae diversorum principum et tyrannorum a diversis compositae*, MS. E. III 19, Biblioteca Nazionale, Turin); attributed to Pisanello by Carta, and to Matteo de' Pasti by Adolfo Venturi,[24] they can probably be regarded as valuable evidence of Antonio's activity as a miniaturist. The restored folios which I saw on display at the exhibition of Gonzaga codices, organized in 1966 in Mantua by Meroni,[25] even though some were done by the assistants from his workshop, seemed to me to represent the pictorial fineness and intensity which the artist attained in the fifth decade of the century. When it was mistakenly believed that the codex had been lost in the fire in the Turin library in 1904, Fogolari, though he did not go so far as to name Pisanello directly, when trying 'to determine the illustrious artist who had created this marvellous work', considered the miniatures to be very close to many of Pisanello's drawings. The detailed description which he gave of the pictorial values and the courtly and chivalrous tone of these illustrations[26] was like a paraphrase of the poetic world and the extreme refinement of certain of Antonio Pisano's late works. Some of the folios depicted a series of medals with portraits of emperors, taken with great iconographic licence from Roman coins: their facial features and colour were so sharply differentiated that it seemed as though they had been portrayed from life (Figs. 192–4). What I noticed above all, however, was that the vivid pictorial images painted in miniature on those luminous sheets of vellum, displayed an elegance which reflected the sights and splendours of the courtly and chivalric environment in which the artist lived, and keen curiosity about the infinitely varied aspects of nature. The first folio showed the Gonzaga coat of arms supported by two *putti* (which might have some connection with the similar theme shown in drawing No. 2278 in the Louvre) (Fig. 208); five medallions containing figures of warriors in black and white armour; St. George on a white horse killing the dragon with his lance in order to free the princess; figures of pages and young girls in elegant fifteenth-century costumes; and various animals. On the other folios followed busts of emperors and tyrants, the lives of whom were described in the text; but the artist's keenest interest lay in the representation of knights and ladies wearing costumes of unparalleled refine-

ment.[27] Fogolari's notes on these miniatures[28] almost seem a description of the fashionable costumes represented in the watercolour drawings in the Bonnat Museum at Bayonne, the Condé Museum at Chantilly, and the Ashmolean at Oxford (Figs. 195, 196, 198), where the gentlemen and their ladies are seen and portrayed with enjoyment and admiring wonder, as though the artist were carried away by the fascination of that strange beauty. Yet at the same time they are observed with a critical eye as though they were animals of some rare species, caught in the postures and the multi-coloured apparel of their ceremonious courtly game. In all the miniatures the artist was intent on capturing the vitality and beauty of nature in full bloom—daisies, violets, snapdragons, wild roses of bright red or pale pink among green leaves, cyclamens, cornflowers and dozens of other flowers of woods and meadows. Here and there among this lovingly observed vegetation, the animals dear to Pisanello can be discerned: sharply foreshortened horses, a bearcub, a greyhound and other dogs, a hind cornered by an archer, rabbits quietly scuttling over the grass, hares and roebucks surprised among the bushes.[29] These miniatures were not all destroyed as other critics were led to believe following the publication of Fogolari's article;[30] and perhaps the fact that this fine Gonzaga codex was presumed to have been totally lost is the reason why they have passed almost unnoticed, though Hill, on the basis of Fogolari's painstaking description, refers to their similarity with Pisanello's style.[31] Although seriously damaged by the fire of 1904, many folios of the codex survive and the remaining miniatures—which may well have been executed at Mantua towards the end of the 1450s by Pisanello and others—ought to be made the object of a special study, in view of the great interest attaching to them.[32] The comments made here are intended only to point out their exceptional quality, and the direct relationship they have with some drawings executed by Antonio in the fifth decade of the century, with the pictorial cycle in the Gonzaga palace in Mantua, and with the small panel depicting the *Vision of St. Eustace* in the National Gallery of London.

Opinions of critics as to the date of the *St. Eustace* differ widely, although the emblematic character of the painting is typical of Pisanello's late activity. Once again we see how many problems are raised by the stylistic and poetic development of this elusive artist and how difficult it is to trace the chronology of his pictorial and graphic production. Documentary evidence is full of gaps since such a small number of works remain. Attributed to Pisanello by Bode and Tschudi,[33] rejected by Manteuffel and by Richter,[34] the *St. Eustace* was regarded as a juvenile work by Van Marle, who saw in it a direct reflection of the late Gothic Lombard naturalism prominent in Antonio's early works.[35] It was assigned to the period between the decoration of S. Fermo and that of S. Anastasia by Hill and Adolfo Venturi,[36] while Coletti placed it among the juvenile works done prior to the decoration of S. Fermo, on the basis of what he considered to be its formal affinity with the work of Gentile da Fabriano.[37] Chiarelli in a new interpretation judged the painting to have been executed at the same time as the mural decoration of the entrance to the Pellegrini chapel in S. Anastasia and assumed that it was placed above the altar of the chapel.[38] Following Chiarelli's theory, then, the National Gallery painting is to be identified with the St. Eustace which, according to Vasari, was on the other side of 'the wall where Pisanello had depicted a St. George carrying sidearms'.[39] But Vasari's description does not correspond to the iconography of the London painting, and it is

unlikely that it refers to anything other than the figures of St. Eustace and St. George facing each other on the walls of the Pellegrini chapel, according to the iconographical plan desired by the patrons. These figures were perhaps painted by Pisanello, like the other images of saints in Gothic niches sculpted by Michele da Firenze.

This chronology, which places the *Vision of St. Eustace* between the juvenile period and the time of the decoration of S. Anastasia, was rejected by Degenhart and Sindona who, though they considered the *St. Eustace* to be quite close in time to the S. Anastasia fresco,[40] understood its nature as that of a work very similar to those which Pisanello executed in his last period. Miss Fossi Todorow avoided expressing any precise opinion on the London painting, but linked the drawings Nos. 2368 and 2490 in the Louvre, depicting a horse and knight, studies for a crucifixion and heads of deer, to the vanished representation of St. Eustace inside the Pellegrini chapel. She excluded the possibility of their having been used for the *Vision of St. Eustace*, whose 'miniaturistic quality' seems to have caused her some doubts, similar to those expressed by Manteuffel in 1909, about Pisanello's authorship of this work. She found it difficult to explain how Pisanello could have created in the same period two pictorial works which were 'stylistically so far apart, as are the frescoed scene in S. Anastasia of *St. George and the Princess* and the London *St. Eustace*.'[41] However, if the decoration in the Pellegrini chapel is dated no later than 1438 and if the London *St. Eustace*, in view of its stylistic characteristics, is placed among the late works of Pisanello, the problem does not arise.

Regarding the drawings which have been linked with this painting,[42] it is not illogical to assume that the artist, following the customary procedure of his workshop, drew partly on the numerous models in his repertoire and therefore also, for some of the animals, on those which he had prepared at the time of S. Anastasia. But there are also drawings, as for example the very beautiful horse and knight on the recto of folio 2368 in the Louvre (Fig. 188) and the studies of a crucifixion on the verso, which were executed for the London picture, probably towards the end of the fifth decade when Pisanello had perhaps already begun work in the Mantuan palace. Although the different techniques used for *sinopie* and for drawings on paper render a comparison not altogether easy, it is possible to detect a pronounced affinity between the free-flowing line, drawn with a considerable understanding of the rules of perspective, of the drawings, and the sweeping, airy line of the Mantuan *sinopie* which achieves a similar effect of depth and luminosity (Fig. 250).

The miniature-like quality of the *Vision of St. Eustace* is not very different from that which can be noticed in the other small paintings by Pisanello, and the formal problems are the same as those which surround all the work of Pisanello's last period, where there is a more strongly marked tendency towards Franco-Flemish painting and an increasingly stringent dialogue with Ghiberti and his great pupil Paolo Uccello. The same graphic and pictorial technique is used in all Pisanello's works, juvenile or late, large or small, indicating a definite link with the art of miniature painting, which Pisanello must have constantly practised.[43] Furthermore, many of his watercolour drawings, even though executed as models for other pictorial works, show characteristics similar to those of a miniature. This tendency towards miniaturism therefore cannot be regarded as an unusual aspect and even less a restrictive aspect of Pisanello's art, if we remember what incom-

parable miniaturists the great painters of the International style were, from the Limbourg brothers to the Van Eycks, from the Master of the *Heures de Boucicault* to the Master of the *Heures de Rohan*, from Giovannino de' Grassi to Michelino da Besozzo, from the Lombard illustrators of the romances of chivalry such as *Gyron le courtois* and *Lancelot*, to Belbello da Pavia, to name only a few of those whose activity as miniaturists was known and followed with great interest by Pisanello. It would be surprising if an 'excessively miniaturistic' painter, as Pisanello has been judged, even in his frescoes,[44] did not display the same tendencies in his small paintings such as the *St. Eustace*. Here, in this enchanted kingdom of wonderful animals one's attention is not distracted but stimulated by the analytical treatment of details, and intensified by that delicate vibration, inspired by Flemish influence, which Pisanello gave to his painting.

Pisanello's links with Paolo Uccello—which I shall return to when examining details of the Mantua Battle—are revealed in the surrealism of the phosphorescent colours which shine against the shady landscape background, the Gothic thrust of the greyhound chasing the hare, and the ribbon (with its elegant tension like that of a spring) which repeats the undulating flow of that movement in elastic but precise geometric curves containing a hint of Uccello's 'sweet perspective'. If we then take an overall look at the animals moving with natural ease against the nocturnal matrix of the landscape, we realize that their position on the surface is determined by an invisible network of axes radiating from a point situated almost at the centre of the painting, between St. Eustace and the deer bearing the crucifix. This empirical manner of realizing a composition in co-ordination with a central point, conforms with the practice followed in Tuscan workshops in the fourteenth century of tracing the orthogonals of a number of horizontal planes in the composition, marking them with a thread tied to a nail placed in the centre of the painting. Cennini also referred to this practice.[45]

It may seem strange that Pisanello, so skilful in representing groups or individual figures with effective perspective arrangement, should, towards the middle of the Quattrocento, turn to a procedure which had been in use for more than a century, in order to give unity to the composition of the *St. Eustace*. This procedure was far removed from the geometric rationality of Brunelleschi's 'centric' system and from Alberti's 'costruzione legittima', which he had moreover studied carefully, as the drawing No. 2520 in the Louvre proves (Fig. 118). And yet in those years Pisanello was judged one of the best, up-to-date artists of his day. However, for him the 'modern way' of painting was the one which had been established by Gentile da Fabriano and Jan van Eyck, and whose real continuators—according to Facio—were Roger van der Weyden and Pisanello himself. In this scheme of things it was normal that the naturalistic viewpoint which he employed in expressing his poetic world was closer to that which had been developed by Ghiberti, not without a certain degree of deliberate polemicizing against Brunelleschi's theory.

Ghiberti proposed a different solution to the problem of space, founded on the principles of a naturalness of representation which the Florentine artist, in his description of the second Baptistery door, tried to define as 'the rule of the eye's measurements'.[46] Krautheimer believed that in some of the reliefs of the Door of Paradise the application of this system at any rate partially complied with Alberti's principles.[47] It does not seem, however, that Alberti's strictly geometric system of the intersection of the visual pyramid—

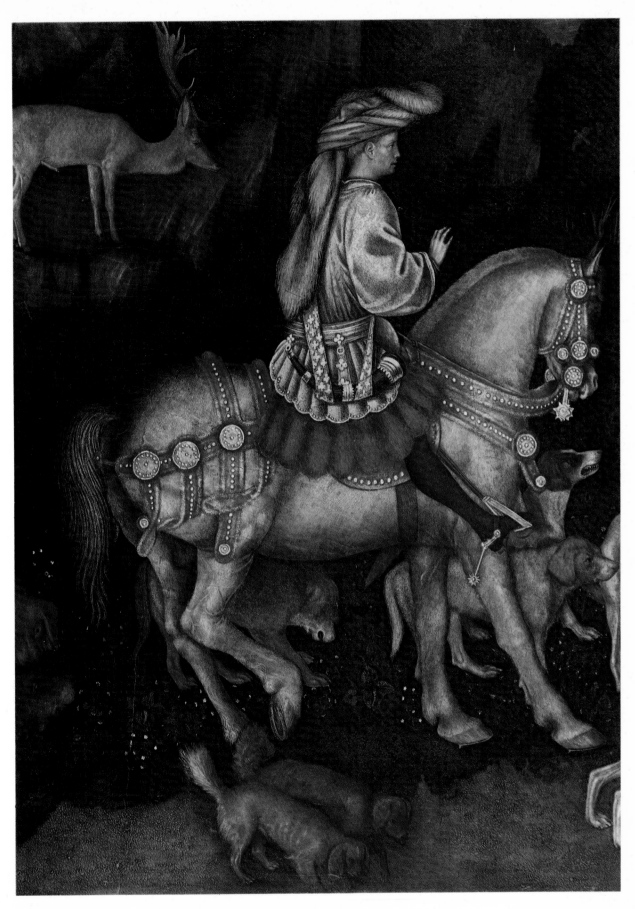

XIX. The Vision of St. Eustace, detail. London, National Gallery.

as well-known to Ghiberti as was the system invented by Brunelleschi from which it derived—is the one which most closely corresponded to Ghiberti's 'rule of eye'. The criteria followed by Ghiberti in the Door of Paradise have been interpreted by Parronchi as follows: 'I have not made use of any expedient, but just as the eye looks and encounters the object, so I have modelled these stories, so that they appear as if in real life... In the whole of this work I have followed these measurements: the eye's measurements.'[48] For various reasons it is far from clear how we are to understand these measurements, explained by Ghiberti in the third *Commentario*; Parronchi tried to unravel their meaning from the one copy in existence of the very confused text which Ghiberti left unfinished.[49] His careful work of deciphering seems to be a faithful rendering of the Florentine sculptor's line of thought, and I have referred to it in tracing the relations which I consider can be detected between the perspective realized by Ghiberti in the second door and that of Pisanello's late works. Already in the *St. Eustace* panel one can see the harmonious outline of the animals, foreshortened to a greater or lesser degree according to the Ghibertian concept of 'the eye's view' (Figs. 189–91), and arranged along lines which radiate in various directions, in an attempt to achieve a spatial recession which is empirical, but which nonetheless does exist, among the undergrowth and crags of that vertical rocky landscape, devoid of horizon and depicted as though seen from above. This composition structure seems to derive from the first panels of the Door of Paradise illustrating the stories of Noah, of Cain and Abel, and of Abraham, constructed with detailed naturalism and giving an illusion of diffused space which is characteristic of late International Gothic. The two rapidly sketched compositions of Pisanello's on folio 2594*v* in the Louvre (Fig. 204), also seem to reflect the pictorial naturalism of those panels, and their structure with a single viewpoint recalls the solution which Ghiberti with his 'rule of eye' found for the problem of obtaining a single overall vision of the scenes on the Door of Paradise. The two sketches in the Louvre were probably a preliminary idea for the distribution of the chivalrous narrative material in the mural decoration in Mantua, which Pisanello planned to illustrate with scenes set within frames, and arranged in two rows one above the other. The scenes in the drawings are in fact placed one above the other and they have the same rectangular shape, the height being greater than the width, giving both compositions a feeling of vertical development; and they are seen from two different viewpoints along the same visual axis. It is therefore clear that they were not drawn on the same sheet casually and for different purposes, as is often the case with Pisanello's studies, but that they were in fact done as a model: perhaps a first attempt at planning the disposition in two rows of the episodes already chosen for the chivalric cycle envisaged for the walls of the room in the Gonzaga court, which I have suggested was the Hall of the Round Table.[50]

The scene at the top is the more difficult to interpret,[51] but it may represent a hermit, surrounded by a large number of animals, in a wooded hilly landscape whose horizon, for the reasons already explained, is higher than that of the scene below where a knight and a lady, accompanied by two dwarfs wearing mailsuits and helmets decorated with large fluttering plumes, are riding along a narrow valley: to the left, on the steep hillside, rise the towers of some castles and at the end of the valley some rapidly sketched lines seem to represent one or two knights disappearing into the distance, probably

put to flight by the arrival of the group of people shown in the foreground. The chivalric nature of the two scenes is obvious and their significance must be sought among the many episodes from Arthurian legends: but of particular interest is the fact that in the two sketches there is evidence of a spatial investigation which is more striking than that displayed in the three panesl of Ghiberti's Door of Paradise. Particularly in the bottom scene the use of perspective, with the lines of the hills and of the deep valley meeting at the vanishing point on the horizon, is a considerable achievement in a scene set in rough landscape, which of course could not have the precise, geometrical lines that the architectural structures gave to the well-known townscapes in perspective by Brunelleschi.

Drawing No. 2595r in the Louvre (Fig. 205), whose subject is incorrectly thought to be a cavalcade, is a more detailed development of one of the stories in the Mantuan chivalrous cycle. As I have mentioned elsewhere, Marchese Ludovico or some man of letters at his court had probably drawn up an exact description of the episodes which Pisanello was to paint in this room. The formal relationship between the drawing (which according to Heiss (1881) was executed in about 1446–7 as a preparatory study for the composition to be created on the reverse of the posthumous medal of Gianfrancesco) and the chivalric illustrations in the Mantuan palace, is so explicit that it hardly needs to be pointed out. It is also certain however that Pisanello never realized the scene he had composed in that drawing, but he did make use of it, both for the figure of Gianfrancesco and of the dwarf who is seen from behind on the reverse of the Gianfrancesco medal (Fig. 165), and for some of the figures depicted in the Battle. Among these were the elegant knight who is outlined at bottom right of the *sinopia* (Figs. 66, 74) (with the variant of the large fur hat which is in other drawings by Pisanello), and the grotesque, very effective frescoed figure of the armed dwarf, who is adorned with a large plumed crest and dressed in the gay colours of the Gonzaga family (Plate XI), and riding beside his master, his stunted hands grasping a disproportionately large lance. It is an image which both fascinates and repels, with its strange animal-like appearance reminiscent of a large beetle with iridescent wings.

Manteuffel suggested that the drawing was related to the lost frescoes of the Mantuan palace, and rightly thought that the two compositions sketched on the single folio 2594 had also been executed for these frescoes. But the more accentuated spatial structure of the two sketches he judged to be a subsequent version of drawing No. 2595r in the Louvre.[52] Yet it is precisely this use of centrally placed perspective, with individual scenes within rectangular frames, which reveals in these sketches a preliminary scheme for the Mantuan cycle. Drawing No. 2595r, on the other hand, which is executed with a line similar to that of the Mantuan *sinopie* and of the Neapolitan drawings, though it still retains a plasticity which gives a feeling of depth to the composition, already shows a different trend. There is a horizontal development which is a prelude to the solution finally adopted in the decoration of the Gonzaga palace, where the various episodes of chivalry flow into one another in a continuous illustration, spreading without division over the entire wall surface.

A decoration of this kind was an innovation, a bold attempt at creating in that room a circular, panoramic representation which was not confined within the limits of a rectangular frame, and not to be observed from a fixed viewpoint. The oldest known fif-

teenth-century examples of this kind of representation, spreading over a wall surface in a continuous scenographic picture, were the decorations by Benozzo Gozzoli in the Medici Chapel in Florence in 1459, which followed very different criteria; the scenes Gozzoli painted a short time later in the Camposanto at Pisa; and the scenes painted by Andrea Mantegna at Mantua in the *Camera picta* in the Castello di San Giorgio and completed in 1474.

There may have been more than one reason which led Pisanello to alter radically the idea reflected in drawing No. 2594 in the Louvre which, as far as one can see, envisaged the execution of a pictorial cycle comprising a series of rectangular-shaped stories arranged in two rows. It is likely that he immediately realized that the first project, which may have been imposed on him by a set iconographic programme, was dispersive and unsatisfactory, and that the best way of tackling the problem was to compose the endless chivalrous material from Arthurian legends in a continuous and unified representation. His penetrating vision of nature and his awareness of the most modern Florentine researches into perspective, which he had studied and partly attempted, though with 'cautious experiments',[53] had led him to sense the visual incongruity of a series of perspective scenes placed one above the other. This was the system which Leonardo later criticized strongly in his *Trattato* where he explained 'Why depicting rows of figures one above the other is a method of working to be avoided'.[54] These compositions arranged on planes one above the other, the use of which Leonardo termed 'utmost stupidity', in fact necessitated using the 'old system of making the horizon and the centric line of every picture recede, continuing in the direction in which the observer was looking':[55] and this was in fact the system used in the two scenes which Pisanello had drawn on folio 2594 in the Louvre. The solution which he then found for the problem in the Mantuan decoration was naturally not that of Leonardo, but there was the same desire to attain unity of representation; and Pisanello turned to that 'rule of the eye's measurements' which Ghiberti had written about and applied in his works. It is possible that the development and radical transformations of the project for Ghiberti's second door, may have contributed to the unitary conception of the Mantuan decoration. The first project for the Door of Paradise prepared by the humanist Leonardo Bruni, which envisaged twenty panels illustrating individual scenes, was replaced by a second project, quite different, which reduced the number of panels to ten. This second scheme introduced the principle of the continuous narration of several stories united in one panel and arranged in an organic landscape or townscape structure; the plan unified, or rather tried to unify, the ten panels into an overall view of all the compositions on the door.[56] Using these criteria, Ghiberti created in the Door of Paradise his most important masterpiece which, while in keeping with his International background and with the Trecento tradition which merged with that background, was at the same time an absolutely new work, a point of arrival for the whole of his activity. The main ingredients which matured in that great creation derived from his exhaustive study of ancient art,[57] but above all from the experience he gained from his lengthy contemplation of the problems of vision which Brunelleschi and Alberti had resolved with uncompromising rationalism. Ghiberti grasped the importance of their solution though he did not fully understand the necessity for it. Indeed he demonstrated the limits of Brunelleschi's system of single-viewpoint perspective,

with his own theory of the mobile viewpoint and of binocular vision, which in his opinion was an innate part of the 'rule of eye' according to which 'a seen object is understood from two viewpoints'.[58]

The criterion of binocular vision, developed according to Ghiberti's principles, seemed even more necessary for a pictorial decoration in which Pisanello, with a large, unbroken composition covering the entire wall surface of the room, had to resolve the problem of how to create a unitary setting in the imaginary kingdom of Arthur for the deeds of chivalry he was to illustrate. The perspective systems of Brunelleschi and Alberti were not yet suitable instruments for resolving the difficulties of a circular scenographic view of such large proportions: they were intended only to give a rational, strictly geometric representation of space through a 'perspective window' which would enclose it from a fixed central viewpoint, within a visual angle which was theoretically 90° but in reality much less. For the realization of a scene such as that conceived by Pisanello there was still a useful lesson to be learned from the great wall paintings of the Trecento, in particular from the panoramic views of Sienese painting of the first half of the century, and from the later ones deriving from them. It is interesting to note that Ghiberti and Pisanello agreed on this point, as proved by the attention they both paid to Tuscan pictorial cycles of the Trecento and especially to the Sienese cycles, while they were working on the major undertakings of their late activity.

Ghiberti in his *Commentari* assesses Sienese mural paintings with unconditional admiration, especially the works of Ambrogio Lorenzetti[59] which he analysed, Krautheimer noted, 'with the same loving attention to detail that he gave to the description of his own Gates of Paradise'.[60] His interest was stimulated by the way in which the Sienese mural painters of the first half of the fourteenth century conceived their landscapes and townscapes: in wide, deep representations made up of innumerable details drawn from direct observation, with an abundance of hills and valleys extending as far as the eye could see, interspersed with small plains, with trees and woods, cultivated fields, houses, rivers, roads and paths, all depicted with the feel of things seen and encountered every day; in the creation of urban settings whose architectural structures stood out clearly in varied planes of colour; in the distribution of voids and solids; in the variety of heights and volumes. In these huge panoramic views seen, one might say, from above through a lens pointed at the land of real everyday life (the sky at the very top edge was almost left out of the scene), the eye could wander in various directions. The episodes were arranged naturally and freely in the landscape setting, so as to constitute a single scene. Ambrogio Lorenzetti's frescoes of *Good and Bad Government* are the greatest and most typical example of this concept in Sienese mural decoration. The liveliness and naturalness of these compositions spread to other centres as well during the second half of the Trecento: for example in Florence there were the scenes painted by Andrea Bonaiuti in the Cappellone degli Spagnoli, and in Pisa the series of frescoes on the walls of the Camposanto, where Andrea Bonaiuti executed the *Scenes from the Life of S. Ranieri* among the other illustrations frescoed by the painters who preceded or followed him in the great decorative project. Of particular significance for this line of development were the scenes of the *Triumph of Death* and of the *Thebaid*, but perhaps to an even greater degree the *Genesis* painted in the Pisan Camposanto by Piero di Puccio,

from whose new compositional elements Ghiberti drew considerable inspiration for his first scenes on the Door of Paradise.[61]

Ghiberti's familiarity with Trecento mural painting thus was similar to Pisanello's experiences. Certainly Pisanello must have seen the Cappellone degli Spagnoli in Florence and since boyhood been familiar with the mural decorations in the Camposanto in Pisa, to which he must have paid growing attention every time he returned, during the course of his many journeys, to his native city.[62] As regards the magnificent views in Ambrogio Lorenzetti's *Good and Bad Government*, I think it is clear how much Pisanello was influenced by these compositions, which created on the walls of the Sala dei Nove in the Palazzo Pubblico in Siena a wide panoramic view of the city of Siena and surrounding country, with just a short strip of sky at the very top edge of the composition. It was, of course, only the structure of the composition which influenced Pisanello, for Ambrogio's poetic world has nothing in common with Pisanello's. But that structure was still so important and exemplary in the first half of the Quattrocento that a painter who studied and made use of the ideas it offered on how to develop a narrative illustration in a single landscape setting was certainly not adopting the attitude of a backward-looking artist. Furthermore it is worth noting that Brunelleschi's recent theory of perspective which was codified in Alberti's *Trattato della pittura*, is not mentioned by Ghiberti in his *Commentari*. Instead, as Krautheimer observes, 'only Ambrogio and himself among the moderns did he call experts in *teorica dell'arte*, directly referring to Ambrogio as such, and by implication to himself.'[63] Presumably the theory Ghiberti refers to was the graphic study of the problems of perspective[64] for which Ambrogio too had to resort to the use of empirical, binocular vision which as a means of imitating natural vision, pre-dates the perspective construction of Brunelleschi based on the principle of the vanishing point.[65] But after Brunelleschi had resolved the problem mathematically and elaborated his theory of the single viewpoint which made it possible to produce a projection in perspective of the plan and the elevation,[66] it was no longer possible to ignore his system. It was to be a fundamental point of reference even for Ghiberti in his attempts to give a strictly scientific basis to his own theory of binocular vision. Thus, as Parronchi observed, 'real bifocal perspective which attempts to resolve the phenomenon of binocular vision by dividing the image into two parts in some way, occurs only in the complicated attempts which were no more than half-explained by Ghiberti, in Masolino's graphic compositions and, perhaps, in those of Van Eyck, in the "cock-eyed" perspectives of Paolo Uccello ... and finally in the *Annunciation* by Leonardo, who in later commentaries (MS E, *circa* 1513–14) observed the distinction between the image in perspective and the image received by the retina, and for particular cases, he prescribed a return to the system of scenographically "composed" perspective.'[67]

Among artists who in the first half of the Quattrocento tried to work out their compositions with the use of bifocal perspective was Pisanello who, after a few attempts at arranging his scenes of chivalry in a series of pictures with centralized perspective, finally decided to realize the Mantuan decoration as a unitary representation, based on the visual system with which Ghiberti opposed Brunelleschi's theory. Ghiberti's 'measurements of the eye' have been thoroughly investigated by Krautheimer and by Parronchi, and I would refer the reader to their valuable studies.[68] But it is important to remember

here, since the question is linked with the system which was also applied by Pisanello in his Mantuan decoration, that Ghiberti's theoretical formulation of the problem of vision and the concrete solutions he adopted in the Door of Paradise opened the way for some of the solutions found by two of his greatest pupils, Paolo Uccello and Masolino: for example the structure based on Ghibertian principles of Masolino's *Miracle of the Snow* and the bifocal arrangements of Paolo Uccello's compositions.[69] Of particular interest moreover is Parronchi's statement that 'both the phenomenon of binocular vision and that of the source of light radiating from above (as in the *Miracle of the Snow*), are used in none less than the centre of the great composition of Jan van Eyck's *Adoration of the Mystical Lamb* in Ghent Cathedral', whose centrally arranged double viewpoint seems to bear some relation to the analogous centralized construction of the *Miracle of St. Zanobius* by Ghiberti and the *Miracle of the Snow* by Masolino.[70] The question of this special arrangement of space in the *Adoration of the Mystical Lamb* had already been examined in an important study by Brandi on the different concept of space in Italian and Flemish painting.[71] Brandi observed that the 'centralized construction' of Jan van Eyck's *Adoration* in which even the rays issuing from the Dove suggest a kind of optical pyramid as in Paolo Uccello, is perhaps based on a viewpoint which was 'much further *inside* the picture than the oranges and cypresses' of that famous composition, confirming that 'knowledge of Italian perspective at that time had already reached France' (p. 12). Brandi's overall judgement is that 'the apparent perspective framework' of the *Mystical Lamb*, 'even if it were possible to demonstrate its early Italian derivation, would still not constitute a substantial link between the two great contemporary schools of painting, Florentine and Flemish' (p. 21), since 'the false orthogonals suggested by the rays from the dove do not give rise to, and nor do they govern, the extraordinary poetic truth of that landscape' (p. 12). This is indisputable when the comparison is drawn with the Florentine innovators who followed Brunelleschi and Masaccio along the path which they had opened up, that of using determinate and rational space to establish a new relationship with reality. Brandi rightly set the Italian representation of space, synthetic and dazzling in Masaccio's images, against the quite different use of space in the work of Jan van Eyck, with its 'relative, highly detailed environmental values', in which the object is seen 'in its reality as a phenomenon' (p. 24), and where there is a need for each detail to be considered in its entirety because even a dewdrop 'instead of constituting an inert naturalistic detail, will intensify the *frequency* of the image, rather as increased faceting of a precious stone will multiply its reflections' (p. 25).

In a recent study on the Flemish concept of 'environment space', Philippot states that 'the divergence (between the position of the Flemish painters and that of the 'Florentine pioneers'), beyond the common discovery of the infinite unity of space, appears to be immense'.[72] However, the connection which Facio had established in his *De viris illustribus* did not refer to the different tendencies of the Flemish painters and the Florentine innovators, but to those few artists who around the middle of the Quattrocento he felt to be still caught up in the same international current. Without a doubt his own personal inclinations and his aesthetic principles led him to express particular admiration for the Flemish painters, for Gentile da Fabriano and Pisanello,[73] and to prefer Ghiberti among the sculptors. But Facio would not have placed Pisanello side by side with Jan van Eyck,

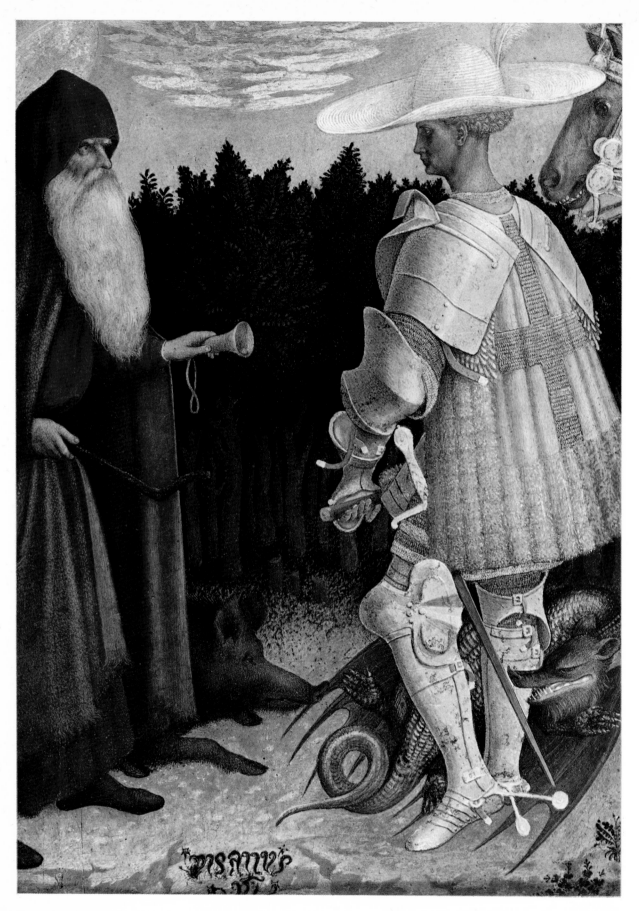

XX. Madonna and Child with Saints Anthony and George, detail. London, National Gallery.

Roger van der Weyden and Ghiberti unless Pisanello's last works—whose creation he would have been able to follow during the latter's stay in Naples between 1449 and 1450 approximately—had confirmed that the artist's attention was by then completely turned towards that 'direct, cogent grasp of things according to the evidence of their details', which Philippot pointed out in the great Flemish painters of the early Quattrocento.[74] This is the kind of vision which Pisanello wanted to realize on monumental scale in the great panoramic composition begun at Mantua, constructed according to the principles of the binocular system adopted by Ghiberti. It did not mean a change of direction, since Ghiberti's researches had been carried out along the same lines and were indeed the conclusion of those which Pisanello had begun and gradually developed together with Gentile da Fabriano.

The pictorial decoration of the room in Mantua is a dramatic and thrilling document of this grandiose attempt of Pisanello's, largely left unrealized but perhaps not so much because of the vastness of the task, as for its unrealistic conceptual premise: that of wanting to evoke, as if by magic, the illusive presence of things, indeed the very life of things.[75] In order to give his fantasy picture of chivalry the natural appearance of something being actually seen by the spectator, he made wide use of the Ghibertian 'ragione dell'occhio' ('rule of eye'). It is worth examining in detail Pisanello's application of this system and reconstructing that series of visual axes on which the artist tried to arrange the structure of his representation and to give a concrete sense of proportion and distance to the objects and persons depicted. Since it is not possible here to develop a complex graphic and technical analysis of the arrangement of his composition, I shall merely quote some of Ghiberti's precepts which Pisanello followed: '... la magnitudine della cosa visa si comprende per l'angolo. I visibili adunque assueti quando sono nella remozione assueta, quando il viso arà conosciuti questi, arà conosciuto la quantità della remozione ... Si comprendono la quantità della remozione de' visibili del senso distinte dal centro del viso all'estremità delle parti della terra propinque all'uomo, si comprendono dal sensiente e dalla virtù distintive e certificata dal senso, ... perché essa longitudine di questa verticazione sempre si mensura per il corpo dell'uomo'. ('The size of a thing seen is appreciated through the angle of vision. When the sight apprehends ordinary visible objects at their usual distance, it grasps the extent of that distance. Distances of visible objects are apprehended from the centre of the line of sight to the extremities of the parts of the ground nearest to where the man is standing; they are grasped by the sentient observer, by the distinctive power of sight and certified by the senses—for vertical measurement is always appreciated in relation to the size of the human body.') But the distance of things is measured by eye by means of 'verticazione'—and here Ghiberti follows the treatise *De Aspectibus* by Alhazen, to which he often refers in his *Commentari*—that is, tracing vertical axes which go from the feet of the observer to the objects seen: 'Quando adunque il viso arà guatato la parte la quale è appresso a' piedi, subito comprenderà la verticazione pertinente all'estremità di quella parte, immaginerà la virtù distintiva la quantità della longitudine della verticazione perveniente all'estremità d'esse e della qualità degli angoli i quali contiene quella virtù di verticazione, e comprenderà la quantità degli spigoli'.[76] ('When the sight looks at the part near the feet, it will immediately apprehend the vertical related to that part, the distinctive power of sight will mea-

sure the vertical reaching to the extremities, and appreciate the size of the angles which that vertical contains, and the extent of the extremities of the object.')

These rules of binocular perspective and above all their application in the most significant and important works of the great Florentine sculptor, the Door of Paradise and the Reliquary of St. Zanobius, show quite clearly that Ghiberti considered that vision was governed by visual axes which went from the eyes to the objects. Once the position of these objects had been identified, the 'two lines of vision' moved horizontally towards them in order to take full cognition of them.[77] The visual axis leading to the visible object was therefore for Ghiberti, as Parronchi pointed out, 'not an immobile pivot upon which to co-ordinate everything which falls within the visual cone, but a tentacle continually moving out from the feet of the observer to the visible object. For Ghiberti, this was the only way of considering space, real or imaginary, as it appears to the eye.'[78]

Pisanello made use of Ghibertian binocular vision in solving the problems he encountered in organizing the unitary space of the chivalric cycle in Mantua. Here, in order to achieve natural continuity of vision, 'as happens in reality', the 'verticazione' operations were much more necessary than they had been in the Door of Paradise, because of the size of the room to be decorated.[79] The eye of the observer moves over the vast decorated surfaces of the room and perceives a panoramic illustration in which the position assumed by the represented objects is related to the continual movement of the visual axis. Pisanello's representation—rather like the circular movement of the band of light projected from a lighthouse and gradually illuminating the whole horizon, section by section—must have been unfolded over the wall surfaces according to the system of binocular vision, enclosing within the natural angle of vision whatever appeared along the line of the spectator's mobile visual axis: castles and towers, city walls, houses, palaces and churches, woods and mountains and the animals which lived in them, knights riding along valleys or fighting in the great battle, while from the balcony adorned with flowers and decorated fabrics the ladies watched the bloody spectacle. Naturally there were invisible joins between the partial views arranged along the various vertical axes upon which this great panoramic vision was built; and the evocative, archaic landscape of the *sinopie* with its diminishing, rounded hills perhaps also had the function of masking those joins. But the impression received is a very striking one, almost hallucinatory, since the representation gives the sensation of a concrete visual reality and at the same time that of a dreamlike vision which may dissolve from one moment to the next. An artist who has tackled such a complex undertaking could indeed have been regarded as one of the greatest of his day. It does not matter that the decoration was left largely unfinished: for an artist, what counted was how to resolve the problem of uniting scenographically the wall space of an entire room. Having understood this, one can then appreciate that Mantegna—even with his more extensive knowledge of perspective, as can be seen in the *Camera degli Sposi*[80]—was also able to learn from Pisanello's composition.

The first *sinopia* of the Battle scene in the Sala del Pisanello, outlined initially in charcoal,[81] then with a firm brush stroke in black (though some of the knights above were traced in red *sinopia* mixed with black), ends on the adjacent wall with a group of knights in suits of mail. In the fresco this group was re-composed without reference to the *sinopia* underneath. In the same way, a large part of the first *sinopia* was reworked on a fur-

ther thin layer of light-coloured *intonaco*: the new images are drawn with a freer, more sketchy line, apparently indicating that this further phase in the graphic composition of the Battle was not done immediately. The *sinopie* of the other walls also seem to belong stylistically to the more intensely pictorial phase of the second draft of the Battle scene,[82] during which the artist added some very beautiful details not included in the first draft. One example is the almost Leonardo-like group,[83] in which knights are fighting around a warrior and his horse. The neck of the horse is covered with scaled armour, similar to that shown in drawing No. 2486 in the Louvre which was a study for the medal of Alfonso of Aragon and never executed (Figs. 73, 234). Another example, at the far left of the Battle wall, is the bareheaded knight on foot, seen from behind, who is looking at his defeated adversary lying on the ground (Plate V). These are substantial and very effective alterations, which were then used in the definitive fresco.[84] They are indicative of a restless reworking of the Battle scheme, which was probably transformed not only for formal reasons, but also because of some inner reflection on the theme of chivalry on which the cycle was based. It is noticeable that there are some fine illustrations to be found in the Battle fresco (Plates VI, VII) which were not even hinted at in the second *sinopia* phase; and yet their poetic tone is the most beautiful and significant of all the episodes in this tragic representation. Many of the scenes are constructed with that bold use of foreshortening which Leonardo later advocated—though he realized that its use, at least where individual figures were concerned, meant that 'you will have to contend with the ignorance of those who are uneducated in that art'—whenever 'you have an opportunity and especially in battles, where necessarily there occurs an infinite number of distortions and contortions of those who take part in such discord or, you might say, most brutal madness'.[85]

Pisanello's use of foreshortening brings us again, and more explicitly, to the question of his links with Paolo Uccello. In addition to the similarity of details of all kinds in their two Battle scenes, the way in which the warriors and their horses are sharply foreshortened in every direction, and especially the two contracted bodies of the fallen warriors lying face downwards, one in Pisanello's Battle, the other in Uccello's *Battle of San Romano* episode in London, clearly demonstrates the interest which the two artists had in each other's current work towards the middle of the century. The solutions adopted in illustrating the 'madness' of war are of course basically very different: in Paolo Uccello's representation feelings are firmly controlled by a formal logic of absolute geometric precision; Pisanello's scene is driven by a naturalistic instinct and inspired by strong human emotions. An investigation into the relationship between the two artists (often referred to by various Pisanellian scholars such as Degenhart, Coletti, Chiarelli, and Sindona, who has made some interesting observations on Tuscan artistic life of that period[86]) would be a lengthy task. But I must at least point out that the Battle painted by Pisanello offers a large number of basic points of comparison which establish beyond doubt certain iconographical and compositional connections between the two Battle episodes. From these comparisons it is clear that in this balance sheet Uccello is the debtor. A great number of iconographical details in the Mantua Battle were recalled by Uccello for the composition of the three episodes of the *Battle of San Romano*, which tells the story of the battle fought between the Florentines and the Sienese near San Romano in 1432. Today the three

panels are divided between the National Gallery in London, the Uffizi and the Louvre. After the Uffizi episode had been restored, Baldini advanced a theory about the original arrangement of the three panels in the Camera di Lorenzo in the Palazzo Medici.[87]

Keeping in mind the unitary development of both Battle scenes and the mutual borrowing of many motives, the comparison of the overall width of 9.57 metres of the *Battle of San Romano*[88] with that of the 9.60 metres of the Battle in the Sala del Pisanello, does seem to suggest a deliberate link between the dimensions of the two scenes. The fact that they were almost identical in length is also unlikely to have been merely fortuitous.

Almost all present-day critics agree in placing the *Battle of San Romano* in the second half of the sixth decade of the century. Pisanello died in 1455, after having painted most of his Battle scene, leaving unfinished only the details in the lower part, though these had already been defined in graphic form. It does seem therefore that there must be some connection between the last phases of execution of Pisanello's cycle at Mantua and the execution of the *Battle of San Romano* which followed soon afterwards.

The Battle scene depicted by Pisanello over the whole wall of the room stands out with its luminous images against the dark backdrop which was to have been further developed with details of the vegetation and the rough, steep terrain where the battle was being fought. The various groups of warriors, though always lifelike, are represented with increasingly pronounced foreshortening—according to the Ghibertian concept of 'rule of eye'—as the visual axis moves from the bottom upwards. On this vertical surface the battle rises like a huge wave, breaking up and moving off in various directions between the rocks and undergrowth, where the violence of single combats surges and is driven further into ravines concealed by brambles. Pisanello's imagination is given free rein in a series of episodes which, because of the reality and intensity of expression, are so even in quality that it is difficult if not impossible to choose between them: the emblematic portraits of the leaders, the trumpeters, groups of armed men standing by in reserve or waiting in ambush, combatants clashing hand-to-hand; the wounded, those overcome and clinging to their horses, or remaining upright in the saddle in wide-eyed terror, with a lance-shaft piercing their chest; tussles between groups where the entangled warriors are endeavouring to aim blows at their enemy's weakest point with lances, swords, daggers and maces; bodies of fallen men and horses, lances breaking and flying into fragments, scattered pieces of armour and limbs (Plates IV, VIII, IX; Figs. 15, 56, 64). Here and there in this theatre of fierce and mortal combat flutter the bright multi-coloured plumed crests of the 'gentlemen of war' almost as if Pisanello were mocking them; the great crest of the dwarf certainly seems to have a satirical intent. Pisanello was familiar with the cruelties perpetrated in battle; in 1439 he had taken part in the war waged by Marchese Gianfrancesco against the Republic of Venice, and in the short-lived conquest of Verona, with bitter personal consequences for the 'pentor rebello'.[89] It is not surprising that the incidents of war which he represented should have the feel of events actually seen and vividly remembered.

Among the many images in the Battle scene, two details in particular stand out, partly because they are good examples of the wealth and complexity of shapes and human figures in this great composition, and partly because of their dramatic iconography. One of these is the fallen knight in the middle area towards the right (Plate VIII), with his legs con-

tracted like a frog's. The pronounced foreshortening of this figure recalls that of the warrior in armour lying face down on the ground in Uccello's Battle episode in London. A comparison between this and other details in Pisanello's Battle with details in the three panels of the *Battle of San Romano*, seems to confirm that the two scenes were in fact executed within a short space of time. However, Pisanello began planning his Battle in about 1447 and could have continued working on it only up to 1455 at the latest, for it is definitely known that by the end of that year he was dead. Presumably Paolo Uccello could not have begun the *Battle of San Romano* until after the completion of the Medici Palace around 1451 (Morne, Pope-Hennessy), and it is generally thought that the panels were executed between 1455 and 1460. In this case Paolo Uccello may have seen the Mantuan room in the state in which Pisanello had left it, or perhaps during the execution of the work. He must have been impressed by the wealth of pictorial invention and the figurative material which he may well have developed according to the precepts of his own science of perspective in the three panels of the *Battle of San Romano* whose length coincides, as already noted, with that of Pisanello's mural painting. But Uccello with his 'sophistical and subtle talent'[90] took from that picture of chivalry only the material which would best express his spirit as metaphysical dreamer (it is significant that he always felt strongly attracted to the late Gothic art of the north where he worked for a long time). He applied this material in the *Battle of San Romano* panels with his boldly rigorous linear perspective, which acted as a filter to separate all emotion from the dross of contingent reality until a truth was attained which could be contemplated exclusively within the sphere of the intellect. This however was a totally different concept from that of Pisanello, who gave even the most unrealistic visions of his imagination the sensuous concrete quality of things happening in the natural world, existing in the mystery of life, which were to be scrutinized with curiosity and wonder. For this reason the figure of the warrior lying on the ground, enclosed in his sharply defined cuirass, in Paolo Uccello becomes pure geometric rhythm, and the sight of this lifeless body is made less tragic by the impassive, abstract perfection of its volumes. In Pisanello's Battle on the other hand the fallen knight who lies face downwards, while his horse twists its neck round to look at him in fright, is impregnated with human feeling and the grotesque foreshortening of the body has been done with the intention of showing this man's last breath, the throb of his suffering bound up in the emotions of hate, fear and pain which grip all those participating in this 'mad discord'.

The other detail to which I should like to draw attention, so moving and impressive in its exceptional poetic power and sense of tragedy, is the single episode showing two fallen knights, on the left of the middle area of the Battle. These two figures stand out clearly from the great cavity of shadow, isolated from the tumult which surrounds them (Plates VI, VII; Fig. 56), and plunged in the silence and stupor of death. Death seems already to have overtaken the older warrior who is lying on his back, his eyes dull and swollen, and with the ghastly pallor of death on his distorted face. The fair young man has a broken lance piercing his back. He is stretched out in front of the other knight and is crawling towards the lifeless body; cautiously he touches one foot and stares intensely. What is it in that look: hate or pity for the fallen man; fear that the adversary might get up again and recommence fighting; or hope of glimpsing in him some sign of life? Pro-

bably all of this together: that psychological complexity, so rich in nuances and contradictions, which is typical of Pisanello's characters, the ambiguity of emotions in reaction to the everyday experiences of life which he perceives in himself and in his fellowmen.

The overall picture of Arthurian chivalric society which had been planned for the painted cycle in Mantua was to have been very complex but it was to have presented that great epic in a single view.[91] The representation had already been defined in general terms in the *sinopie* traced on the walls of the room. From these *sinopie* and from the finished painted areas, we can get a fairly accurate idea of the aims which the artist had set himself in that decoration. The project conceived by Pisanello was grandiose and innovatory; but, even without taking into consideration the damage which must have been suffered by the surfaces in the ceiling collapse of 1480 and in the repeated *rifacimenti* carried out in later centuries, it is certain that of that project Antonio Pisano completed the painting of only the great tourney or battle, the bare landscape on the outside wall and the very beautiful group of portraits at the end of the inside wall adjacent to the Battle: in other words not much more than those painted surfaces which have now been recovered. In them Pisanello gave particular importance not only to the beautiful figures of ladies and knights on the wall to the left of the Battle, but also to the most dramatic moment of that chivalrous epic, using the whole of one wall for his illustration of the great conflict between Arthurian knights. The images in this episode are naturalistic and extraordinarily lifelike yet at the same time they appear as projections of the imagination on that unreal, black-painted backcloth. This background was really only a preparatory foundation upon which the artist was going to add the mountain landscape in which the combat was taking place, among the winding ravines and trees and bushes whose leafy fronds partly hid the warriors as they fought or lay in ambush. However, that funereal surface from which the figures of warriors emerged as if from nowhere, must have enthralled Pisanello's visionary fantasy. It may even be that he left until last the execution of those parts which were necessary for defining the landscape background, precisely because in that unfinished state, with the silvered armour and other uncompleted images shining in strong luminous relief against the dark background, the Battle was for Pisanello a representation which was already complete, even if he knew that the work could not really be considered finished unless all the naturalistic details of the painted surface had been fully realized.

There may well have been a marked disparity between the commemorative type of illustration thought out by Marchese Ludovico and the men of letters at his court, and what Pisanello actually painted.[92] That '*Pulcra et delectabilis materia*', as Luchino Visconti had described it when asking the Gonzaga family for the loan of some of their numerous French romances, was well known and popular everywhere, for not only were the original and rewritten French texts in circulation, but also the numerous versions of those legends of chivalry translated into Italian and dialect. Pisanello had had plenty of opportunity to become very familiar with this kind of literary material which was so congenial to his imagination;[93] but the Arthurian world as depicted in chivalrous narrative, became through his eyes an overall picture, a retrospective view. He saw history as a continuous cycle, devoid of any intelligible meaning, and he observed the rise and fall of civilizations, just as he observed the decay intrinsic in existence, the indissoluble relationship between

becomes meaningful if it is related to Tristram's various changes of clothing in the tourney of Louverzep which he makes in order not to be recognized each time he passes from one side to the other, proving his superior strength at all times.[98] On the back of the beautiful drawings already mentioned, Nos. 2594 *v* and 2595 *r*, which are part of the 'red album' group and show the two scenes of chivalry one above the other (Fig. 204) and the so-called Cavalcade (Fig. 205), are two heads which can also be related to the decoration in Mantua. On the back of the Cavalcade is the head of a warrior, either wounded or dead, depicted with his mouth open, his nose and eyes swollen (Fig. 224). This is certainly an initial draft of an idea which was then developed in the tragic figure of the elderly warrior with swollen face (Plate VII), one of the most powerful and moving images in the Battle scene. Furthermore, the absolute freedom of pictorial movement displayed in the Mantuan *sinopie* recalls the similar freedom and luminous force of some of the Neapolitan drawings which was noted by Passavant:[99] for example, the head of a man, perhaps a monk (Fig. 223), on folio 2606 *v* in the Louvre, sketched with strong pictorial effect in quick, rudimentary lines in black pencil. Drawing No. 2330 in the Louvre of the head of a handsome young man (Fig. 218) in my opinion is also close to the Mantuan decoration (as are other drawings of people, animals, plants and floral motives in the Vallardi collection) and this is easy to see when the drawing is compared to some of the portraits painted in the frescoes (Plate III; Fig. 7). The variation of line and technique which can quite frequently be observed even among the late drawings, is a result of their different functions, which I have already referred to when discussing the various formal aspects of Pisanello's graphic art in relation to the changeable technical procedures he used; and it is also a consequence of the richness and variety of poetic tone pervading even those drawings which are very close in date. For example the graphic works quoted above are very different from the other drawings of the same period, such as the delicately drawn Negro's head (Fig. 6) executed in metal point on parchment (Louvre No. 2324) which Middeldorf rightly places in Pisanello's late activity, considering it to show signs of strong Flemish influence.[100]

Pisanello's more direct links with Flemish art are noticeable in the extraordinarily rich and vital production of his last years (and I do not refer only to drawing or actual painting, but also to the medals; one has only to quote as an example the splendid Neapolitan portrait of Iñigo d'Avalos which, though it may recall Paolo Uccello, is much closer to contemporary Flemish forms of expression).

The greater degree of intensity displayed by the late small panel paintings examined earlier derives from Flemish art, but that intensity is manifest even more clearly in the very high quality of many Mantuan and Neapolitan drawings, above all in the wealth of invention and in the exceptional power and variety of pictorial inflexions which are found in the images which Pisanello painted, or drew in the *sinopie*, in the chivalric representation at the Gonzaga court. Among the most significant drawings of those years are the two groups which Miss Fossi Todorow assigned to the Mantuan[101] and Neapolitan[102] periods. With regard to the Mantuan drawings on folios 2275 *r* and 2277 it is interesting to note the many ideas they contain which were perhaps intended for the Mantuan frescoes: the young woman looking out from the balcony, the heraldic motive of a dog, the pages (Figs. 207, 214) and the beautiful costumes which I believe were used for the figures in

the episodes shown on the lower parts of the walls. It may be that the aim was to create a relationship between the illustrations of chivalry painted above, and actual space, by means of these elegant lifesize figures drawn almost at floor level, for in this room the Gonzaga family and members of their court were to meet, dressed in the same refined costumes as the knights and their ladies illustrated on the walls. These figures, apart from those on the wall with the Battle scene, probably illustrated Arthurian episodes of love and courtesy; they also of course were developed as continuous scenes and set in the same unitary environment as the illustrations on the upper wall areas. Some idea of what they must have looked like can be gained from these drawings and from the elegant models of costumes now at Bayonne, Bonnat and Chantilly.[103]

Belonging to the last years of Pisanello's activity is a group of drawings of high quality in which the Flemish influence is indeed very marked: one of these is the head of a Negro (Fig. 6) already mentioned, which is obviously related to the very beautiful, though damaged figure of a Negro painted by the artist in that outstanding set of portraits, among the most expressive and innovatory he ever did, at the end of the inside wall of the room in Mantua (Plate III; Figs. 17, 18). A more subtle delicacy of form is shown in the other drawings of male heads (Figs. 218-220) and of these I shall mention only those of highest quality which Miss Fossi Todorow places among the drawings of uncertain attribution.[104] It is regrettable that this very able scholar did not feel she could confirm the attribution to Pisanello of these drawings, accepted by so many others,[105] though when making her penetrating analysis of their modernity and very high quality, she seemed to be on the point of agreeing that they really did constitute a document of the artist's 'greatest achievement' of his last years. When they are compared to the portraits painted by Pisanello in his Mantuan cycle of chivalry all doubts are dispelled, since in both the drawings and the paintings there is the same search after a more diffuse, sweeping type of modelling, a more inward form of expression, a lighter, more vibrant pictorial quality, and this is also to be seen in some of the Neapolitan medals and drawings.

Although the store of knowledge which Pisanello had accumulated during his long artistic activity was already considerable, and although he had been familiar with the Franco-Flemish miniature for some time, a new experience was needed to act as a catalyst in order for this last reaction to take place. This element cannot have been the relationship with Jacopo Bellini as hesitantly suggested by Miss Fossi Todorow.[106] Pisanello had known Jacopo since the time when the latter had been working with Gentile da Fabriano in Florence in 1423. Instead, it must have been his direct knowledge of some of the important works by the greatest Flemish painters of the first half of the Quattrocento, Jan van Eyck and Roger van der Weyden, which he was able to see and study in Naples and Ferrara between the fifth and sixth decade of the century. In 1449 Pisanello began his stay in Naples where he remained perhaps until the end of 1450[107] and he would certainly have seen at the court of Alfonso of Aragon those paintings by Jan van Eyck and Roger van der Weyden which Facio describes with admiration, referring to the visual naturalness and lifelikeness of the one and the pathos of the other.[108] Facio also recalled the triptych, with the *Descent from the Cross* in the centre and the *Expulsion of Adam and Eve* on the lateral panels, which Roger van der Weyden had painted at Ferrara. Lionello d'Este had shown this triptych in 1449 to Ciriaco d'Ancona[109] who was struck by the force of emotion in the figures por-

trayed ('*vivos spirare vultos videres*'). These works must have excited Pisanello and stimulated him to achieve in his very last years the pictorial intensity and the inwardness of the superb drawings of male half-length portraits and of the mural paintings in Mantua.

However, in 1449-50 Pisanello was in Naples and we know nothing more of him in the following years except that he died almost certainly in 1455. Nevertheless, the Mantuan decoration can indeed be regarded as the most important and dramatic work of his late activity, setting the seal on the whole of his artistic career. A dense veil of mystery surrounds this work which, without a doubt, was the greatest pictorial undertaking which Pisanello ever attempted. There is no mention of it in contemporary documents and Marchese Ludovico never refers to it, even though he habitually supplied information in one form or another, in accordance with his skilfully planned policies regarding the arts, about the numerous projects he entrusted to many famous artists of the day. Facio does not speak of the mural cycle at all, yet he was normally well-informed of the activity carried on by his old friend,[110] with whom he had a continual exchange of ideas during the two years or so Pisanello spent in Naples. It would seem that Antonio never mentioned it to him, which might mean that, because of a disagreement with Marchese Ludovico over the manner of realizing the mural cycle, Pisanello had abandoned the undertaking once and for all before his departure for Naples. It is more likely, however, that his reticence was due to the fact that he had only just begun the decoration, which he intended to take up again as soon as he was able to leave Naples and return to Mantua. At any rate, although some of the preparatory drawings made for the Mantuan cycle pre-date his journey to Naples, others done during the Neapolitan period, for example those on folio 2318 in the Louvre, are to be regarded as almost contemporary with the Mantuan *sinopie;* they share with these *sinopie* the same graphic freedom aimed at achieving strong luminous effects, by means of extremely synthetic light and shade contrasts (Figs. 230, 231). Many decorative motives assigned to the Neapolitan period, such as the elegant drawings displaying a masterly formal equilibrium, which bear the motto '*guarden les forces*' written on fluttering ribbons, are similar in style and partly also in iconography, to those on the frieze and in other decorative parts of the Battle scene in Mantua (Figs. 57, 232), to such an extent that it almost seems that they were all prepared for the same decoration.[111] Drawing No. 2486 in the Louvre which is one of the most beautiful of the Neapolitan period (Fig. 234) appears to have been prepared for one of the knights at Mantua, but in fact it is known that it was done as a study for a medal of Alfonso of Aragon.[112]

Perhaps the very close relationship of drawing No. 2486 to the Mantuan cycle, and the fact that the medal of Alfonso of Aragon was never executed, may indicate that Pisanello had already left Naples to conclude the Mantuan work he had left unfinished. The plan to decorate the room in Mantua goes back to about 1447 and it is certainly linked to the appointment in that year of Ludovico Gonzaga as Captain of the Florentine troops in the league between Venice and Florence against Filippo Maria Visconti. That date however has to be understood as a *terminus post quem* for the execution of Ludovico's programme with which he intended to raise the prestige of the Gonzagas. Their position had been shaken and weakened by the disastrous war which his father Gianfrancesco had waged against the Republic of Venice, and by the fact that Gianfrancesco before dying had split up the territory of the marquisate of Mantua between his sons. Ludovico

wanted to celebrate the military prowess of his family by decorating this room with a theme of chivalry and by creating a commemorative medal of Gianfrancesco *primus marchio Mantue capitaneus maximus armigerorum*[113] and another medal in which he had himself portrayed as *marchio Mantue et cet, capitaneus armigerorum*. The preparation of the Arthurian illustration painted in this room which I have called the Hall of the Round Table certainly involved complex literary and iconographical questions, and others of a more strictly artistic nature, which concerned composition and structure. It would hardly be surprising then if long arguments ensued as a result. Moreover it must not be forgotten that the illustration of that great story of chivalry had above all an emblematic function relating to present-day deeds of the Gonzagas. Therefore the Arthurian knights depicted must have included portraits of many real people of those times, and this would have given rise to further complications. The Gonzagas, as *condottieri* of great armies in the Po Valley, undoubtedly played a leading role in that representation; and probably the two bareheaded warriors (Fig. 57) placed one in front of the other at the top of the Battle scene, directly under the Gonzaghesque heraldry of the frieze, are intended as portraits of the first Marchese Gianfrancesco and his son Ludovico II, shown in their capacity as leaders, just as Ludovico had had the two medals made to commemorate their military valour. The warriors in the battle-tourney certainly included Carlo Gonzaga, *condottiere* and unlucky rival of his brother Ludovico, but nevertheless a Gonzaga; he is perhaps depicted in the part of Lancelot, as I earlier proposed for him.[114] Many other great *condottieri* of that period with whom, or against whom the Gonzagas fought, were depicted in the clothes of Arthurian knights, always in accordance with the pre-arranged iconographic plan. Ludovico must have been given the most important role of Tristram, who emerged as absolute winner in the tourney; and in this case the posthumous representation of Gianfrancesco in this cycle is probably to be found in the figure of Meliadus, Tristram's father. Quite a number of other personages from the court, perhaps some of Pisanello's humanist friends, were included by the artist in this his last mural decoration, and these are to be found in the beautiful portraits surrounding the triumphant figure of Tristram. It is not immediately possible to explain the figure of the haughty Negro (perhaps representing the Saracen Palamedès, rival and friend of Tristram), who may have been a member of the court of Mantua or of Ferrara. However, the feminine delicacy of Belloto Cumano's profile and the square face of Pier Candido Decembrio as shown in Pisanello's medals (Figs. 177, 178) are obviously related to, respectively, the superb portrait of the fair-haired, melancholy young man with bowed head, shown to the right of the Negro, in very effective pictorial contrast, and the portrait of an older man with short brown hair, shown to the left (Plate III). Several other hypotheses could be made about the numerous Arthurian characters represented in the Battle, but this is a matter to be dealt with by a specialist in Romance philology.

Marchese Ludovico must have attached great importance to this cycle, the first of many projects which he tried, often unsuccessfully, to realize during his lifetime, employing some of the greatest artists of his day. The iconographic significance and the complex symbolism of the chivalrous decoration which Pisanello was to carry out must have been particularly close to his heart, since it reflected the events of the most difficult, early years of his political and military career. The project for a room dedicated to the Round Table

was moreover not just the fulfilment of a personal whim, but a result of the current fashion for late Gothic courtly customs and artistic taste, which gave rise to all kinds of works of art, including many mural paintings of deeds of chivalry and of portraits of *preux* and *preuses* like those in the Castle of Runkelstein, near Bolzano, and of La Manta in the Saluzzo district.[115]

Pisanello must have encountered many difficulties in the complicated symbolism and literary references contained in the iconographic programme put to him. It was probably his reaction to the first plan which envisaged the arrangement of the material in a series of different scenes without a common thread, as interminable and uniform as the episodes of those romances often were, which gave birth to the idea of a continuous and unitary illustration of the Arthurian world, composed of just a few episodes freely utilized by the artist in the service of his poetic vision. Furthermore, while according to Marchese Ludovico's intentions, this was to have been an encomiastic representation, stressing the fair and sporting character of the combat (which Huizinga defined as an essential element of chivalrous society and of its idea of war 'as a noble game of honour and virtue'[116]), Pisanello depicted it very differently, following the pessimistic concept he had gained from his experience of life. This experience had made him understand only too well how such commemorations of nobility and valour often served to disguise with splendid outward show a reality which was far from likeable. In the quarrels between the 'gentlemen of war' he saw only injustice and cruelty, which his imagination transformed into an enthralling and frightening apocalyptic vision of the Arthurian world of chivalry.[117] He himself had suffered the consequences of this kind of game, destined as he was to be a wandering artist without roots, and little more than a refugee in his mother's native city of Verona, where he had moved from Pisa after his father's death, and from where he was eventually expelled as a traitor. Perhaps this was why, through the distortions of memory and nostalgia, he always felt bound to the city of his birth, which in the tragic game of war had lost both prosperity and political freedom. It was a destiny which certainly fitted his concept of the world as an incoherent set of occurrences which escaped human reason; as the experience of reality with a dual aspect, attractive and repellent; as a changeable, discontinuous spectacle to be observed with wonder and close attention, but always with his own kind of inner judgement, secret and enigmatic. This, I believe, is also the reason for the lack of synthesis and the contradictory aspect of his researches which are embodied in his poetic expressions, that uneasiness detected by Gnudi in the 'apparent objectivity' of his vision.[117]

Perhaps if Pisanello had not had in his blood that restlessness which led him to destroy relentlessly and to re-do what he had only just conceived, as appears in many of the remaining parts of his chivalrous cycle, if he had possessed the ability to synthesize, with which he could have dominated his creative turmoil and all the stimuli that life provided him with, then presumbly he would have managed to complete the great pictorial undertaking in Mantua. It is still puzzling, and will continue to be so, why this decoration, begun in about 1447 and probably taken up again enthusiastically after the Neapolitan period, and already clearly defined in all its details in the enormous *sinopie*, should have then been left when the work of painting was at such an early stage. Apart from the likelihood of differences of opinion about the manner of realizing the cycle which may

have prolonged the preparation of such a complex work but could not have caused its cessation, the most realistic hypothesis is that Pisanello died before he was able to complete his work. At any rate his death in 1455, or his earlier departure from Mantua, seems to mark the end of an artistic period and of the fashion for the International style at the Gonzaga court, even though there were still some reminiscences of it in the decorations done in the second half of the century. Marchese Ludovico, who had met Brunelleschi during the latter's two short stays in Mantua, had called to his court in about 1450 a young architect and sculptor, also a Florentine, called Luca Fancelli.[119] The same year he was in contact with Donatello, who was then at Padua, and commissioned him to execute a monument dedicated to St. Anselm, which was begun but never completed. A few years later Leon Battista Alberti was in Mantua for the Council of 1459, and the following year he planned for Ludovico, among other works, the Temple of St. Sebastian; and in the meantime Mantegna became painter to the Gonzaga family, introducing his new Classical style into their court. For Marchese Ludovico too, the fantasies of the chivalrous world whose climate had been the background to his youth, were by now no more than a memory, 'neiges d'antan'. Shortly before the Council he transferred his residence to the renovated apartments of Castello di S. Giorgio, to which Fancelli, Mantegna and other artists were giving a sumptuous Renaissance appearance; and the great unfinished pictorial decoration of the 'Sala del Pisanello' was to be left abandoned for a long time until, as a result of the sixteenth-century alterations to the Corte Vecchia, it eventually disappeared.

NOTES

1. See pp. 49–50.

2. For a collection of elegies, odes and sonnets dedicated to Pisanello see VENTURI, A., *Gentile da Fabriano e il Pisanello*, cit., 1896, pp. 35, 39, 49, 52, 55, 57, 61, 62, 65, 67.

3. In the foreword to the first edition of his masterpiece Huizinga wrote: 'In this book I have tried to see in the fourteenth and fifteenth centuries not the dawn of the Renaissance, but the twilight of the Middle Ages, what medieval civilization was like in the last period of its life, a civilization which had become like a fully-grown tree laden with over-ripe fruit. These pages describe how the vital gist of medieval thought was subjected to new and overriding concepts and how a rich and flourishing civilization was condemned to become arid and inflexible. As I wrote, I was gazing into the depths of an evening sky, a sky red with blood, heavy with livid shadows and permeated by an artificial copper light.

'When I re-read what I have written, I wonder whether I have not become aware, by dint of gazing at that evening sky, of the turbid colours changing into pure clarity; and then it seems to me that the picture I outlined and coloured turned out more dismal and less serene than I had intended when I started writing. It is all too easy, if one's attention is constantly focused on something which is declining, dying and withering, for the shadow of death to spread its veil a little too much over the whole work.' (HUIZINGA, J., *Herfsttij der Middeleeuwen*, Harlem, 1928, English translation published as *The Waning of the Middle Ages*)

4. 'The second half of the fourteenth century, for the history of art as well as for the history of literature, means the age when medieval form and material was most widespread and dominant; it means a luxuriant, iridescent sunset, of deep colours, and ripening fruits almost ready for harvest: an age which had one and the same character throughout Western Europe...' (VAN SCHLOSSER, J., *L'arte di corte nel secolo XIV*, Italian translation by Mellini, G.L., 1965, p. 21, of the German original 'Ein Veronesisches Bilderbuch und die höfische Kunst des XV. Jahrhunderts' in *Jahrbuch der Kunsthistorischen Sammlungen der allerhöchsten Kaiserhauses*, Vienna, XVI, 1895).

5. ANTAL, F., *Florentine Painting and its Social Background*, London, 1948, Ch. V; LONGHI, op. cit., in *L'Approdo letterario*, 1958, p. 8.

6. From the end of the fourteenth century onwards the word 'modern' is very much used; it is indicative of the way in which contemporary civilization was laboriously searching for a means of renewal. (Cf. LHOTSKY, A., 'Die Zeitenwende um das Jahr 1400', in *Catalogue to the Vienna Exhibition*, cit., 1962, p. 23)

7. PÄCHT, O., 'Die Gotik der Zeit um '400 als Gesamteuropäische Kunstsprache', in *Catalogue to the Vienna Exhibition*, cit., 1962, p. 59; CASTELFRANCHI VEGAS, op. cit., p. 7.

8. For a full bibliography on the development of the International Gothic in Europe and in Italy see: CASTELFRANCHI VEGAS, op. cit., bibliographical notes, pp. 163–70; the brief outline on 'Gotico internazionale' by EMILIANI, A., in *Encicl. Univ. dell'Arte*, VI, 1958, pp. 512–515, and in the same volume the bibliography, 489–501, which however refers to Gothic art in general.

9. PANOFSKY, E., *Renaissance and Renascences in Western Art*, Stockholm, 1960. For Pisanello's relations with the Limbourg brothers cf. PÄCHT, *The Limbourgs and Pisanello*, cit., pp. 109–22; MEISS, op. cit., 1963, pp. 147–70.

10. *L'ouvraige de Lombardie* is not to be understood as referring to works coming from a geographical area more or less coinciding with present-day Lombardy, nor to a specific kind of work. The term must have been used to indicate the formal character of these works, a kind of expression typical of the Po Valley. But what it did indicate was above all the naturalism of the *Tacuina* and of the various illuminated books, the freshness of the works by Giovannino de' Grassi and by Michelino, the aristocratic refinement of the illustrations of fashionable romances of chivalry and books of hours, prayerbooks, bibles, treatises, etc. (Cf. pp. 140–41). The most important work which is still of fundamental use for the study of the *ouvraige de Lombardie* and the developments of International painting in Northern Italy is that by TOESCA, P., *La pittura e la miniatura in Lombardia dai più antichi monumenti alla metà del Quattrocento*, Milan, 1902; new edition with introduction by C. Castelnuovo and an updated bibliography, Turin, 1966.

11. FACIO, op. cit., pp. 43–51.

12. KRAUTHEIMER, op. cit., pp. 16–17; PARRONCHI, A., 'Le misure dell'occhio secondo Ghiberti', in *Paragone*, 1961, and in *Studi sulla dolce prospettiva*, cit., pp. 338–9; CASTELFRANCHI VEGAS, L., 'I rapporti Italia-Fiandra' (I), in *Paragone*, 1966, pp. 15–16.

13. FACIO, op. cit., p. 47.

14. DAVIES, M., *National Gallery Catalogues. The Earlier Italian Schools*, 2nd ed., London, 1961, pp. 439–42.

15. 'Mantuae aediculum pinxit, et tabulas valde laudatas' (FACIO, op. cit., p. 47). A lost work painted in Mantua at the beginning of the 1440s was an 'Our Lord God', taken to Ferrara by Pisanello; Marchese Gianfresco then asked him to return it in 1443 (VENTURI, A., op. cit., 1896, p. 48).

16. GLASER, C., 'Italienische Bildmotive in der altdeutschen Malerei', in *Zeitschrift für bildende Kunst*, Leipzig, 1914, p. 156.

17. PÄCHT, op. cit., 1963, pp. 109–22.

18. PÄCHT, op. cit., 1963, pp. 114–19. Cf. also PORCHER, J., *Les Belles Heures de Jean de France, Duc de Berry*, Paris, 1953; LEVI D'ANCONA, M., *The Iconography of the Immaculate Conception in the Middle Ages and Early Renaissance*, New York, 1957; DAVIES, op. cit., p. 440.

19. PÄCHT, op. cit., 1963, p. 119.

20. According to Parronchi, the shape of the halo which surrounds the disc of the sun is proof that Pisanello was aware of the then widely read text on optics, Peckham's *Perspectiva Communis*, and that when painting this aureole he was thinking of 'the redounding shape of radiated light which illustrates theorem No. 4' (on the effect of radiance) (PARRONCHI, op. cit., p. 333, note 1). This seems to me to be quite likely and confirms the fact that Pisanello learnt about this subject from Ghiberti, who drew widely on Peckham's work.

21. At the beginning of the fifteenth century the Gonzaga family built the Sanctuary of S. Maria delle Grazie on the site of an old oratory, a few kilometres from Mantua, in the Curtatone district. Here they frequently made *ex voto* offerings of the armour they had worn in battle; these suits of armour were identified by J.G. Mann (MANN, J.G., 'The Sanctuary of Madonna delle Grazie, with notes on Italian armour of the fifteenth century', in *Archaeologia*, 1930, pp. 117–42). Some of them are very similar to the one depicted by Pisanello in the painting in London and to the armour worn by the warriors in the mural decoration in Mantua.

22. In addition to the coat of arms with the cross of St. George recalled by Gerola in his study of the deeds of the Gonzaga family (GEROLA, op. cit., 1918, pp. 107–8 and note 4), many shields, weapons and other objects belonging to the Gonzagas listed in the 1407 inventory also bore the cross of St. George: 'Penerium unum ... cum arma Gonzaga aquartirato arma Boemie et S. Georgii' – 'Lancegayga una cum caveno ad arma S. Georgii et Boemie et Gonzaga aquartirata ... Zornea una sindonis granati a tornerio cum arma S. Georgii' – 'Elmetum unum signatum F, cum ... frontale argenti aurati, cum arme Gonzaghe et S. Georgii' – 'Bantum unum magnum, cum duabus viseriis cum frontale argenti aurati, cum arma S. Georgii, Boemie et Gonzage' – 'Elmetum unum axalis cohopertum veluto grano cum uno frontale argenti albi, cum arma S. Georgii et domini Johannis de Gonzaga'. (TRUFFI, R., *Giostre e cantori di giostre*, Rocca S. Casciano, 1911, pp. 193, 206, 209.)

23. Cf. p. 51.

24. LUZIO, A., and RENIER, R., 'La coltura e le relazioni letterarie di Isabella d'Este Gonzaga', in *Giornale Stor. della Lett. Ital.*, XXXIII, 1899, pp. 6–7, note 3. Although the Codex is recorded in certain documents as being by Helio Sparciano, it also contained biographies of emperors compiled by other writers of imperial history.

25. MERONI, *Catal. Mostra Cod. Gonz.*, cit., p. 60 note 83, p. 78 note 13, plates 84–7.

26. FOGOLARI, G., 'Un manoscritto perduto della biblioteca di Torino', in *L'Arte*, VII, 1904, pp. 159–61.

27. FOGOLARI, op. cit., pp. 159–61.

28. 'On sheet 11 ... there was a gentleman leaning against a red pole, with a delicate, feminine face and thin hands, one leg clad in purple and the other in sky blue, and wearing a long flowing robe with baggy sleeves hanging down, a golden belt and a huge hat of red damask, edged with fur, its brim sewn at each side to the crown in a strange fashion ... the garments worn by the pages and knights were decorated all over the sleeves and the part hanging from the yoke with a deep knitted fringe composed of bands of white, red and green, giving a most attractive effect. Then there were the caps and hats with many-folded brims, which would certainly have been named in the accounts of the Mantuan court. Never before, I believe, had fashionable dress been exalted as a work of art! I recall on sheet 136 a lady, tall and slender, standing on a leaf, with her back turned to show off in all its splendour her dress of pale pink silk, clinched tightly at the top by a gold belt, and flaring out to a long train and wide sleeves which seemed like the immense wings of this beautiful person. Below the shoulders the rosy-coloured background was crossed by a band of light green and lower down by another broader one in sky blue, while below this, gold decorations covered the whole of the mantle, which at the bottom was edged with a deep border of white fur, as fine and light as ostrich feathers. Her small head was covered with the same silk also decorated with gold.' (FOGOLARI, op. cit., p. 160)

29. FOGOLARI, op. cit., passim.

30. HILL, op. cit., 1905, pp. 123–4; FOSSI TODOROW, op. cit., 1966, p. 39 note 52.

31. HILL, op. cit., 1905, p. 123.

32. It transpires from the *explicit* of a codex in the Vatican Library (Cod. Lat. 1903), which derives from the Helio Sparciano of Turin but contains miniatures of inferior quality, that the Vatican copy was compiled by order of Count Bartolomeo Visconti, bishop of Novara, who died in 1457. The Turin original must have dated from a few years before and was probably executed in Mantua towards the end of the fifth decade (Cf. FOGOLARI, op. cit., p. 161; HILL, op. cit., 1905, p. 123). It may be the Turin codex which is referred to in a letter of 1449 mentioned by Stefano Davari

(A.S.M., schede Davari, busta 1). However, the letter, as G. Amadei notes in his reconstruction of Pisanello's life which I have already quoted, has never been traced (cf. AMADEI, G., op. cit., p. 381, note 77).

33. BODE, W., and VON TSCHUDI, H., op. cit., *Jahrbuch*, 1885, p. 16.

34. MANTEUFFEL, op. cit., 1909, pp. 47–9; RICHTER, op. cit., 1929, p. 135 et seqq.

35. VAN MARLE, op. cit., VIII, p. 77 et seqq.

36. HILL, op. cit., 1905, p. 62 et seqq.; VENTURI, A., *Pisanello*, cit., 1939, pp. 20–1. Davies (op. cit., 1961, p. 441), while agreeing with Hill's opinion on the authenticity of the work, which was damaged and has been partly repainted, considered it to be earlier than the *Madonna and Child with Saints Anthony and George*, but he does not give a precise date for it.

37. COLETTI, op. cit., 1953, p. 31 No. 10.

38. CHIARELLI, op. cit., 1966, p. 34; id., 'Due questioni pisanelliane', cit., 1967, p. 381. Hentzen (1948), Magagnato (1958) and Bettini (1959) also consider the *St. Eustace* to be contemporary with the painted decoration in S. Anastasia; Pallucchini (1956) believes it is perhaps earlier.

39. VASARI, *Le Vite*, cit., III, pp. 8–9.

40. According to Degenhart, it was executed a short time after the S. Anastasia fresco (op. cit., 1945, p. 40 et seqq. and under 'Pisanello' in *Enc. Univ. dell'Arte*, 1963, 614); according to Sindona, in about 1440 (op. cit., p. 32). Brenzoni too regards the London *St. Eustace* as later by a few years than the S. Anastasia (op. cit., 1952, p. 161); but it must be remembered that Brenzoni considered the S. Anastasia decoration to have been painted around 1429–30, in other words before Pisanello's journey to Rome.

41. FOSSI TODOROW, op. cit., 1966, pp. 25, 26 note 47, 68, 69; Plates XXVI, XXVII, XXVIII.

42. DEGENHART, op. cit., 1945, pp. 36, 76; HENTZEN, op. cit., pp. 10–12; DAVIES, op. cit., p. 442; FOSSI TODOROW, op. cit., 1966, pp. 68, 69, 97, 107–10, 115, 186.

43. Van Marle, placing the *St. Eustace* in Pisanello's juvenile period, presumed that the young artist had begun to make miniatures right at the beginning of his career (VAN MARLE, op. cit., VIII, p. 74).

44. LONGHI, op. cit., in *L'Approdo letterario*, p. 11.

45. With regard to this procedure see PANOFSKY, E., *Die Perspektive als 'symbolische Form'*, Leipzig and Berlin, 1927, p. 279 et seqq.; id., *Renaissance and Renascences*, cit.; KRAUTHEIMER, op. cit., II, p. 241; CENNINI, op. cit., Ch. LXVII.

46. 'I was allocated the other door, that is the third door of S. Giovanni, which I was given permission to execute in whatever manner I believed would be most perfect, most ornate and most rich. I began this work which consisted of pictures one and a third *braccia* in size. These scenes, containing a great quantity of figures, were stories from the Old Testament. I did everything I could to try and imitate nature as far as possible, with all the principles I could produce in them, and creating excellent compositions abounding in figures. I placed about one hundred figures in some of the scenes; more in some, fewer in others. I carried out the work with great diligence and with great love. There were ten scenes, each framed in the way that *the eye measures them* and arranged so that, from a distance, they appear in relief ... The relief is very low and the figures are seen on the planes in such a way that those which are nearer look larger than the ones further away, as happens in reality. And I have carried out this whole work with the said rules.' (GHIBERTI, *Commenatri*, ed. 1947 cit., II, p. 45.)

47. KRAUTHEIMER, op. cit., I, Ch. XVI, p. 229 et seqq.

48. PARRONCHI, op. cit., 1964, p. 320.

49. Presumably Ghiberti began writing his *Commentari* in about 1448. He was prevented by his death in 1455 from revising and concluding them. The Magliabechiano Codex XVII, 33, in the Biblioteca Nazionale in Florence (II, I, 333) is a copy of the text by Ghiberti. As Parronchi noted

when referring to the comment which Schlosser made in the first critical edition of the *Commentari* (Berlin, 1912) and to the careful comparisons made by G. ten Doesschate (Utrecht, 1940) between the Magliabechiano Codex and earlier treatises (Alhazen, Bacon, Peckham), this text appears to be 'a collection of numerous passages taken from various treatises on optics and put together in a confused compilation'. (PARRONCHI, op. cit., p. 318.)

50. See p. 73.

51. For the various interpretations and dating of the two sketches see the relevant data compiled by Miss Fossi Todorow who ascribes these drawings, together with those on folios 519r, 2275r, 2276, 2277, 2278, 2300, 2537r, to Pisanello's late activity in Mantua (FOSSI TODOROW, op. cit., 1960, pp. 32–7, 83–8).

52. MANTEUFFEL, op. cit., p. 67. For other opinions on drawing No. 2595r in the Louvre cf. FOSSI TODOROW, op. cit., 1966, note 65, pp. 83–4.

53. LONGHI, *Prefaz. Catal. Mostra dai Visconti agli Sforza*, cit., p. XXX.

54. 'There is a universal custom followed by those who paint on the walls of chapels which is much to be deplored. They make a composition with its landscape and buildings on one plane, then go higher and make a composition in which they change the point of view, and then paint a third and a fourth, so that one wall has four points of view. That is utmost stupidity on the part of these masters. We know that the point of view is placed opposite the eye of the observer of the composition. If you ask: how shall I paint the life of a saint divided into many episodes on one and the same wall? I answer, that you must put the first plane with the point of view at the height of the eye of the observers of the composition, and on this plane represent the first episode large in size, and then, diminishing the figures and buildings on the various hills and plains progressively, you will make provision for the whole narrative. The rest of the wall, up to the top, paint full of trees of a size that bears relation to the figures, or fill it with angels if these should be suitable to the story, or birds or clouds or such subjects. Do not exert yourself in any other way, or all your work will be false.' (LEONARDO, *Treatise on Painting*, ed. and transl. by McMahon, A.P., Princeton, N.J., 1956, pp. 109–10.)

55. PARRONCHI, op. cit., p. 315.

56. KRAUTHEIMER, op. cit., I, Chapters XI, XII, XIII, p. 150 et seqq.; PARRONCHI, op. cit., pp. 347–8.

57. Krautheimer assumes that Ghiberti made a study of ancient monuments together with Pisanello during a stay in Rome at the time when the latter, while executing the St. John Lateran frescoes, was deeply involved with researches of this kind (KRAUTHEIMER, op. cit., I, p. 288).

58. GHIBERTI, *Commentari*, cit., III, p. 133.

59. GHIBERTI, *Commentari*, cit., II, pp. 37–9.

60. KRAUTHEIMER, op. cit., I, p. 220.

61. In this brief outline I have made great use of the ideas developed by Krautheimer on the subject, and I hope I have not distorted these in the inevitable brevity of my summary (KRAUTHEIMER, op. cit., pp. 219–22).

62. See p. 121.

63. KRAUTHEIMER, op. cit., p. 220.

64. Ghiberti wrote: 'He was a most perfect master, a man of great genius. He was a most noble draughtsman and was very skilled in the *theory* of this art' (*Commentari*, II, p. 38). It seems therefore that he was referring to studies in perspective carried out with the graphic skill he attributes to Ambrogio: the science of drawing had been defined, at the beginning of the *Commentari*, as 'the basis and theory of these two arts (painting and sculpture)' (*Commentari*, I, p. 3).

65. In connection with the application of the two perspective systems, one based on the vanishing point discovered by Brunelleschi and Alberti, the other on bifocal vision, see KLEIN, R., 'Pomponius Gauricus on Perspective' (in *The*

Art Bulletin, 1961, XIII, pp. 211–30). For our purposes here it will be sufficient to mention Klein's reference to the 'pre-Albertian preponderence of the bifocal system' and, among his various examples of works in which the bifocal system has been applied, the *Scenes from the Life of St. Catherine* by Masolino in S. Clemente in Rome, the *Nativity* by Paolo Uccello which was originally in the Florentine cloister of S. Martino alla Scala, and of the predella depicting the *Profanation of the Host* by Paolo Uccello in the Urbino Museum.

66. Brunelleschi was not unaware of the binocular system and the numerous treatises which had been written on the problems of 'physiological vision'; in fact he took them for granted and at a certain point he abandoned the arguments regarding *perspectiva naturalis* when he managed to resolve the problem of centralized *perspectiva artificialis* along the rational lines of a geometrical theorem. (Cf. ARGAN, G.C., 'The architecture of Brunelleschi and the origins of perspective theory in the fifteenth century', in *Journal of the Warburg and Courtauld Institutes*, IX, X (1946–7); id., *Brunelleschi*, Milan, 1955, pp. 15–19; GIOSEFFI, D., *Perspectiva artificialis*, Trieste, 1957; SANPAOLESI, P., *Brunelleschi*, Milan, 1962, pp. 41–53.)

67. PARRONCHI, 'Il "punctum dolens" della costruzione legittima', op. cit., pp. 298–9. Parronchi in his article on the *Misure dell'occhio* (p. 348) adds that even Michelangelo, whose great admiration for Ghiberti's second door gave rise to the definition 'Door of Paradise', 'did not depart from Ghiberti's principles, claiming that the artist had to have "compasses in his eyes"'.

68. KRAUTHEIMER, op. cit., I, pp. 229–53 and passim; PARRONCHI, op. cit., pp. 313–48.

69. Cf. KRAUTHEIMER, op. cit., I, pp. 200–3 and passim; PARRONCHI, op. cit., p. 331 et seqq.

70. PARRONCHI, op. cit., pp. 334–5.

71. BRANDI, C., *Spazio italiano, ambiente fiammingo*, Milan, 1960, pp. 11–35.

72. PHILIPPOT, P., *Pittura fiamminga e rinascimento italiano*, Turin, 1970, p. 23, translated from the original French, *Le problème de la Renaissance dans la peinture des Pays-Bas*, by Paola Argan.

73. For Facio's ideas on aesthetics, deriving from those of Guarino and those of the Greek Chrysoloras, see BAXANDALL, M., 'Bartholomeus Facius on Painting', in *Journal of the Warburg and Courtauld Institutes*, XXVII, 1964; id., *Giotto and the Orators*, Oxford, 1971.

74. PHILIPPOT, op. cit., p. 21.

75. This was his most impressive gift which was recognized by his humanist friends in their eulogistic compositions.

76. GHIBERTI, *Commentari*, cit., III, p. 127.

77. '... when the observer has turned his eye in the direction of the object ... then both lines of vision will be in position, that is, directed towards the seen object. If one line of vision moves, then the other will follow it' (GHIBERTI, *Commentari* cit., III, p. 133).

78. PARRONCHI, 'Le misure dell'occhio', cit., pp. 263–7.

79. The existing floor and ceiling of the rectangular Sala del Pisanello are different from the former ones. Originally, the room was about 7 metres high. The length of the walls however was the same as in the present room, the short walls both being 9.60 metres and the long inside and outside walls 17.50 metres. The total length of wall surface was therefore 54.20 metres.

80. From his study of the mural painting techniques used by Pisanello, *fresco*, *mezzo fresco* and *secco*, which we examined in Chapter II, Mantegna also learned a great deal which was to be of special use to him in the pictorial technique he adopted in the Camera degli Sposi, to which I have drawn attention elsewhere. (Cf. PACCAGNINI, G., 'Appunti sulla tecnica della "Camera picta" di Andrea Mantegna', in *Scritti di Storia dell'arte in onore di M. Salmi*, Rome, 1962, pp. 395–403; id., *Il Palazzo Ducale di Mantova*, cit., pp. 74–9.)

81. Cf. pp. 27–8.

82. This is confirmed by a technical detail; that is that the red *sinopia* traced on a lighter coloured *arriccio* on the long inside wall is superimposed, along the edge where the new *arriccio* joins the older one, over the fragment of black *sinopia* depicting a group of warriors, completely transformed in the fresco. This black *sinopia* had been executed on a darker *arriccio*, the same as that underneath the first *sinopia* of the Battle.

83. It is possible that there are reminiscences of it in some of the episodes, known through drawings and copies, of Leonardo's *Battle of Anghiari*. He may have had occasion to see the Sala del Pisanello, in its state of abandonment after the collapse of 1480, during his brief stay in Mantua in 1500; Pisanello's decoration in fact disappeared during the first *rifacimento* of the room towards the end of the sixteenth century.

84. For the sake of simplicity, I continue to use this strictly-speaking incorrect term when referring to Pisanello's pictorial surfaces, whose complex constitution has already been discussed.

85. LEONARDO, *Trattato*, cit., II, 59 (translated by McMahon, Vol. I, p. 110).

86. SINDONA, op. cit., p. 90 et seqq.

87. BALDINI, U., 'Restauri di dipinti fiorentini', in *Bollettino d'Arte*, XXXIX, 1954, pp. 226–34. The question of how the three panels were originally arranged and what their form was, is still the subject of much discussion, but Baldini's work has contributed a great deal towards solving it. The opinions of various art historians on this matter have been examined by Martin Davies, according to whom Baldini's explanations 'would seem to be on the right lines', although he does not believe it is possible yet to come to a definite conclusion (DAVIES, M., *The Earlier Italian Schools*, cit., pp. 525–31). The important thing here is to note the equal width of the Battle scenes painted by Pisanello and Paolo Uccello; and to add that Parronchi seems to be correct when he suggests that Paolo Uccello's panels, in which the standards seem to have been cut off, continued at the top on to the surfaces of the lunettes of the room (PARRONCHI, *Le fonti di Paolo Uccello*, op. cit., p. 478 note 1). If this was indeed the case, then there is an even closer relationship between the motives used in the *Battle of San Romano* and those in Pisanello's Battle. The Gothic style of the latter artist's decorative motives of ribbons, ensigns and standards fluttering in elegant curves was recalled not only by Alberti, as Brandi rightly pointed out (BRANDI, C., 'Il nuovo Pisanello di Mantova', in *Corriere della Sera*, 27 February 1969), but also, in a more congenial way, by Paolo Uccello.

88. 'The widths of the three panels in London, Florence and Paris are respectively 3.19 m., 3.22 m., 3.16 m.' (BALDINI, op. cit., p. 230).

89. For the trial proceedings and sentence passed on Pisanello and the other rebels from Verona, see BIADEGO, G., 'Pisanus Pictor, nota prima', cit., 1908; BRENZONI, R., op. cit., 1952, pp. 49–56.

90. VASARI, *Le Vite*, cit., II, p. 303.

91. Cf. pp. 52 et seqq.

92. Cf. p. 53.

93. He would have found the French romances not only in the Gonzaga library, but also at the other courts where he worked. The romance by Rustichello da Pisa and the *Tavola Ritonda*, which was also written by a Tuscan, must have been well known to him, and finding them again at Mantua must surely have reawakened old fantasies in his memory.

94. Cf. p. 73 and p. 76 note 57.

95. LÖSETH, E., op. cit., pp. 11, 460; LIMENTANI, op. cit., p. 19 et seqq.

96. On the subject of the Palazzo Trinci frescoes at Foligno see: VENTURI, A., *Storia dell'Arte Ital.*, cit., VII, 1911, p. 173; SALMI, M., 'Gli affreschi del Palazzo Trinci a Foligno', in *Boll. d'Arte*, 1919, pp. 139-73; VAN MARLE, op. cit., VIII, 1927, pp. 321, 323–4; OERTEL, R., 'Wamalerei und Zeich-

nung in Italien', in *Mitteil. d. Kunsth. Inst. in Florenz*, pp.
295–7; PROCACCI, U., *Sinopie e affreschi*, cit., 1960, pp. 58,
240 and fig. 45; DEGENHART and SCHMITT, *Corpus der Ital.
Zeichn.*, cit., Vol. I, p. 2, pp. 335, 594, 620.

97. DEGENHART and SCHMITT, *Corpus*, cit., *Süd und Mittel-
italien - 1300–1450*, Berlin, 1968.

98. Cf. pp. 70–1. In the upper part of the Battle scene,
beside the group of armed men wearing black colours like
those worn by Tristram and his warriors on one of the three
days of the tourney of Louverzep, there was a figure (now
completely obliterated) half-hidden behind a bush, and the
few remaining lines of the *sinopia* for this figure seem to
repeat the iconography of drawing No. 2597r in the Louvre.

99. PASSAVANT, G., 'Wiederentdeckte Pisanello-Fresken in
Mantua', in *Kunstcronik*, XX, June 1969, pp. 158–9.

100. MIDDELDORF, U., 'B. Degenhart: Pisanello', in *Art
Bulletin*, XXIX, December 1947, p. 281. In some of the
portraits which I consider to belong to this period (Figs.
221–222) Degenhart, suggesting that some of the charac-
ters were part of the retinue of Emperor Sigismund, stated
that they were 'a particularly early example of the contact
which Italian art had with that of the Netherlands' (DE-
GENHART, op. cit., 1945, p. 39).

101. FOSSI TODOROW, op. cit., pp. 32–7 and 83–8. I have
listed in note 51 the drawings which Miss Fossi Todorow
places in Pisanello's Mantuan period. I agree with her in
relating all these drawings to Pisanello's last period of
activity at the court of the Gonzaga; but, as I have mentioned,
I think that many more of the drawings were done in Mantua.

102. FOSSI TODOROW, op. cit., pp. 38–40 and 88–91. I consi-
der that in the case of the Neapolitan drawings too, many
additions should be made to the list of works executed by
Pisanello or by his workshop under his control and direction.

103. Cf. p. 54. The Palatine Codex 556 in the Biblioteca
Nazionale in Florence, containing the text of a story of
Tristano or the *Tavola Ritonda*, written in 1446 and illustra-
ted by a Lombard artist influenced by Pisanello, also has a
similar set of elegant costumes of that period. (On the sub-
ject of this Codex see: LOOMIS, R.S. and LOOMIS, L. HIB-
BARD, op. cit., p. 121; BERTI TOESCA, E., 'Un romanzo il-
lustrato del '400', in *L'Arte*, 1939, pp. 135–43; RASMO, N.,
'Il codice Palatino 556 e le sue illustrazioni', in *Rivista
d'Arte*, XXI, 1939, pp. 245–81.) The Codex has been attri-
buted to various artists; Rasmo assigns the illustrations to
Bonifacio Bembo, correctly in my opinion, on the basis of
their stylistic features. The figures in the well-known '*Giochi*'
at Casa Borromeo in Milan also recall the elegance of those
costumes; although they are the work of a Lombard painter
they definitely show a relationship with Pisanello which led
Consoli to ascribe these frescoes to Pisanello himself (CON-
SOLI, G., *I 'Giuochi' Borromeo ed il Pisanello*, Milan, 1966).

104. FOSSI TODOROW, op. cit., pp. 40–3, 94–5.

105. For the various attributions of these drawings see the
data carefully compiled by FOSSI TODOROW, op. cit., pp.
94–5.

106. FOSSI TODOROW, op. cit., p. 42.

107. The diplomatic document issued by Alfonso of Ara-
gon to *Pisanello de Pisis* is dated 14 February 1449 (Cf. SCHULZ,
H.W., *Denkmäler der Kunst des Mittelalters in Unteritalien*, IV,
Dresden, 1860, pp. 184–5; VENTURI, A., op. cit., 1896, p. 59).
There exists a drawing (Louvre No. 2307) for the medal of
Alfonso of Aragon 'Triumphator et Pacificus' bearing the
date 1448 which has been crossed out (Fig. 228). In my
opinion this means that the drawing was done by Pisanello
at Ferrara before his departure for Naples. The composition
was in fact later altered, as can be seen in the medal which
was executed at Naples and bears the date 1449.

108. FACIO, op. cit., pp. 46–7, 48–9.

109. PANOFSKY, E., *Early Netherlandish Painting*, Cambridge,
1953, p. 361, note 4; CASTELFRANCHI VEGAS, 'I rapporti
Italia-Fiandra I', cit., p. 15.

110. Pisanello and Facio must have met when Facio was
a pupil of Guarino at Verona between 1420 and *circa* 1426.

111. The curling ribbon depicted in the London *St. Eustace*
also makes a similar pattern, though its purpose is different,
to that of the elegant unfurling of ribbons in that group
of decorative drawings. This confirms not only the stylistic
relationship but also the chronological nearness of these
works.

112. DEGENHART, op. cit., 1945, p. 45; FOSSI TODOROW,
op. cit., p. 88.

113. The relationship already pointed out (p. 227) between
the drawing of a Cavalcade (Louvre No. 2595 r) and the
medal of Gianfrancesco (which is often placed in the period
1439–44, that is when the Marchese was no longer alive)
does not mean that the date of this drawing should be put
back, for it belongs to the group of graphic works executed
by Pisanello for the Gonzagas during his last period of ac-
tivity, as Miss Fossi Todorow rightly notes when she ac-
cepts the dating of the Gianfrancesco medal at around 1446–
7 as proposed by Heiss in 1881 (FOSSI TODOROW, op. cit.,
p. 95). Hill, who in his *Corpus* of Renaissance medals pub-
lished in 1930 dated the Gianfrancesco medal between
1439 and 1444, had previously believed, for a number of
stylistic and historical reasons which are still valid, that the
medal was posthumous, and executed between 1445 and
1447 (HILL, *Pisanello*, 1905, pp. 168–9).

114. Cf. p. 68.

115. See in this connection p. 73. With regard to the Run-
kelstein and Manta frescoes, about which much has been
written, I mention here only the general work on Arthurian
illustrations by LOOMIS, R.S. and LOOMIS, L.H., *Arthurian
Legends*, etc., cit., pp. 39, 48–50.

116. HUIZINGA, J., *Homo ludens*, London, 1949, p. 96.

117. It may be that Pisanello was influenced, with regard
to the figurative aspects of a representation of this kind,
by apocalyptic scenes in fourteenth-century works, and also
by artists of the International Gothic period. One has only
to recall the small *tempere* of the Apocalypse by Robert
d'Anjou executed during the fifth decade of the fourteenth
century, now in the Württembergische Staatsgalerie at
Stuttgart, and the later series of tapestries of the Apocalypse
by Louis I d'Anjou, done in about the eighth decade, pre-
served at Angers; these are very different works both in
size and in technique but they are to be placed among the
most important masterpieces of the fourteenth century.

118. GNUDI, C., 'La pittura del Trecento nell'Italia del Nord
e il Gotico internazionale', in *Pittura Italiana*, Vol. I, Milan,
1959, pp. 192–3.

119. However, courtly fashion continued into the sixth
decade of the century and was to influence the early works
of Fancelli; this could be taken as confirmation of Pisanello's
presence in Mantua up to the time of his death in 1455.
Pisanello's drawing (No. 519r in the Louvre) which inclu-
des, among other images, a picture of castle walls crowned
with Ghibelline battlements, reflects ideas which seem to
relate to the Castle of Revere, which is regarded as one of
the first of Fancelli's works executed for Ludovico Gonzaga.
The eclectic but elegant late Gothic character of the deco-
rations in brickwork in the house of the merchant Giovanni
Boniforte, dated 1455, places them among the last manifesta-
tions of the courtly taste which up to then had prevailed at
Mantua.

Postscript: While I was correcting the proofs of this book,
an article by Bernhard Degenhart appeared in the journal
Pantheon in which he published a miniature by Pisanello
depicting Marchese Ludovico II Gonzaga with other knights
in a hilly landscape (DEGENHART, B., 'Ludovico II Gonzaga
in einer Miniatur Pisanellos, in *Pantheon*, XX, May 1972,
pp. 193–210). I feel I ought to mention, however briefly,
this important new contribution to the reconstruction of
Pisanello's late activity, and I am glad to note how many
of the opinions I have expressed here are in agreement with
the conclusions drawn by Degenhart in his article. Pisanello's
authorship of the miniatures contained in Codex E.III.19
in the Biblioteca Nazionale in Turin, which I have maintained,
is also asserted by Degenhart, who indeed lays particular
stress on Antonio Pisano's activity as miniaturist.

The high degree of pictorial maturity shown in the Mantuan frescoes and *sinopie* which I had pointed out in the short articles I wrote while their discovery and restoration was in progress (cf. Ch. III, Note 11) was already apparent not only in the famous medals but also in the two paintings in the National Gallery in London and in the many late Mantuan and Neapolitan drawings. Through his research, which has been conducted entirely independently of my own, Degenhart has now arrived at conclusions which seem to agree substantially with those which I have set out in these pages. He places the miniature of Ludovico Gonzaga, the miniatures in Turin and the two London panels, between 1444 and *circa* 1447. The London paintings are really to be seen in connection with the beginning of the programme realized in the Mantuan mural decoration and it is natural that a scholar with such a profound knowledge of Pisanello as Degenhart should finally come to identify the St. George in the London painting as Marchese Ludovico Gonzaga, as I too have suggested. A comparison between the profile of Marchese Ludovico in the miniature published by Degenhart, and the London St. Eustace, moreover, seems to me to be proof of the votive nature of both the *Vision of St. Eustace*, as suggested by Degenhart, and of the portrayal of Ludovico II Gonzaga as a hunter dressed in the clothes of that saint (DEGENHART, op. cit., p. 206, Figs. 6, 7). Another of Degenhart's statements worth pointing out is that in these late works by Pisanello there is no longer any trace of the influence of Gentile da Fabriano. This is not to say that that experience was not still of fundamental importance to Antonio Pisano; but without a doubt, in his last period other interests prevail: in other words those which, as I have explained, came to maturity through the increasingly intense relations which the artist had during the last decade with Ghiberti, Paolo Uccello and the Flemish painters.

I cannot dwell here upon various other interesting points in Degenhart's article, but I should like to devote the remainder of this note to the connection which he mentions between the armour worn by Ludovico's horse in the miniature published in his article and the tournament armour of a horse in drawing No. 2632 in the Louvre. In this drawing, the horse's reins and breastplate bear inscriptions in Old French which Degenhart interprets as follows: 'vers la *file de mon amy*' and '*vers la filgeta fyle de mon am(y)*'. These can be roughly translated as: 'For the girl who is my friend's daughter' (DEGENHART, op. cit., pp. 197 and 208 note 9, Fig. 3). Drawing No. 2632—which Degenhart had long ago attributed to Pisanello, though he placed it in the S. Anastasia period (DEGENHART, *Pisanello*, cit., 1945, p. 35, 64 note 21, Fig. 73)—puzzled me because though I understood quite clearly the connection between the literary and iconographic content and the Gothic lettering of the inscriptions, and those placed beside the knights in the Mantuan Sala, I was unable to detect in this drawing (which I too judged to be close to those executed for S. Anastasia by Pisanello and his workshop) any real relationship with the *sinopie* and drawings later executed for the Gonzagas. The publication of the miniature of Ludovico Gonzaga now makes it clear that drawing No. 2632 is to be linked with Pisanello's activity as a miniaturist. These works, it seems, were among the early manifestations of Ludovico's taste for chivalrous style and customs immediately after his nomination as Marchese; the later, and more complex project for the Arthurian cycle of chivalry in the Sala del Pisanello, which is the artist's greatest masterpiece was, as we have seen, the last.

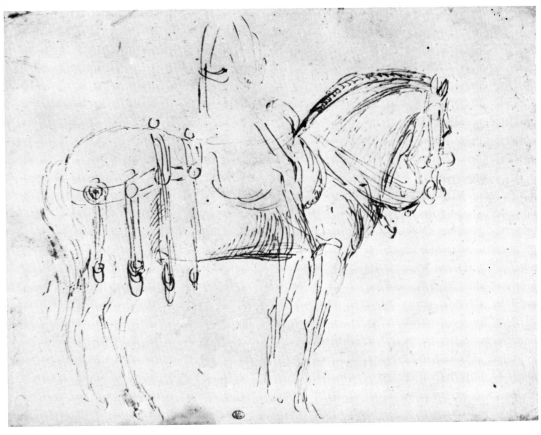

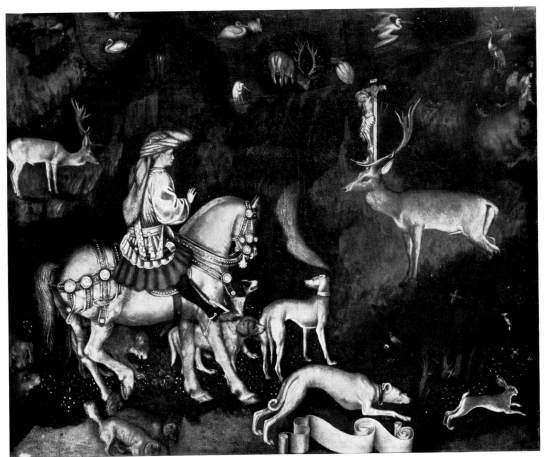

188. *Horse and knight. Paris, Louvre (Drawing No. 2368r).*
189. *The Vision of St. Eustace. London, National Gallery.*

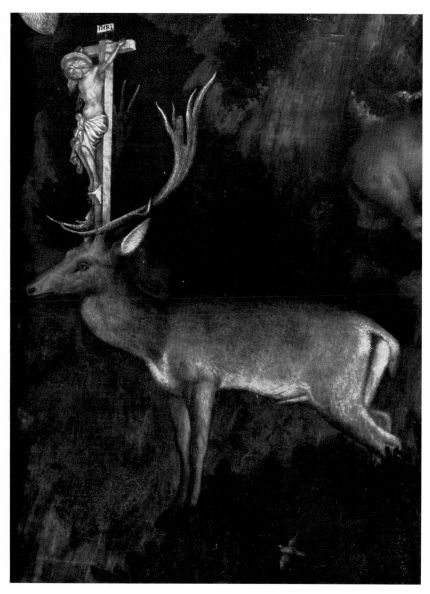

190. *The Vision of St. Eustace, detail of the stag with the cross. London, National Gallery.*

191. *The Vision of St. Eustace, detail showing the bear and birds. London, National Gallery.*

192–194. Miniatures from MS. E.III.19, 'Scriptores Historiae Augustae, Vitae diversorum principum et tyrannorum a diversis compositae', cc. 114vv. 35v., 42. Turin, Biblioteca Nazionale.

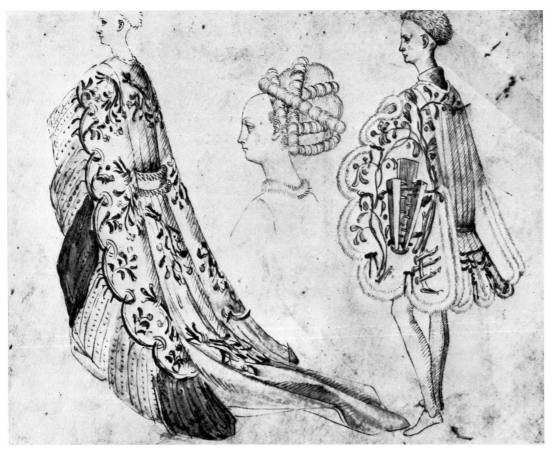

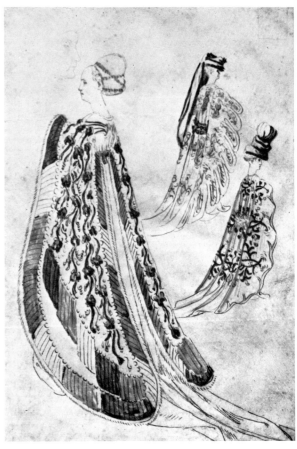

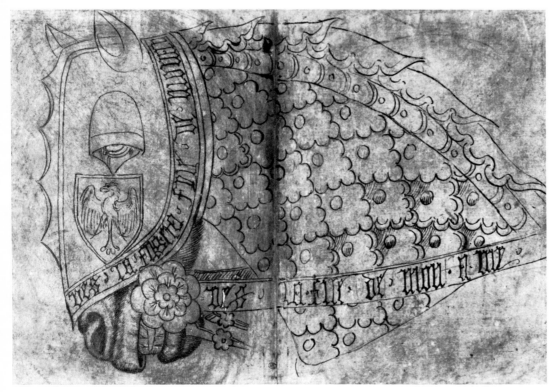

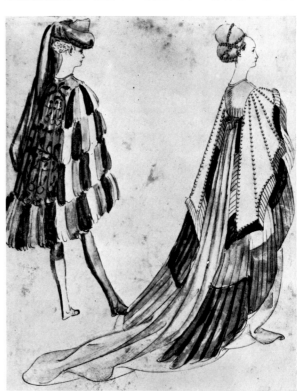

195. Studies of costumes. Oxford, Ashmolean Museum.
196. Head of a horse in tournament armour. Paris, Louvre (Drawing No. 2632).

197, 198. Studies of costumes. Bayonne, Musée Bonnat (Drawing No. 141r). Chantilly, Musée Condé (Drawing No. 3r).

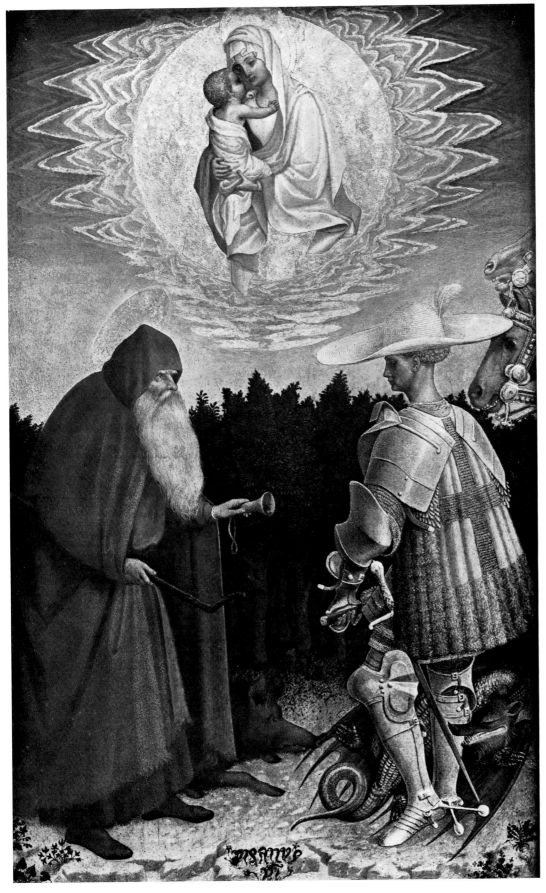

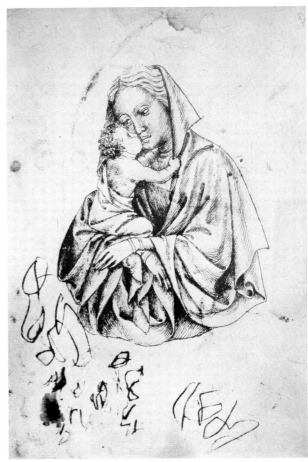

199. *Madonna and Child with Saints Anthony and George. London, National Gallery.*

200. *Madonna and Child. Paris, Louvre (Drawing No. 2623v).*

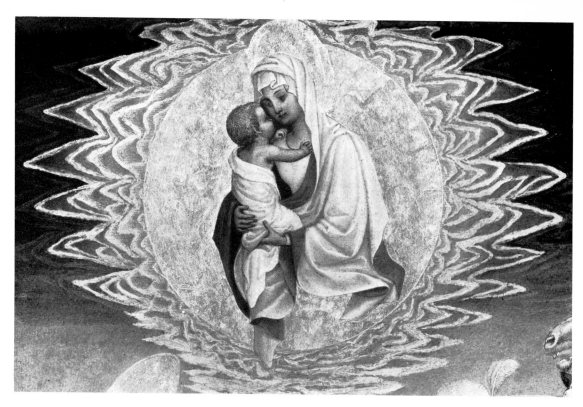

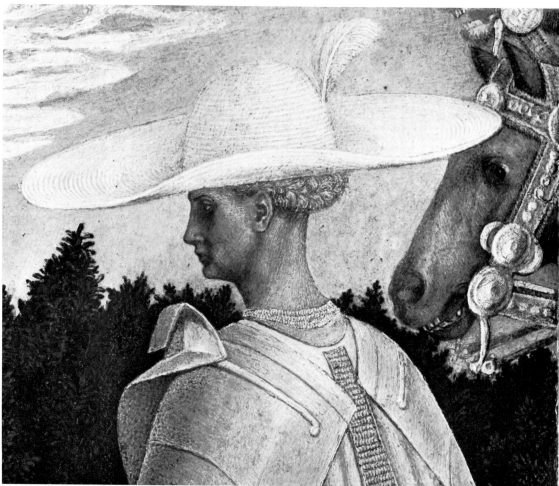

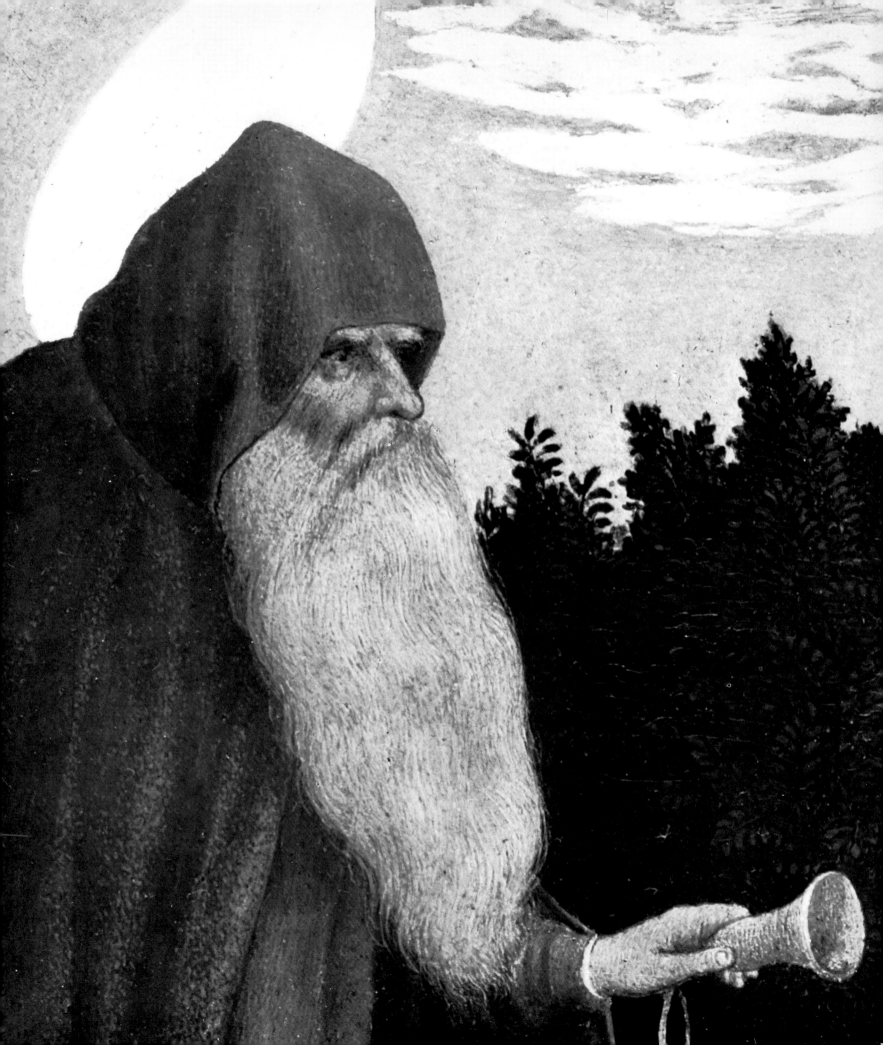

204. *Scenes of chivalry. Paris, Louvre (Drawing No. 2594v).*
205. *Cavalcade. Paris, Louvre (Drawing No. 2595r).*
206. *Gothic buildings in a hilly landscape. Paris, Louvre (Drawing No. 2280).*

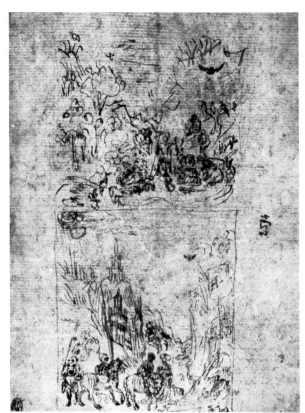

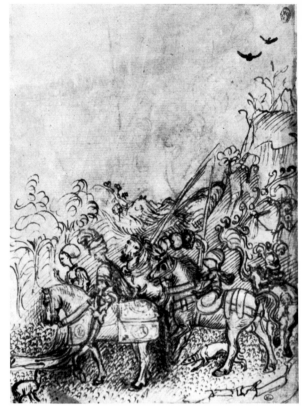

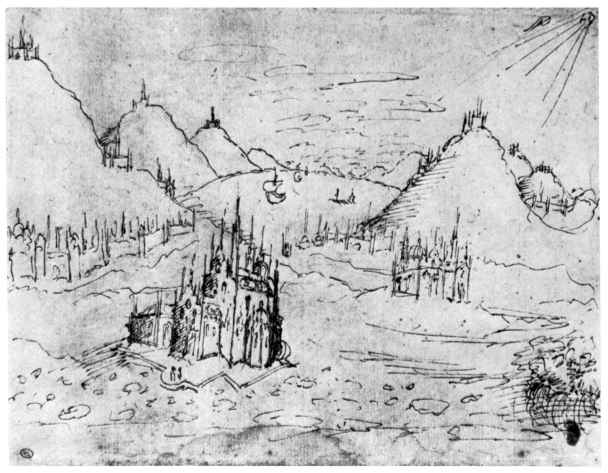

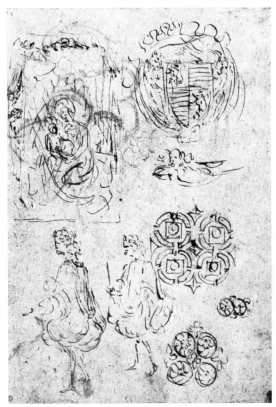

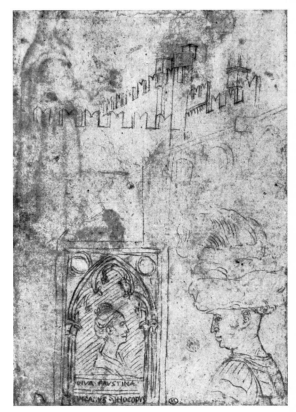

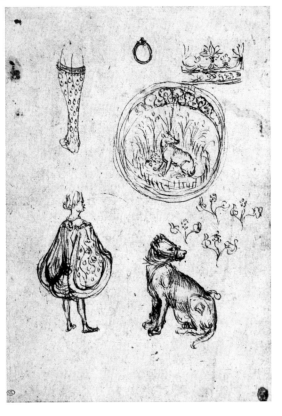

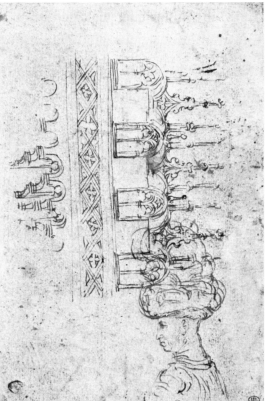

207. *Page, dog, ornamental motives, leg, Gonzaga crest with dog. Paris, Louvre (Drawing No. 2277).*

208. *Ornamental motives, Madonna and Child, two pages, Gonzaga crest with two lions rampant. Paris, Louvre (Drawing No. 2278).*

209. *Sketch of the walls of a castle, two male profiles, 'diva Faustina'. Paris, Louvre (Drawing No. RF 519r).*

210. *Male profile and architectural drawings. Paris, Louvre (Drawing No. 2276r).*

211. *Architectural motives. Paris, Louvre (Drawing No. 2276v).*

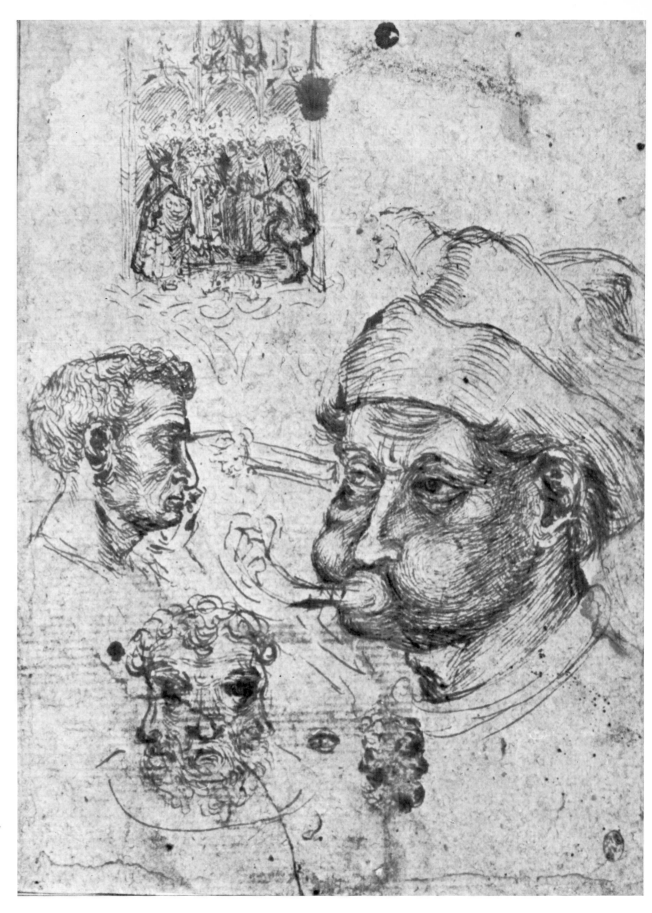

212. Sketch for an altarpiece, male heads and three-faced head. Paris, Louvre (Drawing No. 2300).

On the opposite page:

213. Horse seen from behind. Paris, Louvre (Drawing No. 2444).

214. Cloak trimmed with fur and woman looking out of a balcony decorated with medallions. Paris, Louvre (Drawing No. 2275r).

215. Sketch of firearms and helmets. Paris, Louvre (Drawing No. 2295r).

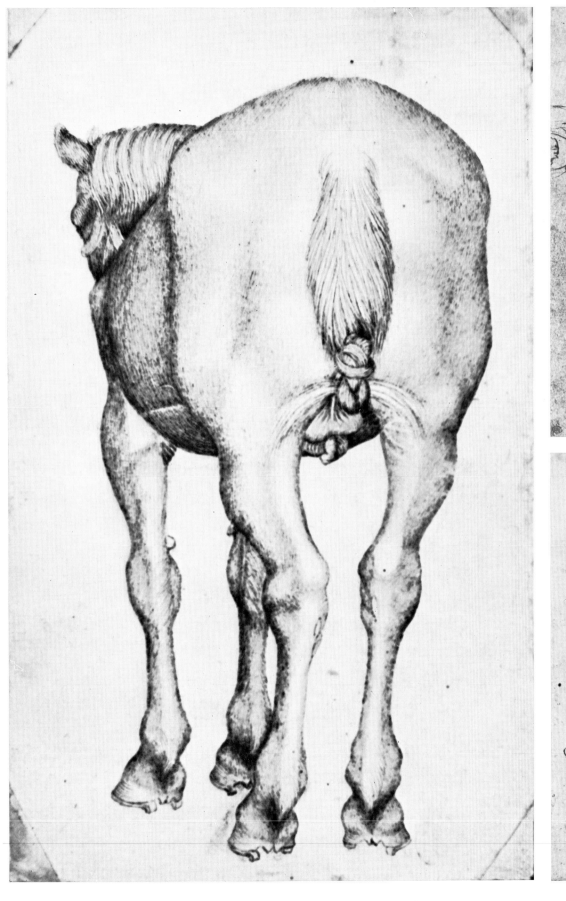

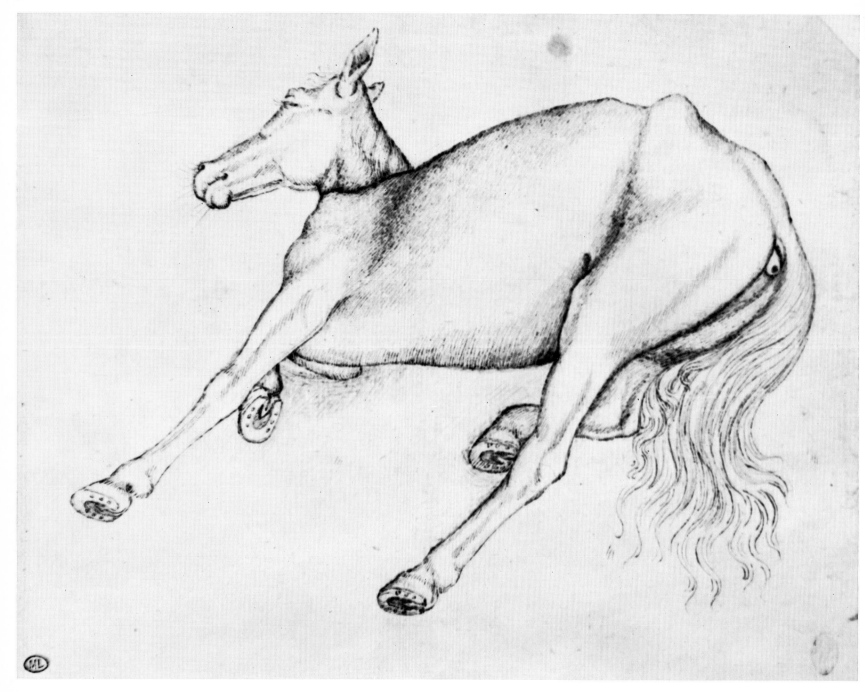

216. Horse lying down. Paris, Louvre (Drawing No. 2369).

217. Man of arms. Paris, Louvre (Drawing No. 2509v).

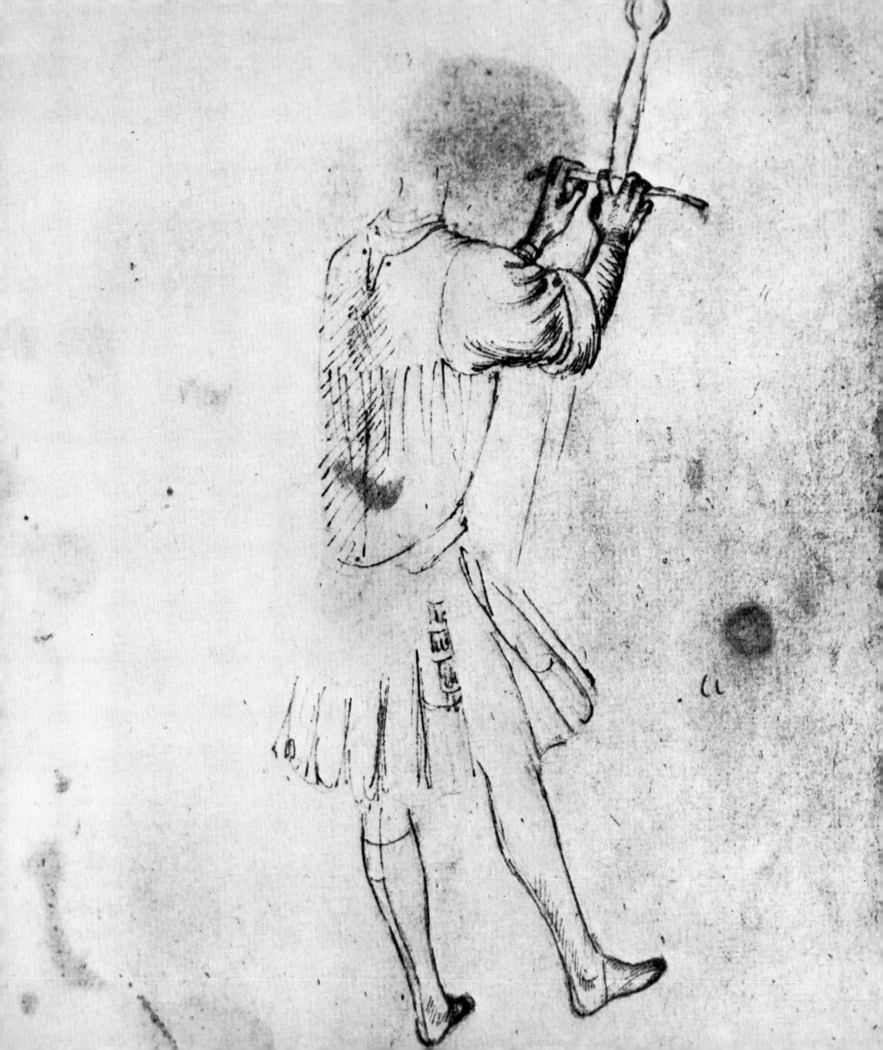

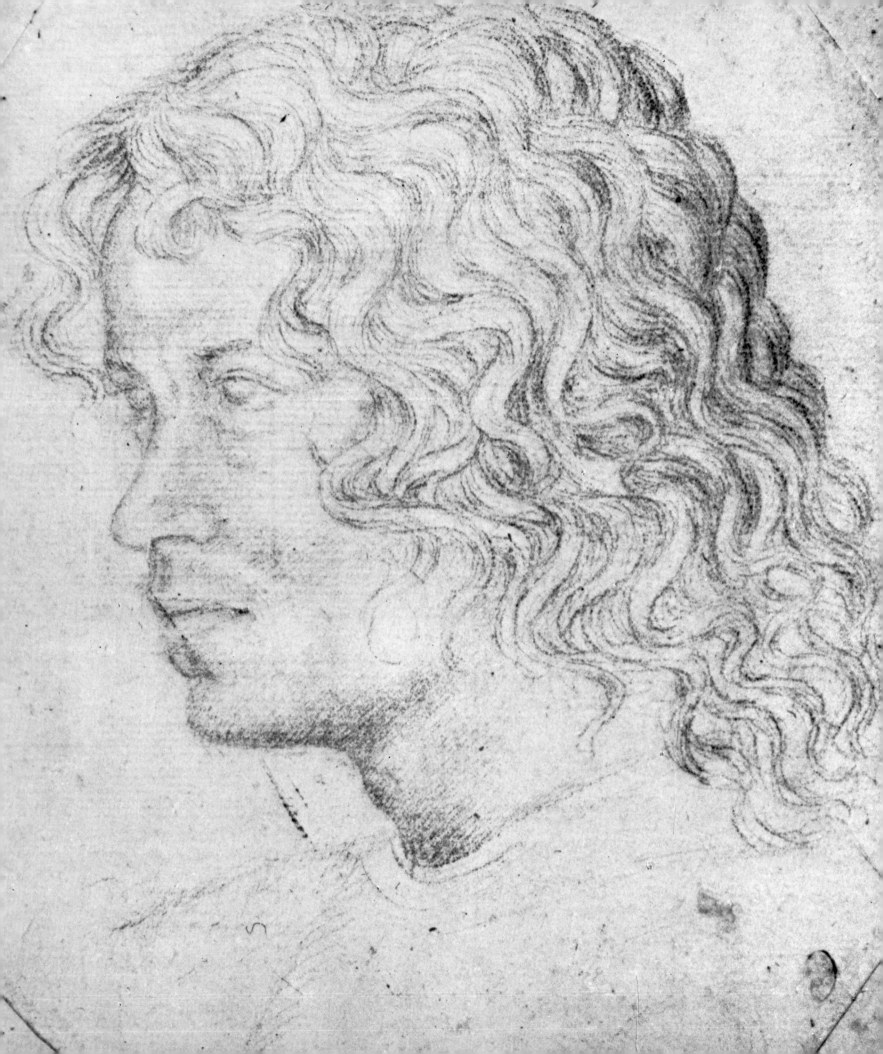

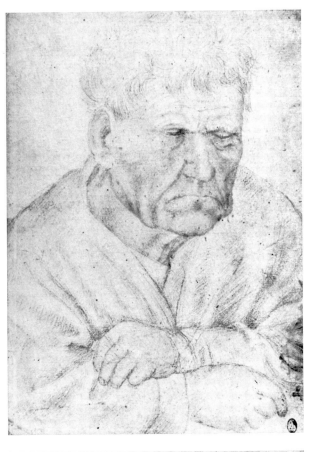

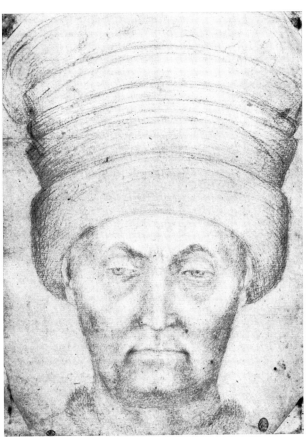

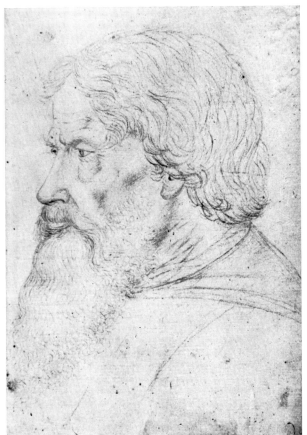

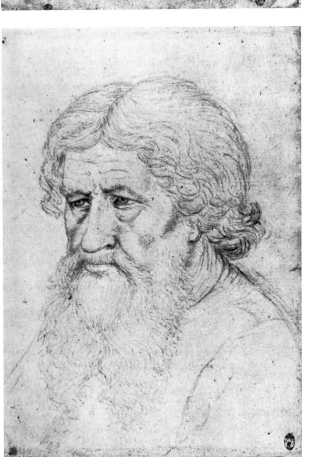

218. *Head of a man. Paris, Louvre (Drawing No. 2330).*

219. *Head of a man. Paris, Louvre (Drawing No. 2336).*

220. *Head of a man. Paris, Louvre (Drawing No. 2480).*

221. *Head of a bearded man. Paris, Louvre (Drawing No. 2335).*

222. *Head of a bearded man. Paris, Louvre (Drawing No. 2337).*

223. *Head of a man. Paris, Louvre (Drawing No. 2606v).*

224. *Warrior supporting a pole with his right hand. Paris, Louvre (Drawing No. 2612r).*

225. *Head of a dead warrior. Paris, Louvre (Drawing No. 2595v).*

226. *Head of a warrior. Paris, Louvre (Drawing No. 2616r).*

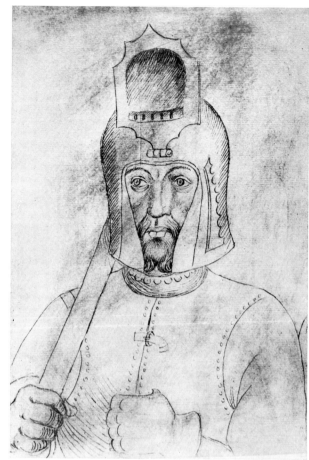

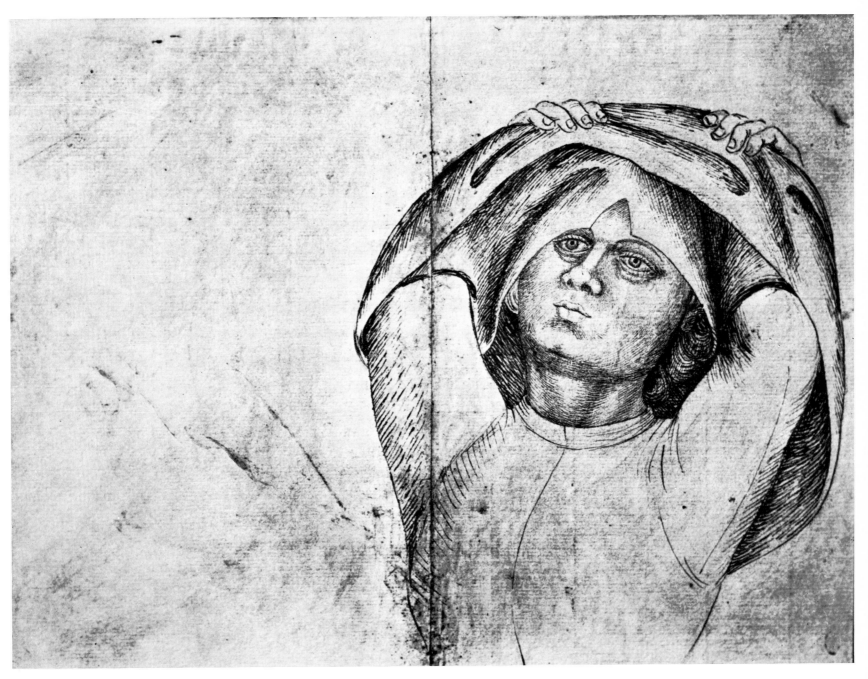

227. Young man taking off his jerkin. Paris, Louvre (Drawing No. 2597r).

228. *Study for a medal with bust of Alfonso V of Aragon. Paris, Louvre (Drawing No. 2307).*

229. *Study for the medal of Alfonso V of Aragon. Paris, Louvre (Drawing No. 2306r).*

230. *Six studies for medallions. Paris, Louvre (Drawing No. 2318v).*

231. *Four studies for medallions. Paris Louvre (Drawing No. 2318r).*

232. *Ornamental motive. Paris, Louvre (Drawing No. 2538).*

233. *Ornamental motive for fabrics. Paris, Louvre (Drawings No. 2533).*

On the opposite page:

234. *Study for the reverse of a medal of Alfonso V of Aragon. Paris, Louvre (Drawing No. 2486).*

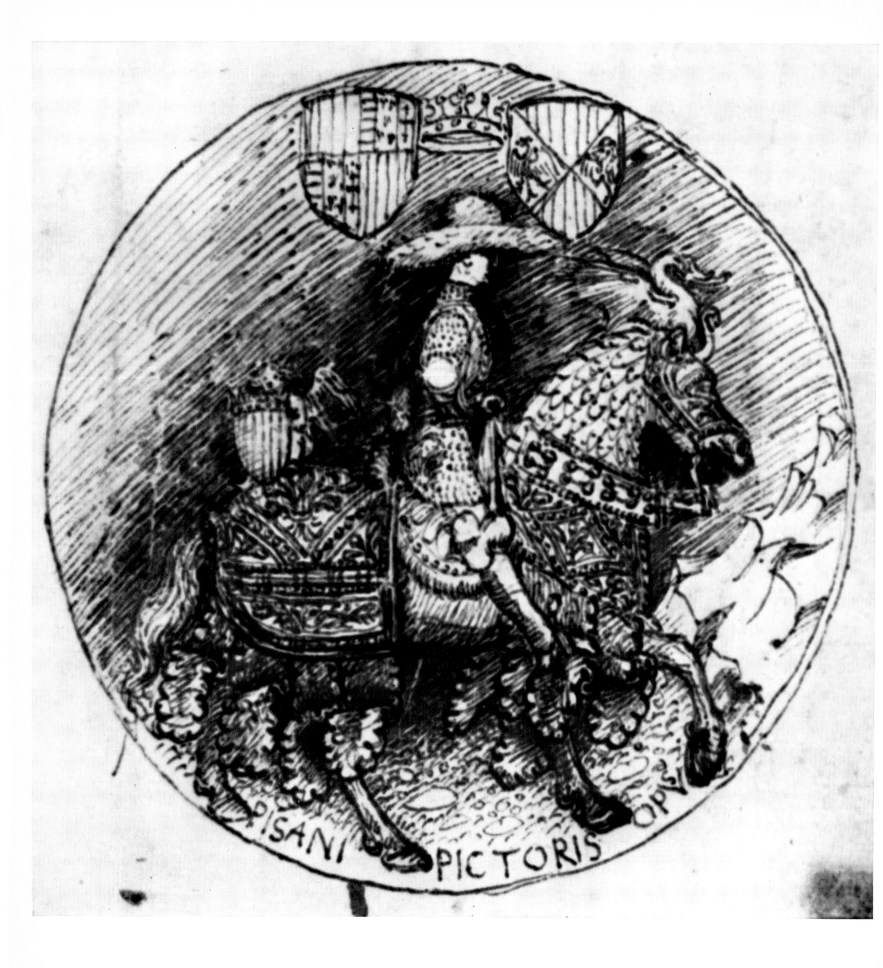

DETAILS OF THE DISCOVERY OF PISANELLO'S FRESCOES
IN THE PALAZZO DUCALE IN MANTUA

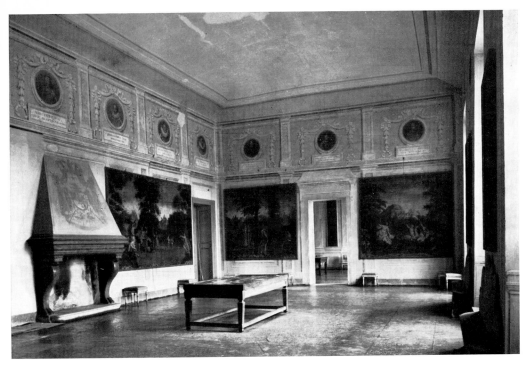

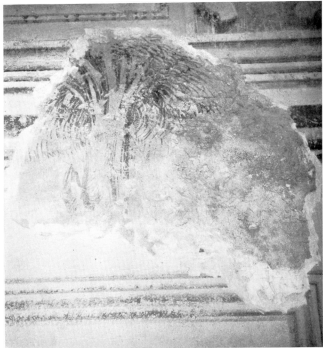

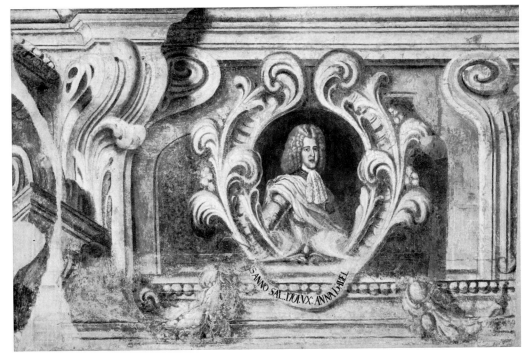

235. *Sala dei Principi: The room as it appeared before Pisanello's frescoes were rediscovered.*
236. *Sala dei Principi: Portrait of Ferdinando Carlo Gonzaga with the date 1701.*

237. *Sala dei Principi: Group of trees discovered under the* intonaco *of the eighteenth-century frieze.*
238. *Sala dei Principi: Head of a Woman, charcoal drawing, late fourteenth century or early fifteenth.*

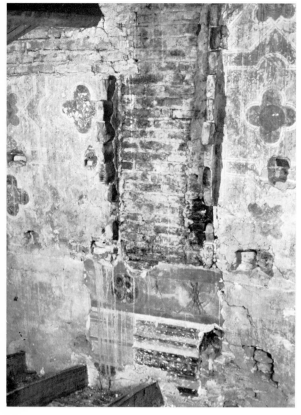

239. *Attic: above, the Gothic decoration of the end of the fourteenth century; below, decoration of the end of the sixteenth century superimposed over the fifteenth-century surface.*

240. *Attic: above, frieze, of the end of the fourteenth century; below, Battle frieze.*

241. *Attic: upper part of the Battle during the uncovering process (on the left fragments of* intonaco *superimposed in the eighteenth century).*

On the opposite page:

242, 243. *Attic: attempted removal of a fragment of the frieze made some time before the rediscovery.*

244. *Attic: Detail of Battle frieze with signs of the spolvero technique.*

245. *Attic: Detail of Battle frieze continuing on the adjacent wall.*

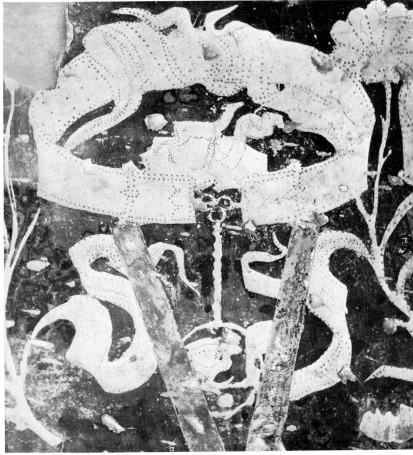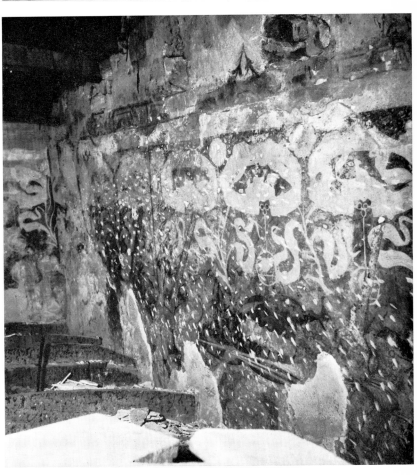

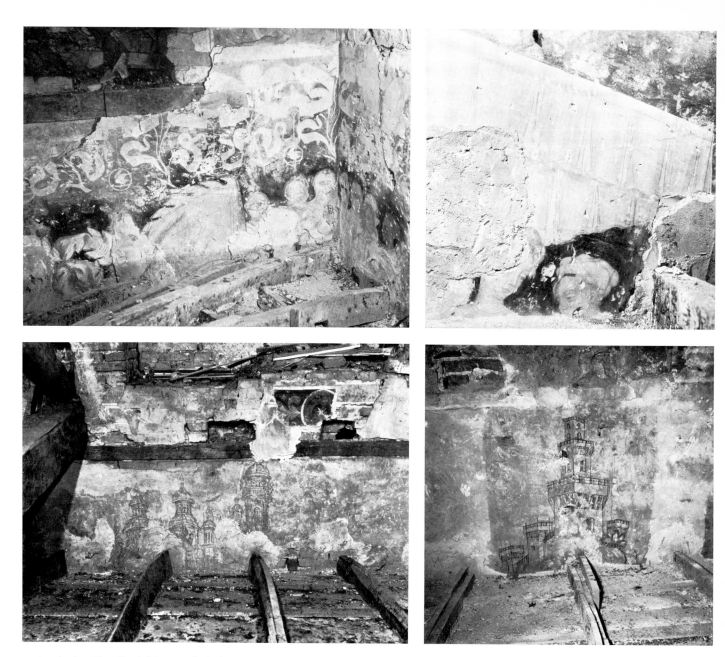

246. *Attic: Detail of frieze and of the group of knights on the long inside wall.*

247. *Attic: Architectural details of the upper part of the* sinopia *on the inside wall.*

248. *Attic: Detail of two female heads after they had been uncovered.*

249. *Attic: Short left hand wall, detail of a castle.*

250. Sala dei Principi: The Battle after the removal of the eighteenth-century intonaco.

251. *Sala dei Principi: Detail of the Battle, figures of two knights during the cleaning of the fresco.*

252. *Sala dei Principi: Detail of the Battle, the lioness during the cleaning of the fresco.*

253. *Sala dei Principi: Detail of the Battle, figure of a warrior at bottom left, during the uncovering process (parts of the superimposed layers of intonaco of the sixteenth and eighteenth centuries can still be seen).*

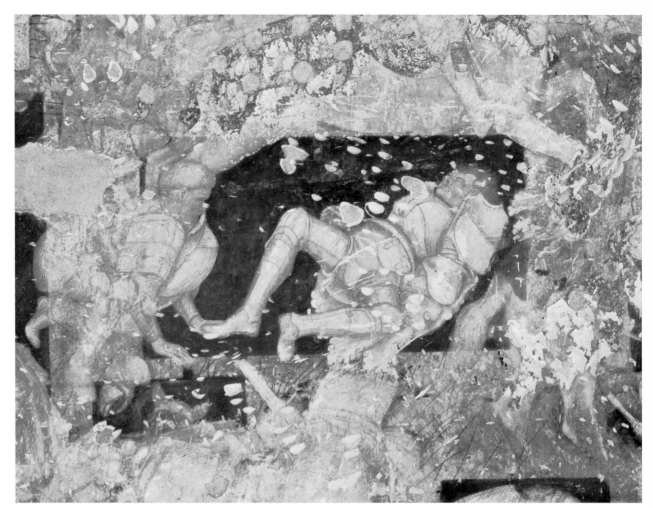

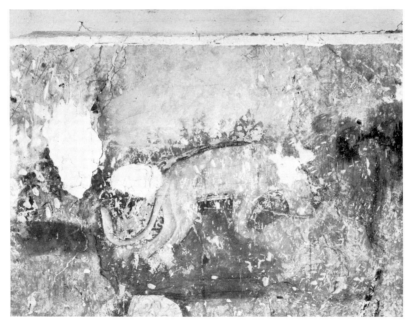

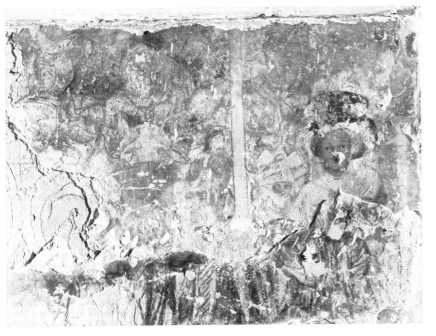

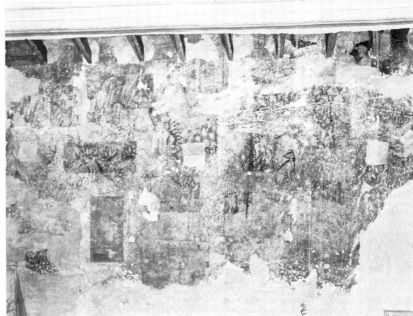

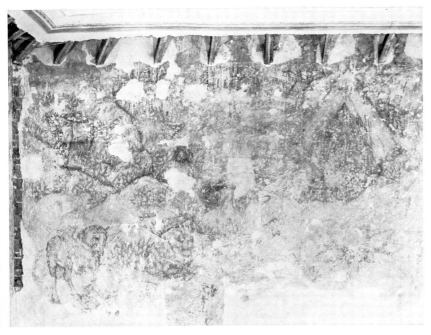

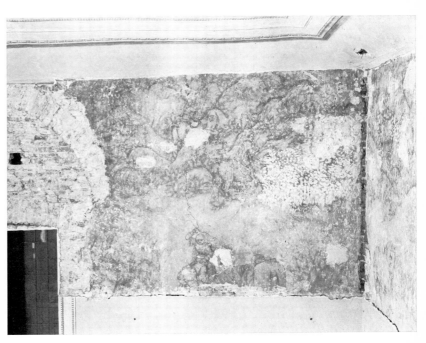

254. *Sala dei Principi: Group of warriors at the right end of the long inside wall, after it had been uncovered.*

255. *Sala dei Principi: Left hand part of the* sinopia *on the long inside wall, after it had been uncovered.*

256. *Sala dei Principi: Right hand part of the* sinopia *on the long inside wall with first attempts at cleaning.*

257. *Sala dei Principi: Sinopia on the short left hand wall, after it had been uncovered.*

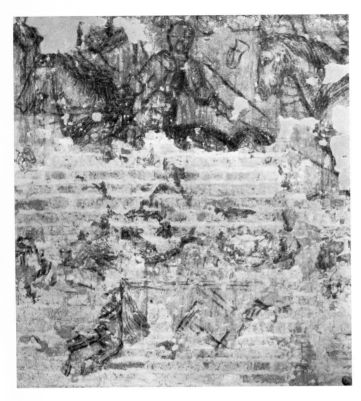

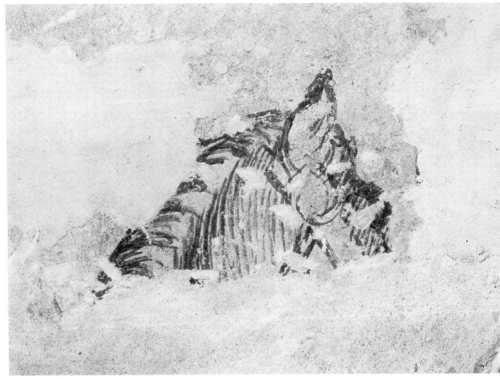

258. *Sala dei Principi: Fragments of* sinopia *with a horse lying down and other indecipherable details on the lower area of the Battle wall.*

259. *Sala dei Principi: Detail of the head of a horse discovered on the bottom part of the long inside wall.*

260. *Sala dei Principi: '...or Lo...' ([Man]or Lo[verzep]?). Mutilated inscription on the lower part of the inside wall, corresponding to the great Castle.*

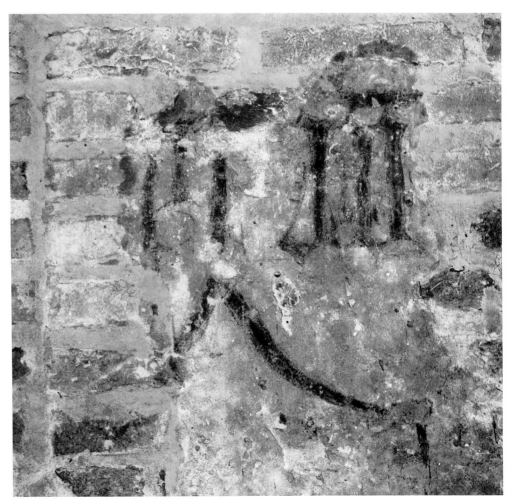

BIBLIOGRAPHY / LIST OF ILLUSTRATIONS
ACKNOWLEDGEMENTS / INDEX OF NAMES

BIBLIOGRAPHY

1456
FACIUS, B., *De viris illustribus liber*, ed. L. Mehus, Florence, 1745.

1519
Gyron le courtois, republished by J. Petit and M. Le Noir, Paris.

1521
CESARIANO, C., *Lucius Pollio Vitruvius. De Architectura. Lib. X.*, translated from the Latin, Como.

1525
MICHIEL, M.A., *Notizie d'opere di disegno pubblicate e illustrate da G. Morelli*, 1880, (2nd ed. edited by G. Frizzoni, Bologna, 1884).

1550
VASARI, G., *Le vite de' più eccellenti pittori, architetti e scultori*, Florence; 2nd ed. Florence, 1568 (ed. with notes and commentary by G. Milanese, Florence, 1878).

1581
SANSOVINO, F., *Venetia città nobilissima et singolare, descritta in XIII libri*, Venice.

1617
POSSEVINO, A., *Gonzagae*, Mantua.

1718
DAL POZZO, B.C., *Le Vite de' pittori, degli scultori et architetti veronesi*, Verona.

1733
SANUTO, M., 'Vitae ducum venetorum', in *Rerum Italicarum Scriptores*, XXII, Milan.

1815
ANTOLDI, F., *Descrizione del Regio Cesareo Palazzo di Mantova*, Mantua.

1843–9
BONUCCI, A., *Opere volgari di L.B. Alberti*, Florence.

1855
VALLARDI, G., *Disegni di Leonardo da Vinci posseduti da G. Vallardi, dal medesimo descritti e in parte illustrati*, Milan.

1860
SCHULZ, H.W., *Denkmäler der Kunst des Mittelalters in Unteritalien*, IV, Dresden.

1864
NANIN, P., *Disegni di varie dipinture a fresco che sono in Verona*, Verona.

Osio, L., *Documenti diplomatici tratti dagli archivi milanesi*, Milan.

1864–5
La Tavola Ritonda o l'Istoria di Tristano, ed. by F.L. Polidori, Bologna.

1865
MAFFEI, S., *Studi sopra la storia della pittura italiana dei secoli XIV e XV e della scuola pittorica veronese dai medi tempi a tutto il secolo XVIII*, Verona.

1868
LORENZI, G., *Monumenti per servire alla storia del Palazzo Ducale di Venezia*, Pt. I from 1253 to 1600, Venice.

1870
CAMPORI, G., *Raccolta di cataloghi ed inventari inediti, di quadri, statue, disegni ecc., dal sec. XV al XVI*, Modena.

1880
BRAGHIROLLI, W., MEYER, P., PARIS, G., 'Inventaire des manuscrits en langue française possédés par Francesco Gonzaga I, Capitaine de Mantoue, mort en 1407', in *Romania*, IX.

1881
HEISS, A., *Les médailleurs de la Renaissance: I. Vittore Pisano*, Paris.

1883
WICKOFF, F., 'Der Saal des grossen Rathes zu Venedig', in *Repert. für Kunstwissenschaft*, IV.

1885
BODE, U., TSCHUDI, H., 'Die Ambetung der Könige von Vittore Pisano und die Madonna mit Heiligen aus dem Besitz des Cav. dal Pozzo', in *Jahrbuch der Königlich Preussischen Kunstsamml.*, IV.

1887
JANITSCHEK, H., 'L.B. Albertis, Kleinere Kunsttheoretische Schriften', in *Eitellberger Quellenschriften*, XI, Vienna.

1888
ROSSI, U., 'Il Pisanello e i Gonzaga', in *Archivio Storico dell'Arte*.

1889
VENTURI, A., 'La scoperta di un ritratto estense del Pisanello', in *Archivio Storico dell'Arte*.

1890
NOVATI, F., 'I Codici francesi dei Gonzaga, secondo nuovi documenti', in *Romania*, XIX.

LÖSETH, E., *Le roman en prose de Tristan, le roman de Palamède et la compilation de Rusticien de Pise. Analyse critique d'après les manuscrits de Paris*, Paris.

1891

CARTA, F., *Codici, corali e libri a stampa miniati della Biblioteca Nazionale di Milano*, Rome.

1892

MARIOTTI, R., 'Nuovi documenti di Gentile da Fabriano sui freschi della Cappella Malatestiana a Brescia', in *Nuova Rivista Misena*.

1893–4

GRUYER, G., 'Vittore Pisano appelé aussi le Pisanello', in *Gazette des Beaux-Arts*, X-XI-XII.

1895

COLVIN, S., *Guide to an exhibition of drawings and engravings by the old masters principally from the Malcolm Collection*, London.

VON SCHLOSSER, J., 'Ein veronesisches Bilderbuch und die höfische Kunst des XIV. Jahrhunderts, in *Jahrbuch der Kunsthist. Samml. des Allerhöchstein Kaiserhauses*, XVI (trans. into Italian by G.L. Mellini, *L'Arte di corte nel XIV secolo*, ediz. di Comunità 1965).

RAVAISSON, F., 'Une oeuvre de Pisanello', in *Mémoires de l'Académie des Inscriptions et Belles Lettres*.

1896

VENTURI, A., *Le Vite dei più eccellenti pittori, scultori e architetti scritte da Giorgio Vasari. I: Gentile da Fabriano e il Pisanello*, critical ed., Florence.

1897

MÜNTZ, E., 'Vittore Pisanello à propos de la nouvelle édition de Vasari publiée par A. Venturi', in *Revue de l'Art ancien et moderne*, I.

BRAGHIROLLI, W., *Sulle manifatture di arazzi in Mantova*, Mantua.

1899

MORETTI, G., *Relazione ufficiale regionale per la conservazione dei monumenti in Lombardia*, Milan.

LUZIO, A., and RENIER, R., 'La coltura e le relazioni letterarie di Isabella d'Este Gonzaga', in *Giornale Storico della Letteratura Italiana*, XXXIII.

1901

HORNE, H.P., 'The Battle-piece by Uccello in the National Gallery, in *The Monthly Review*, V.

1902

BÉDIER, J., *Le roman de Tristan par Thomas*, Paris.

ZIPPEL, G., 'Artisti alla corte degli Estensi nel Quattrocento', in *L'Arte*, V.

TARDUCCI, F., 'Gianfrancesco Gonzaga Signore di Mantova', in *Archivio Storico Lombardo*, XVII-XVIII.

1903

DAVARI, S., *Notizie storiche topografiche della città di Mantova nei secoli XIII-XIV-XV*, Mantua.

1904

FOGOLARI, G., 'Un manoscritto perduto della Biblioteca di Torino', in *L'Arte*.

1905

HILL, G.F., *Pisanello*, London (2nd ed. 1911).

1907

BURGER, F.B., *Francesco Laurana: eine Studie zur italienischen Quattrocento Skulptur*, Strasburg.

BERENSON, B., *North Italian Painters of the Renaissance*, London.

1908

VENTURI, A., *Storia dell'Arte italiana, VI: La scultura del Quattrocento*, Milan.

BIADEGO, G., 'Pisanus Pictor, nota I', in *Atti del R. Istituto Veneto di Scienze, Lettere ed Arti*.

VENTURI, A., 'Giuseppe Biadego: Pisanus Pictor', in *L'Arte*, XI.

DE FOVILLE, J., 'Pisanello d'après des découvertes récentes', in *Revue de l'Art ancien et moderne*.

PATRICOLO, A., *Guida del Palazzo Ducale di Mantova*, Mantua.

1909

BIADEGO, G., 'Pisanus Pictor, note II e III', in *Atti del R. Istituto Veneto di Scienze, Lettere ed Arti*.

VON MANTEUFFEL, K.Z., *Die Gemälde und Zeichnungen des Antonio Pisano aus Verona*, Halle.

TESTI, L., *Storia della pittura veneziana*, I, Bergamo.

1909–13

SOMMER, O., *The Vulgate Version of the Arthurian Romances*, Vols. I-VII, London.

1910

SOMMER, E., 'La leggenda di Tristano in Italia', in *Rivista d'Italia*, XIII.

TESTI, L., 'Vittore Pisanello o Pisanus Pictor', in *Rassegna d'Arte*, X.

VENTURI, A., 'Pisanus Pictor: nota III', in *L'Arte*, XIII.

BIADEGO, G., 'Pisanus Pictor, note IV e V', in *Atti del R. Istituto Veneto di Scienze, Lettere ed Arti*.

1911

VENTURI, A., *Storia dell'Arte italiana, VII, p. I: La pittura del Quattrocento*, Milan.

TRUFFI, R., *Giostre e cantori di giostre*, Rocca San Casciano.

1912

TOESCA, P., *La pittura e la miniatura in Lombardia dai più antichi monumenti alla metà del Quattrocento*, Milan (new ed. with introduction by C. Castelnuovo, Turin, 1966).

VON MANTEUFFEL, K.Z., 'Über zwei Handzeichnungen des A. Pisano', in *Mitteil. des Kunsthist. Inst. in Florenz*, II.

GHIBERTI, L., *I Commentari*, critical edition by J. von Schlosser; edition by O. Morisani, Naples 1927.

1913

BIADEGO, G., 'Pisanus Pictor, nota VI', in *Atti del R. Istituto Veneto di Scienze, Lettere ed Arti*.

LUZIO, A., *I Corradi di Gonzaga Signori di Mantova*, Milan.

1914

GLASER, C., 'Italienische Bildmotive in der altdeutschen Malerei', in *Zeitschrift für bildende Kunst*, Leipzig.

RICHTER, J.P., *A descriptive catalogue of old Masters of the Italian schools*, Florence.

1918

GEROLA, G., 'Vecchie insegne di Casa Gonzaga', in *Archivio Storico Lombardo*.

1919

SALMI, M., 'Gli affreschi del Palazzo Trinci a Foligno', in *Bollettino d'Arte*.

1920

KRASCENINNIKOWA, M., 'Catalogo dei disegni del Pisanello nel Codice Vallardi del Louvre', in *L'Arte*, XXIII.

1921

GIROLLA, P., *Pittori e miniatori a Mantova sulla fine del '300 e sul principio del '400*, Mantua.

PACCHIONI, G., *Il Palazzo Ducale di Mantova*, Florence.

CARPI, P., *Giulio Romano ai servigi di Federico II Gonzaga*, Mantua.

1923

GIROLLA, P., 'La biblioteca di Francesco Gonzaga secondo l'inventario del 1407', in *Atti e Memorie dell'Accademia Virgiliana di Mantova*, XIV-XVII.

HERMANIN, F., 'Una tavola di Stefano da Zevio a Palazzo Venezia', in *Bollettino d'Arte*.

La Queste del Saint Graal, roman du XIII siècle, ed. by A. Pauphilet, Paris.

1924

VON SCHLOSSER, J., *Die Kunstliteratur*, Vienna (Italian trans. and revision by F. Rossi, *La Letteratura artistica*, Florence, 1935; 2nd Italian ed. Florence, 1956).

1926

VAN MARLE, R., *The Development of the Italian schools of painting*, VII, The Hague.

LONGHI, R., 'Lettere pittoriche: Roberto Longhi a G. Fiocco', in *Vita artistica*, I.

SANDBERG VAVALÀ, E., *La pittura veronese del Trecento e del primo Quattrocento*, Verona.

1927

VAN MARLE, R., *The Development of the Italian schools of painting*, VIII, The Hague.

PANOFSKY, E., *Die Perspective als 'symbolische Form'*, Leipzig, Berlin (Italian trans. by E. Filippini, *La prospettiva come forma simbolica*, Milan, 1961).

FIOCCO, G., *L'arte di Andrea Mantegna*, Bologna (2nd ed., Venice, 1959).

1928

L'Intelligenza, ed. by V. Mistruzzi, Bologna.

HUIZINGA, J., *Herfsttji der Middeleeuwen*, Harlem, 3rd ed. (Eng. translation *The Waning of the Middle Ages*).

1928-9

LONGHI, R., ' "Me pinxit". I resti del politico di Cristoforo Moretti. La restituzione di un trittico di arte cremonese', in *Pinacotheca*, I.

SALMI, M., 'Antonio Veneziano', in *Bollettino d'Arte*.

1929

GEROLA, G., 'Trasmigrazioni e vicende dei camerini di Isabella d'Este', in *Atti e Memorie dell'Accademia Virgiliana di Mantova*.

1930

MANN, J.G., 'The Sanctuary of Madonna delle Grazie, with notes on Italian armour of the fifteenth century', in *Archaelogia*.

HILL, G.F., *A corpus of Italian medals of the Renaissance before Cellini*, London.

MORASSI, A., 'La Mostra d'Arte italiana a Londra', in *Emporium*, LXXI.

MARTINIE, A.H., *Pisanello*, Paris.

1931

RICHTER, G.M., 'Pisanello Again', in *The Burlington Magazine*.

1931-2

VON MANTEUFFEL, K.Z., 'Anzeigen zu G.F. Hill "Dessins etc." ', in *Zeitschrift für bildende Kunst*, LXV.

1932

BERENSON, B., 'Quadri senza casa. Il Trecento fiorentino', V, in *Dedalo*, I.

COTTAFAVI, C., 'I Gabinetti d'Isabella d'Este: vicende, discussioni, restauri', in *Bollettino d'Arte*.

FILIPPINI, F., 'La Collezione dei quadri del Museo Civico di Bologna', in *Rivista del Comune di Bologna*.

BERENSON, B., *Italian Pictures of the Renaissance*, Oxford.

BERENSON, B., *North Italian Painters of the Renaissance*, New York, Oxford.

1933

FISCHER, O., and PLANISCIG, L., 'Zwei Beiträge zu Pisanello: I. Zwei Bildnisse des deutscher Kaisers Sigismund von Pisanello. II. Ein Entwurf den Triumhbogen um Castelnuovo zu Neapel', in *Jahrbuch der Königl-Preuss. Kunstsamml.*, LIV.

PLANISCIG, L., 'Disegni per l'arco trionfale del Castel Nuovo di Napoli', in *Jahrbuch der Preuss. Kunstsamml.*

1934

LONGHI, R., *Officina ferrarese*, Rome (2nd enlarged ed., Florence, 1956).

TOESCA, P., Under 'Masaccio', in *Enciclopedia Italiana*, XXII, Rome.

1936

MORASSI, A., *Il Museo Poldi Pezzoli in Milano*, Rome.

1937

DEGENHART, B., Under 'Stefano da Zevio', in "Thieme-Becker", *Künstler Lexikon*, XXXI, Leipzig.

WITTGENS, F., *Il Museo Poldi Pezzoli a Milano*, Milan.

GIANNANTONI, N., *Catalogo della Mostra Iconografica Gonzaghesca*, Mantua.

1938

LOOMIS, R.S., and LOOMIS, HIBBARD L., *Arthurian Legends in Medieval Art*, London, New York.

1939

BERTI TOESCA, E., 'Un romanzo illustrato del '400', in *L'Arte*.

RASMO, N., 'Il Codice Palatino 556 e le sue illustrazioni', in *Rivista d'Arte*, XXI.

HUIZINGA, J., *Homo ludens*, Amsterdam (Italian trans., Turin, 1949).

SANDBERG VAVALÀ, E., 'Nicolò di Pietro', in *Art Quarterly*, II.

VENTURI, A., *Pisanello*, Rome.

LOOMIS, R.S., 'Chivalrie and dramatic imitations of Arthurian romance', in *Medieval Studies in Memory of A. Kingsley Porter*, Cambridge.

1940

OERTEL, R., 'Wandmalerei und Zeichnung in Italien', in *Mitteil. d. Kunsth. Inst. in Florenz*.

LONGHI, R., 'Fatti di Masolino e di Masaccio', in *La Critica d'Arte*, V.

DEGENHART, B., *Pisanello*, Vienna.

1943

ARSLAN, W., 'Un affresco di Stefano da Verona', in *Le Arti*.

1944

DEGENHART, B., 'Das Wiener Bildnis Kaiser Sigismunds, ein Werk Pisanellos', in *Jahrb. der Kunsthist. Samml. in Wien*, XIII.

1945

DEGENHART, B., *Pisanello*, Turin.

1946

LONGHI, R., *Viatico per cinque secoli di pittura veneziana*, Florence.

RAGGHIANTI, C.L., *Miscellanea minore di critica d'arte*, Bari.

PALLUCCHINI, R., *Catalogo della mostra dei capolavori dei Musei Veneti*, Venice.

COLETTI, L., *I Primitivi: I Senesi e i Giotteschi, II*, Novara.

POPHAM, A.E., 'B. Degenhart: Pisanello', in *The Burlington Magazine*.

DEGENHART, B., 'Un'opera di Pisanello: Il ritratto dell'imperatore Sigismondo a Vienna,' in *Arti Figurative*, II, 3-4.

WESCHER, P., 'Eine Modellzeichnung des Paul von Limbourg', in *Phoebus*.

1946-7

ARGAN, G.C., 'The architecture of Brunelleschi and the origins of perspective theory in the fifteenth century,' in *Journal of the Warburg and Courtauld Institutes*, IX-X.

1947

AVENA, A., *Catalogo della Mostra capolavori della pittura veronese*, Verona.

MIDDELDORF, U., 'B. Degenhart: Pisanello', in *The Art Bulletin*, XXIX.

COLETTI, L., 'Pittura veneta dal Tre al Quattrocento', I, in *Arte Veneta*.

COLETTI, L., *I Primitivi: I Padani, III*, Novara.

1948

COLETTI, L., 'Il Maestro degli Innocenti', in *Arte Veneta*.

HENTZEN, A., *Die Vision des Heiliges Eustachius von Antonio Pisanello*, Berlin.

SANTANGELO, A., *Catalogo del Museo di Palazzo Venezia: I dipinti*, Rome.

ARSLAN, E., 'Intorno a Giambono e a Francesco dei Franceschi', in *Emporium*, CVIII.

ANTAL, F., *Florentine Painting and its Social Background*, London.

1949

DEGENHART, B., 'Le quattro tavole della leggenda di S. Benedetto, opere giovanili del Pisanello', in *Arte Veneta*.

RING, G., *A Century of French painting: 1400-1500*. London.

1950

FIOCCO, G., Disegni di Stefano da Verona', in *Proporzioni*, III.

POPE-HENNESSY, J., *The complete work of Paolo Uccello*, London (2nd ed. 1969).

POPHAM-POUNCEY, A.E., *Italian drawings in the department of prints and drawings in the British Museum. The fourteenth and fifteenth centuries*, London.

ALBERTI, L.B., *Della Pittura*, critical edition by L. Mallè, Florence.

1951

DAVIES, M., *National Gallery Catalogues. The earlier Italian Schools*, London (2nd ed. 1961).

TOESCA, P., *Il Trecento*, Turin.

DEGENHART, B., 'Zu Pisanellos Wandbild in S. Anastasia in Verona', in *Zeitschrift für Kunstwiss.*, V.

1952

DELL'ACQUA, G.A., *I grandi maestri del disegno: Pisanello*, Milan.

KAFTAL, G., *Iconography of the Saints in Tuscan Painting*, Florence.

BOLOGNA, F., 'Contributi allo studio della pittura veneziana del Trecento', II, in *Arte Veneta*.

BRENZONI, R., *Pisanello*, Florence.

FIOCCO, G., 'Niccolò di Pietro, Pisanello, Venceslao', in *Bollettino d'Arte*.

RASMO, N., 'Note sui rapporti tra Verona e l'Alto Adige nella pittura del tardo Trecento', in *Cultura Atesina*, VI.

1953

PANOFSKY, E., *Early Netherlandish Painting*, Cambridge (Mass.).

COLETTI, L., *Pisanello*, Milan.

COLETTI, L., *Pittura veneta del Quattrocento*, Novara.

GRASSI, L., *Gentile da Fabriano*, Milan.

FERRARI, O., 'Un'opera di Niccolò di Pietro', in *Commentari*.

PORCHER, J., *Les Belles Heures de Jean de France, Duc de Berry*, Paris.

1953-4

DEGENHART, B., 'Di una pubblicazione su Pisanello e di altri fatti', in *Arte Veneta*, VII-VIII.

1954

BALDINI, U., 'Restauri di dipinti fiorentini', in *Bollettino d'Arte*.

DUPONT, J., and GNUDI, C., *La peinture gothique*, Paris, Geneva, New York.

ZUMTHOR, P., *Histoire littéraire de la France Médiévale*, Paris.

CAUSA, R., 'Sagrera, Laurana e l'arco di Castelnuovo', in *Paragone*, 55.

RAGGHIANTI, C.L., 'Pisanello' (Review of the book by L. Coletti), in *Sele-Arte*, III, 14.

1954-7

AMADEI, F., *Cronaca Universale della città di Mantova*, ed. by G. Amadei, E. Marani, G. Praticò, L. Mazzoldi, Mantua.

1955

BRENZONI, R., *L'arte pittorica di Pisanello nelle sue opere autentiche*, Florence.

SALMI, M., 'La pittura e la miniatura tardo gotica', in *Storia di Milano*, VI.

ARGAN, G.C., *Brunelleschi*, Milan.

RASMO, N., 'Il Pisanello e il ritratto dell'imperatore Sigismondo a Vienna', in *Cultura Atesina*, IX.

RUSSOLI, F., *La Pinacoteca Poldi Pezzoli*, Milan.

VOLPE, C., 'Donato Bragadin ultimo gotico', in *Arte Veneta*.

1956

GRASSI, L., *Il disegno italiano dal Trecento al Seicento*, Rome.

KRAUTHEIMER, R., *Lorenzo Ghiberti*, Princeton (2nd ed. 1970).

PALLUCCHINI, R., *La pittura veneta del Quattrocento*, Bologna.

PALLUCCHINI, R., 'Nuove proposte per Niccolò di Pietro', in *Arte Veneta*.

LEONARDO, *Treatise on painting*, ed. and trans. by A.P. McMahon, Princeton, N.J.

CHRÉTIEN DE TROYES, *Le Roman de Perceval ou le Conte du Graal*, ed. by W. Roach, Paris.

1957

LEVI D'ANCONA, M., *The iconography of the Immaculate Conception in the Middle Ages and Early Renaissance*, New York.

GIOSEFFI, D., *Perspectiva artificialis*, Trieste.

SALMI, M., 'Riflessioni sul Pisanello medaglista', in *Annali dell'Istituto Italiano di Numismatica*.

SALMI, M., 'La "Divi Julii Caesaris effigies" del Pisanello', in *Commentari*.

BRANDI, C., 'I cinque anni cruciali per la pittura fiorentina del '400', in *Studi in onore di Matteo Marangoni*, Florence.

KELLER, H., 'Bildhauerzeichnungen Pisanellos', in *Festschrift Kurt Bauch*, Munich.

1958

CHIARELLI, R., *Pisanello*, Milan.

MAGAGNATO, L., *Da Altichiero a Pisanello. Catalogo della Mostra*, Venice.

KRAUTHEIMER, R., Under 'Ghiberti', in *Enciclopedia Universale dell'Arte*, Venice-Rome, VI.

LONGHI, R., 'Sul catalogo della Mostra di Verona', in *Paragone*, 107.

LONGHI, R., 'Una mostra a Verona (Altichiero, Stefano, Pisanello)', in *L'Approdo Letterario*, IV, 4.

COLETTI, L., 'La Mostra da Altichiero a Pisanello', in *Arte Veneta*.

VOLPE, C., 'Da Altichiero a Pisanello', in *Arte Antica e Moderna*.

Arte Lombarda dai Visconti agli Sforza. Exhibition catalogue with preface by R. Longhi, Milan.

EMILIANI, A., 'Il Gotico Internazionale', in *Enciclopedia Universale dell'Arte*, Venice-Rome, VII.

1958-9

BETTINI, S., *La pittura gotica internazionale a Verona*, University lectures.

1959

FOSSI TODOROW, M., 'The Exhibition "Da Altichiero a Pisanello" in Verona', in *The Burlington Magazine*.

MARCENARO, C., 'Un ritratto del Pisanello ritrovato a Genova', in *Studies in the history of art dedicated to W.E. Suida*, London.

BRENZONI, R., *Rettifiche e problemi pisanelliani in occasione della Mostra in Castelvecchio*, Verona.

GNUDI, C., 'La pittura del Trecento nell'Italia del Nord e il Gotico internazionale', in *Pittura Italiana*, I, Milan.

1960

BORSOOK, E., *The mural painters of Tuscany, from Cimabue to Andrea del Sarto*, London.

PROCACCI, U., *Sinopie e affreschi*, Florence.

PACCAGNINI, G., *Mantova. Le Arti, I*, Mantua.

BUCCI, M., and BERTOLINI, L., *Camposanto monumentale di Pisa. Affreschi e sinopie*, Milan.

BRANDI, C., *Spazio italiano, ambiente fiammingo*, Milan.

PANOFSKY, E., *Renaissance and Renascences in Western Art*, Stockholm.

DEGENHART, B., and SCHMITT, A., 'Gentile da Fabriano in Rom und die Anfänge des Antikenstudiums', in *Münchner Jahrb. der Bildenden Kunst*.

1961

MAZZOLDI, L., *Mantova. La Storia, II*, Mantua.

PARRONCHI, A., 'Le misure dell'occhio secondo Ghiberti', in *Paragone*, 133.

MELLINI, G.L., 'Problemi di archeologia pisanelliana', in *Critica d'Arte*.

SINDONA, E., *Pisanello*, Milan.

MEISS, M., '"Highlands" in the Lowlands. Jan van Eyck, the Master of Flémalle and the Franco-Italian tradition', in *Gazette des Beaux-Arts*.

MEISS, M., 'An early Lombard altarpiece', in *Arte Antica e Moderna*.

BRYER, A., 'Pisanello and the Princess of Trebisonda', in *Apollo*.

KLEIN, R., 'Pomponius Gauricus on Perspective', in *The Art Bulletin, XIII*.

MARANI, E., and PERINA, C., *Mantova. Le Arti. II*, Mantua.

DEL BRAVO, C., 'Proposte e appunti per Nanni di Bartolo nel Veneto', in *Paragone*, 137.

1962

PACCAGNINI, G., 'Appunti sulla tecnica della "Camera Picta" di Andra Mantegna', in *Scritti di Storia dell'Arte in onore di Mario Salmi*, Rome.

LIMENTANI, A., *Dal Roman de Palamedès ai cantari di Febus-el-fort*, Bologna.

ZERI, F., 'Aggiunte a Zanino di Pietro', in *Paragone*, 153.

LONGHI, R., 'Ancora un pannello di Zanino di Pietro', in *Paragone*, 153.

RUGGIERI, R.M., *L'umanesimo cavalleresco italiano: da Dante al Pulci*, Rome.

SANPAOLESI, P., *Brunelleschi*, Milan.

FLÛTRE, L., *Table des noms propres avec toutes leurs variantes figurant dans les romans du Moyen Age écrits en français ou en provençal*, Poitiers.

VAYER, L., *Masolino és Ròma*, Budapest.

MAGAGNATO, L., *Arte e civiltà del Medioevo Veronese*, Turin.

LONGHI, R., 'Tracciato orvietano', in *Paragone*, 149.

FOSSI TODOROW, M., 'Un taccuino di viaggi del Pisanello e della sua bottega', in *Scritti di Storia dell'Arte in onore di Mario Salmi*, II, Rome (article dated 1959).

1963

CHRÉTIEN DE TROYES, *Romanzi*, ed. by C. Pellegrini, Florence.

PÄCHT, O., 'Zur Enstehung des "Hieronimus in Gehäus"', in *Pantheon*.

FOLENA, G.C., 'La cultura volgare e l'umanesimo cavalleresco nel Veneto', in *Umanesimo europeo e umanesimo veneziano*, Florence.

DEGENHART, B., Under 'Pisanello', in *Enciclopedia Universale dell'Arte*, Venice-Rome, X.

PÄCHT, O., 'The Limbourgs and Pisanello', in *Gazette des Beaux-Arts*.

MEISS, M., 'French and Italian variations on an early fifteenth century theme: S. Jerome and his study', in *Gazette des Beaux-Arts*.

MEISS, M., and TINTORI, L., *The painting of the life of S. Francis in Assisi*, New York.

PANAZZA, G., 'La pittura nei secoli XV e XVI', in *Storia di Brescia*, II, p. VII, Brescia.

1964

MELLINI, G.L., 'Studi su Cennino Cennini,' in *Critica d'Arte*.

PALLUCCHINI, R., *La pittura veneziana del Trecento*, Venice.

MEISS, M., and TINTORI, L., 'Additional observations on Italian mural technique', in *The Art Bulletin*.

VENTURI, L., *Storia della critica d'arte*, Turin.

BAXANDALL, M., 'Bartholomaeus Facius on Painting. A fifteenth century manuscript of "De viris illustribus"', in *Journal of the Warburg and Courtauld Institutes*, XXVII.

1965

MELLINI, G.L., 'Studi su Cennino Cennini', in *Critica d'Arte*.

SANTORO, C., 'La biblioteca dei Gonzaga e cinque suoi codici nella Trivulziana di Milano', in *Arte, pensiero e cultura a Mantova nel primo Rinascimento*, Florence.

GENTHON, I., 'Note sul volume di L. Vayer dedicato a Masolino,' in *Acta Historiae Artium*, XI, 1-2.

MELLINI, G., *Altichiero e Jacopo Avanzi*, Milan.

FASANELLI, J.A., 'Some notes on Pisanello and the Council of Florence', in *Master Drawings*, II, 1.

LONGHI, R., 'Un'aggiunta al "Maestro del Bambino Vispo"', in *Paragone*, 185.

BELLOSI, L., 'Da Spinello Aretino a Lorenzo Monaco', in *Paragone*, 187.

LONGHI, R., 'Ancora su Spinello Aretino', in *Paragone*, 187.

1966

CHIARELLI, R., *Pisanello*, Florence.

MERONI, U., *Catalogo della Mostra dei Codici Gonzagheschi*, Mantua.

FOSSI TODOROW, M., *I disegni del Pisanello e della sua cerchia*, Florence.

DEGENHART, B., and SCHMITT, A., *Italienische Zeichnungen der Frührenaissance*, Munich.

Disegni del Pisanello e di maestri del suo tempo. Catalogue ed. by B. Degenhart and A. Schmitt, Venice.

CASTELFRANCHI VEGAS, L., *Il Gotico internazionale in Italia*, Rome.

DE ROBERTIS, D., 'Ferrara e la cultura cavalleresca', in *Storia della Letteratura Italiana*, III, Ch. V ('La letteratura dell'Italia del Nord'), Milan.

PARRONCHI, A., *Studi sulla dolce prospettiva*, Milan.

CONSOLI, G., *I 'Giuochi' Borromeo e il Pisanello*, Milan.

CASTELFRANCHI VEGAS, L., 'I rapporti Italia-Fiandra, I e II', in *Paragone*, 195, 201.

WOLTERS, W., 'Der Programmentwurf zur Dekoration des Dogenpalastes', in *Mitteil. des Kunsthist. Inst. in Florence*.

1967

CHIARELLI, R., 'Due questioni pisanelliane: Il Pisanello a Firenze e gli affreschi "perduti" della Cappella Pellegrini', in *Atti e Memorie dell'Accademia di Scienze e Lettere di Verona*.

GENGARO, M.L., 'Masolino e Pisanello in Lombardia e a Milano', in *Arte Lombarda*, XII, 2.

1968

SCHMITT, A., 'Ein Musterblatt des Pisanello', in *Festschrift Ulrich Middeldorf*, Berlin.

DEGENHART, B., and SCHMITT, A., *Corpus der Italienischen Zeichnungen 1300-1450. I, 1-4: Süd und Mittelitalien*, Berlin.

BRANCA, D., *I romanzi italiani di Tristano e la Tavola Ritonda*, Florence.

1969

RIVA, F., 'Il Trecento volgare', in *Verona e il suo territorio*, III, p. 2, Verona.

DONATI, P.P., 'Inediti orvietani del Trecento', in *Paragone*, 229.

ZAMPETTI, P., *La pittura marchigiana da Gentile a Raffaello*, Milan.

PACCAGNINI, G., 'Il ritrovamento del Pisanello nel Palazzo Ducale di Mantova', in *Bollettino d'Arte* (fasc. I, Jan.-March 1967).

PACCAGNINI, G., 'Il Pisanello ritrovato a Mantova', in *Commentari*, XIX, (fasc. 4, Sept.-Dec. 1968).

BRANDI, C., 'Il nuovo Pisanello di Mantova', in *Corriere della Sera*, 27 February.

PACCAGNINI, G., *Il Palazzo Ducale di Mantova*, Turin-Rome.

AMADEI, G., 'Il Pisanello di Mantova', in *Civiltà Mantovana*, 17.

PASSAVANT, G., 'Wiederentdeckte Pisanello-Fresken in Mantua', in *Kunstchronik* XX, 6.

FIOCCO, G., 'Profilo dell'arte scaligera', in *Verona e il suo territorio*, III, p. 2, Verona.

CUPPINI, M.T., 'L'arte gotica a Verona nei secoli XIV e XV', in *Verona e il suo territorio*, III, p. 2, Verona.

1970

HUTER, C., 'Gentile da Fabriano and the Madonna of Humility', in *Arte Veneta*.

PHILIPPOT, P., *Le problème de la Renaissance dans la peinture des Pays-Bas*.

1971

Il Palazzo Ducale di Venezia, ed. by A. Zorzi, E. Bassi, T. Pignatti, C. Semenzato, Turin.

CENNINO CENNINI, *Il libro dell'Arte*, ed. by F. Brunello and L. Magagnato, Vicenza, (earlier Italian editions: G. Tambroni, Rome, 1821; G. and C. Milanesi, Florence, 1859; R. Simi, Lanciano, 1913, reprinted in Florence, 1943).

BAXANDALL, M., *Giotto and the Orators*, Oxford.

1972

DEGENHART, B., 'Ludovico II Gonzaga in einer Miniatur Pisanellos', in *Pantheon*, III, May-June.

LIST OF ILLUSTRATIONS

98. *Enthroned Madonna and Child. Rome, Palazzo Venezia Museum.*

99. *Maestro del Bambino Vispo: Enthroned Madonna and Child with Angels. London, Private Collection.*

100, 101. *Gentile da Fabriano: Adoration of the Magi, details. Florence, Uffizi.*

102. *Limbourg Brothers (?): St. Jerome in his Study. Paris, Bibliothèque Nationale (Fr. MS. 166, fol. A).*

103. *Architectural study. Rotterdam, Boymans Museum (Drawing No. 1, 526r).*

104. *St. Jerome Reading and Statues of Prophets. Paris, Louvre (Drawing No. RF 423).*

105. *Female Nudes. Rotterdam, Boymans Museum (Drawing No. I, 520r).*

106. *Allegory of Luxuria. Vienna, Albertina (Drawing No. 24018r).*

107, 108. *Brenzoni Monument. Verona, Church of S. Fermo Maggiore.*

109. *Serego Monument. Verona, Church of S. Anastasia.*

110. *Brenzoni Monument, engraving by Pietro Nanin.*

111–116. *Brenzoni Monument: Details of fresco. Verona, Church of S. Fermo Maggiore.*

117. *Jan van Eyck: Hours of Milan, Mass for the Dead. Turin, Museo Civico.*

118. *Perspective study. Paris, Louvre (Drawing No. 2520).*

119. *Masolino and assistant: Crucifixion, detail of* sinopia. *Rome, Church of S. Clemente.*

120. *Brenzoni Monument: Candle-bearing angel, detail. Verona, Church of S. Fermo Maggiore.*

121. *Portrait of the Emperor Sigismund. Paris, Louvre (Drawing No. 2479).*

122. *Portrait of the Emperor Sigismund. Vienna, Kunsthistorisches Museum.*

123. *Portrait of the Emperor Sigismund. Paris, Louvre (Drawing No. 2339).*

124. *Portrait of Margherita Gonzaga. Paris, Louvre.*

125–129. *St. George and the Princess. Verona, Church of St. Anastasia.*

130. *Head of a woman. Paris, Louvre (Drawing No. 2342v).*

131, 132. *St. George and the Princess, details. Verona, Church of S. Anastasia.*

133. *Hanged men and two portraits. London, British Museum (Drawing No. 1895.9.15.441).*

134–139. *St. George and the Princess, details. Verona, Church of S. Anastasia.*

140. *A knight, figures of orientals and text in Arabic script. Paris, Louvre (Drawing No. M.I. 1062r).*

141, 142. *Medal of John VIII Palaeologus. Florence, Bargello Museum.*

143. *Lorenzo Ghiberti: The Flagellation of Christ. Vienna, Albertina (Drawing No. 24409).*

144, 145. *Medal of Niccolò Piccinino. Mantua, Museo del Palazzo Ducale.*

146, 147. *Medal of Francesco Sforza. Milan, Civici Musei del Castello.*

148, 149. *Medal of Filippo Maria Visconti. Milan, Civici Musei del Castello.*

150, 151. *Medal of Lionello d'Este. Brescia, Museo Cristiano.*

152–155. *Medals of Lionello d'Este. Modena, Galleria Estense.*

156, 157. *Medal of Lionello d'Este. Milan, Civici Musei del Castello.*

158, 159. *Medal of Lionello d'Este. Brescia, Museo Cristiano.*

160, 161. *Medal of Lionello d'Este. Milan, Civici Musei del Castello.*

162, 163. *Medal of Sigismondo Pandolfo Malatesta. Florence, Bargello Museum.*

164, 165. *Medal of Novello Malatesta. Florence, Bargello Museum.*

166, 167. *Medal of Gianfrancesco Gonzaga. Mantua, Museo del Palazzo Ducale.*

168, 169. *Medal of Sigismondo Pandolfo Malatesta. Brescia, Museo Cristiano.*

170, 171. *Medal of Cecilia Gonzaga. Milan, Civici Musei del Castello.*

172, 173. *Medal of Ludovico II Gonzaga. Mantua, Museo del Palazzo Ducale.*

174, 175. *Medal of Vittorino da Feltre. Florence, Bargello Museum.*

176, 177. *Medal of Belloto Cumano. Milan, Musei Civici del Castello.*

178, 179. *Medal of Pier Candido Decembrio. Brescia, Museo Cristiano.*

180, 181. *Medal of Alfonso V of Aragon (Liberalitas Augusta). Florence, Bargello Museum.*

182, 183. *Medal of Alfonso V of Aragon (Venator intrepidus). Florence, Bargello Museum.*

184, 185. *Medal of Alfonso V of Aragon. Florence, Bargello Museum.*

186, 187. *Medal of Iñigo d'Avalos. Florence, Bargello Museum.*

188. *Horse and knight. Paris, Louvre (Drawing No. 2368r).*

189–191. *The Vision of St. Eustace. London, National Gallery.*

192–194. *Miniatures from MS. E. III. 19 'Scriptores Historiae Augustae. Vitae diversorum principum et tyrannorum a diversis compositae', cc. 114v. 35v., 42. Turin, Biblioteca Nazionale.*

195. *Studies of costumes. Oxford, Ashmolean Museum.*

196. *Head of a horse in tournament armour. Paris, Louvre (Drawing No. 2632).*

197. *Studies of costumes. Bayonne, Musée Bonnat (Drawing No. 141r).*

198. *Studies of costumes. Chantilly, Musée Condé (Drawing No. 3r).*

199. *Madonna and Child with Saints Anthony and George. London, National Gallery.*

200. *Madonna and Child. Paris, Louvre (Drawing No. 2623v).*

201–203. *Madonna and Child with Saints Anthony and George, details. London, National Gallery.*

204. *Scenes of chivalry. Paris, Louvre (Drawing No. 2594v).*

205. *Cavalcade. Paris, Louvre (Drawing No. 2595r).*

206. *Gothic buildings in a hilly landscape. Paris, Louvre (Drawing No. 2280).*

207. *Page, dog, ornamental motives, leg, Gonzaga crest with dog. Paris, Louvre (Drawing No. 2277).*

208. *Ornamental motives, Madonna and Child, two pages, Gonzaga crest with two lions rampant. Paris, Louvre (Drawing No. 2278).*

209. *Sketch of the walls of a castle, two male profiles, 'diva Faustina'. Paris, Louvre (Drawing No. RF 519r).*

210. *Male profile and architectural drawings. Paris, Louvre (Drawing No. 2276r).*

211. *Architectural motives. Paris, Louvre (Drawing No. 2276v).*

212. *Sketch for an altarpiece, male heads and three-faced head. Paris, Louvre (Drawing No. 2300).*

213. *Horse seen from behind. Paris, Louvre (Drawing No. 2444).*

214. *Cloak trimmed with fur and woman looking out of a balcony decorated with medallions. Paris, Louvre (Drawing No. 2275r).*

215. *Sketch of firearms and helmets. Paris, Louvre (Drawing No. 2295r).*

216. *Horse lying down. Paris, Louvre (Drawing No. 2369).*

217. *Man of arms. Paris, Louvre (Drawing No. 2509v).*

218. *Head of a man. Paris, Louvre (Drawing No. 2330).*

219. *Head of a man. Paris, Louvre (Drawing No. 2336).*

220. *Head of a man. Paris, Louvre (Drawing No. 2480).*

221. *Head of a bearded man. Paris, Louvre (Drawing No. 2335).*

222. *Head of a bearded man. Paris, Louvre (Drawing No. 2337).*

223. *Head of a man. Paris, Louvre (Drawing No. 2606v).*

224. *Warrior supporting a pole with his right hand. Paris, Louvre (Drawing No. 2612r).*

225. *Head of a dead warrior. Paris, Louvre (Drawing No. 2595v).*

226. *Head of a warrior. Paris, Louvre (Drawing No. 2616r).*

227. *Young man taking off his jerkin. Paris, Louvre (Drawing No. 2597r).*

228. *Study for a medal with bust of Alfonso V of Aragon. Paris, Louvre (Drawing No. 2307).*

229. *Study for the medal of Alfonso V of Aragon. Paris, Louvre (Drawing No. 2306r).*

230. *Six studies for medallions. Paris, Louvre (Drawing No. 2318v).*

231. *Four studies for medallions. Paris, Louvre (Drawing No. 2318r).*

232. *Ornamental motive. Paris, Louvre (Drawing No. 2538).*

233. *Ornamental motive for fabrics. Paris, Louvre (Drawing No. 2533).*

234. *Study for the reverse of a medal of Alfonso V of Aragon. Paris, Louvre (Drawing N. 2486).*

235–260. *Documentation on the recovery of Pisanello's frescoes in the Ducal Palace at Mantua.*

ACKNOWLEDGEMENTS

The publishers are grateful to the following photographers and collections for the supply of photographic material:

Anelli, Sergio. Electa: 146, 147, 148, 149, 156, 157, 160, 161, 170, 171, 177 and plate XVIII.

Balestrini, Bruno. Milan: 13, 14, 15, 16, 17, 18, 19, 20, 21, 22, 23, 24, 25, 26, 28, 29, 30, 31, 32, 33, 34, 35, 36, 37, 38, 44, 45, 46, 47, 48, 49, 50, 51, 52, 53, 54, 55, 56, 57, 58, 59, 60, 61, 62, 63, 64, 66, 67, 68, 69, 70, 71, 72, 73, 74, 81, 83, 84, 85, 89, 94, 95, 96, 97, 100, 101, 107, 111, 112, 113, 114, 115, 116, 120, 125, 126, 127, 128, 129, 131, 132, 134, 135, 136, 137, 138, 139, 141, 142, 162, 163, 164, 165, 166, 167, 172, 173, 174, 175, 180, 181, 182, 183, 186, 187 and plates I, II, III, IV, V, VI, VII, VIII, IX, X, XI, XII, XIII, XIV, XV, XVI, XVII.

Bandieri, Benvenuto. Modena: 152, 153, 154, 155.

Bildarchiv der Öst. Nationalbibliothek, Vienna: 106, 143.

Boymans van Beuningen Museum, Rotterdam: 103, 105.

British Museum, London: 90, 91, 133.

Foto Lux, Pisa: 75, 76, 77, 78, 79, 80.

Gabinetto Fotografico Nazionale, Rome: 98, 119.

Kunsthistorisches Museum, Vienna: 122.

Museo Civico, Turin: 117.

Museo Cristiano, Brescia: 150, 151, 158, 159, 168, 169, 178, 179.

National Gallery, London: 189, 190, 191, 199, 201, 202, 203 and plates XIX, XX.

Service de Documentation Photographique, Musées Nationaux, Paris: 6, 8, 92, 93, 104, 118, 121, 123, 124, 130, 140, 188, 196, 204, 205, 206, 207, 208, 209, 210, 211, 212, 213, 214, 215, 216, 217, 218, 219, 220, 221, 222, 223, 224, 225, 226, 227, 228, 229, 230, 231, 234.

Sovrintendenza alle Gallerie, Mantua: 1, 2, 3, 4, 5, 7, 9, 10, 11, 12, 27, 39, 40, 41, 42, 43, 65, 82, 86, 87, 88, 99, 102, 108, 109, 110, 144, 145, 184, 185, 192, 193, 194, 195, 197, 198, 200, 232, 233, 235, 236, 237, 238, 239, 240, 241, 242, 243, 244, 245, 246, 247, 248, 249, 250, 251, 252, 253, 254, 255, 256, 257, 258, 259, 260.

INDEX OF NAMES